GW00370424

NORFOLK

THE CLASSIC GUIDE

ARTHUR MEE

AMBERLEY

First published 1940
This edition first published 2014

Amberley Publishing
The Hill, Stroud
Gloucestershire, GL5 4EP

www.amberley-books.com

British Library Cataloguing in Publication Data.
A catalogue record for this book is available from the British Library.

ISBN 978 1 4456 4218 5 (print)
ISBN 978 1 4456 4240 6 (ebook)

Typeset in 9.5pt on 12pt Minion.
Typesetting and Origination by Amberley Publishing.
Printed in the UK.

Contents

PICTURES OF NORFOLK

Green Pastures and Still Waters

NORFOLK is that part of our Motherland which gives such a beautiful shape to the map of England; it throws itself out, we may say, to face the full force of the North Sea.

With nearly a hundred miles of coastline it receives the full power of the great tides sweeping round the north of Scotland, and stands four-square to all the storms that blow across this sea which has been the salvation of our island. It is the land of the North Folk, separated from the land of the South Folk by two rivers. Together with Suffolk, it is known as East Anglia, the east land of the English; it has the proud distinction among our counties of being named after the race that gave our country its name. When the German tribes from the mouth of the River Elbe crossed the North Sea (the Jutes, the Angles, and the Safxons) the Angles came into this part of Britain, which therefore became known as East Anglia before the rest of the country was called England. So the people of this North Sea county changed the name of our country from the Britain of Roman days to the England which has survived (in spite of the Scots) till now. It stands fourth in size among the counties, having more than 2,000 square miles of surface, and being surpassed only by Yorkshire, Devon, and Lincoln. Just over forty Norfolks would fill the map of England.

And for the traveller in search of the English heritage this county is a paradise. It has great cliffs and chalk downs, a history far older than any written documents, delightful rivers, unique still waters, low-lying fens, captivating towns, a historic roll of famous folk, and a group of Saxon, Norman, and medieval churches crammed with the beauty that makes England the matchless country of the world.

The North Sea, beating on its shore, has worn it away in some places and silted up old seaports in others. It is a result of this give-and-take of the sea that Norfolk has only two seaports today, with the width of the whole county between them. They are Yarmouth and King's Lynn, sixty-seven miles apart. The ancient harbours of Cley and Wells are to be sought almost out of sight of the sea at the edge of the chalk which forms quite half of the county. These chalk downs, known as the East Anglian heights, are the continuation of the Chilterns, and are the north end of a range which sweeps like a bow across the southern half of England from Hunstanton with its bold cliffs, and Weybourne on the northern shores of Norfolk, until it faces the setting sun far away in Dorset. This dome of chalk gives the county its highest points, and, though these seldom rise more than 300 feet above the sea, the chalk itself is over 1,000 feet deep in several places.

To the east of the downs still flows the sea that made the chalk; to the west lie the beds of Gault, Greensand, and Kimmeridge Clay with marine reptiles buried in it, the rocks that were old when the chalk was laid down. These are the oldest of the strata in Norfolk, and are overlaid in the far west by the soil brought down and deposited by the Great Ouse, which reaches the sea at King's Lynn, ancient port and captivating town. East of the chalk and overlying it is what is known as the Red Crag and the Forest Beds, with deposits of the Pliocene Age among which we find richly-coloured sea-shells. So we know that a sea warm enough for the coral builder extended over much of Norfolk long ago, while from the presence of the later beds we know that here there was formed a great river estuary after the retreat of the sea. The Forest Beds near Cromer have proved of great importance to the student of early man, for they were formed towards the close of the Pliocene Age and before the first Ice Age covered the county. The period received its name of Forest Beds from the immense number of tree- trunks which probably floated down by a river and were stranded on its mud banks, where they were found with the bones of the sabre-toothed tiger, the cave bear, and the elephant.

Science owes a very great debt to Mr Reid Moir for the years of patience and indefatigable labour he has given to the exploration of this world so much older than history. It is the world of the first men who are known to have lived in what is now England, the shapers of stone tools as old as those found in Kent by Benjamin Harrison of Ightham. They are older than the Ice Age, older than the glaciers which carried here boulder clay and the later sands and gravels across the frozen miles from Scandinavia. The crumbling cliffs round Cromer are made of the material left by the ice when it melted in the warmer climate returning to our country. Even to those of us who grasp little of geology and its significance it is thrilling to think that beneath our feet as we walk about the Norfolk heights are rocks borne here on glaciers from the Arctic North in the days when much of what is now the North Sea, so closely woven with our fate today, was a mass of solid ice.

It is in the low-lying land between these heights and the sea that we find the Broads, an area of shallow lakes on which we may see on any summer's day as delightful a spectacle as greets us anywhere in England.

These lakes that are the pleasure-grounds of Norfolk are what is left of a great estuary once spreading over much of the east of the county—not so long ago as we reckon time when thinking of the changing earth. The waters are made brackish by the inflow of the sea up rivers that run lazily at low levels. They are only about eight or nine feet deep on an average, and are beloved by the water-hen, the kingfisher, the heron, the bittern, and the snipe, which find friendly shelter among the reeds and sedges. The total

area of the waters is about 5000 acres, and it is said that the tendency is for the Broads to grow smaller as the generations pass, though on the coast the tendency is for the sea to encroach, engulfing the villages, of which several have vanished since the Norman Conquest. The Broads are linked up by the rivers, and the greatest of them all, Breydon Water (over four miles long and covering 1,200 acres) gathers the three chief rivers of Broadland before they pass into the North Sea through the sand dunes at Yarmouth.

The longest of these three rivers is the Yare, rising 50 miles away in the middle of the county near East Dereham, flowing to Norwich where it is joined by the Wensum, and becoming navigable for wherries and small steamers for the last 30 miles, most of which is tidal. Before it reaches the sea at Yarmouth's neighbour Gorleston, the Yare has two links with its southern tributary the Waveney, a natural link in Breydon Water and an artificial channel known as the New Cut, which saves many miles for a boat. The Waveney has risen in a fen by the Suffolk border, then running east to separate the two counties for 50 miles as far as Breydon Water, which with the River Yare continues the boundary to the sea. The third big tributary of the Yare is the Bure, which rises near Melton Constable and has a delightful course of about 50 miles, finally joining the Yare at the eastern end of Breydon Water in the very streets of Yarmouth.

The Bure and its tributaries flow through the most beautiful of all the lakes: Wroxham Broad with its 100 acres of lovely water within a short run from Norwich; Ranworth Broad with 150 acres; and Hoveton's Great and Little Broads with 200 acres together. The Ant tributary of the Bure, rising in ponds near North Walsham (so that Nelson probably knew it) flows through Barton Broad's 270 shallow acres to join the Bure near Ranworth Marshes. Hickling Broad of 400 acres (all fresh water), Heigham Sounds, and Horsey Mere, feed the River Thurne, a tributary joining the Bure at the village of Thurne, rising rather curiously on a hill by the North Sea and flowing inland. There is one other tributary of the Bure with the curious name of the Muck Fleet, a link for three big Broads: Ormesby with 207 acres, Rollesby with 240, and Filby with 136, all the delight of the angler. These three Broads formed the eastern arm of the great estuary that gave Norfolk the beautiful region of Broadland, which we owe to the flowing-in of the North Sea to the little hollows of the land in ages past. It is one of the individual regions of our countryside with a character of their own, and has the same temptation to those in search of peace and rest as the Lakes. Nature has been lavish in building up rare forms of life in the Broads and for sportsmen these tranquil waters have a great attraction.

It is perhaps a little odd to see that in this county of many waters only three important rivers flow directly into the sea: the 18-mile-long Stiffkey, on which stands the famous town of Walsingham, the Yare which gives Yarmouth its name, and the Great Ouse which emerges across the county at King's Lynn, where the river pours itself into the Wash. The Norfolk tributaries of the Great Ouse flow west across the county, the first being the Little Ouse, which rises in the same fen as the Waveney but runs the opposite way, going west to form the boundary with Suffolk, picking up the River Thet at Thetford, and becoming the boundary with Cambridgeshire before it flows into the Great Ouse to reach the sea. Two other tributaries bring the clear waters from the downs to the Great Ouse: the Wissey, 30 miles long and rising near East Bradenham, and the Nar, rising near Mileham and entering the sea with the Ouse at King's Lynn. At the extreme west of the county the Old River Nene and the Old Welney form part of the Cambridgeshire boundary, and here, between these derelict rivers and the Great Ouse, south of the Wash, we are in that part of Norfolk so much like Lincolnshire, for it is Fenland.

This extreme west of Norfolk shares with its bordering counties the characteristic problems arising from the low-lying land through which four big rivers pass to pour themselves into the Wash. The river which mostly concerns Norfolk is, of course, the Great Ouse, which was practically a gift to the county by the monks of Ely, for in the days when they were controlling the floods round Ely they cut a channel to take the Great Ouse to the Little Ouse, and so to the sea at King's Lynn. Norfolk, then, has had its share of the romantic age-old fight between land and sea, involving Acts of Parliament to control vast engineering schemes for the reclamation of Fenland and the draining of the fens. Work has been in progress for nearly two centuries at Lynn in order that the channel may be well and truly scoured by the sea. The great John Rennie was one of the engineers whose energies Norfolk summoned for this work, and since the Great War the walls confining the river have been extended into the Wash. One of the pumping stations (at Wiggenhall St Germans) was said to be the biggest of its kind in Europe when it was set up, and it drains 170,000 acres of what is known as the Middle Level Main Drain in about half the time it took before the pump was built. This vast scientific enterprise for dealing with the fens has given Norfolk hundreds of new acres. In medieval days the tower of the church of Terrington St Clement was nearer the sea than it is today, and is soon to find itself farther inland. Walls have been built 700 feet out from high-water mark, the land inside the walls being drained to prepare it for grazing. The existence of the wall causes the sea to deposit alluvium over a thousand feet

beyond, and coarse sand grasses, samphire, and other plants help the silt to settle, so that in due course the area will be ready for reclamation, and the cattle will wander in safety where once the sea-waves rolled.

This winning of fertile land from the sea is one of the natural achievements that stand to the credit of Norfolk, and it ranks with the winning of wood from the wastelands in the region known as Breckland on the Suffolk border near Brandon, the country of the prehistoric Grime's Graves. For centuries this great stretch of sandy heath was left to the rabbits whose warrens spread over it far and wide, but the soil is suitable for firs and pines and has been planted by the Forestry Department, so that today the whole area is well in the running for fame as one of our first National Parks. It was here that the last of the Great Bustards survived up to a century or so ago. Norfolk is fortunate in the number of its rare birds, and two of our most valuable bird sanctuaries have been established at Scolt Head and Blakeney Point, both belonging to the National Trust and each covering 1,000 acres. Other sanctuaries belonging to the National Trust are Bale Oaks, five miles from Blakeney, and famous for its ilex-trees; and Bullfer Grove near by.

Norfolk has made precious contributions to agricultural knowledge in the past, and is still doing so. Coke of Norfolk made Holkham Hall a centre of new knowledge in the eighteenth century and in the twentieth century

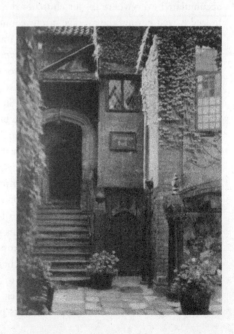

Strangers Hall in Norwich

King George the Fifth began the growing of flax and the development of the flax industry on his Sandringham estate. It is an industry which has become successful at a leap, and King George the Sixth is carrying it on.

It was Coke of Norfolk, the famous Earl of Leicester, who raised the agricultural status of the whole county by the inspired development of his estates in the eighteenth and nineteenth centuries. He lived for ninety years, almost equally in both centuries, and came into possession of Holkham Halt when the estate was falling into ruin after long neglect. One of his tenants refusing to renew his lease at a rent of an acre, Coke opened his eyes to the facts and resolved to farm the lands himself. He sowed wheat on the farms for the first time it had ever grown there, and converted West Norfolk from a rye-growing into a wheatgrowing country. He greatly improved the breeding of sheep and pigs. He spent over £100,000 on reconstructing the estates, raised their rental values ten times, and became renowned as the chief agriculturist in England.

This county of such infinite variety, with so much English character in it everywhere, is in every sense one of the rarest parts of our national heritage. If we look at our map (so curiously like a human skull) we see that it is packed with about 500 villages no traveller can overlook, and they are rich in what this book seeks to describe, the old and beautiful things that have accumulated everywhere in our churches through the centuries. Norfolk indeed is well beyond the average of our counties for its great possessions. If its treasures were more widely known, as much advertised (let us say) as the precious herrings of Yarmouth, Norfolk would be one of the most visited counties in England and none would come home disappointed. If we would come to the scene of the discovery of the oldest pictures made in this country we come to Grime's Graves, the Sheffield of Stone Age Britain, and the long chain of craftsmanship seems never to have broken in East Anglia. Saxon work we find in more than twenty places, and notably at Great Dunham, East Lexham, Coltishall, and Haddiscoe. Norman work we find everywhere. In at least three-score places and ten we come upon noble doorways through which the Normans passed, and among Norman towers the cathedral's is almost without a rival, while that at South Lopham is a superb possession for a village. Walsoken, Wymondham, and King's Lynn have magnetic Norman work. The legacy of the Middle Ages remains magnificent in Norfolk, and the architect in search of impressive and beautiful structures may well bow down and worship before many of its churches.

Thinking of all this beauty the mind leaps to the heart of it all in Norwich itself, Norwich the incomparable city, which all must know who would England know. Not to know this wondrous piece of our Island is for an

Englishman a gap in his education. Far the most attractive centre of East Anglia, it is one of the most attractive centres of Historic England. It is matchless. It has forty churches we have not been able to ignore in our census of what it is necessary for a traveller to see in a tour of its castle and its cathedral both have their origins in the Conqueror's England, and both are unsurpassed. It has history and beauty and surprise everywhere in its narrow streets and winding alleys; we remember turning round to walk again and again up and down these delightful ways, under the overhanging storeys, past the neat white fronts and the little old windows. It has a twentieth century City Hall which puts the City of Westminster to shame, and it has kept its ancient Guildhall. It has so many churches that it has wisely and nobly spared one for a Music House, as rare a place as you would find in England to spend an hour in; and it has another place perhaps unique in name at least—Strangers' Hall, where any stranger instantly becomes a friend.

Norwich has, indeed, whatever holds a traveller's interest among the enduring things that make up our beautiful homeland, and to crown it all it has the Norman Castle set on a hill so that it cannot be hid, and the Norman and medieval cathedral which holds us spellbound down below. It is set in a loop of the river and is one of the jewels in England's crown. The cathedral has a lovely spire which might well have tempted Constable and saved him the journey down to Salisbury; though Salisbury's spire is higher, there is not in all England a loftier or grander Norman tower than this from which the spire of Norwich rises. From east or west it is a noble spectacle. And, majestic as are the cathedral walls, the wonder they enshrine is exquisitely beautiful. The Norman walls rise in stately tiers, the great columns rise with slender shafts, the long vault of the nave has 329 bosses glowing like perfect works of art—and there are 900 more elsewhere, with many thousands of sculptured figures in them. There would seem to be no end to the great possessions of this cathedral, for no man can exhaust them, unless it be the verger who lives his long life with them, and even the verger is always finding something new. Stone screens, arches and vaults, oak stalls, monuments, chapels, cloisters, museum—Norwich Cathedral is a boundless paradise, a central and vital part of our English Scene.

For their rich store of woodwork the churches of Norfolk are unequalled anywhere save in the West of England. It is one of the best counties for screens, with over 200 examples of medieval work among them. Quite half of these have panels with paintings of saints still visible; the best of them we may see at Ranworth, where the screen has lovely fan tracery and portraits of about thirty saints. Other notable screens are at Attleborough and Upper

Sheringham (both with lofts), Cawston, Barton Turf, Filby, Tunstead, and Worstead. The churches are famous also for the splendour of their medieval roofs. The roofs of the cathedral are, of course, beyond compare, but other roofs of rare beauty are at Knapton, with 140 figures, and at Carbrooke, Cawston, Gissing, Hartley, Necton, Tilney-All-Saints, Wymondham. The fonts are a fine collection. There are Norman fonts at Sherborne, Toftrees, Sculthorpe, and South Wootton in North-West Norfolk, all the work of the same sculptor; and notable ones at Fincham, Burnham Deepdale (with carvings of the months), Stalham (a mass of carving), and Trunch, where the cover of the font is like a miniature cathedral spire. The Norfolk brasses are many in number and fine in quality; two at King's Lynn have every inch covered with Flemish engraving and are without a rival. Erpingham has the magnificent brass of Sir John Erpingham; Felbrigg has one with Richard the Second's standard-bearer holding the royal banner of England; at Hunstanton is the wonderful brass of Roger Lestrange in his heraldic tabard and with eight weepers in niches; and at Ingham is the brass of Sir Brian de Stapleton, with a pet dog named Jakke which is known to all antiquaries because it is one of only two pets named on a brass (the other is at Deerhurst in Gloucestershire). Wiggenhall St Mary the Virgin has benches which many believe to be the best fifteenth century benches in England, and there are other fine ones at Tottington, Wiggenhall St Germans, and Forncett St Peter. There is beautiful old glass at East Harling, Martham, Wiggenhall St Mary Magdalen, and St Peter Mancroft in Norwich—a church which even in

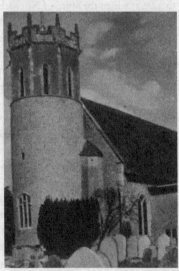

The tower at Acle

Norwich city stands out as something supreme. At Beighton is a richly carved oak chest believed to have been the treasure chest of an Armada ship, and other grand old chests are at Dersingham and East Dereham. At Burnham Thorpe, the village of Lord Nelson, the cross and lectern are made from the timbers of Nelson's *Victory.*

Norfolk, of course, has the King's country home, 14,000 acres of meadow, villages, and woods, and hundreds of thousands of our people know Sandringham, a model to all England for its neatly kept roads, and a delightful place for those who manage to see the King's gardens on one of their open days. The little church is full of interest, set in the park within sight of the great house built by Edward the Seventh. Cromer, the town set on the noble cliffs washed by the North Sea waves, has the highest tower in Norfolk after the cathedral; it soars 160 feet up, a landmark in this town known to so great a multitude. Yarmouth, with its sea-front five miles long, is one of England's greatest playing-grounds, and is in itself a captivating old fishing town, with magnificent sands and much to see. King's Lynn, the marvellous town of a thousand years, has lost the sea but has kept its irresistible enchantment; it stands like a stout old burgess keeping watch over the mouth of the Ouse. Little Walsingham is once more what it was for centuries, a place of pilgrimage; its restoration has brought to it a long procession of those who are moved by the thought of our legendary past. It is a long procession, too, that comes and goes at Castle Acre and Castle Rising, where Antiquity and Tranquillity abide together. So it is at Binham Priory, with its glorious west front. Blakeney has kept its Guildhall, its quaint houses, and its splendid old church. Holkham has the great hall in which Coke of Norfolk lived, still packed with treasures and clothed in loveliness; East Barsham has its beautiful Tudor Hall; the fascinating market towns of Holt and Diss and Thetford have a claim on every traveller; and Blickling has the home of Lord Lothian, the House Magnificent, set in gardens like a dream; a matchless spectacle it is of Jacobean England.

Norfolk, we see, is of the spirit of which England is made, as historic as it is beautiful. But far back beyond the reach of History it goes. If we come to the Suffolk border near Weeting we find ourselves in the presence of something that must stir any Englishman who has a soul to stir. We are at Grime's Graves, a centre of life before history was written, before England was heard of, before Greece and Rome had begun to be. Here are hundreds of workshops of Stone Age men, in which have been found charcoal from fires, engravings in flints, cooking vessels, and workmen's tools. Here, layer over layer, have been the witnesses of life from age to age. At the top lay the pottery of the Romans, below it the pottery of the Iron Age, and below

that the charcoal from the fires of the Bronze Age men; some of it is on our desk as we write, a relic of the life of man in England forty centuries ago. Next appeared the flints on which the clever fingers of men thousands of years before the Bronze Age had sketched the pictures of the animals they knew, one of them a wonderful drawing of an elk. It is perhaps the oldest known picture made in these islands, and the artist may have imagined that the best way to kill the elk was with the magic picture stone. All this wonder has been brought to light in our time by Mr Leslie Armstrong.

All this comes to the mind as we stand here in the middle of East Anglia, witness of the Ice Age, land of the English from the German Elbe, our bulwark against the buffetings of the sea, home of men of imperishable fame, and as fine a piece of England as God and man have made together anywhere.

Acle

Its invigorating air is a reminder that the sea is only eight miles across the marshes. Old thatched houses and cottages with bright red tiles surround an open space, and the attractive Queen's Head Inn has great oak beams in the low roofs of its parlours. A mile from the last group of steeply gabled cottages is Acle Bridge spanning the River Bure, embodying the three arches of the old bridge so familiar to yachtsmen and anglers, for Acle is one of the gates of Windmill Land. To every broadsman who quants his wherry along the slow rivers Acle Bridge is a haven or a port of call, and many are the little ships of adventure which lower their masts and sails to pass beneath. Here summer nights are as gay as a Venetian gala.

The fine old church is a landmark with its round Norman cobblestone tower, crowned by a fifteenth-century belfry, and looking down on the thatched roof of the nave. Eight figures look out from the battlements of the tower, one with a crown and one with folded wings, all imposing when contrasted with the impudent gargoyle faces under them. Those facing the sea once looked on to a small priory founded by Roger Bigod.

A shady walk under the limes leads to a fine north porch with an upper room, and decorated with 500-year-old sculpture, a saint at prayer in a niche, and in the spandrels carving of roses and kneeling figures of a man and a woman with rosaries; the figures may be the builders of the porch a few years before Agincourt.

Alburgh

Its old church is a landmark as it stands on the edge of the village, with a strikingly tall tower; its houses are on the edge of the fields; and about

a mile away is the River Waveney, the boundary with Suffolk. Lilacs and laburnums bloom in the churchyard, and battlements and pinnacles crown the 500-year-old tower. The nave is as old as the tower, and the chancel a century older.

Alby

Its scattered houses are within sight of the lovely woodlands of Gunton Park, and the fifteenth-century tower of its handsome church rises high above a group of sycamores and chestnuts.

Aldborough

It has cottages grouped round the green, a watermill by the River Bure, and a church with a statue of the Madonna in a medieval niche over the porch. In the church are portraits in brass of three village folk of 500 years ago. Outside can be traced the foundations of the vanished Norman tower, now replaced by a curious bell turret.

Aldeby

Here, where the River Waveney divides Norfolk from Suffolk, the road that winds through the marshy fields climbs up the hill to the inn, a cluster of red-roofed houses, and their church, with rich plough-land all round.

The rambling, odd-shaped church, looking its best outside, has something from Norman days. The tower stands between a twelfth-century nave and a chancel of about 1,300, its side arches opening on to a 700-year-old transept 33 feet long. The 100-feet nave, so long that an extra altar stands under the tower, has the finest thing here in its beautiful Norman doorway, with capitals on triple shafts and fine zigzag in the arch. The nave has also a Norman window, with old glass showing flowers.

Anmer

The King's Avenue of lovely trees leads to this wooded village on the Sandringham estate, with its few farms and cottages and a fine park sheltering the church and the sixteenth-century hall, companions in a charming setting. The hall has a two-storeyed porch, and low pantiled roofs crowning walls hung with ivy and wistaria.

Antingham

It has a big pond from which the River Ant rises to begin its busy journey to Barton Broad, and a churchyard in which two churches stand side by side. St Margaret's has Norman masonry among the ivied ruins from which the

fifteenth-century tower still rises proudly; St Mary's, which keeps the village treasures and still does service, comes chiefly from the fourteenth century.

Arminghall

It has only a hundred people, and a tiny church L at the corner of a lane, but an aeroplane flying above it a few years ago has brought it fame.

Like most of the church, the tower is thirteenth and fourteenth century; some windows are fifteenth, and the porch is new. An oak arch divides the nave and chancel, and built into the modern stalls are parts of medieval poppyhead bench-ends, edged with flowers and leaves.

Curious markings on a photograph of a field near Arminghall, taken from an aeroplane in 1929, showing eight dark patches within a broad ring like a horse-shoe and a narrower outer ring, have led to the discovery here of a second Woodhenge—an oak temple thirty-five centuries old around which chieftains of the Bronze Age were buried in barrows.

Ashby St Mary

It is one of the small neighbours of Norwich, where we found Darby and Joan in a churchyard shaded by firs and oaks, and a beautiful Norman doorway leading into its trim little church, which has a high flint tower rising above mellowed red roofs.

Ashill

About its high ground the Romans drew the lines of an encampment, and traces of its occupation are still found in the soil. The pleasant winding Ashill of today has a great common, a big pond round which the houses cluster, and a goose green where you may pasture your geese if you live in this village and do not pay more than £5 a year for land or tenement.

At one end of the village is the low flint church with a fourteenth-century chancel, and a stout tower of the same time with gargoyle heads, entered by a west doorway with fine mouldings. The rest of the building is mainly thirteenth century.

A memorial to John Cotton of 1696 and his son Robert recalls a famous name, for they belonged to the family of Sir Robert, the antiquary who founded the Cottonian Library. A poignant memory is in two Flanders crosses, one torn with shrapnel.

Ashmanhaugh

It lies about a green at the meeting of two lanes, and has a tiny church dedicated to St Swithin, who is remembered less for his saintliness than

for his place in weather lore. Its one possession of distinction is the round Norman tower, the smallest and lowest in Norfolk.

Ashwellthorpe

It has cottages and farms with cream and rose-coloured walls, a quaint little church climbing from east to west by the wayside green, and a fine Elizabethan hall, now modernised and looking out on terraced lawns.

The great house was the home of the Knyvets, many of whom lie in the church. A treasure of the church is the handsome alabaster tomb with the fine figures of Edmund de Thorpe and his wife, perfect except that it is marred by the initials of many louts.

The lofty and compact church in which they lie has a fifteenth-century nave lit by great windows between a fourteenth-century chancel and a fourteenth-century tower. On the walls is a medieval mass dial.

Aslacton

Like a sentinel looking out from the hill to a pleasant countryside stands a round weathered tower from Norman England. It rises above a pretty little church which has Saint George and the Dragon over the doorway of a fifteenth-century porch, and an old door letting us in to see the massive arch of the tower and a nave arcade rather overpowering in this small place.

Attleborough

Pleasant with a small green shaded by trees, with old houses and a fine old church, this small market town of less than 3,000 folk clusters round the crossing of two highways and hears the curfew twice a day. Between the town and Old Buckenham is an ancient earthwork overgrown by trees, known as Bunn's Bank.

The church is a squat pile, full of ancient story and of an unusual plan. Saxon foundations are still to be seen, and a square Norman tower, once the central tower of a great Norman and medieval church, now rises at the east end, only a little higher than the clerestoried nave.

The whole of the eastern part of the great church was appropriated for the use of the College of the Holy Cross founded by Sir Robert Mortimer in the closing years of the fourteenth century, and was destroyed at the Dissolution of the Monasteries by the Earl of Sussex, who took the lead roofing and the marble stones and brasses of his ancestors for use in his manor house.

The striking possessions of the church are the lofty arcades and the arresting screen, which, after being for about a century at the west end, is now in its rightful place, stretching across the nave and aisles in front of the

tower and the chapel arches. The screen is one of the precious possessions of our English churches. It comes from about 1500, and still has its fine traceried loft from end to end, adorned along the front with brightly coloured shields of the English dioceses as they were painted on it soon after the Reformation.

Aylmerton

It lies in a valley sheltered from northern blasts by a hill with wooded slopes and glorious vistas, now in the keeping of the National Trust. Here among the oaks and heather is an enclosure called the Roman Camp, and near it are hollows called Shrieking Pits where men of the Stone Age lived. A strange community this must have been with its circle of huts below the hill, for it has been calculated that there were nearly 2,000 of these pits before cultivation levelled most of them.

The church on the hillside is a lofty fifteenth-century building with a round tower 700 years old. Over the porch is a priest's room which can be entered through its original ironbound door in the nave; the last priests to use it served the chantry chapel which is now an ivied ruin on the other side of the chancel.

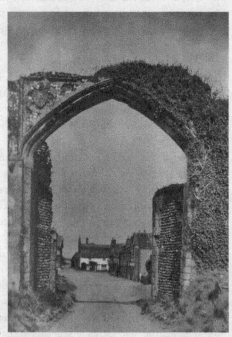

Through the priory
gateway at Bacton

At the cross-roads beyond the village is a tall wayside cross recalling quieter days when it was the halting-place for pilgrims to the shrine at Walsingham.

Aylsham

Along these streets winding down to the River Bure L old John o'Gaunt, time-honoured Lancaster, would ride with his rich retinue, for in the Guildhall of this town of wool and worsted he held the court of his Duchy.

Tradition makes him the founder of the church, and certainly he must have seen the arches of its nave rise up in splendour. After his death the town's rich burgesses raised the high tower and added the aisle, the chancel, and the transepts. Then they gave the church one of the finest fifteenth-century fonts in England, with the lion of John o' Gaunt among the heraldry carved in the pedestal, above the encircling roses on the base.

Babingley

None should pass Babingley by, for King and Saint have had it in their care. Its few people go to the simple church given them by Edward the Seventh, when their old church became unsafe for use. It is a charming picture with its thatched roof and shingled bell-turret, ivy and flowery creeper happily hiding its iron walls; and it stands at the cross-roads by Sandringham's lovely woods, splashed with the purple of rhododendrons.

From the main road we see the old church ruined and lonely in the fields, but its story is a proud one, for it is said to be on the site of the first Christian church in East Anglia, founded in the seventh century by St Felix. The ruined walls (with Norman masonry in them) are heavily draped with ivy up to the eaves, and are now a sanctuary for birds. They are mainly fourteenth century. Two arches stood in the aisle and the tower stands bravely above the battered roof of the nave. One broken stone coffin still stands in its recess and another at the west end.

Not far from the old church, in meadows which were white and gold when we came, is the beautiful old manor house with a stepped gable and a porch with an upper room. Now it is a farmhouse, with water lilies and golden iris growing in the moat. By the main road is the stump of an ancient cross which marked the boundary of a deer park extending from Castle Rising to Sandringham.

Baconsthorpe

Here above the wooded valley of the River Glaber the old Norfolk family of the Heydons built their hall and beautified the church which keeps alive

their memory in brass portraits, monuments, and windows. The church has a screen which has been rescued from the obscurity of a village loft at Bessingham; it was carved with merry cherubs 500 years ago and is now used to form the organ chamber.

Bacton

Past the cottages on the coast road, past the avenue of beeches and sycamores leading to the church, is all that remains of a priory famous in its day, to which we come through a gatehouse set here by the Normans and crowned by our medieval builders, the way King Henry the Third came when he visited Broom-Holm Priory in 1233. Facing the gate is the farmhouse where the guests of the monks used to lodge. In the Middle Ages this was a priory of widespread fame, when innumerable pilgrims came here to gaze on what was reputed to be a fragment of the Cross. The Miller's Wife in the *Canterbury Tales* cries, 'Helpe, Holy Cross of Bromholm', and Piers Plowman cries later, 'Bid the Rood of Bromholm bring me out of debt.'

Bagthorpe

It has only a sprinkling of homes, and a tiny church by the lovely trees of the park, in which is the fine hall. We remember the church (which was made new in the middle of last century) for its beautiful lawn outside and for its font within. The low square bowl with corner shafts, adorned on one side with a circle and interlacing work, show that the font comes from early Norman if not Saxon days, but it rests on a modern base. The pulpit, with quaint carved figures of the four Evangelists, is interesting for being local work, and is made from the wood of the park trees. Oddly near it hang the ropes for ringing the two bells housed in a turret over the chancel.

Bale

Long red barns, a farm, and some cottages keep company with the modest little church, and facing it on the green is a noble company of twenty-one evergreen oaks rising as high as the tower and making perpetual shade. Most of the old work, including the tower, is fourteenth century, and the chancel is a century older.

Banham

It is a village of old and new, running along the twisting road from Attleborough to Diss. At one end of it a fine chestnut tree rises from a green patch, and on each side of the green in front of the church are long rows of stately limes. Very attractive are the old houses, some with thatched roofs,

some with overhanging storeys, and one with Dutch gables. In the middle of the green is the peace memorial cross, mounted on steps and outlined against the sky, and behind it a lead spire with a bellcot rises from the tower of an imposing flint church. There is a charming peep of the spire in its trees from the old hall on the edge of the village, an Elizabethan house with gables and a wet moat overhung with yews.

The church is largely fourteenth and fifteenth century, with gargoyles on the tower, flowers on the doorway of the splendid porch, and an old sundial. Inside, a fine old roof with massive tie-beams looks down on a nave with lofty arcades on clustered columns.

Banningham

In its rectory lived the writer of one of our most moving hymns, *Peace, perfect Peace*. He was Richard Cleary, who died at Cannes in 1907. A Spanish chestnut throws his shade before the windows of his old home, and close by is the charming fourteenth-century church with a mantle of thatch. ...Three of the windows have lovely medieval glass in the tracery.

Barnham Broom

When the lord of the manor built his house by the Yare in the seventeenth century, naming it Hauteyn's Hall after himself, the rushes grew so thickly by the river that the place was called Barnham Ryskes. The yellow broom has outgrown the 'ryskes' and given the village its new name, and the hall is now a rambling farmhouse in the fields. We see it from the road as we come to the fifteenth-century church, framed by a fine wood.

Barningham Norwood

It has a few farms and cottages and a lonely church with a font to which the village folk have brought their children for many generations. There is a Jacobean pulpit beautifully carved, and monuments to the Palgraves who lived for centuries at the hall down the lane, the earliest of them being a brass to Henry Palgrave, in rich Tudor armour with his wife and twelve children.

Barningham Winter

At the very heart of it is a park with rolling turf and age-old trees about the Jacobean hall which Sir William Paston built in 1612. From a lake near it a stream begins its journey to the River Bure, and the church is in a meadow beyond; its tower and nave in ruins but with an evergreen mantle of ivy which makes them a lovely portal to the medieval chancel where the services are held.

A medieval mass dial is on the wall. There is a remarkable nineteenth-century dovecot at the Hall Farm; it has been ingeniously attached to the gable of a granary.

Barton Bendish

Trees border the roads in this scattered village of the byways, where two churches have stood 600 years little more than a field apart. More remarkable still is the fact that it had three until All Saints was pulled down, much of its material used for roads and for repairing St Mary's.

Behind tall elms and limes stands the simple church of St Andrew, with a short tower, and a very old door opening to lead us in. Near the rood stairway is a canopied niche with panels of tracery. The old font has a modern stem. On one side of the nave are low Jacobean pews. Old tiles by the altar have flowers and shields on them, and the canopied piscina has leaf tracery.

St Mary's is buried in trees facing the old rectory, a cypress and a fir towering over it like sentinels. The fine little Norman doorway at the west end, with carved shafts and an arch with beakheads under a hood, was brought here from the lost church of All Saints. On its door is an ancient ring.

Tiny and trim, the church is hardly more than 15 feet wide inside, where a faded painting of St Catherine bound to the wheel stands out on the cream wall. On the splay of the south doorway is faintly seen a crowned head. The priest's doorway has a canopy outside, and on each side of the vestry doorway are the heads of a man and a woman in square headdress. A window-seat served as sedilia, and in the wall below it is a band of panelling with flowers in quatrefoils. Four plain benches and the small altar table with simple carving are 300 years old, and a worn coffin stone by the altar marks the grave of a fourteenth-century rector.

St Mary's tower fell in a storm early in the eighteenth century, and the bellcot now housing the bell is one of the memorials to the Berneys, lords of the manor in the time of Charles the Second. Their hall has clustered chimneys and stepped gables.

Here was born a Speaker of the House of Commons who entered into history as one of the bulwarks of the House of Tudor while the future Henry the Seventh was still a hunted exile. He was Sir Thomas Lovell, and in the first Parliament after the victory at Bosworth Field he was made Chancellor of the Exchequer for life. In the struggle to dethrone Henry and set Lambert Simnel on the throne Sir Thomas took the side of the king, and the king, having kept Lambert Simnel as a scullion in the royal kitchen for some years, handed him over to Sir Thomas in whose service he became a falconer.

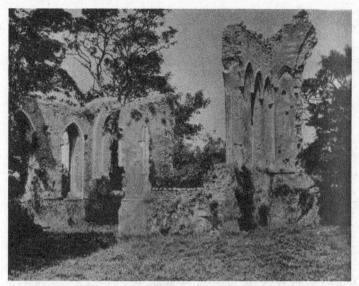

The ruined priory at Beeston Regis

Barton Turf

Here the River Ant widens out into the 300 acres of one of the loveliest broads of Norfolk, fringed with reeds and haunted by wild fowl. The medieval tower of the big church stands out boldly in the flat countryside, and it has a rare possession in one of the few actual portraits of Henry the Sixth, painted in a yellow robe with the orb and sceptre, on one of the panels of a fifteenth-century screen.

Bawburgh

We see the pretty church from afar, peeping from trees on the hillside. Its round Saxon tower wears a red conical cap from which rises a post tipped with a golden flame, and it looks down on the bright red roof of a nave with stepped gables. As we draw nearer, the red roofs of the houses come into view, one old gabled house so low that its roof is little higher than the church gate, magnificent beeches keeping both of them company. The village is like a horseshoe in the valley of the Yare, with the mill at one end, the church at the other, and the bridge at the bend.

Here St Walstan was born, here he lived and was buried, the son of Benedict and Blide, who sent him to work on a farm at Taverham a few miles away. There he found God among the furrows, and grew up to be so holy a man that he became the patron saint of all who till the soil, and made

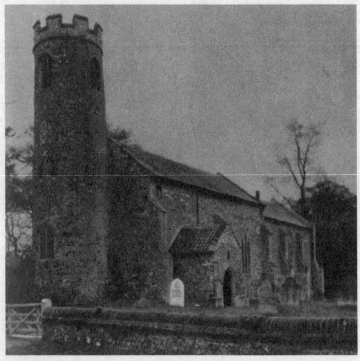

The church with its round tower at Beeston St Lawrence

Bawburgh famous as a place of pilgrimage. The shrine was on the north side of the church, and was destroyed in the time of Henry the Eighth and Thomas Cromwell, when the saint's bones were burned and scattered.

The church looks its best outside. The old porch has a mass dial at the side of the creepered entrance arch, and there is rosemary on each side. The windows are fourteenth and fifteenth century, and all in the nave have fragments of old glass showing crowned heads, shields, pinnacles, angels, and a woman saint. The old sedilia and piscina are still here. The much restored fifteenth-century chancel screen has rich old carving in the base and a new vaulted canopy; and over it is an arched beam with traceried spandrels which may be sixteenth century.

Bedingham

The main road passes it by, all the better for its peace. The old church has for a neighbour the priory farmhouse, picturesque with gables and a fine old stack of chimneys; and by the little stream below the church is an inn with a very curious painted sign. It is called the Triple Plea, and shows three

men arguing over the body of a woman, the Law represented by one with a sword, Physic by a doctor, and Divinity by a priest with a book. Behind the three is the devil himself, waiting for a victim. The round tower of the bright church was built by the Normans, and the fifteenth century topped it with a belfry. There are two Norman doorways, but the rest of the old work is for the most part as young as the belfry (which is now leaning).

Beechamwell

A village of a thousand years, it lies among fine woods, the Scots pines pointing the way to the ancient earthwork west of the village. Known as Devil's Dyke, it is nine miles long, from Narborough to Caldecote.

The modest church of St Mary is the one survival of three churches that once stood here, a proud and ancient group. The east wall of another still stands south of the village, and the ruinous tower and walls of the third are near the fine hall in the park. The Saxons built the round tower of St Mary's a thousand years ago, and gave it a double-gabled window with a baluster between the lights, and the crude round arch inside. The fourteenth century added the octagonal belfry. There is long-and-short work in the north-west corner by the tower. The continuous nave and chancel, under a thatched roof, are divided from the aisle by a medieval arcade running the whole length. Bright light streams through clear glass in most of the windows. By the entrance of the battlemented porch is the basin of an old font and part of a coffin lid.

Beeston

Lonely by the wayside, its only companion a house a field away, is the surprisingly big church of this scattered village of the byways. Built in the fourteenth century, with a tower and spire made new in 1873 after being burned by lightning, it is a fine place outside and in, reflecting a still greater splendour of days gone by. The fine roof growing from the fifteenth-century clerestory has battered figures on the hammerbeams and on the supports between the windows. A battered old roof looks down on the north aisle.

Beeston Regis

Between Sheringham and Cromer and close to the sea, it has on a farm the ruined fragments of a priory of the time of Magna Carta. Its 600-year-old church has a fine un- buttressed tower with small flints paving its porch, and with many heads looking out from its walls. There is also a medieval mass dial. In the church is a brass portrait of John Deynes, who worshipped here in Tudor days; he is as bold as brass can make him, with his

wife beside him but with a pistol dangling from his neck. There is an Elizabethan altar table, and a delightful bench-end with a crouching hare, but the chief interest of the church is in its sixteenth-century screen with twelve painted saints. In the spandrels are bats and eagles, with gilt flowers, and above them is a delicate frieze.

Beeston St Lawrence

It has a little round thing and a great round thing, the little one treasured at Barton Hall, the big one built by the Saxons, for it is the round tower of the church, which has Saxon stones in its rough walls, an ancient scratch dial, and the impressive altar tomb of Jacob Preston, who lived at the hall in Charles Stuart's days and was loyal to the king. When the Scots surrendered Charles to Parliament four gentlemen were appointed to wait on the king, and Jacob Preston was one of them, and when the king's treachery led to their withdrawal from his service Charles gave a ring to the faithful Jacob, who brought it home to Barton Hall, where it is cherished to this day.

Beighton

If we take the fir-lined road to the fourteenth-century church on its low hilltop, with trees and a pond keeping it company, we find a link with Queen Elizabeth's day. It is a fine old oak chest, said to have been the treasure-chest of some ship that fell in the Armada, a rich example of poker work, though its colour is faded now. In the elaborate decoration covering its front, the ends, and the lid, are knights in armour, a courtier in jerkin with wide collar and breeches tied with bows, and the pictured story of Susanna and the Elders. The two Elders are tied to a tree to receive their punishment pronounced by Daniel.

A laburnum by the porch was like a shower of gold when we came to the church, with its finely thatched nave, and a massive tower with the Four Evangelists for pinnacles. A traceried door lets us inside, where tall arcades divide the clerestoried nave from the aisles. On the south aisle wall is an old consecration cross. The chancel has lovely sedilia and piscina, and fine Elizabethan candlesticks.

Belaugh

It has pretty lanes, and its small church is on the crest of a hill about which the dwellings gather. As we stand in the churchyard, with Broadland at our feet, we see the River Bure twisting in loops on the way to Broads far away. Into the view the tower of another church comes peeping from some hidden retreat in this lovely wooded valley. The walls of the church have Norman work in them, and from the Normans comes the font, with a round bowl. The nave arcade and

part of the chancel are fourteenth century, and the rest of the church, including the fine tower with panelled battlements, sound-holes, and turret staircase, is late fifteenth. There is a seventeenth-century table at the west end.

Bergh Apton

It has its roots deep in the past, for here the Romans pitched their camp, and in that camp the English built their cross-shaped church. It stands on the mound which Caesar's legions either found or raised in this place. We imagine they found it here, for near it have been discovered Bronze Age swords and the burial urns of the earliest fighting tribes of Eastern Britain.

Standing finely on its hill, the church looks out on a wooded countryside a mile from the village. Its nave and tower are fourteenth century except for the battlements. It has little for us to see, but there are two Jacobean chairs with quaint faces in their mass of carving, and a magnificent font with angels round the bowl, more angels under it, and men and lions round the stem.

Bessingham

Here men have lived and died nearly twenty centuries, for in a mound Roman pottery has been found, and in the church are Roman tiles found lying about by Saxon builders who put them where we see them. They frame a niche in the porch. The round flint tower has stood a thousand years and has the characteristic Saxon window with twin-pointed lights. It is a Saxon arch that leads us from the tower into the nave, a narrow arch with a remarkable pointed opening above it. Tire roof of the nave, supported by fourteen angels, is 500 years old, and there are four bench-ends with poppy-heads probably made by the same craftsmen. The plain font is also fifteenth century. In the park stands the great house which has succeeded the manor house of the Bessinghams.

Besthorpe

Its lonely church, enshrining much that is lovely, has an Elizabethan hall for its neighbour, and looks over the fields to scattered cottages and an old windmill. We see the hall from the churchyard, a red brick house built by Sir William Drury in 1590, but now much altered. There is a fine chestnut in its garden, and the walls of the old tilting ground. Sir William died in 1639 and has a fine monument in the church, where he lies in armour on a mat, one hand on his sword, the other supporting his curly head.

Coming from late in the fourteenth century as it stands like a cross with a tower at the west end, the church is filled with light from splendid windows, those of the chancel very fine.

The nave at the priory church at Binham

Bexwell

By the main road from Downham Market a few cottages and a farmhouse cluster shyly about a handsome old rectory and an old church big enough for all the village folk.

The round base of the tower, which some believe to be Saxon, has an arch opening to the nave, and a ring of Norman windows below the octagonal belfry. There is also a Norman window in the church, and another blocked. The west window is as old as the belfry, fifteenth century.

On an old road from Bexwell to Downham Market stood a way-side shrine; now there is only an overgrown footpath, but where bygone generations paused to pray is something else holy, a memorial raised by two fathers to their sons. In September 1915 the son of the squire of Ryston Hall (close by) gave his life for his country, and exactly a year later the eldest son of the rector of Bexwell fell while leading his men. A white cross, resting on the old lichen-covered stone remaining from the ancient shrine, is their memorial, and the wooden cross of one of them is in the church.

Billingford

It will seem to us right that a Francis Drake has been sleeping in this churchyard for a hundred years and more, a kinsman of the famous family whose name he bears. There were four Flowerdews in the war, carrying on,

with five Blomfields and four men named Race. It is a proud village that remembers them, Billingford a little way from Diss, with a church set on a hill among the trees, looking down on the cottages, the inn, and the old windmill. The old tower of the church fell down last century, and only the lower part remains with a red cap just topping the nave. Its lofty arch reaches almost to the rafters of the old nave roof, the battered porch shelters a door carved with roses by a medieval craftsman, and there are Tudor flowers on another old door which led to the priest's room in other days. From the floor by the neat Jacobean pulpit (still with its hourglass stand) the steep narrow roodstairs with original oak treads lead to their lower doorway in the splay of a fourteenth-century window, and up to the second doorway above the pulpit canopy.

The church is still, in our Electric Age, lit by candles, but it has a pure and shining light of memory; how far a little candle throws its beams, so shines a famous deed in this dark world.

Billingford

It is near East Dereham. Two houses recall the old story of this village of a long trim street with orchards and cottages, a few of them in the lane by the old church. High House, a farmhouse now, is on the site of a burial mound in which a Roman urn was found. Half a mile from the church is the ancient Beck Hall, surrounded by a well-filled moat, and having in the gardens a splendid box hedge about 40 yards long and 20 feet wide. In olden days it was Beck Hostel, where poor travellers who came this way found rest and succour. In the next century there came to live in the village Sir Simon Burley, a favourite of the Black Prince, minister and ambassador of Richard the Second, for whom he had the honour of bringing Anne of Bohemia to England to be queen. But honour and wealth passed from him, and he died far away from Billingford, losing his head on Tower Hill. Much of the fine lofty church is of his day, with some remains of the thirteenth and fifteenth centuries. The tower is octagonal and embattled. Two fine arcades with clustered pillars divide the nave and aisles, and over them are the quatrefoil windows of the clerestory. There are two piscinas, a fine medieval font with a bowl set on five pillars, and fifteenth-century tracery and old poppyheads on the benches. The lectern is a great metal eagle with four lions at the foot. It is perhaps over 400 years old, and is said to have come from the same foundry as the eagle in Peterborough Cathedral.

Binham

Long barns and old cottages with lovely roofs gather round the green, where among elms and chestnuts the shaft of the old cross stands finely on its great

The church with two towers at Blakeney

base. From the green we have a peep of Binham's great heritage, the remains of the famous priory founded here 800 years ago and left ruinous at the Dissolution. The nave was spared because it was used as the parish church, and it has so continued. It is only about a sixth of the original church, which had the shape of a cross and a central tower, but it is a noble fragment, a splendid tribute to its Norman and medieval builders.

Through the ruined gatehouse the glory of the west front is before us. Built by Prior Richard de Parco 700 years ago, it has rich arcading on each side of a doorway with beautiful mouldings, and a great window, mostly bricked up. The bellcot crowning the gable is original.

As we cross the threshold of this church among the ruins we are arrested by the magnificence of the lofty nave, with tier on tier of Norman arches in massive walls. The arches of the triforium resemble those of the blocked arcades. The round-headed windows of the clerestory are plain outside, but inside the arch of every window is between smaller arches on detached pillars. The aisles have gone. By lowering the floor to its old level restoration has exposed the bases of sixteen Norman and medieval pillars. A massive stoup on one of these, the fourteenth-century sedilia, and an altar piscina were almost covered till the restoration, which has also brought to light a fifteenth-century doorway and stairs leading to the triforium, a doorway to

a chantry chapel, and four altars with their great stones.

The pillars that supported the tower are here, and the transept remains are now exposed, with the lady chapel, the chantries, and the choir. What is left of the monastic buildings is coming to light after being long buried under grassy mounds, and the fishponds are still by the little River Stiffkey.

Bintree

One road brings us to cross the River Wensum by a watermill, another leads us by an avenue of great trees to a 600-year-old church with two relics from the church before it. One is the richly traceried thirteenth-century font, the other a rare Norman pillar piscina about 20 inches high, with a carved capital. On the altar is a lovely silver crucifix brought home from France by the rector, who was a chaplain with the Fifth Army.

One bad thing the village has to keep company with these good things, for it still has its ancient whipping-post.

Bittering Parva

Its people are few, and its thirteenth-century church stands alone in a field, looking rather like a barn with cattle grazing under its red-roofed walls, for there is no churchyard. A field away is the white-walled rectory in the trees. One bell hangs in its turret. The nave and chancel are 51 feet long and 18

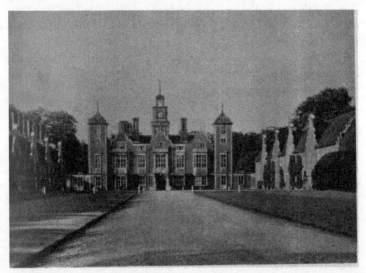

The Jacobean Hall at Blickling

feet wide, divided by an old oak screen. The chancel has its old east window of three lancets. On the stone seat for the priest is a piscina. The round font on five pillars comes either from Norman days or soon after, and of three ancient coffin stones one has a cross-head at each end of the stem.

Bixley

A shady lane brings us to the church on the edge of a field of oaks, and gives us a sight of the cathedral spire three miles away. The churchyard is brightened by clumps of gold in daffodil time, and it has a ring of firs growing taller than the tower.

The tower comes chiefly from the thirteenth century and has no belfry windows other than small sound holes. The rest of the plain little building is nineteenth century, and has taken the place of a church built in 1272 by William of Dunwich, Bailiff of Norwich, to whom there is an ancient stone against an outside wall.

Bixley church is the only one in England dedicated to a saint with the odd name of Wandregesilus. Pilgrimages were made to St Wandrede of Byskely in the Middle Ages. Often known as St Wando, the saint began his career at the Frankish Court, but, rebelling against its luxury, he left the palace and became a monk. The king recalled him, and Wando started to obey, but as he was returning through the streets of Metz he came upon a carter trying to extricate his horse from the mud. Wando helped him out, covering himself with mud, and on seeing his mud-stained clothes the king praised his noble action and set him free. After a pilgrimage to Rome, and ten solitary years in the Jura Mountains, Wando went to Rouen, and five miles from the city, at a spot called Fontonelles, founded a settlement for 300 monks. For twenty years he governed it until he died in 667, and was buried in the monastery he had founded.

Blakeney

In its great days as a seaport it was the home of many Dutch merchants, and it gave and provisioned two tall ships for the Crusaders, and despatched a great concourse of English pilgrims to Spain. That was before the encroaching sands silted up its harbour, sapping its industry and its prosperity. But Blakeney has lost none of its quaint charm, and the salt marshes and the sands are a happy hunting-ground for lovers of wild birds and wild flowers. Sea-pinks in June and sea-lavender in August colour the marshes; and rare birds haunt the glorious stretches of sand and the hillocks of Blakeney Point, where 1,100 acres, protecting the tidal estuary from the sea, now belong to the National Trust for all time.

The shipping is more leisured now. Pleasure boats wait by the quay to sail with the tide, and some of the old buildings here have given place to a modern hotel. The old Guildhall, tucked into the hillside facing the quay, is built of Flemish bricks beaten out by hand; and though its upper room is ruinous and open to the sky a doorway opens to the lower room, where a vaulted brick ceiling rests on arches as perfect as when they were built six centuries ago. It was used as a storehouse when we called, and early rhubarb was growing in a corner. Old houses climb the narrow streets towards the old church which is the pride of this countryside. Not far away is the Old Rectory, with a Tudor chimneypiece among its woodwork; it is thought the rectory was built when an old monastery was suppressed at Blakeney.

The church stands among the trees on a hilltop 100 feet above the sea, and its fine west tower rises 100 feet higher still. A slender tower at the north-east corner of the chancel used to shine a beacon light to guide those at sea. The old windmill adds a romantic touch to the fine view from the church. Both towers are fifteenth century, though their outside walls have been refaced. On the buttresses of the west tower are the arms of the sees of Thetford and Norwich; inside the tower opens to the great nave with a soaring arch that would grace a cathedral, dwarfing the chancel arch and arcades.

The lovely old hammerbeam roof of the nave, enriched with twenty-six angels, looks down on poppyhead benches with animals on the armrests. The chancel screen with a vaulted loft extends round the chapels. The stalls are old and new, the new in the fashion of the old, which have misereres carved with flowers and lions, and armrests with quaint figures of hooded men, men with animal bodies, and a griffin. The chancel, low compared with the nave, is a fine tribute to the builders of seven centuries ago, with the arches of its beautiful vaulted roof framing the side windows, its rare seven-light east window, and its bold sedilia. The stone screen behind the altar is new. The fifteenth-century font is adorned with Passion emblems and heads of angels, and a graceful communion cup is Elizabethan.

Blickling

It is a captivating place, its history lifting the curtain on the last Saxon king of England and again on the last of the Stuarts; and it has one of the finest Jacobean halls in England.

Blickling Hall, and the estate of 4,523 acres, now belongs to the National Trust. The hall is approached along a drive between clipped hedges of yew and rows of limes, and then by an ornamental bridge bestriding the dry moat and leading on to a gateway with an old oak door. The knocker on

the door is the bull's head emblem of the family of Anne Boleyn, ancestors of the builder of the hall, Sir Henry Hobart.

At the end of the drive the smooth lawns, the gables, the turrets, the towers, the oriel windows, face us in their Tudor splendour. The square towers at the corners are crowned with a pavilion dome and a vane, the higher turret over the gatehouse rises in three tiers to a bell cupola, and the chimneystacks behind the gables enhance the charm of this architectural spectacle. The hall is built round two open courts, and the garden front (repeating the step gables, the oriel windows, and the domed towers) looks on a garden of roses, box hedges, and flowering borders a mile round. Beyond the garden stretches the great park with its lake like a crescent and its grove of beeches. The park is 600 acres, and has statues set about, a summerhouse which is a copy of a Greek temple, and fountains brought from Oxnead, the last home of the Pastons.

Centuries before this hall was built the manor of Blickling was held by our Saxon King Harold, the site of whose palace is about a mile away. After Harold had fallen before the Conqueror at Hastings William gave the manor to his chaplain, and in course of time, passing through such famous families as the Erpinghams and the Fastolfs, it came into the hands of the great-grandfather of Anne Boleyn and finally to Sir Henry Hobart, Lord Chief Justice, who, while his fortunes were ascending, built the marvellous house we see.

In it is one relic with the old home about which Anne Boleyn walked in her childhood, for there remains the old chimneypiece with the Fastolf Arms.

The tower at Booton

The church near the hall fills in some details of Blickling's old story. Though the tower is modern, the work of George Edmund Street, most of the church is fifteenth century, and the pillars supporting the arch of the porch are believed to be from the Saxon church Harold knew. The font with eight lions sitting in pomp about its base and four other crouching on its panels is 600 years old.

Blofield

The road to the sea runs through this pleasant village seven miles from Norwich. Withdrawn from the bustle of the highway, from which a lovely avenue comes creeping round the churchyard with its flower-bordered path, stands the 500-year-old church, its magnificent tower a landmark for the countryside. Here too is the rectory, and the old brick school with diamond-paned windows which a seventeenth-century rector built, now turned into a house.

Bodney

The remote air of heath and woodland belongs to this charming little place, where the Saxons found a home a thousand years ago in the smiling valley of the River Wissey, a countryside where new forests are now growing up. The stream is delightful, meandering under the trees below the tiny trim church, which stands on a mound looking out to a farmhouse with a story. It stands where once stood the hall, which gave a home and a refuge to a community of French nuns who fled from their land in the time of its Revolution. One was the daughter of the Prince of Conde; and some of them lie in the peace of this churchyard, with firs and elms about it, and below it the common land, radiant with gorse in Spring.

With one bell in its turret, the church tells its ancient story in fragments of Saxon stone, carved with interlacing work in a chancel buttress. Except for the font and the east window, which are fourteenth century, most of it comes from the fifteenth century.

Booton

It looks across the valley towards Reepham, and its striking possession is a modern church with a story that takes us back to the days when Sir Walter Raleigh was dreaming of the British Empire and Captain John Smith was fighting battles all over the world. The builder of this remarkable church was a descendant of that famous man of the early days of the British Empire, John Rolfe, the seaman who went out to Virginia with the heroic John Smith and there met Pocahontas, the Red Indian princess who saved John Smith's life.

Bracon Ash

Its cream-walled cottages with thatched and tiled roofs stand by the roadside, not far from the towerless church hiding modestly among the trees. Bracon Hall in the park is a modern house on the site of one where Queen Elizabeth is said to have stayed; it has belonged to the Berneys for centuries. On the other side of the village is the fine old Mergate Hall which belonged to the Kemps for about 500 years.

Three arches on clustered pillars divide the fifteenth-century nave and aisle of the church; the chancel is older, and we can imagine its beauty as the builders left it 600 years ago, for here still are the remains of their fine windows, which had shafts on each side and heads and flowers between their arches. The ancient font and the winding rood stairway remain.

Bradeston

On the knoll above the marshes, away from the hamlet, stands the lofty little church, so narrow that its stout walls are hardly more than 14 feet apart. There may be Saxon masonry in one of them, but most of it is fourteenth century. The traceried east window has lovely glass in memory of four men who did not come back, showing Faith, Hope, and Charity in rich robes. Part of a clustered shaft is in the wall of the nave, which has fifteenth-century windows with clear glass. The old rood stairway is still here, the traceried font is like a pillar with six sides. Most unusual is a fireplace in the tower, perhaps used for baking the sacred wafers long ago.

Bramerton

It has lovely fields round it and is a mile from the sweeping bend of the River Yare, charming with old houses roofed with thatch and tile, and nestling among beautiful trees. At one end of the village is the hall, an old house refashioned last century; at the other end is the Grange, an Elizabethan house with a splendid cedar reaching across the road. Between the two houses is the church, to which we come through a beautiful lychgate with stout timbers and a thatched roof. Most of it is fourteenth century, but the transept was added in the nineteenth when the rest was much restored.

The chancel has a thirteenth-century lancet, and a quaint face peeps from the corner of the rood stairway. There is a small traceried peephole, and another blocked in the tower, where we found the old font, carved with flowers, lying by the new one.

Brampton

A lane running by the River Bure leads to a farmhouse which was once the home of the Bramptons, lords of the manor from the Conquest to the days of Cromwell. Close by is the ancient church in which they lie, most of it thirteenth century but the round tower Norman, with a brick belfry added 500 years ago.

Brancaster

Roman, Briton, and Saxon pirate knew it as a base of operations for Rome's British Fleet, but today there are no ramparts but the bunkers, and no warfare but with niblicks. It is one of the finest golf links in the land, with a mild beauty of salt marsh, sandy waste, and emerald turf. Over the marshes to Brancaster Bay winds the road from the village, which has a wayside church with something left from its medieval days. A row of sturdy elms lines the churchyard wall, and small plants creep in the crannied walls of the ancient tower.

About two miles from the village is Brancaster Staithe, where ships of 250 tons come into harbour. Its coastguard station is the nearest point for crossing to Scolt Head, a fine range of sand dunes with 1,200 acres of sanctuary for wild life. On this lonely island, cut off the mainland by winding creeks, lives the Watcher for the National Trust, hearing only the cry of birds and the deep roar of the North Sea. He walks eight miles round the island and knows 2,000 nests, more than half of them built by terns. He makes notes of about thirty varieties of birds that breed here, among them the very rare oyster-catcher, a black and white bird with orange beak and legs.

Brandiston

A lane of oaks leads us by the deep woods of the lovely Haveringland Park, and beyond them to the churchyard of Brandiston, shadowed by elms and overhung by beeches. Its few dwellings are scattered, but the big house, Brandiston Hall, is near the church, its brick mellowed by the three centuries that have passed since its building.

The low round tower of the bright little church rises no higher than the fifteenth-century nave, and has been rebuilt after being blown down last century. The chancel and the porch come from the fourteenth century.

Breckles

Its few houses and farms are scattered about the fields, and its old church is near an Elizabethan house, with gables and clustered chimneys and the memory of many Roman Catholic priests who sought refuge here in the troubled times of the Reformation.

The Normans built the round part of the church tower and its plain arch, resting on shafts carved with serpents. The fifteenth century added the belfry, with eight sides and eight grotesque gargoyles. The great windows have been filling the aisleless nave with light for 500 years. The east window, the priest's doorway, the south porch, and the finely moulded doorway are fourteenth century. The chancel has its old piscina; the roodstairs and doorways still remain; and the registers, dating from 1540, are among the oldest in the county. The church's finest possession is the Norman font, with five pillars supporting the square bowl with its mass of carving and arcading, two grotesque heads with leaves coming from their mouths, a quaint figure like a monkey, and, best of all, a row of robed figures under an arcade.

Bressingham

Thatched cottages with orchards on the edge of green fields, clipped yews in front of old farmhouses, with white-walled cottages made out of a Guildhall, and a thatched inn yellow walls facing a lofty church, all help to make up this pretty village which has grown along the road from Diss.

In a churchyard surrounded by oaks and elms, with an avenue of limes by its path, is the church Sir Richard Boyland is said to have built about 1280, and the work of this corrupt judge (who lived at the moated Boyland Hall, three miles away) remains in the walls of the chancel, the two nave arcades and the north and south doorways. A chest with seven locks and a lid in two parts is of his time; so is the font.

Bridgham

It is said that on the heath near by the Danes were victorious in a battle with the Saxons; but all is peaceful now in Bridgbam, where houses and farms straggle along the road, with the old church at one end among the trees, and the River Thet running through the meadows.

It is a quaint fourteenth-century church, with a timber bell turret and a chancel higher than the nave. Inside it is lofty and light with cream walls. The old oak bar still holds the south door, a few old glass fragments have wings, pinnacles, and leaves, and the lower part of the old screen remains.

Nearly a mile away, at Roudham, is the forlorn ruin of an old flint church standing by the thatched lodge of the hall, the tower and parts of the walls, with windows and doorways, left to tell of a fire which swept through it long ago.

Brinton

It nestles in lovely trees, a little place where the Saxons chose to build their church because the hollow offered shelter from the winds. Some of their

masonry may still be in the nave, and the twelfth century is represented by a shaft piscina from Norman days. Of the thirteenth century there remain two buttresses and a small figure of St Andrew over the transept window, in a niche which was plastered over to preserve him during the seventeenth century. The tower was built at the end of the fourteenth century, and from the fifteenth comes the fine arcade which reaches the roof and leads to the aisle and transept. The font is 600 years old, and the east window is filled with Munich glass.

Brisley

The high tower of the church is seen from afar, rising above the trees and red roofs of the village. The fine, lofty, and spacious place is almost all medieval, and is ghostly inside with the stark whiteness of walls, windows, and pillars. The soaring tower arch, marred by a gallery, reaches the ancient nave roof of open timbering. There are many quaintly patched benches with battered poppyheads, and a few high oak pews, with traceried backs, one with an original cupboard in front with hinges and lock, and another with a dog with a goose on an arm-rest.

Very quaint is the wandering old three-decker pulpit, with a square canopy trying to shelter it. It is a curious mixture of styles, spoiled by painting, and at its side are old box pews. The old screen is still here, and the font as old as the church.

Three lovely sedilia and a piscina, adorned with tracery and battlements, have slender clustered shafts supporting rich arches. An ancient doorway with an old door opens from the chancel to a stairway leading to a small crypt below the altar, lighted by narrow slits and said to have been used as a burial place.

Briston

A small town near the source of the River Bure, it lies between a great common and lovely woodlands. It has a pretty green and a fourteenth-century church, with a handsome east window of neat tracery, a double piscina in the chancel and a huge ironbound chest secured by four locks.

Brockdish

The village is attractive with pink-washed cottages in the valley of the Waveney, and reaches Syleham in Suffolk by a small toll bridge. In a secluded corner surrounded by trees is the hall, built 300 years ago by Robert Laurence, and one of several places claiming association with the ballad of the Mistletoe Bough. On the way to the hall we pass Grove Farm,

a two-gabled house with a spreading cedar in front of it, and near it is a mellowed old house with Dutch gables, the most charming of all old houses here, known as the Grange.

In a peaceful setting by the fields, not too far away to hear the hum of traffic on the road from Diss, stand the church and the rectory in delightful companionship. The little church has creepered walls of flint and stone, and stands in a churchyard with firs, maples, and a copper beech. The rectory garden is worth a long journey for its lovely weeping larch, one of only two in the county. Propped up here and there, this extraordinary tree forms a great arbour 28 yards across, flat-roofed with tracery of living green against the sky.

We found at the rectory a fire-engine of 1616, a simple arrangement for carrying hose, ladder, and pump on solid wooden wheels; it was being turned out of the parish room a few years ago, and to save it from being destroyed the rector bought it for two pounds, its date then being discovered when a child found a picture of one like it on a cigarette card.

Brooke

It is charming with thatched cottages gathered about a pool fringed with trees. The church keeps company with a great barn finely thatched and a delightful thatched lodge by the grounds of Brooke Hall. In the house standing here before this Sir Astley Cooper was born.

The round church tower has been here 800 years, but its windows are English of the thirteenth century and its parapet is fifteenth. A fine old door still swings in its medieval doorway and keeps its ancient ring. By the lofty arch leading into the 600-year-old chancel is a cupboard door carved with a copy of Rubens's Descent from the Cross; and on another wall is a tiny fragment of carving which is precious for being all that is left of the ancient screen.

Broome

The Jacobean Broome Place stands above the Broome Beck flowing to join the Waveney. The church stands in the fields, alone but for a farm, with a cluster of firs in the churchyard and a larch wood near by, and looking out to Ditchingham's tower a mile away. Coming from the fourteenth and fifteenth centuries and much restored in the nineteenth, it has a fine gargoyled tower, and an old door with strap hinges and a ring.

Brundall

The name of this pretty village, high above the Yare and the marshes, means the Dale of the Spring, and in Brundall Gardens the spring may still be seen;

it is near the landing- place in the water garden where Roman galleys used to put in for repairs. Some traces of a Roman villa and a few fragments of pottery have been found near the spring, and the place is known here as the Roman Dock.

Brundall has the view of a splendid sweep of the river, which bends eastward on its way to Yarmouth near the pretty thatched inn at Coldham Hall Ferry. Not many years ago the black-sailed wherries had the river to themselves; now the place has become a yachting centre, but the Yare is still a wilder river than the Bure, and guards many lovely secret places.

It is easy to miss the tiny bellcot church, for it stands in a sequestered corner at the end of the street of modern houses and thatched cottages, hiding in a churchyard like a garden, with rockeries, flower beds, lawn, and lovely trees. One of the prettiest of the county's churchyards, it has a lovely view of the countryside and is entered by a thatched lychgate. The old work of the dim little church is 600 years old.

Buckenham

We come to the village among the woods like pilgrims of old, crossing the ferry over the River Yare. An avenue of oaks and elms guides us to where the lonely church has for its only companion the old hall of the Godsalves, lords of the manor through the Wars of the Roses. Their arms are carved

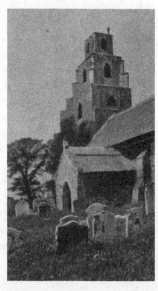

The tower at Burgh St Peter

in the room where they sat down to dine, and though the old house is now part of a farm it is pretty enough still, with its thatched roofs and its welcoming porch.

The church looks over the lowlands and catches gleams of the river and flitting sails. Though much restored last century, it has something still to show of Norman and medieval days.

The octagonal tower has a Norman doorway, the south doorway has a Norman arch adorned with zigzag, and a fine thirteenth-century doorway leads into the vestry. The fine 500-year-old font has eight saints under canopies on its bowl, angels at the corners, and four men and four women, all with books of devotion, round the stem. Its old cover is crowned by a dove. An alabaster carving of the murder of St Erasmus and a very precious old crucifix were found in the chancel floor a hundred years ago, and given to Norwich Museum.

Buckenham

About a mile from the village a moat overhung with trees surrounds an earthwork marking the site of the castle built by a follower of the Conqueror, who was granted land here for being butler to the kings of England on the day of their coronation. The castle is gone, but by its site is a delightful farmhouse, with quaint stacks of chimneys and trailing plants over its porch. It is Abbey Farm, a name recalling a vanished priory. Slight remains of it are in fragments of walling and carved stones joined up to two cottages.

The church has a Norman doorway and thatched roofs; the porch has its original gable cross and the door its old ring. Four arc on clustered pillars divide the nave and aisle.

New Buckenham is a small town of 500 people, but has a charter from Queen Elizabeth, a fine old church, and a tree-covered mound (still surrounded by a wet moat) on which a proud Norman castle stood. Angels with shields of the castle builder adorn the ancient market house, an open shelter with a roof on wooden pillars, its unusual feature being the old whipping-post, which reaches from the middle of the floor to the roof and has iron staples driven into it on each side.

Near the square is the beautiful flint church, chiefly fifteenth century, lighted by a fine array of windows, twenty in a splendid clerestory, with sixty lights. The tower has four great gargoyles, and pinnacles rising from the battlements. A door with fifteenth-century panels leads us inside, where a hammerbeam roof looks down on the nave, supported by twenty-two stone figures of saints and angels.

Left: The tower at Burnham Deepdale

Below: Burnham Deepdale font

Bunwell

It straggles along the highway to Norwich, its farm withdrawn from the road, and a white-walled inn near the church, which stands by an orchard at

one end of the village. Coming chiefly from the fifteenth century, impressive in width and height though it has no aisles, the church has an embattled tower, old hammerbeam roofs, a medieval mass dial, and a goodly array of modern craftsmanship adding to its charm. The stalls are richly carved, and the fine pulpit has panels of linenfold and tracery in which two leaves are cunningly contrived to show little faces with furrowed brows. The tower has a narrow soaring arch, and the arch of the chancel is wide and a little askew.

Burgh-Next-Aylsham

Under the thatched roof of its church in a thirteenth-century chancel is some of the most exquisite work of its kind in Norfolk, eight arcaded lancet windows ranged above a blind arcade recalling one of the beautiful decorated features of Lincoln Cathedral. The archway into the chancel is worthy of it, and a charming touch is given to its simplicity by the birds pecking at the foliage of the capitals.

Burgh St Margaret

The Age of Petrol has destroyed whatever beauty the village had; strange that the Motor Industry, dependent for its prosperity on the attraction of our countryside, should be its chief destroyer. Yet the long church with the small tower, all of it much restored, has touches of beauty still. An odd dormer peeps out of the thatched roof of the nave, and within the porch (which has an upper room) is a Norman doorway crudely carved with zigzag.

In a field not far away stands a fragment of a mighty past, a Norman tower which has lost its church and has a fifteenth-century cap.

Burgh St Peter

It was perhaps a Roman station, but its great days have passed away. The old windmill with one sail stands boldly with the village clustering about it, and a rough and lonely road winds for a mile before it comes to the church by the Wavency, the river gleaming among the reeds as it flows between Norfolk and Suffolk. North of the church lies a vast stretch of marshland, where brown sails are gliding along unseen waters of river and dyke.

The church is a fascinating picture outside, its nave and chancel under a thatched roof 100 feet long, a thatched porch red with creeper in autumn, and an extraordinary tower like no other we have seen. Built of brick in five stages, growing smaller as they rise to the top storey (which is like a cube), it is more like a pyramid than a tower, and was added to the church in the eighteenth century. A mass dial is on a wall. A thirteenth-century

doorway and a door with hinges of delicate leafwork lead us inside, where the church looks even longer than it is, with side walls only 14 feet apart. A fine roof with moulded beams looks down on the nave, the 500-year-old font is carved with roses and faces, and the chancel has fine old canopied stone seats for the priests.

Burnham Deepdale

Sheltered by low wooded hills and looking over the marshes to the sea is this home of a few people whose church is a shrine for an ancient treasure. Much restoration has left the thirteenth-century walls of nave and chancel and the sturdy round tower, just topping the nave, which is old enough to be Saxon keeping its original arch with a gabled Saxon window above it Steps mount to the chancel and again to the sanctuary.

Burnham Market

Lying in a wooded hollow sheltered from the sea, it is the chief of all the Burnhams, a town holding a fortnightly market. Round its long green, criss-crossed by roads, are gathered its old houses, inns, and small shops. The green is an imposing approach to the medieval church of St Mary, with its fifteenth-century tower.

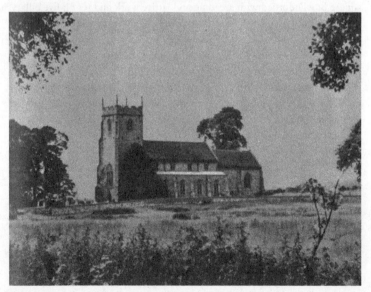

The church where Nelson was baptised at Burnham Thorpe

Near the other end of the green is the church of Burnham Ulph, its walls adorned with roses and crowned by a bellcot. A window on each side of the nave, and the chancel arch with battered capitals of stiff leaves, come from the twelfth century, and earlier still is a priest's doorway. The porch is fourteenth century. To this church come the people of Burnham Sutton, whose own church has long been in ruins.

Burnham Norton

Its few people live in cottages and farms near the sandy estuary, but the church stands proudly near Burnham Market. There is a charming corner by the water mill and the bridge over the River Burn, and here too are flower-decked cottages and an old windmill on the hillside.

Not far from the church is a gatehouse with a flowing tracery window and a vaulted ceiling. It is a shelter for cattle now, but under a bower of May at the other side of the field there still remains some walling of the Carmelite friary to which it once belonged. It is said the old cottage near the ruins was the dining-room of the monks.

A round tower of flint and pebbles, as the Normans left it except for fifteenth-century battlements, crowns the church, which has an extraordinary thing to show us and presents an extraordinary appearance as we enter. Alone in its glory in a clear space at the west end is the fine Norman font, its square bowl adorned with arcading and lattice work and set on five pillars. All else is oddly screened. Screens enclose part of the nave and shut off the aisle chapels, and a battered fifteenth-century screen, bereft of its painted saints, spans the chancel arch, which has image brackets at each side.

The nave arcades come chiefly from the twelfth century. The chancel has thirteenth and fourteenth-century windows, and a modern east window glowing with red and purple, showing two women saints, one walking among marguerites and carrying them, one a crowned and stately figure reading as she walks among the lilies.

Burnham Overy

It meanders from the cottage rows down to Overy Staithe, where a diminutive river comes from South Creake and Burnham Thorpe to wind through creek and marsh and sandhill safe to sea. It is a pretty little port where small ships come in from sea.

The low church, with a squat massive tower crowned by brick battlements and a quaint domed canopy for its bell, looks down on red roofs from its little hill. In the days when town and staithe were more important the church had the shape of a cross, but the Norman and medieval tower, which

has weakened with time, was lowered in the eighteenth century, when the arms of the cross were removed. Serving now as a vestry, with two ladders climbing to the belfry, the old tower cuts the church in two, opening to both nave and chancel with a small Norman archway in its east and west walls. The chancel is like a chapel, and keeps up the odd appearance of the rest. It has gleaming white walls and windows. The medieval arcade, which seems to be leaning on the south wall for support, once led to a chapel, and its pillars stand on a tiled platform level with the sanctuary, which is up three steps. Below one of the pillars is a projecting piscina. On one side of the nave is a massive Norman arch, and on the other a medieval arcade with round and clustered pillars, adorned with stiff foliage and four tiny heads. There is a battered Norman font, a wall painting of St Christopher, and brass inscriptions asking prayers for two sixteenth-century Thurlows.

The base and part of the shaft of the medieval cross are doing traffic duty as a signpost below the church.

Burnham Thorpe

It is holy English ground, for here our great Nelson was born. He played by the little river that comes to life at South Creake and falls into the sea at Burnham Overy Staithe. He helped to make the pond in the rectory grounds, and walked along the field path by these twisted old elms to hear his father preach in the little flint church a mile away, with only the old manor, now a farmhouse, to keep it company. It was here that his grandmother, a sister of our first Prime

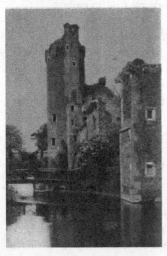

The ruined castle at Caister

Minister, Sir Robert Walpole, found him one day sitting by a brook. He had been bird-nesting with a cowboy and was missing for hours. 'Fear, what is that?' he said when his grandmother wondered that fear had not driven him home.

The old rectory has gone, but there is much in his beautiful birth- place that remains as he knew it, old cottages, houses, and farms scattered in leisurely fashion by meadows which are white and gold in spring. He knew the old tower of the church, in which there now hangs one of his letters for us to read, written from the Mediterranean. The ancient church has been much restored but has still its medieval windows, and there is an old coffin stone carved with two crosses, battered stone seats for the priests, a piscina with its arches tipped with roses, and a plain chest made from the pulpit in which Nelson's father preached. The village's own memorial to its hero is a hall with a copper turret, built at the end of last century for the man who died at its beginning, the Norfolk boy who broke the sea power of Napoleon and sleeps under the Dome of St Paul's.

Buxton

Its old watermill stands beside the Bure, and the thirteenth- century church looks out across the green as when Thomas Cubitt, a journeyman carpenter, left here a hundred years ago to make his mark on London.

He built half Bloomsbury, much of Belgravia and the Thames Embankment, much of Pimlico, and more of nineteenth-century London than any other man who can be named. He made his mark, and when he died he left a million pounds. The small church still has the thirteenth-century font at which he was christened, and it has a handsome modern cover.

Bylaugh

It is a charming bit of the countryside, where the River Wensum winds through the valley, and the great house, built last century in classical style, stands on the hillside in a park of a thousand acres.

The tiny church for the very few people is lonely and hidden in trees between the park and the river. Except for the tower, with its round Norman base and its octagonal belfry, it was made almost new over a century ago, and is plainly furnished with painted box pews, from which rises an ordinary three-decker pulpit. It keeps a small fifteenth-century font, and two fine brass portraits of Sir John Curson and his wife.

Caister

The Romans built here one of their chain of fortified posts for the better guardianship of the Saxon shore against North Sea raiders. One old church,

the fragment of another, and a ruined castle are its links with medieval days; and a great water- tower is its landmark in our twentieth century. The houses go down to the sands, and at its prettiest corner is the flint church of Holy Trinity, with a lofty medieval tower looking out to sea. Most of the church comes from the end of the fourteenth century.

Fragments of the old church of St Edmund are to be seen in the hamlet of West Caister, half a mile from the old castle, which stands above the muddy waters of the wide moat, rearing itself proud and high among the trees, though it is an empty shell. The row of windows along the west wall shows where the great hall stood, and we can still see where the loop-holed towers strengthened the eastern side.

Caister St Edmund

It is charming with cottages and gardens where the ways meet under bowers of trees, and up a shady lane is a brick house, half hidden by fruit trees, and with mossy red tiles and casement windows, known as Queen Anne's Cottage.

The church is away up the road, believed to be built within the area of a Roman walled town called Venta Icenorum. Before the Romans came kings of the ancient Iceni tribe are said to have lived here, and here may have come Boadicea in the days before she led the Icenian hordes in an avenging

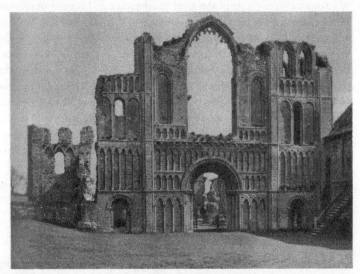

The west front of the Norman priory at Castle Acre

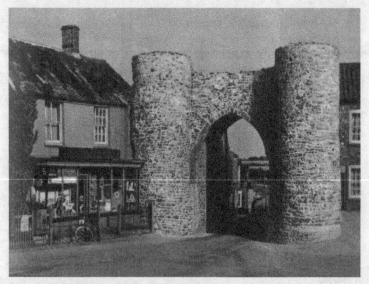

The gateway of the Norman castle at Castle Acre

flood to the gates of London. Over the site of the old Pretorium Gate we come to the small medieval church, standing within the deep fosse which still remains on one side of the great encampment and is most impressive as it borders the highway. From the churchyard, shaded by oaks, we have a glimpse of Norwich and look out on peaceful fields where once was the busy Roman town on this hilltop above the River Tas. Among many traces of their occupation that have come to light are bracelets so tiny that they were surely meant for babies, much pottery, brooches, a mirror, a head of Diana, a bust of the Emperor Geta, and a coin of Nero. Venta Icenorum was the terminus of the Roman road which swept north-east from London through Colchester.

The church was built largely of materials from the Roman walls, and comes from the three medieval centuries. The priest's doorway, the lancets, and a low window in the chancel are thirteenth century. The east window, two in the nave, the chancel arch, and the tower battlements, are fifteenth century; but the tower and the north and south doorways are 600 years old.

Carbrooke

It stands high in the byways, near a stream, the tower of its lofty church rising like a great beacon. Here was a religious house of the Knights Templars 800

years ago, two stones left to tell the story of the Order which stretched out its arm from the Holy Land to this quiet village. The stones are in the fifteenth-century church, and are believed to be those of the founder's wife, Maud, Countess of Clare, and one of her sons.

The church is as fine inside as it is imposing without. The north porch has a vaulted roof supporting a room in which is some old armour; the south porch shelters a massive doorway with deep mouldings, opening to a clerestoried nave with soaring arcades and a splendid old hammerbeam roof enriched with bosses and resting on angels. A lofty fifteenth-century screen with elaborate tracery leads to the chancel, which has older work than the rest of the church in the lovely fourteenth-century east window and the medieval sedilia.

Carleton St Peter

Its cottages and farms are dotted about the fields and lanes, and a grassy path leads over a ploughed field to the church framed by spindly firs and ivied churchyard walls. Long and narrow, neat and trim, it has a tower mostly from the thirteenth century, its arch reaching the white roof of the nave. The oak screen has remains of the old one in its central bay, in the top rail with a painted border, and in fragments of tracery. About fifty candles were lighting the dark hours when we called, many of them in sticks on the

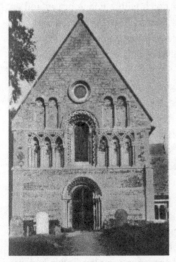

Above left: The west front of the fine Norman church at Castle Rising

Above right: The entrance to the keep of the Norman fortress at Castle Rising

pews. The chief treasure of the church is kept in a case; it is a black letter Bible of 1611, the year of the Authorised Version.

Castle Acre

Antiquity and beauty go hand in hand in this old place the Romans, Saxons, and Normans knew. It lies on the line of the Pedlar's Way, in a countryside where the long habitation of men seems to have exhausted the fruitfulness of the earth, so that blackthorn or wild rose spring where once were woods and fields of waving corn.

After the Romans and the Saxons its new life began with William de Warenne, who married the Conqueror's daughter, and was granted land on which he built the castle and the priory. Noble and prior have passed away, and the very stones of the Norman stronghold have been scattered. But neither neglect nor forgetfulness have utterly destroyed the greatness of the past, for something of its grandeur lives in the magnificent ruin near the River Nar, flowing sluggishly between the water meadows.

Crowning the hill with the village church is what remains of the castle, now overgrown fragments of walls with mounds and deep moats littered with masonry. It stands on the site of a Roman camp and must have been one of the biggest East Anglian fortresses. The great gateway by which knights and men-at-arms would enter spans the top of the village street.

Crowned by a tower and entered by a porch with a fine doorway and an ancient door, the church is chiefly fifteenth century. It has soaring arcades and an old timbered roof, old pews with fleur-de-lys poppyheads and quaint animals on the arm-rests, and panels of fifteenth- century glass showing a lamb, a knight in armour, and a king.

Norman castle, medieval church, and Saxon cemetery (where a hundred burial urns have been found) all have their interest, but it is for the priory ruins that we come. Now an ancient monument cared for by the Office of Works, it is reached by a fine Tudor gatehouse, which brings us to green lawns reminding us of the entrance to an Oxford college. It covers about 36 acres, and its foundations are laid bare and clearly defined, so that it needs little imagination to walk through the refectory, the cloisters, and the church in spirit with the monks of old. We can see the remains of the little infirmary chapel with their actual altar still in its place, at which the last sacrament was given to those about to die. There are great arches, fragments of massive walling, the rubble of pillars standing like pinnacles, and a Norman west front beyond compare for many miles around. The prior's house, joining this front, is charming, a complete Tudor building with gabled roof and oriel windows, a simple chapel in the upper storey, and old oak beams.

Castle Rising

Deserted by the sea, which is now two miles away, it has lost the great days of its history as an important port with a market and a fair, its mayor second to none in the county, now it dreams among the relics of its past, relics of beauty and great interest. Looking out from the hill to the sea, it lies on the road from King's Lynn to Sandringham, and peace wraps it like a garment under a coverlet of trees. It is one of Norfolk's prettiest villages, charming us at every turn.

There are charming groups of houses with pantiled roofs and clustered chimneys. The old inn has a carved and painted sign of a black horse under a bower of grapes. On a small green which was once a marketplace stands a magnificent medieval cross on a flight of steps. The Norman Church looks down on delightful Jacobean almshouses, and lighting the way at night are two delightful lamps on tall oak posts, set up to mark the end of the Great War. Crowning all this is the ruined Norman castle, a fine row of Scots firs giving it a romantic aspect.

In this enchanting place there is no more gracious relic of the past than Bede House, which Henry Howard, Earl of Northampton, gave the town when James was first king. Gathered around a green lawn, with roses and honeysuckle climbing to doorways and windows the houses are quaint with gabled pyramid roofs and clustered chimneys.

Though the noble church was much restored last century (when the central tower was given a saddleback-roof and the porch made new) it remains a striking tribute to the builders of Norman and medieval days. The gabled west front is charming; over its round-arched doorway, enriched with bold zigzag moulding, is a window with Norman arcading each side showing a fine mass of zigzag and quaint men peeping from the capitals.

The tower, its splendid vaulted roof having carved ribs, rests on massive arches of varying styles. The western arch with zigzag and cable mouldings is slightly horse-shoe shaped, and over it is fine arcading of three bays, the arches and capitals a mass of carving, opening to a gallery in the thickness of the tower wall. The eastern arch of the tower is pointed but has the Norman zigzag; it is the simple forerunner of the magnificent thirteenth-century arch, with wonderful mouldings and clustered columns, which leads to the south transept. A rare feature on the south side of the tower's western arch is a thirteenth-century altar recess, a pretty corner piscina with a peep-hole behind it.

Impressive in its decay, the castle stands within mighty earthworks rising to 112 feet. Part of the keep remains, the finest stronghold of its time left in the county; and in its roofless walls, enriched here and there with arcading

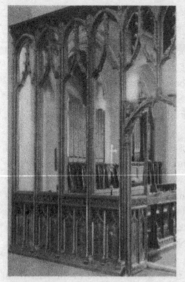
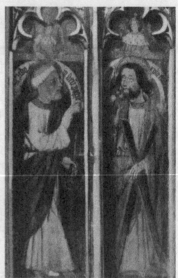

Above left: The fifteenth century screen at Cawston

Above right: The painted panels at Cawston

and relieved with windows and doorways, are written chapters of our island story. The Romans raised or fortified the ramparts, the Saxons claimed them, a Norman knight seized them and built this grim castle to dominate the town. It is believed that the builder was William d'Albini, first Earl of Arundel and son of the Conqueror's butler, whose name he bore; he was known as William of the Strong Hand from the story of his brave act in pulling out a lion's tongue, and he married the widowed queen of Henry the First.

Caston

It straggles along the highway, a fine old windmill greeting us as we come from Watton. The fourteenth-century towed of the church stands guard by the green, round which are gathered the school, the smithy, and an old farmhouse with remains of arcading in its walls. It was once a refectory for pilgrims on their way to the shrine at Walsingham, and the pilgrims would see the old cross, of which the great base is still on the green.

The tower is the best feature of this church which Sir John de Caston restored in the second half of the fourteenth century. The porch with its upper room and the windows of the nave come from the next century. The

font is of Sir John's day, as is the arched recess in the nave, which may have been built for his remains.

Catfield

Down the lane a little way from the old post windmill stands the big fifteenth-century flint church with a sturdy fourteenth- century tower. A thatched cottage and the rectory where Cowper stayed for a time are its companions, and on the small green at its gate is a beautiful Calvary on three steps, with flowers round the base, in memory of the men who did not come back.

The church is on the way to Barton Broad, and the priest's room over the porch reminds us of the time when winter roads were hard to travel. An ancient mass dial is on the wall.

Catton

There is a country air about the ancient haunts of this pleasant suburb of Norwich. Its trim houses are big and small, old and new. Its church has a round Norman tower with a Kith-century belfry, and by it is a fine timbered manor house with Kacat and a tun over the door to show the village's name in picture. What is called the Hall is a great house in a park, and modern;

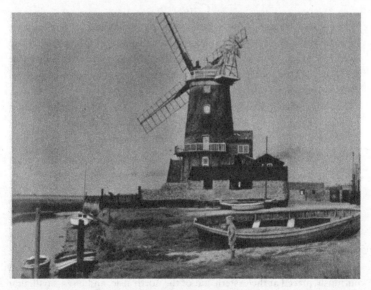

A Norfolk windmill at Cley-Next-the-Sea

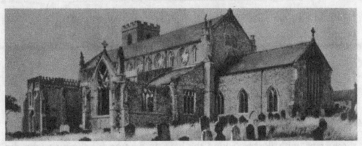

The fine medieval church at Cley-Next-the-Sea

what is called the Old Hall is a fine brick house with stone windows and old sundial, and now turned into small dwellings.

The church stands in a pretty corner, set in a lawn with a rose bordered path, and the porch has a 200-year-old sundial and modern figure of St Margaret and the dragon.

The treasure of the church is a beautiful pedestal pulpit 400 years old, carved with linenfold and enriched with symbols of saints arms of the guilds of Norwich; the lower part, making it into a two-decker, has rich carving of tracery with birds and grotesques.

Cawston

Here in splendour stands one of the finest churches in the county. The vast nave has one of the finest double hammerbeam roofs in Norfolk, with cherubim round the cornice and on the beams angels with wings eight feet across. The finest view of the roof is from the ringer's gallery, another splendid piece of medieval carpentry, open to the nave.

The magnificent screen was carved about 1460 and paid for from a bequest of ten marks. Another great treasure here is the ancient leather case in which the Communion Plate is kept; it is stamped with the arms of benefactors of the church.

Chedgrave

Its chief charm is in the situation of its tiny Church enthroned in lonely state on the mound where the Romans put it, a line border of spindly firs keeping it company in the churchyard as it looks across to Loddon's high tower. It is very quaint outside, seeming to be all gables, which are only just topped by the thatched roof of the low Norman tower. This is curiously placed at the eastern end of the north aisle, and has a small altar and a piscina. The curious old ironwork on the door, with four oval grilles

as part of the design of a cross of elaborate scrollwork, was put here just after Waterloo.

Claxton

We found its grey old windmill fallen on hard times and having joined the unemployed, but a fourteenth-century tower with flint walls holds up its head proudly above the thatched roof of the church, which stands well on its hill girdled by trees. We see the thatch-like basketwork through the trussed rafters inside medieval windows light the narrow nave, which keeps in the wall the arches that led to a vanished aisle.

The heraldic shields here are those of the Kerdistons, who in the fourteenth century built a castle mentioned in the Paston Letters, of which a wall with two watchtowers still stands by Claxton Hall.

Cley-Next-The-Sea

Its greatness is gone, though some of its glory remains, and barrows on the heather uplands stir the imagination with the thought of ancestors of Norfolk folk 3,000 years ago. It lies on the River Glaven on the edge of wide tracts of marshes through which run innumerable creeks and a great dyke goes to the sea.

As we come from Salthouse, the quaint little town is a delightful picture, with old houses and a windmill, and what seems to be its fine church rising behind them in the trees. But the church of this view turns out to be Blakeney's, and as we wind through the town another comes into sight, only to deceive us, for this one is Wiveton's. It is only when we come to the green that a turn of the head brings a rare surprise at the sudden sight of Cley's own splendid church tucked away in a corner.

Many of the houses are flint, but the old Custom House is red brick with Georgian windows, the Maison de Quai has walls of brick and cobble and an ancient stone doorway, and one of the inns has brick and stone walls with Dutch gables. There is still a Flemish atmosphere in this place which was a wealthy seaport before its harbour was silted up; and it remembers the time when Flemish woolbuyers were as frequent in this winding street as English merchants and shippers were. It was in the prosperous days of 600 years ago that the burghers set to work to make their church one of the best in Norfolk, keeping the thirteenth-century tower and continuing their alterations till the early years of the fifteenth, the century of the north and south porches, the west window, and the fine array of flint battlements.

Its great charm is outside, especially the south side with the beautiful porch, the fourteenth-century transept with pinnacles and buttresses, a

lovely window under a gable, and the delightful clerestory of round windows with cinquefoils alternating with windows of two lights. There is nothing lovelier here than the south porch, with its traceried battlements, and a beautiful niche and windows over an entrance arch adorned with flowers and shields, on the shields being the arms of Richard the Second and his queen, Anne of Bohemia.

Clippesby

Buried in trees and easily lost is this tiny place, far enough away from the main road to Caister to escape the noise and bustle. There are tall elms in the churchyard, prettily set against a wood, and the church looks out to clumps of dark firs and green fields. From its high wooded ground the great house has wide views of the countryside.

Cockthorpe

It has only about half a hundred people, but its church has memories of two famous men. The church is fifteenth century with a fourteenth-century aisle, and is unusual for having no windows on the north, the doorway being the only break in the white wall. There are some old poppyhead seats and an ancient roof, and two simple candelabra hanging like diadems with their thirty-six candles.

Colby

Above it stretch the lovely glades of Gunton Park, paying an evergreen tribute to the landscape gardener Humphrey Repton, who laid out Kensington Gardens. The church has a 700-year-old tower but comes chiefly from the fifteenth century, and fine medieval carving. By the porch is the stump of a medieval cross, and over the door is a spirited carving of St George thrusting his spear into the mouth of a huge dragon. But the masterpiece here is a fifteenth-century font with elaborate foliage and weird heads round its bowl; on one of the panels is a kneeling man with a hatchet over his shoulder, and in another is an exquisite carving of the Madonna enthroned.

Colney

The village makes a pretty patch of one of the roads from Norwich, with attractive gabled houses and a wayside church with a round tower. Near a cluster of barns and cottages by the church three ash trees stand guard over the peace memorial cross on a green knoll, and the churchyard slopes down to the water meadows bordering the winding river—so narrow here that it is hard to believe it is the Yare. The smithy is at the Norwich end of

the village, and at the other end the road goes by the lovely park in which Colney Hall stands on the hilltop.

The church was much restored last century, but the tower is partly Saxon, with windows in double splays halfway up. A fifteenth-century porch leads to the fourteenth-century nave and chapel. Older than the Reformation is the fine font on steps like a Maltese cross, and under its bowl (carved with Evangelistic symbols, the Crucifixion scene, and the figure of a martyr) is vine and grape growing from the arches of the stem.

Coltishall

It is a gateway to Beautiful Broadland, a lovely place built on a low hill above the winding Bure, with many a garden running down to the river bank. All through history men have lived here, Roman urns have been unearthed, and Roman tiles now frame two Saxon windows in the hilltop church. There is Saxon masonry in the chancel walls, though most of the church comes from the thirteenth and fourteenth centuries. Above the thatched roofs of the nave and the chancel rises a fine tower with the chalice of St John engraved in smooth white stone among the flints. One of the doors has hinges of Norman ironwork, and the panelled font is also Norman.

Colton

Compact with old farms and cottages, orchards and ponds, it lies between two rivers two miles apart, the Tud bounding it on the north and the Yare flowing south, close to Colton Wood. Between the Yare and the rest of the village is the little ivied church buried by a spreading cedar and great trees, and with the rectory for company. It comes from the fourteenth century though the tower has fifteenth-century battlements. There are quatrefo.ls on the fifteenth-century font and in the tracery of the fifteenth-century screen which has a tiny peephole in a panel.

Congham

A quiet little place, with an avenue of homes and silver birches leading us to its 600-year-old church, we found its walls the memorials of a family which gave one of its sons to lie among our kings in Westminster Abbey.

There is an old font in the church and an old piscina but little else of interest except a brass tablet to John Norris and his son, Elizabethans who 'lived in God's grace and died in His favour'; the portrait of a parish clerk for forty-four years; and a tablet to Thomas Bendish, probably a kinsman of the family into which Cromwell's extraordinary granddaughter Bridget married; she was Bridget Bendish, and sleeps at Yarmouth.

Norfolk's highest church tower
at Cromer

Costessey

It lines a road nearly two miles long, making half a circle as it runs round a
loop of the River Wensum. At one end is the church, prettily set on a knoll
and looking down on the river; near the other end are the lovely grounds
of Costessey Park with the River Tud flowing by.

Costessey Hall was rebuilt last century and is partly pulled down, and from
the tower of the ruins there is a fine view over Norwich. Only a few hundred
yards away is an Elizabethan house in a delightful old-world garden. It may
have been the dower house for the old hall which Mary Tudor knew. Here
she was the guest of Sir Henry Jerningham, to whom she gave the manor
as a reward for his faithful support of her cause. He was her first notable
adherent. From the garden we see through the trees the ragged grey wall left
from an ancient friary, and in the opposite direction we look out to a red
tower known in the village as Mary's Tower, the tradition being that Mary
Tudor was taken there by the Jerninghams when it was no longer safe for her
to be in their house. The family, whose present representative is Lord Stafford,
have always been staunch Roman Catholics, and suffered much in the Civil
War for their devotion to their faith.

In a peaceful spot in the grounds, in a setting of woods, bracken-covered
sloped and old oaks, is St Walstan's Well, fed by a stream.

The quaint brick and flint tower of the fourteenth-century church has a parapet no higher than the nave, and crowned by a wooden spire of 1800. The porch and the chancel windows are fifteenth century. The font with heads at the corners and eight shafts round the stem is over 500 years old. The fine old screen has tracery over arches enriched with leaves, and is spoiled by painting.

Cranwich

Only a handful of folk live in this small place of a few cottages, a farm by a pond, and a church with a rectory to a wayside field half a mile from the River Wissey. The rectory has a fine cedar in its garden; the church has a very old story, and stands on a mound which has been hallowed by Christian burial longer than these walls have stood.

The tower, with a tiny bull's-eye window and some round windows with interlacing tracery, is the most interesting as well as the oldest part of the simple church, for its lower part is said to be Saxon. The rest of it, with grotesque heads under the parapet, is thirteenth century The Normans built the low doorway through which we enter, and fifteenth-century builders gave it the porch for protection. Windows of that time are in the nave, but those of the chancel, which has no arch and is as wide as the nave, are 600 years old. The piscina with a battered arch and a pillar on each side has been here 700 years.

Cranworth

Farms and cottages with thatched and red-tiled roofs, and the broached spire of the fourteenth-century church, peep from the trees, and the old stocks at the churchyard gate still exhort us to fear God and honour the King.

Arcades with clustered pillars divide the nave and aisles. The plain font and the double piscina are old, and old pillars support the new arches of the sedilia.

Cringleford

It is always a surprise to come upon this 1,000-year-old village so close to Norwich, where all the year the meadows are emerald green by the eighteenth-century bridge with high parapets over two arches spanning the Yare. Here the air is overhung with beautiful trees, and the weir still sings its song as it races past the mill, whose old story has ended in its becoming a dwelling. Just across the river is Eaton church with its high tower and thatched roof.

The road climbs from the bridge to Cringleford's church on a high bank by the busy road, in company with the vicarage which has grown out of the

old priest's house and has a room about 600 years old. The church is neat and its aisle is new, but it has thirteenth-century chancel work, a fourteenth-century tower, and relics of Norman and Saxon days. There are many stones of both these times built into the walls, and some Saxon fragments carved with interlacing were once used to make the roodstairs. One of these has been made up with new stone into the shape of a coffin lid.

The nave and the chancel have each a Saxon window doubly splayed, the one in the chancel still showing original parting on us inner splay. A low window which is very old has a peephole opening into its splay. The sill of a thirteenth-century lancet forms a seat with a piscine at the side.

The Saxon window in the chancel frames St George in gold and silver armour. Part of an old altar stone with two crosses is set in the chancel wall; and the lovely 500-year-old font with flowers on the bowl and vines on the stem stands on steps like a Maltese cross. A communion cup is 300 years old, and a bell of the same time is one of three which play the nursery rhyme of Ding Dong Bell every Sunday.

Cromer

If we would go back to its beginning we must tell the story of the forest bed of that Pliocene Age before men walked the earth, for its fossil trees are still exposed when fierce storms rage across the grey North Sea. Here on these noble cliffs stands Cromer, a new Cromer we must call it, for an older one lies down beneath the waves, and this is a Cromer which has defied the sea with a strong wall and put the church and the houses beyond its reach.

The great tower of the church soars for 160 feet with a superb trace the highest tower in Norfolk after the cathedral; and Cromer has a striking tower that is higher still, the lighthouse on the loftiest cliff, which with its powerful beam sweeps the passage every night.

Towards the end of the eighteenth century the chancel of the old church was blown up to save the cost of repairing it, and most of the rest of the church, with its square cut flints and its stone panelling, has been built since then. The western porch is older and has handsome medieval battlements and niches. The nave has great bays with soaring columns, and a row of clerestory windows lights the hammer- beam roof. The font is a copy of the masterly font at Yaxham with a pedestal and bowl rising like flowers in stone

The greatest house in Cromer is the fine Cromer Hall, a nineteenth-century house once the seat of the Windhams and the birthplace of Lord Cromer, renewer of the youth of Old Egypt.

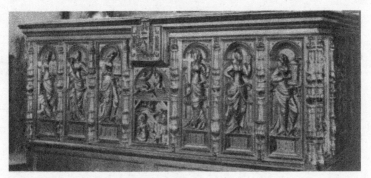

The fourteenth century chest at Dersingham

Crostwick

By the great common with its oaks and its peace memorial cross are the farms and cottages, and from a corner of it an avenue of towering limes leads us to the fifteenth-century church. Its walls are a patchwork of brick and flint, and the embattled tower has a curious lion head at each side of its arch. The pulpit has traceried panels, modern like those of the traceried screen, except for old screen panels of flowers, fruit, and a pelican in the spandrels. There is an old open timbered roof, two chairs are Jacobean, and the fine font has eight seated figures of Apostles round the bowl, with eight saints in niches round the stem.

Crostwight

It has a farm, a rectory, a few cottages by the wayside, and a church in the fields with a thatched roof over its 700-year-old chancel. The craftsmen who fashioned the splendid screen 500 years ago gave the people something of their country scene, for into its tracery he worked the creatures they knew: the dog, the hare, the bats, and birds preening their feathers. The marble font has done service for seven centuries and there are two medieval stone coffins with crosses on the lids.

Denton

Greeting Alburgh's soaring tower a mile away, the flint church of Denton stands on a hill in the quiet of green fields between the village and the River Waveney, and from its hill looks down to where fine oaks cast shadows on the rector's lawn.

A curious thing is Denton's tower; its lower part is half-round, half-square, and the rest is all square. We pass under the vaulted roof of the old porch,

with its five stone bosses carved with scenes in the life of Our Lord, into a church which is mainly fourteenth century. Tall arches open to tower and chancel, elaborate quatrefoil windows crown the arcades, and framed in the 600-year-old east window is a rich medley of old glass. There is a double niche above a single one with a trefoiled arch carved with roses, and by its side is a fine stone seat with roses to match. There is an unusual piscina with a beautifully carved drain, and a chest made from the old oak screen, still with paintings of saints.

Denver

The Fens are very near it. A rough road past the windmill points the way to them and leads to Denver Sluice, where the waters of this powerful and unaccommodating neighbour are kept in check.

Deopham

Here is a surprisingly big church for this lonely countryside, and its noble tower, rising like a beacon a hundred feet above the fields, is worth coming far to see. Built in the middle of the fifteenth century, it is one of Norfolk's highest towers and has an individuality all its own. Sets of three windows with lovely tracery are in three sides of the church, splendid buttresses climb in six steps to end in turrets above the parapet, and between these are leafy gables, surmounted by a cross. Some 18 feet from the ground runs a band adorned with fruit and flowers. The great east window and the splendid doorway framing the old door are both fifteenth century; the rest of the church is sixteenth. The best view inside is from the sanctuary steps, where we see the simple charm of the tall arcades and the soaring arch of the tower with the font standing below. Old relics are the sedilia and the piscina, a coffin stone carved with a cross, and fragments of the medieval screen.

Dersingham

A big village on the road to Hunstanton, it is more attractive for its setting than for itself, except for its fine church. There are charming views over the Wash, and the lovely Woods of Sandringham border the sandy heath that touches the village and is the nesting-place of shelducks. In the brooding season we may see them escorting their young families to the beach.

A charming picture on its south side, the church is reached by an avenue of cypresses and has at its gate a fine barn of 1671, with stepped gables. The tower with angels for pinnacles is 500 years old, as is the rest of the building save for the big fourteenth-century chancel, bright with clear glass in windows of the beautiful tracery, the east one with five lights.

Diss

The River Waveney is still young as it flows by Diss on its journey between Norfolk and Suffolk. This rather fascinating old market town seems to have grown up round its great mere, which comes to the edge of the main street and covers nearly six acres. From it we look up the narrow road to the cold flint walls of the imposing church of St Mary, guarding the town. Between the mere and the church is a sixteenth-century timbered shop with low-beamed rooms, and on one of the beams is an angel with outspread wings and a star over the head. It is one of the many old dwellings and inns sprinkled about the town. Looking across to the church is a finely timbered inn with overhanging storeys, and a yellow house with an overhanging storey and carvings of the Annunciation on a corner post.

Limes and pink mays grow round the clerestoried church, which is a handsome picture with its embattled tower and nave, and its array of fifteenth-century windows. The parapets and cornices have ugly gargoyles of animals and men, and faces, flowers, and figures of curled-up dragons. A sanctus bellcot crowns the east gable of the nave. The porches are fifteenth century; the tower and the nave arcades are the oldest parts and come from about 1290. A fine peal of eight bells rings out from the tower, which has an outside passage from north to south, and a door carved on both sides with tracery, and with headless saints on the inner side. Over twenty stone angels support the nave roof, and twenty-four more the roof of the aisles. The font and its cover, the pulpit, the reading-desk, and the lectern were the work of local craftsmen last century. The oak screen, with cherubs and roses and vine in the cornice above the traceried vaulting, is of our own time. The two chancel chapels were built in the fifteenth century by the two trade guilds of the town. St Nicholas Chapel has been made the finest part of the church in its restoration as a peace memorial. Under a plain tomb sleeps William Burton, who died early in the eighteenth century, leaving money to the poor and also for his tomb to be kept in repair.

Ditchingham

The River Waveney here makes a great circle between Norfolk and Suffolk, with Bungay over the border. The Broome Beck has a fine setting in Ditchingham Park, where it forms a lake before flowing on to join the river. We have a lovely view of it from the road, with the stately house of 200 years ago. The fifteenth-century church is away from the village, set in a byway on a bank among the trees.

Of the church itself the imposing tower is the finest part. Its west doorway is adorned with kings and queens. The fourteenth-century font is carved

with roses and faces. It has memories of a man who loved it, for he was churchwarden. Sir Rider Haggard was an honest-minded man who did varied work of sound value besides writing romantic tales. He became the best-seller storyteller of his day with King Solomon's Mines, and fully sustained his reputation with She and Allan Quatermain.

Docking

It holds its head high, this quiet upland town in the middle of a star of five roads; as soon as we enter it we touch the highest part of Norfolk, a distinction which in days gone by was not without some inconvenience. Because of this altitude, Docking water was so scarce that it had to be brought by pailfuls and the place was known round about as Dry Docking. Now it advertises the changed order of things by a concrete water tower with buzzing en nines rising by a pond near the old church and hall among the trees. Near the church the wooden stocks stand under the shelter built to keep this relic of Merrie England from decay. The hall, which John Hare built in 1612, was enlarged last century. The church is chiefly fifteenth century, but most of the chancel, with its fine windows, is nearly twice as old as the hall. Older still is part of a Norman pillar in a niche in the nave.

Downham Market

The town hall and the clock tower in the small marketplace have come since Nelson's day, and the church, reached by a long avenue of elms, is largely fifteenth century as we see it outside. A reminder of the original Norman church is a small shaft set in the outside wall of the chapel. The oak panels high on the sanctuary wall were once the altar rails, and a fine old chest like a family trunk has massive iron bands and three locks. The fifteenth-century font has eight shields carved with emblems of saints. Since the close of last century the angels and saints adorning the roof, which are said to have been battered by soldiers in the Civil War, have been looking down in their bright new dress. Men holding shields are supporting the beams. The screen and pulpit are both canopied, and enriched with gold leaves and roses.

Drayton

It belongs to the highway and the byways, a pleasant old village with many trees in the valley of the Wensum. On a mound facing the village green, with its group of elms and six feet of an old cross, is the church with a thatched roof to the nave, and near the green is a yellow-walled inn of 1678.

The Old House with Dutch gables advertises its age with the date 1697, and has oak and beech trees on its lawn which are said to have been planted

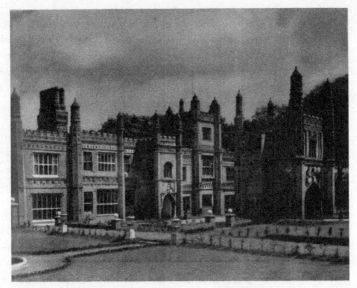

The Manor House at East Barsham

then. Down an avenue of lovely trees, in front of the fine new hall with clustered chimneys, is the Old Lodge, an impressive remnant of an old house with round towers at the corners. The old work left in the church after much rebuilding is of the thirteenth and fourteenth century. The chancel and the nave are restored. Into the twentieth-century aisle have been built some thirteenth-century lancet windows. A few steps of the old rood stairway and its doorway are still here, and the Norman font has an octagonal bowl on a new central column, and the original Norman shafts. The village was on the way to Walsingham, and it is thought the carvings were made by the pilgrims to the Shrine.

Dunston

Within four miles of Norwich, and in a charming setting between the busy highway and the River Tas, is this Arcadia called Dunston. Its cottages are clustered on the edge of a great common with clearings among fine trees. There is a pretty red farmhouse covered with creeper and flowering plants, with long barns at its side; a Queen Anne house peeps out through the trees, and ducks on a pond add charm to the scene. Completely hidden from the road is the little old church, not far from the great house with its gables and quaint old chimney stacks.

The church is chiefly fourteenth century, but is much restored. Its flint tower is crowned with battlements and pinnacles; the fine old font has a bowl with roses, lions, and angels; there are one or two old bench-ends; and the fifteenth-century oak screen is painted in medieval colours. A thirteenth-century lancet in the chancel has fine old glass showing St Remigius, the patron saint, as a bishop with a woman in blue and white kneeling imploringly before him.

Earlham

Beauty and charity join hands in this village which brings the peace of the countryside to the gates of Norwich. The River Yare, flowing under an old stone bridge, winds under overhanging trees and round the park of Earlham Hall, home of the Quaker Gurneys.

The park, with its plantations and its avenue of chestnuts, is completely hospitable. Made enchanting by Nature and inspiring by man, we may wander past the tree-clad island by the river bridge, and over the lawns where for generations walked the famous Gurney brothers, Quakers, bankers, and philanthropists; their immortal sister Elizabeth Fry, and William Wilberforce, here pondering over his great fight for the slaves, and here receiving abundant help and inspiration for it.

Among the trees on the other side of the road from the park is the quaint little fourteenth-century church with a low tower and a two-storeyed medieval porch. Opening on to the churchyard is a house with clustered chimneys. The oldest relic of the church is a Norman window. There is a 600-year-old font, two golden angels hold candles over the altar, and a fine fifteenth-century chancel screen has lovely tracery over rose-tipped arches.

Earsham

The River Waveney sweeps into a half-circle to bring this village into Norfolk. Its beauty lies about the church, which stands near the river, a watermill close to it which turned a mill before the Normans came and turns a mill today.

The fourteenth-century tower of the church is crowned with a wooden spire. An old door with two iron grilles leads us into a nave filled with box pews. The chancel roof has fine hammerbeams, looking down on stone seats which were found buried in the wall last century, they are 600 years old. The font is sixteenth century and is carved with the Seven Sacraments.

East Barsham

A farm, an inn, and a few cottages nestle in the hollow, and above them is a manor house with a fine gateway, built by Sir William Fermor in the time of Henry the Seventh. A charming picture as we come from Houghton St

Giles or down the hill from Fakenham, the manor house and its gateway stand at file wayside for all to admire. Both are of brick. Royal arms and shields adorn the gateway; the noble house has a fine array of battlements and turrets, with ornamental bands of raised medallions and shields, and chimneys with fleur-de-lys and roses. The story is told that a king came this way while the house was new, for Henry the Eighth is said to have walked barefooted from here to the Shrine of Our Lady of Walsingham to intercede (in vain) for the life of Catherine of Aragon's infant son.

Above the manor house stands the small church, as lowly and plain as the house is rich and grand. It is a sad and battered place which, though restored last century, still shows signs of its despoiling after Henry's suppression of the monasteries. What is left of the tower serves as a porch. Other old relics are a Norman doorway, the original altar stone under the present altar, a little medieval glass, some poor poppyhead bench-ends, glazed tiles that once paved the chapel, and broken figures once part of a reredos and found in a barn.

East Bilney

The medieval church stands alone on the hill, looking down on the valley where the oldfashioned houses cluster among the trees. The font is an old relic, and the fine Jacobean stalls and priests' seats are carved with honeysuckle. In harmony with them is the modern pulpit with an old panel. The chancel was restored in 1883 on its old foundations in memory of a rector who served nearly half a century, and the lectern was a nineteenth-century gift by two people thankful for thirty-three years of happy marriage.

East Dereham

A lively market town on the slope of a hill in fertile country, it has the charm of streets of steep-roofed old houses, a fine old church above a stream, and a tale a thousand years old to tell of saint and pilgrim, priest and poet and vagabond, who have passed this way.

Here the poet William Cowper died and was laid to rest in the church. On the site of the house in the marketplace where his last years were spent 'under the care of his faithful friends' a Congregational chapel with a pinnacled tower has been built in his memory, the vestry being fitted with woodwork from the bedroom in which he died.

The Assembly Room was built in 1756 on the site of the old market cross, and is used now partly as a reading-room and institute. The Corn Hall, a hundred years younger, crowned by a statue of Coke of Norfolk, is now a cinema. The town was almost destroyed by fire twice in the seventeenth

century; one house which escaped both fires was the charming dwelling (now two cottages) by the church gate, with dormers in the thatched roof and lovely plaster-work patterned with trailing stems, leaves, roses, flowers, and grapes. The church is an impressive pile with its two towers, its story going back to the seventh century, when Withburga (daughter of a king of the East Anglians) founded here a nunnery and built a church, both being destroyed by the Danes. She was laid to rest in the churchyard in 654, and later taken into the church. Standing detached from the rest is the sixteenth century bell-tower, with an enormous clock and a fine ring of eight bells, used in 1796 as a lodging for French prisoners on their way from Yarmouth. One who tried to escape was shot while hiding in a tree, and was buried in the churchyard.

About a hundred years older than the bell-tower is the graceful lantern tower rising in the middle of the church, with a triforium above the four fine arches on which it rests inside. It was built just west of the thirteenth-century central tower, of which the arches still remain, the seven arches of the existing and vanished towers being a striking feature of the interior. In the sides of the arch leading to the chancel are two twisted pillars from the end of Norman days, and another relic of this time is the lofty south doorway, with four shafts and quaint heads on each side of the crude trefoil arch.

The chancel, with its lovely sedilia and double piscina, is chiefly thirteenth century. It has an Easter Sepulchre carved with angels and Our Lord bearing the Cross. One of its two south doorways is original and the other new, both doors having fine new hinges.

The south arcade is thirteenth and fourteenth century, and the aisle to which it leads has fifteenth-century windows. The north arcade with clustered pillars, its aisle with butterfly tracery in the windows, is 600 years old. The transepts, with their eastern chapels of Thomas Becket and John the Baptist (both with fine painted ceilings) are chiefly fifteenth century. The fine porch of about 1500 has a carving of the Annunciation in the spandrels of its entrance arch, and at each side is a richly pinnacled niche and a canopied stoup; crowning its buttresses are quaint groups of animals and little men, one playing pipes.

Very striking is the fifteenth-century font on two steps, its battered sculpture showing the Seven Sacraments and the Crucifixion on the bowl, with figures of the Apostles and Evangelists round the stem. The brass eagle lectern is older than the Reformation. A great treasure is the handsome old chest, once in Buckenham Castle and given to the church in 1786.

East Harling

Highways and byways lead to this small market town with about a thousand folk, which has its finest possession in a pretty corner by the River Thet.

We mean, of course, the lovely old grey church, arresting in its beauty as it stands on a slope above the stream, elms and willows for its background, and wallflowers, stocks, and forget-me-nots blooming in its churchyard. A bridge close by, a watermill with a wooden gable, and the old dovecot with its thousand nests all add to the charm.

The church is a handsome picture in this scene, with its tower and spire, the tall aisle windows, the lovely clerestory, the steep lead roof, and the fine porch. The tower has a lovely crown of pierced battlements, with corner pinnacles and robed figures; and over it rises the delicate spire covered by lattice work, open at the base and supported by living buttresses. The great charm of the church is in the lofty nave. The clerestory rises above arcades with clustered columns, and has a line array of nine windows on each side. From it grows the magnificent hammer- beam roof, one of the noblest in the county. The beams are richly carved and modern stone angels support the shafts between the windows. Both aisles have old panelled roofs adorned with angels.

Sir Robert Harling, who rebuilt the chapel, has a magnificent altar tomb with a canopy most richly carved. His sword and both his arms are gone, but his helmet is still on his fine head, and his feet are on a lion.

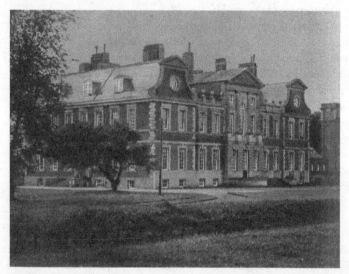

Raynham Hall, home of the Townsends, at East Raynham

East Lexham

As the River Nar goes quietly through the valley, it flows through the park where the boughs of the trees sweep the ground and almost hide the Georgian Hall. There are a handful of cottages by the stream, and the small church is so hidden that it is easily missed as we come by the lovely mile of woodland from Litcham.

It is a church not to be missed, for it has a tower that has stood over a thousand years. Plain but trim, the church stands on a bank under the woods, charmingly grouped with barns and a farmhouse with stepped gables and clustered and patterned chimneys. The Saxons built the round tower, its crude window having a pillar between two lights, but a later age added the brick parapet. There are traces of Saxon long-and-short work in the nave. In a corner of the sedilia is a fine piscina, and a carved chair is made up of an old stall and two miserere seats, one carved with a demon and one with a man's head.

Easton

Some of it lies round the cross-roads between Norwich and East Dereham, its farms are dotted about hill and vale, and the church stands alone by the wayside with a cream-walled farmhouse in the firs not far away. Its old tower fell in the eighteenth century, and a turret now houses the bell. Though much of what is old comes from the fifteenth century, there are a few things to see of the twelfth.

Over the tiny porch a sundial has been counting the hours since 1694, and within the porch is a fine doorway which saw the passing of Norman days; among the carvings on its pointed arch, its pillars and capitals, are stars, foliage, and quaint interlacing work. It frames an old door on its original hinges and with its lock and bolt, letting us into a nave with an old black roof looking down on cream walls. The fifteenth-century windows, a west window 600 years old, and those of the clerestory over the one arcade, fill the church with light. At one end of the arcade is a carved arch moulding as old as the doorway. The font of Purbeck marble is from the dawn of the thirteenth century, its bowl with simple arcading set on a central shaft and eight small ones.

East Raynham

It is Raynham St Mary, one of the three Raynhams on the borders of the thousand acres of the beautiful park sheltering the seat of the Townshends, which Inigo Jones designed 300 years ago in his grandest style for the first baronet, Sir Roger. Remains of their older home still stand by the beautiful

lake on the edge of the park, and between the lake and the great house on the hill is St Mary's embattled church, with gleaming flint walls. It was made new in 1868, and is pleasant inside with graceful arches on clustered columns. Its old relics are a fifteenth-century font, a piscina with a flower drain, and a niche with three twisted Norman pillars.

The oldest of the Townshend memorials is an exceedingly rich and lofty monument crowned by a canopy with a latticed roof, under which are five pinnacled niches with fragments of battered figures.

East Rudham

The River Wensum rises near West Rudham and flows through East, which has a big green and a pond by the church. When East Rudham's tower fell last century so much damage was done that most of the church was rebuilt, but there are lovely old relics worth the finding. There are some thirteenth-century lancet windows in the chancel, and a round window in the south transept is said to have been given by Sir Aylmer de Mordaunt centuries ago for deliverance from a storm on his way from the Holy Land. Adorning the transept outside is a beautiful gable cross 600 years old. The central boss of the fine vaulted roof of the porch is a fifteenth-century carving of the Holy Trinity.

Among the beautiful fragments of sculpture in Derbyshire alabaster which came to light last century, and are believed to be part of a fifteenth-century reredos, is part of a Crucifixion with an angel at the foot holding a cup, a headless figure in a cauldron, and half of the figure of St Anthony with his belled pig. The most charming fragment is a canopied niche showing three angels and the Crowning of the Virgin. They are all under glass for us to see. A thirteenth-century coffin stone has a wheel cross at the head and foot. Older still, and the only Norman relic here, is a lovely pillar piscina.

East Ruston

Its people live round the common, and its church looks out to sea in medieval splendour, its battlemented tower visible for miles. Not far away a two-sailed windmill spins merrily at its work.

The church has two treasures from its prosperous fifteenth-century days, a font and a screen. The font, raised on high steps to display its ancient grandeur, has at the base curious bat-like creatures with human faces, and on the sides of the bowl vigorous carvings of heads, one encircled by rays and another with hair blowing in the wind. The screen has portraits of the Four Evangelists and the Four Doctors of the church. Matthew stands with an open book, Gregory is in a red robe, and Augustine is in green, and sitting on pedestals are lions in pink and gold guarding the entrance to the sanctuary.

East Tuddenham

The pump in its shelter stands on the green of this village, where eight cottages owe their existence to charitable folk of Tudor and Georgian days. The old church is away in the fields, a long avenue of limes leading to the lychgate and splendid copper beeches shading the churchyard.

The fine-looking church has big fifteenth-century windows, a thirteenth- and fourteenth-century tower, and a flint porch with three niches over the entrance arch, which has the Annunciation scene in the spandrels. The beautiful inner doorway, coming from early in the thirteenth century, has a shaft on each side with foliage capitals, supporting an arch richly carved with branchwork. It frames an ancient door with a ring, opening to a wide nave with many fine old bench-ends. On one poppyhead are two faces with bands round their mouths, as if gagged. Looking as fresh as the day it was made, about the end of the twelfth century, the round bowl of the font is carved with trailing leaves and scrolls below a rim of cable moulding. There is a plain piscina in the corner of a window seat. The east window shines brightly with eighteenth-century Flemish glass showing scenes of the Nativity and the Presentation in the Temple, the Descent from the Cross, the Ascension, and the miracles.

A knight unknown has been lying here since the thirteenth century, his stone figure clad in chain mail and his feet on a lion; and a fifteenth- century civilian in a long robe, with a signet ring at the end of his beads is in brass with his two wives wearing draped headdress and rosaries, all three with hands folded in prayer.

East Walton

Past the farmhouses and past the smithy in the row of cottages on the green, the church must be sought down a lane, where the trees conspire to hide it. A round Norman tower with fourteenth-century belfry windows declares its ancient standing, but inside it is gaunt and bare. Nine old corbel brackets carved with heads have lost the roof they once supported, and a plaster ceiling looks down on box pews from which rises the three-decker pulpit, all in deal. There is a little fine carving of undercut foliage in the moulding of one of the old arches, and quatrefoils adorn the medieval font.

East Winch

The church tower rises proudly on a hill above the roofs of the houses. There is a Norman piscina on a carved shaft, but most of this fine building is fifteenth century. The arcades have lovely mouldings, part of the old roofs remain, a block of battered poppyhead benches keeps company with poor deal pews,

the tiny chest is still in its iron bonds, and part of the old screen is made into a desk on which is a Bible of 1611, chained to remind us of old days. One of the windows has a panel of old glass fragments. The west window glows in the sunset with a scene of Simeon and the Holy Child, and in another we see Etheldreda with a model of Ely Cathedral, and King Edmund with an arrow.

East Wretham

We may come to it by a lovely five miles of heath and fir woods from Croxton, finding first the little flint church in a charming corner on the edge of a great park. Between it and the rest of the village is an old windmill on high ground by a row of Scots pines. There are several lakes in the neighbourhood, and on one being drained last century the remains of an old lake-dwelling were found.

Compared with this memory of the Stone Age the fine Norman doorway of the church, enriched with zigzag and nail-head and carved capitals, is very young, but it is the most ancient thing we find in this fourteenth-century shrine. The church is lovingly tended, and a study of white and blue in its walls and furnishings, charmingly lit by candles on iron standards, like little trees among the dark pews. Two lines of them on each side of the chancel make a pretty avenue of light to the sanctuary, where brass candelabra hang by the altar, which is guarded by four golden angels, each holding a candle. With the fine candelabra in the chapel we counted over a hundred candles here.

Edgefield

We come here, beyond the cottages and the ivy-covered farmhouses, upon an old white tower with a tale of the Black Death. This fearful plague, which left England bare of labourers and was to turn Norfolk into a wool-growing county, wiped out nearly all the people of this village. Long afterwards the survivors moved to higher ground half a mile away and left their church behind, its beauty decaying and its walls falling into ruin. For four centuries it stood alone, apart from its flock.

In the early years of our own century Walter Hubert Marcon decided to bring the old church nearer to his people. All but the tower and the porch was taken down (the church moved stone by stone often by the rector's own hands), and the old material was used for the new church standing among the cottages and their orchards. The brave rector spent ten years at this work. Over £2,000 had to be collected, but at last it was done, for Norfolk is proud of its churches and generous towards them.

Old screenwork from the vanished church is in the new, across the chancel and in a side chapel where, on the panels, we see Tudor paintings of the donors, William Harstrong and his wife with their children.

We heard here a story of the organ. Margaret Woods, a poor pedlar, so loved this church that, having neither kith nor kin, she left her savings of a hundred pounds to buy something for it. It went towards the cost of the organ whose strains reach the grave in which she lies in the churchyard.

Edingthorpe

The cottages are scattered about its lanes and the church is on a lonely hill. The round tower is Norman, capped by a belfry added when the nave and chancel were rebuilt in 1400. Little has been changed since. Here still are the ancient doors, grey and crumbling, the medieval mass dial, the windows with rich net tracery, and the old traceried font. Here also is the old screen with six saints vividly painted on green and red panels, Paul with his sword and Andrew with his cross among them.

The pulpit, reading-desk, and many benches with poppyheads come from Elizabethan times. The iron stand that once held the hourglass is still on the pulpit, but instead of recording time it now upholds a lamp to light the Word.

Elmham

It straggles along with many old houses lining its ways, and its fine old church crowning a little hill by the green. It was the seat of a Saxon bishopric centuries before the Normans came, and had a humble church which was swept away by the Danish invasion. Today its most ancient possessions are an earthwork and a dyke from which a militant bishop, converting the defences into a fortified castle, kept watch and ward. The bishop's castle has long since fallen down.

The church has come down from the thirteenth and fifteenth centuries. The tower with its small spire rises nearly 120 feet, and projecting between two of its buttresses is a western porch which shelters a doorway carved with flowers and dragons, and has in the middle of its vaulted roof a boss sculptured with the Coronation of the Madonna. We may enter by this porch or by two other thirteenth- century doorways. As we stand four steps high under the tower we have a striking view of the beautiful nave, divided from the aisles by lovely arcades of six bays. The pillars are round and octagonal, and their height was raised when the clerestory was added 500 years ago.

On the old screens of the chancel and the two fifteenth-century chapels are seventeen paintings of men and women saints, dull but clear, and in the

rich carving in the spandrels of some of the panels are flowers, archangels and warriors, a dragon, and a headless figure riding on a pig. The great screen with a double row of balusters across the tower, a pulpit with its rich carving, and the altar table carved with vine, were all the work of Francis Floyd, a seventeenth-century parish clerk. The altar rails are of his time, and under the tower arc three battered old miserere stalls. Some old poppyhead bench-ends with arm-rests have quaint animals and birds, a griffin with a man s head, and a dog with a goose, and there are good copies of these in modern seats. In some of the windows is old glass, a medley Oil fragments and a Madonna.

Elsing

It is prettily set under the hills near the River Wensum its cottages dotted among the trees. A mile from the church which has a pinnacled tower, is the old Elsing Hall, charming with timbered gables, groups of patterned chimneys, and lilies in the ancient moat. Most of it is sixteenth century, but some of it belongs to the older house of the Hastings, whose arms are over the porch.

It was Sir Hugh Hastings, renowned in the Hundred Years War, who founded the church about 1340; he made it one of the best churches of this time. We see him in the chancel, a splendid lifesize figure in brass in armour and standing under a very rich canopy, an angel at his head. St George is in the canopy and at the top are Our Lord and the Madonna. Some of the figures supporting the canopy are missing, but among the six still here are Edward the Third, Henry Plantagenet, and the Earl of Warwick.

The north doorway has a fine arch with a finial, and part of its old door with a ring. The windows have flowing tracery, and fragments of old glass are three saints, angels, and pinnacles.

A striking feature inside is the great width and height of the aisleless nave; all but 40 feet wide, it is spanned by a roof of eight arches, chiefly old. The base of the original chancel screen is still in its place, and the panels are carved with arches and flowers in the spandrels, though their painted Apostles are gone. Five worm-eaten posts of the upper part are now loose at the west end, nearly 600 years after they were first set up. There are three sedilia seats and a piscina, and three carved and inlaid chairs.

The lofty tower arch is a fine background for the charming fourteenth-century font, with a tall cover only a little less old than itself. The font has a band of carving below the embattled rim; the cover is like an elaborate octagonal and buttressed tower with a leafy spire, still showing medieval colour and still with its golden pinnacles and saints. It is one of the oldest font covers in England.

Emneth

There are fruitful orchards and meadows, barns, and thatched cottages at this outpost of the Fenland, and at a bend of the road is the line church, its greatest possession, with something to show of all the building ages from the twelfth to the fifteenth century. The tower (a patchwork of brick and stone), the porch with a niche and two windows over its entrance, and the nave with its aisles, are all nearly 500 years old. There is an old sanctus bellcot on the east gable of the nave. Crowning the nave, with its array of a dozen arches in the two graceful arcades, is a splendid fifteenth-century roof, angels adorning its embattled beams and hammerbeams, and figures representing Christ, St Michael, St Edmund, and Apostles. The old roofs of the aisles are restored, and the fifteenth-century chancel screen has remains of old painting and gilding. In glass as old as the screen are two minstrel angels and the crowned Madonna and Child set in window tracery, and also old are a saint and angels in other windows.

Some of the chancel walls, and two arches on each side leading to the chancel aisles, come from the twelfth century. The east window is a fine trinity of thirteenth-century lancets reaching to the roof. In the north chancel aisle is a vestry with steps leading to an upper room. The old roodstairs are in a turret by the chancel arch, and the fifteenth- century font is adorned with roses and angels. There are a few old poppyheads, and a Jacobean chair has a carved scene of two men embracing on a mountain.

Erpingham

In the days when men had not yet fixed on surnames the manor of Erpingham came to a family which took his name and became known as the Erpinghams. The family vanished but the name lives on, for Sir Thomas Erpingham is one of the smaller figures in Shakespeare greatly beloved. Sir Thomas Erpingham was one of the faithful few who hazarded their life and fortune for John of Gaunt's son Bolingbroke, and when Richard the Second, on old Gaunt's death, light-heartedly exclaimed:

> *Think what you will, we seize into our hands*
> *His plate, his goods, his money, and his lands*

It was his death warrant, though little did Richard imagine it.

Though his family has gone the noble tower he added to the church still dominates the village. The door that brings us into the nave has been in its place 400 years, and now indoors are four stone figures that stood for centuries looking out on this churchyard. They are headless now but

once stood high on the tower representing the Four Doctors of the Church: Gregory, Jerome, Ambrose, and Augustine.

The 600-year-old font at which the proud Erpinghams were christened is still the village font; here still is the ancient piscina, an old ironbound chest, sixteenth-century poppyheads, and in the chancel (among the quaint corbels that have been here all the time) is a face with a tongue rudely out.

Fakenham

The River Wensum flows by this busy little pleasant market town of about 3,000 folk, and low red-roofed houses and shops crowd round the old church like sheep about their shepherd. The church stands near the marketplace, its 500-year-old tower impressive with panelled buttresses climbing to a crown of battlements and pinnacles, a reading round the base, and a great west window over a doorway with a niche at each side. The doorway is enriched with Passion symbols, the royal arms, and crowned letters representing the Duchy of Lancaster. John of Gaunt was lord of the manor here, and the Lancastrian monogram and arms are seen again on the old font. The big porch with an upper room was built in 1497, and is said to have been used as a powder magazine. The rest of the spacious clerestoried church, lighted by windows with flowing tracery, is nearly 600 years old. The chancel screen has fourteenth-century tracery below a new embattled cornice. The carved almsbox is a year older than the Great Fire of London. A bulky varnished chest has three locks. There is nothing else so beautiful inside as the tall canopied sedilia and piscina in the chancel, richly carved and dotted with flowers. A few of many brasses remain, chiefly fifteenth century and battered. One is the figure of a priest, and among other fragments is a woman with a rosary, wearing veiled headdress and a gown with a girdle, fur cuffs, and wide collar. On a floorstone of the nave are four hearts, each engraved with the prayer, Jhu merci ladi help.

Felbrigg

Avenues of mighty oaks and beeches lead us across a great park, just over the hill from Cromer, to the medieval church aloof in its silence, save for the rooks in the tree-tops. In the park is the hall built by the Felbriggs long ago, and enlarged by the Windhams in the sixteenth century.

We find the arms of Sir Symon de Felbrigg on the buttresses of the church he built and on the spandrels of the door of the tower. Sir Symon is on one of the magnificent brasses for which his church is famous. We see him as he was in his great hours, for he was standard bearer to King Richard the Second, and is here in full panoply holding the royal banner of England.

With him is his wife Margaret with a tiny dog looking up to her, and over them both is a richly decorated canopy.

The fine craftsmanship of this rich church includes a rare fifteenth- century paten with an enamelled figure of St Margaret of Antioch, patron saint of the church. There are memorials to the Windhams, who lived at the hall before the coming of John Netton last century.

Felmingham

It has a magnificent tower little the worse for its 500 years, but the rest of the church, clinging rather humbly is from the eighteenth century. It has a fragment of medieval glass with a fifteenth-century crest in one of its windows, the font bowl is 700 years old set on a base a century younger, and there is an ancient ironbound chest in which this little village kept its registers long ago.

Feltwell

Two old churches greet each other in this big village, which has a common on its western side and a giant oak where the road goes east.

The church of St Nicholas, the smaller and older of the two, stands high at one end of the village, and is now used only for burials. It looks to St Mary's fifteenth-century tower, and if stones can feel it must have sad memories of its own tower, which collapsed last century. It was a round Norman tower with a fifteenth-century belfry, and all that is left of it is the boarded-up Norman arch which led to it. Only the porch, nave, and aisles are left of the church, coming chiefly from the fourteenth and fifteenth century. The arcades have clustered pillars, and set in the wall is a Norman pillar carved with zigzag.

St Mary's fifteenth-century flint tower rises proudly with its pinnacles above the red roofs of the cottages, and the great house is at its side. Most of the church is 500 years old. The old nave roof has carved beams with ten robed figures and ten oak angels looking down on a fine array of old benches. There are more than thirty of them, all with leaf poppyheads, though most of the animals which used to crouch below them are gone. All have charming backs of open tracery and dainty ornament on the rails, and among the carvings on some of the arm-rests are three children standing by a figure tied up in a shroud, a belted figure with a bag, and a face peeping from a window. Some stout old benches in the chancel have fine foliage poppyheads; the oak screen (chiefly new) is richly carved with canopies and minstrel angels; a desk in the sanctuary is enriched with carved Bible scenes. The chancel and the chapel are dim with stained glass, most of it French, showing small scenes of Bible story.

Fersfield

A tranquil place lying off the main road to Diss, it is famous for having been the home of one of Norfolk's great men, Francis Blomefield, the eighteenth-century historian, who was born in the village, probably at the old hall close to the church, where he sleeps. He was rector here for twenty-five years till he died of smallpox and was laid in the chancel.

It is a neat church which shelters them, built in the three medieval centuries. The stone figure of a woman in a recess of the north wall is believed to be that of Amicia, mother of Sir Robert de Bois, who was lord of the manor in 1285 and built this nave. Sir Robert's son Robert carried on his father's good work by building the south aisle where he lies, a splendid figure carved in oak, his features still perfect, his head on a cushion and his feet on a buck. He has a fine belt over his surcoat. There are few oak figures in our churches (perhaps only a hundred in England) and this is a great possession.

Robert's sister Alice, wife of Sir John Howard, built the small tower, which is only 12 feet square and has an extraordinary lancet arch, five feet wide yet tall enough to reach the roof of the nave. The porch, with its old black and white roof, was built with money left by Jeffrey Ellingham in 1493. The door has old ironwork of delicate leaves.

Odd fragments of old glass remain in the windows, chiefly thirteenth- century lancets in the chancel and fifteenth-century in the nave. A cross-shaped peephole in the chancel arch was found last century. The reredos and sanctuary panelling are Jacobean, and the altar table is Elizabethan. A cedarwood chest has carvings of dragons, stags, lions, leopards, angels, and girls playing instruments. The oldest relic is the Norman font, with rope moulding and a Jacobean cover.

Field Dalling

For five centuries the three-staged tower and most of the church has been looking from the hilltop over this wide, wooded countryside. The dim chancel, which comes from the closing years of the fourteenth century, keeps a corner piscina and a windowsill shaped into seats, and by the lofty fourteenth-century arch dividing it from the lighter nave are the roodstairs. An arcade with remarkably slender pillars and continuous mouldings leads us to the north aisle. There are a few old box pews, a number of fifteenth-century benches, and a plain old chest ironbound. The fifteenth-century font is carved with a cross, a shield with three shells, emblems of the Passion, and the crossed swords of St Paul. Its scroll cover comes from 1662. In the good remains of fifteenth-century painted glass, some of it glowing richly with red and blue and gold, is a gallery of saints and Apostles, two figures of Our Lord, and the Madonna and Child.

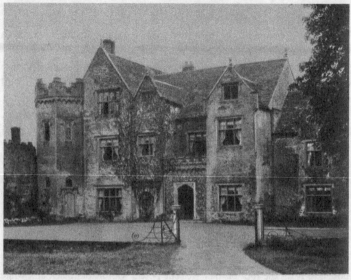

The Hall at Fincham

Filby

Secluded from the busy flow of traffic, this placid village nestles under its great trees, and a little lane with thatched cottages leads us to the old church high above Filby Broad. Long before they built the church this was a fine place to live in, for Scandinavian raiders settled here, and are said to have built their dwellings out on the Broad for better defence. From Filby Broad they drew fish and fowl as well as reeds to thatch their huts, and their prosperity continued through the Dark Ages till the Conqueror came, finding the manor so valuable that he gave it to his engineer Rabell, who had charge of the military train. These are the ancient memories of the village; today it prides itself on the raspberries it sends in vast quantities to the London market.

The Four Latin Doctors stand at the corners of the stately fifteenth-century tower looking down on the thatched roof of the nave—like velvet when we called, and the fourteenth-century quatrefoil windows of the clerestory peep below the deep eaves, some of them shining gaily inside with coloured glass.

Inside the church we look into a chancel dimmed with coloured light, and out through the west doorway of the tower to the beeches on the rector's lawn. Very interesting is the old latticed door to the tower stairway, for

here and there among its ironwork are no fewer than seven locks; it may be that the church's valuables were once locked in the tower. The font is 700 years old, and the six-sided pulpit about 400. The arcades are fourteenth century.

A richly coloured window showing Our Lord crowned, St Michael and St Mary, and a small Crucifixion, is to a churchwarden for thirty years. Among many memorials to the Lucas family is one to Charles Lucas of 1831, showing a boy angel leaning on a broken column, holding a wreath and an inverted torch.

The great treasure of the church is the chancel screen. The richly carved upper portion is nineteenth century, but on the traceried panels of the fourteenth-century base is a splendid gallery of eight saints, Cecilia with her garland of flowers, George and the dragon, Catherine with sword and wheel, Peter with book and keys, Paul with sword and book, Margaret thrusting her cross into the dragon's mouth, Michael weighing the souls of men, and Barbara holding her tower. The remarkable richness of detail in the paintings, showing lions, birds, dogs, and a falcon seizing a hare in the gold brocade of the robes, reminds us of Ranworth's magnificent screen.

Fincham

Fincham has a leisured air with its many old houses in a long street where ducks swim in the shade of a chestnut tree, opposite the fine church of St Martin, which has a tower rising proudly high. Once upon a time it had two fine churches not far apart, but the one dedicated to St Michael disappeared in the eighteenth century; all there is to see of it is a tablet on a wall marking the site, and a big carved stone to keep its memory green.

St Martin's church has for company an avenue of pollarded limes, and the shaft of an old cross said to have been with the vanished church. Very pleasing outside and in, it comes from a rebuilding of 1450, but the porch through which we enter is not yet a century old. The beauty of the interior is well seen from the richly moulded arch of the tower. The light stone of the leaning arcades between the clerestoried nave and the aisles contrasts finely with the dark old roofs. Angels and grotesques adorn the hammerbeam roof of the nave, and many old poppyheads on new benches are carved with two-headed eagles. The old screen with fine pinnacles has tracery with faded colour, and painting of trailing lilies on the panels. On the screen are the arms of the Finchams, who were lords of the manor from King John to Queen Elizabeth. Sir Nicholas, who died in 1503, sleeps under a floorstone in the vestry he built, and John de Fincham, who died seven years earlier, has a window to his memory. Part of their old homes survives in Fincham

Hall at one end of the village, delightful with its embattled walls, and its turret, and odd gables. A shrouded lady, tiny and unknown, lies in brass in the floor of the nave.

The great treasure of the church is the splendid font, its square Norman bowl carved with Bible scenes. On one side is a quaint Nativity; another shows the three crowned kings with their gifts; a third, representing the Baptism, shows the figure of Our Lord with a bishop and John the Baptist; and on the remaining panel we see Adam and Eve, Eve plucking an apple from a tree. This remarkable font belonged to the lost St Michael's church, and was brought here after being in the rectory garden.

Flitcham

It is spick and span and pretty as befits it, for it is part of the Sandringham estate, and is fringed by the lovely park of Hillington Hall with its splendid towered gateway. Its name tells some of its story, for it has grown out of Felixham, and the village has adopted for its quaint sign (one of three signs given by George the Fifth) the portrait of Felix of Burgundy crossing on a ship to England to found the first of the East Anglian churches. Flitcham claims that he built one here about the year 600, and that St Mary s church is on its site.

The church stands in a quiet and spacious corner against a screen of tall trees, looking down the road of creepered cottages with pantiled roofs. It is only nave and aisle, porch, a ruined fourteenth-century transept, and an eastern tower which stood in the middle till the chancel disappeared. It is a Norman tower, with one open arch and others blocked, a top storey added at the end of the fourteenth century, and marks of the old chancel roof being seen in its wall. The rest of the old work is 600 years old. There are two old carved chairs and fragments of old coffin stones.

Flordon

It has a scattering of houses, a small church with an ancient story set on a hill, and an Elizabethan house now a farm. The story goes back to Saxon days and here are windows the Saxon builders made.

A little avenue of limes brings us to the church, with a small brick turret and a spacious porch. A small old door with an iron ring lets us into a neat little nave where windows and traces of arches are oddly jumbled. Two of the windows are Saxon, and are deeply splayed on both sides; they were uncovered in our own time. Others are thirteenth and fourteenth century, and in one of these are old glass fragments with St Peter holding a key and an open book as he walks along. A simple medieval arch opens to the chancel,

where a narrow thirteenth-century priest's doorway was almost squeezed out by a window 600 years ago. By the Jacobean pulpit is a curious roof stairway built into the thickness of the wall.

Forncett St Peter

The Tas stream flows by as the village stretches along a byway, and we come to it thinking of the Long Ago, for it has a Saxon tower, and a memory that stirs within us the thought of one of the oldest and most interesting pieces of music in the world. It is that masterpiece of medieval music Sumer is-i-cumen in, the exquisite part song which thrills us today as it must have thrilled the monks of Reading, the first known example of harmonised secular vocalised music, considered by authorities to be the most remarkable composition that has survived the centuries.

He would know the neat little church as we see it, for it was built of flints 500 years ago, but the round tower is almost twice as old, and there is a mass dial by which the village would tell the time in the days before clocks. The tower John would know, and perhaps the dial. In the belfry are rows of tiny circular windows like peep- holes, deeply splayed on both sides, and here and there are other slits for light.

The glory of the church inside is its splendid array of fifty-four bench-ends, richly carved by medieval craftsmen, one of the finest collections we have come upon in Norfolk. Under their foliage poppyheads are figures at each side, a most interesting gallery with disciples and apostles, Judas with his money bags, a woman in what looks like a sentry box, a man with a coffer of money on his knees and a demon in front of him, another man sitting on the shoulders of a wild creature, a sower with his basket, a baker behind his counter with pies and loaves, and men with scythes. On a big fifteenth-century tomb are the engraved portraits of Thomas Drake and his wife Elizabeth, who founded the aisle in which they lie; he wears an ermine collar and she the kennel headdress of their day.

Both the aisles and the nave have fine old roofs. The font is 500 years old; the pulpit is a survival of the Jacobean three-decker. The roodstairs are still here and the north porch has ancient heads of a bishop and a queen.

Foulsham

The home of a fine soldier of the seventeenth century, Foulsham is a pleasant village of one main street, attractive with the colour of its houses. Some of them have old doorways, and a Queen Anne house is near the church where oaks and chestnuts overhang the road.

More imposing outside than in, the clerestoried church dominates the village and comes from the fourteenth and fifteenth century. The tower, with arcaded battlements and pinnacles, is ninety feet high, and was completed four and a half centuries ago, having had to be restored after a fire of 1770 and again after the great gale near the end of last century. In a little old glass are heads of women saints, a monk, a king, and a crowned woman; and better than the rest is the little figure of St Christopher with the Child on his shoulder. There is fine carving in the great sedilia and the double piscina, with finials crowning the gables and tracery in the spandrels.

On an imposing monument in the chancel kneels Sir Thomas Hunt of 1616, in armour with an iron sword behind him, and with him kneel his three wives, two in black dresses with ruffs, and one in a headdress like a box.

Foxley

It lies, pretty and compact, in the shadow of a handsome tower standing like a stalwart guardian of its ancient church. The tower is 500 years old and the chancel 200 years older, quaint with its box pews for the choir. Here is a fine fifteenth-century screen from which a panel has been cut to give entry to the three- decker pulpit. Four saints are painted in rich colours on its doors, two wearing mitres and the others with inscriptions petitioning prayers for the donors, whose kneeling figures are in the corners; one is a strange figure holding a music book, wearing a big red hat and a red dress speckled with golden flowers. One of the many old bench-ends with poppyheads of varying design has a tiny head carved on it, and perched quaintly on the cover of the traceried font is a golden bird with wings and tail outspread. Among its plate Foxley has a paten of 1350, perhaps the oldest in Norfolk.

Framingham Earl

Lovely trees shade its ways, and from the lychgate we look on to a richly wooded countryside. The trees are the memorial of a man who loved this place and planted them, and in the churchyard where he has been sleeping since 1822 are fine cedars, firs, yews, pine, box, limes, and willows.

Life has been going on in this place for a thousand years, for the church has the hand of the Saxon and the Norman in it, the Saxons in two windows, the Normans in arches, walls, and doorways. The Normans built the small round tower, which has only room enough to shelter the font, and there are two Norman doorways, one extraordinarily narrow with a fine little arch richly carved with wheel, star, and embattled pattern. By it hangs the clapper of an ancient bell. The Norman chancel arch has a hood of diamond pattern over its mouldings, and at each side is a small arch built by a later generation.

Many of the windows dimly lighting the small nave are modern, but the chancel has two bull's-eye windows with the characteristic Saxon splay on both sides. In the west lancet of the tower is a pane of old glass in blue and gold, showing St Catherine with her wheel and sword; and a panel in the nave has St Margaret with her cross on a red dragon. The pulpit is Jacobean.

Freethorpe

At one end of the street is the charming group of old Manor House with thatched tile barns, fine trees overhanging them all; and in front of the house is a wayside pond encircled by a clipped hedge. At the other end a lovely spreading cedar shades the gate of the churchyard, where the grey walls of the church stand out against the rich hue of copper beeches overtopping the small Norman tower, which is round and has a conical roof.

The rest of the little building is restored, and is dim and trim within. There is beautiful linenfold panelling on the sanctuary walls, the oak altar has traceried panels and a border of vine, and the reredos has tracery under a coved canopy. The tiny squire's pew (with a fireplace) on the north side of the chancel was added last century by the Walpoles, who gave the village a pump-house.

Frenze

We come to it by a winding way lined with trees. It has one of the smallest churches in the county, a nave without a chancel, standing in what was the park of the old ball. Some of its walls are 700 years old, and it has an altar stone older than the Reformation, and is rich in ancient brass. The east window has a few fragments of old glass in which we noticed a disciple's head, and there is a Jacobean horsebox pew carved to match the Jacobean pulpit with its canopy. The reading-desk, with tracery from the ancient screen, has arm-rests formed by monkeys. In the floor of the porch is an old coffin-lid.

Frettenham

We may call it the fortunate village, for every cottage was given half an acre of land by the last lord of the manor, Lord Suffield. A long way from the cottages in their spacious gardens, and from the sailless old windmill, is the 600-year-old church, reached by a lychgate and a path shaded by limes. A seventeenth-century brick parapet crowns the old tower, and a door swinging on ancient hinges opens to the nave, divided from its aisle by arcades on clustered columns. Above them are the small quatrefoil windows

of the clerestory. There are a few old poppyhead benches, and a fifteenth-century chest with fine carving of traceried arches on the front and ends. The chancel has two angels in old glass in the tracery of a fourteenth-century window, and the big bowl of the font comes perhaps from the end of the twelfth century.

Near the village, at Stanninghall, an old grey tower is all that is left of a church which became ruinous in the time of Queen Elizabeth.

Fring

It lies in a wooded valley, but its church is on a fragrant hilltop with a field of lavender for company as it looks out to the park hiding the big house, and down to the farmhouse near the bridge which carries the road over a stream. It is a plain little fourteenth and fifteenth-century church, with 600-year-old belfry windows and a fine little traceried one in a diamond frame in the tower. The altar rails, with rose-tipped tracery, are part of the vanished screen; there are faint traces of wall painting by the chancel arch, and a worn St Christopher. The font with simple pointed arcading comes from the thirteenth century. We found a Norman shaft piscina, with a carved cushion capital, serving as a lintel stone in the tower, over a very rare fireplace.

Fritton

It has pictures and portraits for us to see, precious things of days gone by for this little place to keep.

Beautiful avenues of oaks and elms lead to the long straggling common, golden with gorse in spring. On its edge stands the cream-walled Elizabethan hall with a pond made from the old moat.

The Normans built the round tower of the church, a shy, aisleless little place, but the fifteenth century gave it a new top and the whole tower has been refaced. The old studded door lets us into the fifteenth- century nave, in which the original font still stands with its lions and angels. The chancel is a century older. Two chairs are Jacobean. The medieval oak screen (about 1510) has been well restored, but its panels have still their fine old paintings, and quaint carvings in their spandrels, where we see a golden-winged dragon attacked by St George with a huge red spear, unicorns attacking each other with their horns, and a winged griffin.

Facing us as we enter St Christopher is striding through the water and holding his robe to keep it dry; the wall painting is blurred and only dimly seen. The most dramatic of all the paintings is one about eight feet high, a spirited struggle between St George and the dragon.

Fundenhall

Small and tranquil it lies among woods and wheatfields, with thatched cottages and a gabled farmhouse in a winding lane, and one church greeting another across the meadows. With its ivied flint walls, and a massive tower rising between the red roofs of the nave and chancel, Fundenhall's church looks its best outside, standing sturdily among the larch trees. Most of it is fourteenth century and much restored, but some of it has an older tale to tell. The base of the tower is Norman, with original windows in its north and south walls; the upper part comes from just after Agincourt, when John Daniel left twenty marks for the repair of the steeple. The Normans built the south doorway, carving its capitals; the small north doorway is English. The font has four quaint angels with long legs on the base All that is left of the old oak screen is the entrance arch and the canopy, which rests on the high uprights of the pointed arch leading to the chancel; but traces of painting can be seen.

Garboldisham

Its ancient tale is told by burial mounds round about, and by the earthwork known as Devil's Ditch, running across a heath fascinating for its dark firs and its clusters of silver birch. The village is part of a wooded countryside in the valley of the Little Ouse, and dotted about its ways are houses great and small, with thatched and pantiled roofs. Not far from the nineteenth-century manor is the lovely Jacobean hall with a fine background of trees and one enormous chestnut.

The fourteenth and fifteenth-century flint church stands proudly on a bank at one end of the village, its stately 500-year-old tower crowned with patterned battlements, corner pinnacles, and weatherbeaten angels. The porch, built about 1500, has beautiful modern gates. From the steps of the sanctuary we see the spacious beauty of the rest of the church, where lofty arcades divide the clerestoried nave from its aisles, and a still loftier arch leads to the tower. Three Jacobean relics are a chest, a desk, and an altar table. The oak screen across the chapel, with a modern top of fine tracery and old panels with paintings of two bishops and two women saints, was restored as a thankoffering for twenty-five years of happiness. The bowl of an old font lies by the new one, and with it are old stones from a church pulled down 200 years ago.

Gateley

Lonely and out-of-the-way are its few farms and cottages, with a modest church behind one of the farms on a little hill. Its tower, adorned with

coats-of-arms, and the nave with its raftered roof, are fifteenth century. The porch is Tudor, and the chancel is nineteenth century. The font is crude and old, there are traces of what may have been a Saxon doorway in the south wall of the nave, and on the opposite wall are the royal arms of Charles Stuart. The fifteenth-century screen, though battered, still has its original colour, and among the paintings of eight saints on the panels are St Puella Ridibowne holding a spray of leaves, Master John Schorn in a red robe holding a jack boot with a demon in it, the Madonna, St Elizabeth, and Henry the Sixth.

Gayton Thorpe

It is Roman, Saxon, and Norman. Down by the cross-roads, in a ploughed field, are the broken remains of mosaic terracotta pavement of a Roman house, the dwelling place of a Roman landowner who farmed the land, and perhaps grew wheat to send overseas.

With the farm and the cottages by a green is the plain little church which has grown from one of Saxon days. The round tower, its best feature, has two Saxon windows in the base and Norman belfry windows with zigzag hoods. A ladder climbs to the belfry, and a bell which once hung there, said to be the oldest in the county, stands silent now' in the nave. The best possession is the well-preserved fifteenth- century font, carved with the Seven Sacraments and a Crucifixion.

Geldeston

We look across the River Waveney into Suffolk; on this side are the Geldeston Marshes; facing the church is the hall in a park of 60 acres. Long before the Normans built this round tower the Romans found an abiding place at Geldeston, and the British Museum has a sacrificial vessel they left behind them here. The height of the tower was raised by the first English builders 700 years ago, and the rest of the church as we see it is mainly fifteenth century. The chancel, however, is modern, and on one of its roof corbels is a serpent stinging an apple on a tree, done by a medieval craftsman apparently thinking of Eve in the Garden. Two seventeenth-century chairs are carved and inlaid, the old font is carved with lions, roses, and angels, and the church keeps a fragment of its sixteenth-century screen.

Gillingham

It is on the edge of the marshes, an ordinary village with an out-of-the-ordinary church and the ruined tower of another. It has also a Jacobean hall with yellow walls and many windows mantled in trees. Prettily set in the

drive to the great house is the ancient church of St Mary, and on the other side of the drive is the deserted tower of All Saints in its old graveyard. It is all that is left of the church King Stephen gave to Hugh de Bigot, and we found rooks and pigeons nestling in its walls.

St Mary's is an odd picture outside, with its fine Norman tower seeming to rise from the middle of the nave. The curious effect is explained within, where, except for the aisles of last century, the church is much as the Normans left it—the chancel with its apse, the nave with the tower at the west end, and a baptistry west of the tower, all opening from one to the other by Norman arches. Norman faces peep down from the parapet of the tower.

Inside the church is dim, and is seen at its best looking from the dark chancel through its Norman arch, along the nave with its massive arcades (carved last century in Norman fashion) and through the narrow arches of the tower to the font beyond.

Gissing

It has memories of a family who have been lords of the manor here for 600 years, but its church tower is half as old again. Gissing may well be proud of this tower, for it is one of the best preserved of all the round ones in this countryside. Much of it is Saxon, but the windows and the tall arch, all adorned with zigzag, are Norman. The Normans built the south doorway, giving it a head at each side and a muzzled bear at the top. Over their north doorway is a fifteenth-century porch with an owl carved below one of its niches. The porch used to have an upper room, and in it lived John Gibbs, rector in 1668, after he was ejected from his living in 1690, sleeping, it is said, on the roodstairs so that he could lie in his narrow couch and see the altar when he woke. The stairs lead from a window splay and there is a doorway on the other side of the chancel arch, which rises to the roof and is as wide as the nave. Two stout medieval arches open to one chancel chapel, and another round arch leads to the north chapel, which has Jacobean panels in two high pews. About sixteen old bench-ends in the nave have poppy- heads, two old chests have three locks, the old font has a canopied stem, the chalice is Elizabethan, and a lovely silver paten of 1514 is engraved with six groups of cherubs round the head of Our Lord.

The finest possession of the church is the fifteenth-century oak roof of the nave. It has four rows of angels with spreading wings, embattled hammerbeams and wall-plates, and saints in niches supporting the beams. Eight modern angels look down from the simpler roof of the chancel.

Glandford

Its church is a jewel set in a garden on the hill, looking over the wooded valley where the River Glaven flows to the sea. Below it is a rare little museum for all who love beautiful things. It is an old church made new, saved from neglect in memory of a woman. In the fine niche on the porch stands St Martin and the man with whom he shared his cloak, the patron saint and the kneeling beggar. We see him again on the sedilia inside. Fine candelabra and wall brackets light the church by night and beautiful glass glows with rich colour by day, showing the Good Shepherd, the three Marys, David and Peter, St Barbara, St Christopher, Martha, and St George. Every window is stained, even the porch and the vestry.

Richly carved oak and cedar is everywhere. Screens have delicate tracery and friezes of vines. The pews have roses and leaves on traceried ends; and praying angels, fighting dragons, and foliage adorn the poppyhead stalls. The reredos is enriched with vines and berries and a broad band of Passion flowers, and the pulpit is banded with fern. Figures in niches support the roof of the nave, and angels holding shields with emblems of the Cross are at the ends of the beams. Minstrel angels and lovely bosses adorn the roof of the chancel, and a lovely panelled and traceried roof looks down on the chapel, where the altar has panels with richly painted figures.

There are shells from all over the world, miracles of Nature in all kinds of form and of every hue—shells as delicate as butterfly wings; shells exquisitely carved by man and painted; some shaped like ladies in wonderful dress, some egg-shells engraved and painted. Here too are lovely jewels, a bit of Pompeii, and a sugar bowl Queen Elizabeth used.

Gooderstone

The old church stands higher than the houses, the row of pines, and the windmill on the edge of the village, which straggles along in the byways. The tower, like most of the church, comes from the fourteenth century, but the chancel has remains of a century earlier in its stringcourse and the group of three lancets in the east wall. On its south side are three stepped sedilia four yards long, and a fine double piscina with pillars supporting richly moulded arches. A piscina in the aisle chapel is like a window with fourteenth- century tracery. Great windows with embattled transoms fill the nave with light, and fragments of old glass show flowers, the head of Our Lord, angels, and figures rising from tombs. The old porch has two unusual round windows filled with trefoiled tracery.

In 1446 a vicar left forty shillings for the font. The roof is old, as are some carved stalls in the chancel, and the two-decker pulpit is Jacobean.

The tall and battered fifteenth-century screen has traceried bays, and panels with paintings of angels and the Twelve Apostles. On the original doors are damaged figures of the Four Doctors of the Church. The fine old poppyhead benches filling the nave and aisle, all with richly traceried backs, are the chief treasure here, though they have lost the figures that once adorned the arm-rests.

Gorleston

It stands at the gateway of Yarmouth's harbour, overlooking the River Yare and the sea. It has a lighthouse on the quay by the harbour mouth, and is loved for its sandy beach. We must imagine that its people live long, for in the churchyard are eight gravestones of centenarians. The great church, with room enough for a thousand, stands on a bank, and it was perhaps on this site that Felix, Bishop of Dunwich, built a small wooden church in the seventh century. Of the church that followed in the tenth century only rubble foundations are left below the pillars of the present building, which comes from the three medieval centuries.

The fine flint tower, with 127 steps climbing its 90 feet, was used as a watch-tower in old days and is still a good landmark, seen by the fishing fleet as it goes down to the sea and comes home with the catch. Its base, with a fine arch opening to the nave, is thirteenth century, and the rest of it is two centuries younger. The great arcades running the length of the church are chiefly fourteenth century, as is the chancel, and the porch which shelters four coffin lids which covered the bones of the old priors of Gorleston. Guarding the doorway are battered heads of a king and a queen.

The fourteenth-century sedilia and piscina are in the south chapel, which has been restored in memory of nearly 200 men who did not come back. The walls are lined with oak, and in a Te Deum window is Our Lord on a rainbow in a deep blue sky. A flag that flew at the Battle of Jutland is now at rest in this chapel, where lie many of the Bacons who were lords of the manor six and seven centuries ago. The splendid brass portrait of one of them (perhaps Sir John, who was mentioned in the Inquisition Rolls of 1292) is now in the lady chapel, showing him a soldier in armour with sword and shield, his feet gone. It is a famous brass, for there are only five such figures with chain mail and crossed legs left in our churches.

Two fourteenth-century relics in the lady chapel are the piscina, and a beautiful canopied tomb recess in which there is an ancient chest with iron bands and three locks; it is like half a tree trunk hollowed out, and is highly treasured for it is thought to be Saxon. The stone altar may be Norman, and the medieval font is carved with the Seven Sacraments and a Doom scene.

Faint traces of old wall painting are on a pillar of the chancel arch, and at each side of the tower arch hangs an old painting of Moses and Aaron.

Great Bircham

A dismantled windmill and the 600-year-old tower of a church mantled in trees greet us as we come from Fring to this village, where the ancient quiet is disturbed by the drone of planes from the aerodrome. Much of the church is fifteenth century, but a beautiful thirteenth-century doorway, sheltered by the fine north porch, leads us inside, where the striking feature is the lofty nave arcades, having stone seats round the base of pillars with slender clustered shafts. A fifteenth-century screen leads to the chancel which was restored in the middle of last century, and has ten oak figures of men and women supporting the roof. There is nothing here older than the doorway to the tower, which has zigzag in its pointed arch and a carved capital on the shaft at each side, and comes from Norman days. The tapering font, with simple arcading, may also be Norman

Great Cressingham

The old Peddar's Way skirts the hollow where the village lies, and the River Wissey is crossed by a bridge. Thatched cottages are here and there, and near the church is the fine fifteenth-century manor house, partly rebuilt and now a farm, picturesque with corner turrets and a turret chimney stack. Both the lofty tower and the porch of St Michael's are fourteenth century. Graceful arcades with clustered columns divide the aisles from the clerestoried nave, on which looks down the old cradle roof, with two men holding shields at the ends of the beams on each side, and heads carved on the spandrels. The old font has an Elizabethan cover, a little old glass has angels and saints, and the top of the rood stairway is seen.

Great Dunham

Its attraction is a rare little church with rough flint walls, standing among fine elms opposite the rectory, but it has a stirring legacy from the past. A Roman lord lived somewhere near the elms, and the Saxons took the bricks of his house for the walls of their church. Some of them are seen to this day in the round arches of the windows of the simple place which has grown up from that early building. There are those who think the steps of the porch, so dangerously worn by myriads of feet, are also Roman.

The Saxons built so that their work should last. Their windows are in the central tower, those of the belfry having baluster shafts between the lights, and on two sides are small round sound-holes. Long-and-short work is seen

at the corners, and at the west end of the nave is a triangular-headed Saxon doorway, now blocked. On the gleaming cream walls of the nave, under the small windows, is crude Saxon arcading, and fragments of Saxon carving lie on a stone seat, in the corner of which is a tiny piscina. Foundations of an apse were found under the chancel by the builders of the fifteenth century. The eastern arch of the tower has fine cable moulding, the pulpit is made up of Jacobean panels, and the fifteenth-century font has eight angels round the bowl.

Great Ellingham

Houses with roofs of thatch and tile are dotted in the lanes and on the highway, where stands the old windmill that has lost its sails. The church, which saw the passing years of the fourteenth century, has a tower with chequered battlements and a short leaded spire, and is notable inside for its space and light. The windows have leaf tracery, and there are old glass fragments in the chancel, which is ablaze with great windows, the east one of five lights. Arches on clustered columns divide the nave and aisles, and stone heads support the restored old roof. The old font is adorned with shields, there is a piscina at the end of the window-seat sedilia, the altar table is Jacobean, and the battered old screen has still some of its traceried panels. Among the medieval relics that came to light in twentieth-century restoration is a painted niche in the wall, the rood stairway, two consecration crosses, and a rough patch showing a pilgrim in turban-like cap with his staff, passing a preaching cross. In front of him is what is left of an animal in harness.

Great Fransham

Like a shepherd gathering in a widely scattered flock of farms and cottages, stands the plain little old church on the hill. It has a fine medieval arcade with round pillars and capitals standing just clear of the south wall; it opened to an aisle which disappeared about 1800. Of two brasses attesting its former importance, one is a big fine portrait of Galfridus Fransham of 1414, wearing armour, with a canopy over his head, and coats-of- arms; the other is a neat little figure of a woman in a shroud, said to be Cecilia Legge, who died in 1500.

Great Hockham

It has cottages with thatched and pantiled roofs about its green, and a small grey-walled church hiding in the trees of the park round the eighteenth-century house.

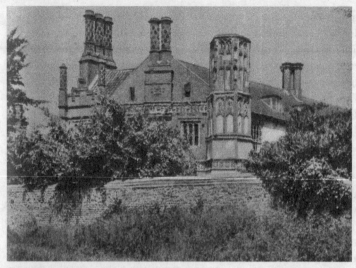

The Tudor rectory at Great Snoring

The tower of the fourteenth-century church fell 200 years ago, and now crowns the west gable. The view of the east tracery, is framed by the soaring chancel arch, at each side, a tiny bearded face over one of clustered pillars divide the clerestoried nave medieval font is carved with simple window battered double piscina in the chancel has tars and a gable with pinnacles. Very dainty is the pinnacle piscine in the south aisle, where a stone seat is a window. Among the fine carvings of the arm-rests in the nave are leaves and flowers, old men holding hands, double heads, and a quaint fellow on his knees with his head thrown back to touch his arm-rest facing him is a mermaid with a comb and a mirror.

Great Massingham

There is as much water as green, and a good deal of both, in this village, which once had a market: site of a priory founded by Nicholas de Syre in the Magna Carta century. The priory is gone, but fragments of it exist in the outbuildings of Abbey Farm. Of the several ponds on the several greens, one is the biggest we have seen in thousands of villages. Between two main greens is the village pump, opposite the fine fifteenth-century church. Imposing outside with its pinnacled tower and its lofty porch, the church has a beautiful doorway with three shafts on each side, and an ancient tower arch is extraordinarily high, the old arcades have clustered pillars,

and quaint old grimacing heads support the roof of chancel. The sedilia, the piscina, and the fonts are old, the font carved on eight sides with leafy gables. Damaged fragments of old glass show saints and the head of Our Lord, and an old painting of Mary with the Holy Child and the boy John hangs by the chancel arch.

Great Ryburgh

At one end of the long village the River Wensum flows through flowery meadows, near the church with its grey flint walls and red pantiles. Fine trees shelter it, and red- roofed houses clustered prettily about it. Built like a cross, the church has a round Norman tower at the west crowned by a fourteenth- century belfry. The rest of the old work is fifteenth century. The font has a charming setting, and its pinnacled cover, shining with gold, has a dove almost touching the massive low arch of the tower. In front of the arch are four oak pillars supporting a gallery of black oak. In the floor round the font are old glazed tiles, and there are others under the chancel arch. There are two piscinas.

The modern roof of the chancel is enriched with wreaths in moulded plaster, and has thirty angels along the sides. Lovely craftsmanship of this century is seen in the alabaster reredos, with delicate traceried panels where, on a blue ground patterned with gold, are beautiful sculptures of four saints, and of the Crucifixion, with Mary and John at the Cross.

Great Snoring

Highways and byways lead to it, and old creepered cottages make the road gay with their flower-bordered walls. The chief street slopes down to the River Stiffkey, at the top is the village well, and near it is a house built in Charles Stuart's day. Older still is the rectory which Sir Ralph Shelton built in the time of Henry the Seventh, beautiful with mellowed ornamental brickwork, gables, panelled turrets, and clustered chimneys.

Impressively lofty and full of light, the church comes for the most part from the close of the fifteenth century. The fourteenth and fifteenth-century chancel has an east window of about 1300, and remains of canopied sedilia with double pillars, carved capitals, and a vaulted roof with vine and foliage bosses, and a pretty piscina at the corner of the seats. Another fine piscina, adorned with foliage, is by a window seat in the aisle, and in the window splay is a terracotta figure of a six-winged angel. The old Commandment board has small paintings of the Last Four Things: Death, Judgment, Heaven, and Hell.

Between the nave and the aisle is a thirteenth-century arcade, its arches on pillars with bell capitals, and leaning. Of the same time is the massive

doorway through which we come and go; it has lost its shafts, but frames a beautiful panelled door with a border of quatrefoils and its old ring. The font is from about 1200, and among old fragments of coloured glass are minstrel angels, a knight, and St Michael with scales.

Great Walsingham

About a mile from the Little Walsingham of the Shrine is the smaller Walsingham called Great. Most of it lies on a bank of the wooded valley where the River Stiffkey is crossed by a ford, but its old church of St Peter is on the other side, above a small green on which an oak has been growing since 1692. In a meadow near the fine old Berry Hall are traces of a still earlier house, and slight ruins of Great Walsingham's vanished church of All Saints are still to be seen.

Of the old chancel of St Peter's stately church only fragments of ruined walls are left, but the nave, aisles, and tower which make the present church are lovely still, a tribute to their fourteenth-century builders. The windows have beautiful flowing tracery (rather rare in Norfolk), and fourteen quatrefoils light the clerestory. A mass dial is on a wall and grey old roof beams look down on medieval benches, with linenfold panels and open tracery in the backs, and there is rich carving in the brave array of poppyheads and arm-rests, showing saints and disciples, angels with shields, and curious animals. Each aisle has a piscina, and the fifteenth-century font's curious Jacobean cover is a dome on an arcade of eight bays. The pedestal pulpit, with simple tracery, is older than the date (1613) painted on it, and has traces of medieval colour under the later painting. Other old remains are the baluster altar rails, a pillar almsbox, wall painting of texts, a consecration cross, and fragments of old glass.

Great Witchingham

Lovely trees line the lanes bringing us to this scattered village, and more trees add to the charm of the lonely corner where the church stands, with only a house and a few cottages for company. A mile from the church as the crow flies the River Wensum flows through the woods by the great house, whose gabled brick walls and clustered chimneys we see through the gates. Half a mile from the hall the busy road to Norwich is carried across the river by a new bridge, the old one standing at its side.

A high tower crowns the imposing fifteenth-century church. We found swallows nesting in its fine old porch, where, carved in the spandrels, the Angel of the Annunciation is unwinding a scroll as the Virgin kneels, a jar of lilies behind her prayer desk. Between the windows of the clerestory are stone heads

and angels supporting the old nave roof, its moulded beams richly bordered; and figures with shields look down from the ridge. The old aisle roofs rest on quaint heads.

Two of four old benches are grey with age and have traceried backs, a demon and an angel carved on the ends. Of two old iron- bound chests one has three locks, the other is enriched with fantastic birds and animals. The bowl of the fifteenth-century font has remains of painted scenes of the Seven Sacraments and the Madonna in glory; under the bowl are heads of kings, queens, and angels, and one stem is Catherine with the wheel.

The oak lectern has one of the biggest birds we have seen—every inch an eagle, a veritable monarch of the eyries. Four winged angels on pinnacles round the stem are holding a sword, a harp, a censer, and a bunch of flowers; and the parson climbs a flight of steps to use as his pulpit this lectern eight feet high. It was the lectern in New College Chapel, Oxford, for nearly fifty years.

Gresham

In a dark thicket surrounded by a deep ditch are the foundations of Gresham Castle, the manor house fortified in 1319. The castle has disappeared except for these foundations, but there were thrilling days within its walls in 1488, when a thousand men marched up and demanded its surrender. Dame Margaret Paston was at home with twelve servants, and stubbornly they defended their castle, but the enemy mined its walls and set pans of file beneath Dame Margaret's room, smoking her out.

Though the castle has gone, the church in which these medieval squires worshipped is little changed and the old mass dial is still on its walls. Its round Norman tower rises above a thirteenth-century nave shaded by fine beeches and pines. The handsome flint porch with priest's room over it was added in the next hundred years. But the great treasure of the church is the font, famous even in this county of splendid fonts; it is one of the sixteen in Norfolk with sculptures of the Seven Sacraments and is a most beautiful example. Its groups are like gems of medieval ivory. In the panel of the Last Sacrament the face of the dying man is portrayed with real sympathy, and the marriage ceremony shows the bride and her friends in lovely headdresses. An eighth panel has been added of the Baptism in Jordan.

Gressenhall

Nearly a mile from the green, with its pond and a fringe of trees, is a company of houses and farms by the church, charmingly set on the edge of the park. It is a fine flint- walled church in the shape of a cross, and has a

story old enough for signs of Saxon building to have come to light. The top storey of the central tower rests on a base with Norman masonry, and over a western arch is a Norman window with a zigzag hood. The tall arcades of the nave are fourteenth century; in the fifteenth-century chancel are canopied sedilia and a piscina with flattened arches. Above these in the wall is a small old sculpture showing the Stoning of Stephen. On a blocked north doorway is a mitre and a crown. The fifteenth- century font has shields among its battered carving, and on remains of the old chancel screen are paintings of saints. Part of an old traceried screen is in the north aisle. A fine traceried door in the porch may be 500 years old, and another old door in the south transept, with its old lock and key and fine handle, and its borders printed with leaves and flowers, opens to a stairway leading to an upper room.

Grimston

Its spacious common is golden with gorse and purple with heather and has a noble view. Its church comes from the three medieval centuries. Its best feature is the splendid fifteenth-century tower, but Saxon corner stones in the north aisle have a tale almost twice as old to tell, and far older still are some bricks in the north aisle, for they belonged to a Roman house. In the 600-year-old porch is a fine fifteenth-century doorway with two shafts on each side supporting rich mouldings. The arcades, with clustered pillars and bell capitals, are also thirteenth century; the shallow transepts are a hundred years later. A little old glass in the east window is the only coloured glass in the church. The base of the chancel screen is old, the stalls have some old tracery and six misereres carved with heads and leaves, and there are quaint animals on fifteenth-century bench-ends with fleur-de-lys poppyheads. The font is 700 years old and faint medieval wall painting shows a Maltese cross.

Yews and pollarded limes shade the churchyard, where an anvil marks a blacksmith's grave. The rectory was made new last century, but it keeps a room in which Cromwell is said to have slept, and is still surrounded by the wet moat of the ancient manor house, on the site of which it stands.

Griston

Pleasant with cream-walled cottages roofed with thatch and tiles, it has a fifteenth-century church at the cross-roads, reached by an avenue of limes. Its handsome old tower of four storeys has a turret stairway, and worked in flint on the base and on the battlements are keys and swords, emblems of Peter and Paul. The best thing indoors is the almost perfect fourteenth-century glass shining red, blue, and gold with figures of angels, four prophets, and St

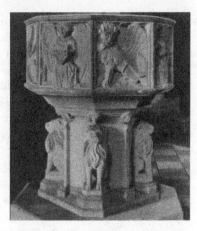

The fifteenth century font at
Haddiscoe

Catherine. Six old angels support the roof of the plain nave, the old traceried
screen is still here, and the Jacobean panels in the reading-desk and in the
backs of the stalls, which have some fifteenth-century bench-ends.

Here are old stones of the centuries which have had queer adventures. In
the chancel floor are set three old altars, which have served as steps in the
porch and at a stile in the churchyard. Part of an old tomb with the arms
of the Cliftons now helps to make a bench after having been used as the
shaft of the font.

Guestwick

Far from any highroad it lies, its church half hid by trees. Most of the
church is thirteenth century, but the age of its tower (once central and now
at a corner) is wrapped in mystery, for although it has two round arches
believed to be Norman it is made of the peculiar Hunstanton rock used by
the Saxons in their finest Norfolk buildings.

The old font has shields with emblems of saints and martyrs, and an
aisle window has splendid fourteenth-century glass with glowing figures,
one a bearded man in a red hat with upturned brim. The village has also
a slender link with Shelley, for William Godwin, the father of the poet's
second wife Mary, spent most of his boyhood here when his father was the
Independent minister.

Gunton

It lies in the heart of one of the loveliest parks in Norfolk with a thousand
acres of beauty round it, trees in stately glades and massed in dark woodlands,

deer flitting like shadows across the pastures and herons nesting by the lake. A lofty lookout tower strides across the drive, which leads to the home of Lord Suffield, whose ancestors settled here in Charles Stuart's days. They were the Harbords, and it was Sir William Harbord who built the church in 1769. The church has a portico with six great columns half hidden by a huge fir, and over the door is a dignified frieze designed by Grinling Gibbons. Behind the altar, set in neat panelling, is an Italian painting of Queen Elizabeth and Mary Tudor.

Hackford

A simple tower crowns the small fourteenth-century church by a quiet lane, and a neat fifteenth-century porch, its walls adorned with arcading, shelters a finely panelled stoup by the old door, which opens to a cream-walled nave and chancel. Among a few old glass fragments in the medieval windows is a figure of an angel. There is an odd corner piscina by the window sedilia, the quaint old rood stairway still remains, and the fifteenth-century font, with eight shafts round the stem, is carved with sacred emblems and family coats-of-arms. There is a carved Jacobean chair, and a sixteenth-century chest has fine carving of ferns.

Haddiscoe

The church, on a high mound commanding the green valley, is conspicuous and famous for a round tower only eight feet across inside, built in four telescopic stages by the Saxons, lighted by narrow slits and arrow-headed windows, and crowned by deep chequered battlements of the fifteenth century. Over its narrow arch inside the Normans built one of the three doorways they set up here.

Even without the striking Saxon tower the church would have an irresistible appeal to the traveller, for its beautiful south doorway would be more than enough to bring us here. Its arch has the rich Norman mouldings, with star pattern outside the pillars; and in a niche above it is a fine figure of Our Lord seated on a throne. The door this lovely doorway frames is a treasure in itself, its mass of fine old ironwork forming a large and a small plaited cross, both with feathery scrollwork. The handle is of twisted ironwork like a cable. The north doorway has a good Norman arch of three orders but has lost its pillars.

Of the odd array of bays between the nave and its aisle, two with primitive pointed arches come from soon after Norman days. A huge beam holds up the south wall of the nave outside. There is a medieval piscina, and the 500-year-old font, remarkably preserved and as fresh as paint, is outstanding even in this county where so many call for admiration. Four lions are round

the stem, and angels are under and on the bowl. There is an ancient wall painting blurred by time, in which we see a fine St Christopher with the child holding fast to the ferryman's green cap.

The loveliest thing inside the church is a window picture of our own day in memory of Mia Arnesby Brown, who painted flowers and children; she was the wife of the famous artist who has given us so many glorious landscapes.

Hales

Some of it lies on the busy road; farms and cottages are gathered round the many-acred green, reached only by tracks; and the church is apart from it all, hiding in a lane.

There is much to see of Norman days in the little church, which stands peacefully among the elms, displaying most of its beauty to the world outside and enshrining one treasure within. The round Norman tower has medieval windows and a fifteenth-century parapet looking on to the thatched roofs of the nave and chancel. The walls of the chancel (which has an apse) are adorned outside with Norman arcading, and below the windows runs a stringcourse of stars which go their way round the Norman buttresses. The glory of the church is the magnificence of its Norman doorway. The pillars on each side have capitals carved with flowers and a dragon-like head, supporting an arch with delicate bands of stars dividing bold, rich mouldings. A hood of stars and wheels crowns the arch, one of the loveliest of many fine ones left by the Normans in this countryside. Their less elaborate south doorway has pillars on each side, with zigzag moulding and an arch with flowers in triangles. The treasure within is the splendid fifteenth-century

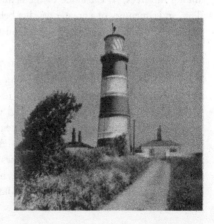

The lighthouse at Happisburgh

font, its base carved with odd medieval beasts. Round the stem are four lions and wild men of the woods with clubs over their shoulders; and above them are angels.

Halvergate

Its thatched cottages, and a church with a splendid fifteenth-century tower, are nestling in haphazard array amid fine trees on the edge of windmill land, looking over the great marshes to Yarmouth. Fine arcading adorns the base of the tower, which has pretty sound holes, buttresses climbing three of its stages, and a battlemented crown, 84 feet from the ground, with modern figures of the Four Evangelists serving as pinnacles. They have taken the place of the Four Doctors who were here till the eighteenth century. Most of the church is as old as the tower, but the chancel was much restored last century. A new porch shelters a charming entrance, which, with its rich mouldings, finial, and pinnacles, is the loveliest medieval doorway in this countryside. In the top of a 600-year-old window is a fine St Christopher with the Holy Child, in old glass of black and gold on a red ground.

Hanworth

Above the trout stream here widening into a lake was the home of the Norfolk Doughtys through all the days when they farmed their lands or fought in our wars from Agincourt to Blenheim. Though they are here no more, the great tree they knew still throws its shade across their walks; it is one of the finest Spanish chestnuts in the country, rising over 100 feet high, 24 feet round its trunk, and with 2,500 cubic feet of living timber.

On the slope facing the white hall the fourteenth-century church stands among the trees. At each side of the chancel arch are helmets of Armada days, and a memory of a greater war lies behind the old medieval altar stone, for it was placed here in memory of Armistice Day in 1918.

Happisburgh

It has two towers rising above its thatched roofs, seen for miles over land and sea. One is the lighthouse tower, the other the tower of the splendid church, rising 110 feet. The church stands on high ground and is mostly fifteenth century, but there is Norman masonry in the tower. The porch has grinning gargoyles, and a slender figure of the Madonna in a niche. A medieval mass dial is still on the wall. In the aisle are three elaborate canopies which have lost their statues, and in the nave is the medieval font with figures of the Evangelists and four musical angels on its bowl, uplifted by lions and wild men of the woods.

Hardley

The River Chet falls into the Yare close by, and the church, set on a bank at the corner of a lane, looks out on a wide landscape of marsh and woodland with a glimpse of several windmills. A Georgian house keeps the church company, and between it and the Chet is a farm with memories of greater days, for the house was once the Hall. The Normans built the round tower before anything else we see was here, the thirteenth century gave it windows, and the fifteenth added the battlements. The nave and chancel are chiefly fifteenth century, and from these days come the old oak screen and the fine font with its lions and angels. The simple pulpit is Jacobean.

Hardwick

It is an Elizabethan Hall turned into a farm and a church with a sturdy Norman tower. The chancel and the nave are for the most part fourteenth century, but a twelfth-century doorway and a door keeping its iron ring lets us into a white-walled nave. There are simple stone seats in a chancel window, and a quaint piscine in a corner of the splay has two arches and a laughing face above it. The roodstairs are in the splay of a nave window. There are fragments of old glass in the chancel, and fine old moulded beams in the roof, which runs from east to west unbroken, there being no chancel arch. The oak screen has been broken and battered by time. Opposite the door is a patchy wall painting of St Christopher showing green bushes with birds pecking at the fruit.

Harleston

Old and new mingle in this pleasant country town on the Waveney. Harleston has taken the village of Redenhall to itself, and with it a fine old church to keep company with its new one. We find Adam doorways in its houses, one old house with a carved porch, a Queen Anne house near the church, and two seventeenth-century inns with attractive signs. As Harleston has taken in Redenhall, so Redenhall takes in the pretty village of Wortwell, with an old moated hall and a group of beeches. It is now a farmhouse, long and attractive with one gable and an overhanging storey, and near it is a watermill.

From the lane leading to the moated house is a fine view of Redenhall's old church, lifting high the head of its magnificent flint tower. It is one of the finest towers in the county, its turrets climbing with their pinnacles well above the tall battlements. It was building for two generations, being finished about 1518, and on one of its pinnacles is a shell and a tun to stand for the name of its builder, Thomas Shelton. The church is fourteenth

century with fifteenth-century windows. The hammerbeam roof of the nave has bosses of angels and lions, and on the corbels is a double-headed eagle and a group of heads, among which one is nineteenth century and looks like Mr Gladstone.

Here is something extremely rare in churches, two finely carved tortoises on the oak pillars at the entrance to the Gawdy Chapel. There are two seventeenth-century chairs in the chapel. The chancel screen has old panels with paintings of the Apostles, and in the chancel is an old brass eagle lectern over six feet high, the eagle with two heads. There are three lions at the foot and four more at the foot of the old wooden eagle lectern, which is now unused but is honoured for the sake of its 400 years.

Harpley

From road or common or from the shady lanes the handsome church is always visible among the trees on the hill with an old farmhouse for a sturdy companion. Black and white gates with fine ironwork bring us to it, and as we look at it from the south it is a charming picture of a grand old tower, a chancel with traceried windows and priest's doorway, an aisle with a striking parapet above medieval windows, and a magnificent porch with three niches at its doorway.

The porch has stone seats and two fine windows on each side, and a splendid doorway with one of the finest medieval doors we have found in a village church. Some of its deeply recessed and studded panels have trefoiled heads tipped with roses, and in lovely niches round the border are the Four Evangelists and saints, a lion and a deer. On its charming wicket, through which we enter the stately interior, are carved an angel, an eagle, and a griffin. Between the arches of the nave arcades is a company of quaint heads. The tower has a fine low arch, and the south aisle's lovely sedilia and double piscina are in perfect state. Small figures of twenty-six saints and angels in old glass make a fine gallery in the window tracery, and there is much old pinnacle work in rich red, green, and gold. Beautiful modern glass shows the Good Shepherd in the meadows with His flock. There is beautiful woodwork, old and new, wherever we look.

Hassingham

The marshes of the River Yare isolate this home of a hundred folk, and the lonely thatched church, standing high on a mound, seems to be reflecting grimly on the centuries that have passed it by, as it looks down on a thatched barn and out to the wooded valley. The Normans built the low round tower, and the fourteenth century gave it its belfry with eight sides, eight heads,

and eight pinnacles. The Norman doorway is carved with zigzag, and 500-year-old windows light the nave and chancel.

Heacham

In the church at Heacham is a fine alabaster portrait of Pocahontas by a pupil of Rodin. In the year Shakespeare died the Governor of Virginia brought her home with him to England, where the princess was received with delight by queen and courtiers alike. It is said that she attended a performance of a masque by Ben Jonson and that she came to Heacham to live at the hall for a time. It shows her in English dress of her day, with a high hat and a fan of three feathers. The fourteenth and fifteenth-century church is fine inside and out, though it has lost its transepts. It stands among great trees, with evergreen oaks and an avenue of clipped yews in the churchyard. Its central tower is 600 years old, and has lofty arches on pillars with seats round the base, one of the arches having traces of painting. The great west window reaches to the roof above the fourteenth-century clerestory. The south porch has lost its vaulted roof, but has a lovely doorway 700 years old, its richly moulded arch resting on carved capitals. The nave has arcades of five bays with stone seats at the foot of their octagonal pillars, and between the arches are faces carved by medieval craftsmen. The old font is still here, and there is medieval tracery in the chancel screen. On the buttresses outside are two mass dials from medieval days. We found in the village, still vigorous in the nineties, a vicar with a fine record of fifty-eight years at this church.

The old road winding through the village is charming, unruffled by the busy stream for ever passing along to its popular neighbour Hunstanton. Charming, too, is each end of the village. Round the green are gathered the flint church, old pantiled dwellings, and a quaint little row of houses with ivied porches and dormer windows, honeysuckle on the walls, and gay gardens. Just below them is a quaint group known as Pinnacle Row, each stone cottage with a high-pitched gable.

At the other end of the village is the lovely old house called Loo-Water, with gables and flowered walls, set in an old-world garden with lawns and flowers and box borders through which wanders a stream crossed by little bridges. We have peeps of it through the gates, which open readily for those who love a garden, and then can be seen a view up stream to a pretty stone bridge and the fine old watermill now at rest. Through a gateway into the courtyard we see an arcaded shelter in which stands a fine figure of Achilles drawing the arrow from his heel.

Heckingham

A little trackway leads us to the thatched church standing well on its high back above the River Chet, looking out over farm, fields, and marshes. The round tower comes from the days when the Norman style was changing into English, but its odd little porch, a medley of brick and flint with fine oak beams in its thatched roof, brings us to the glory of this little place, which is one of the finest pieces of craftsmanship the Normans left in East Anglia.

It is a wonderful Norman doorway, a complete mass of handsome carving with four pillars on each side and with carved capitals, zigzag, wheels, scrolls, shells, stars, and other decoration coming into the scheme. It is thought that so grand a doorway may be accounted for by the fact that in those days Langley Abbey near by was of much monastic importance; through this very doorway one of its abbots was brought to rest in 1283. There is a simpler Norman doorway now blocked up and a square Norman font on five pillars. The chancel walls have still the flat buttresses the Normans gave them, the apse they built, and a Norman window.

Hedenham

We may see in Norwich Castle relics of Roman days found here, witness to Hedenham's past; something of its future we see in a wing of the old red brick hall, which is now All Hallows Preparatory School; the children play round the old dovecot. From its medieval past comes the aisleless church set on a mound beyond the meandering brook; it has a narrow flint tower and plastered walls, and a porch with its old roof still sheltering its ancient door with its old strap-hinges and its closing ring.

Hellesdon

The River Wensum winds prettily through its meadows, near Norwich, making a charming scene where it rushes under a bridge decked with flower-beds. The houses climbing from the river have come closer and closer to the church, a small flint building of quaint shape, with a two-storeyed porch and a bell turret with a leaded spire perched on the west end of the nave.

It is fifteenth century but is much restored. The vaulted roof of the porch has bosses carved with heads, one with an angel. Beautiful old hinges with drooping leaves support the new door of the nave, where the plain roof rests on odd-looking stone heads. There are two piscinas, an old chest with five slits for alms, and a fourteenth-century font.

Hellington

Set among the fields near Norwich, it has saved for us some beauty from Norman England in the lonely church which has an old farmhouse for company. The Normans built the round tower, which has fourteenth-century belfry windows and later battlements. They built the north doorway, now blocked. They built the lovely south doorway which is still the glory of the church, a wonderful spectacle to come upon in so small a place. Taller than most of the fine doorways in this countryside, its shafts have carved capitals, and among the six kinds of carving in the deep mouldings are zigzag, bobbin pattern, and nail-head. The porch sheltering the doorway is battered, but has been very fine; remains of niches are on its buttresses, the entrance arch has clustered pillars, and there are six windows. Like this porch, much of the old work of the church is about 600 years old. Among the tiny heads on the windows inside and out are a laughing man, a laughing lion, a woman in a wimple, and monks in cowls.

Hemblington

In this lonely spot, with a few cottages in sight, a big farmhouse and a small church among spindly firs stand on each side of a field, with the white and gold of daisies and buttercups between them when we called. It is a fifteenth-century church, with a round Norman tower wearing a red cap and lighted by patched-up windows of a later time. There is an ancient coffin stone for a doorstep, and another makes a seat beside it. The roof of the nave is partly original, and on some of its rafters are sacred initials and old red colouring. The old roodstairs remain. The great treasure of the church is the medieval font on two high steps. Saints adorn the stem, and in the rich carving of the bowl are God the Father and the Crucifixion, and a long procession of saints and martyrs.

Hempnall

Here lie the Romans who trod these fields 1,600 years ago. Their burial ground has been found in a field near the church, and some of the urns in which they laid the ashes of their dead are in the British Museum. The weather-beaten and embattled church, spacious and lofty indoors but looking best outside, stands high on a mound in the pleasant village street, with limes and beeches bordering the churchyard. It is chiefly fifteenth century, its tower crowned by a quaint pillared turret set within the parapet, its porch with an upper room, and a mass dial on the wall. The old font has angels and lions on the bowl, angels with crossed wings under the bowl, and five seated figures, worn with time, on the stem.

Hempstead-With-Eccles

Most of Eccles is now under the sea and the sand-dunes, but Hempstead Church, with homely thatched roofs, has been more fortunate; it is a mile inland, and its nave and chancel have stood 700 years. The porch, with handsome battlements, has two doors with lovely fifteenth-century tracery, and the font, with shields, roses, and winged animals on the bowl and lions below, is 500 years old. So also is the piscina in the nave, with an inner recess where the flasks of oil and wine were once kept. Among the fine woodwork is a group of four old bench-ends, a sixteenth-century chest, a solid Jacobean pulpit, and a screen of 1523 surpassing them all, with lovely tracery and a series of panels with figures rarely portrayed. Here is Saint Juliana scourging the enemy of all mankind; Eligius, patron of farriers, with a hammer in his hand, St Leonard with his crozier, St Lawrence carrying his grid, St Theobald with his hawk, and St Egidius with a hind crouching at his feet.

Hemsby

Sunk in the hedgerow on the way to the sea is the mossy base of an old cross carved with the symbols of the Evangelists. It pointed the way to the fine church when the village was apparently a place of great importance, for in the churchyard is the base of another old cross said to mark the boundary of sanctuary. The fine flint tower looking down on the pleasant village has quatrefoil sound-holes and is fourteenth and fifteenth century, most of the church being of the later time. The vaulted roof of the old porch has beautiful bosses, some showing the Annunciation, a very quaint Nativity, the Resurrection with Christ treading on a soldier as He steps from the tomb, and a group of disciples at the Ascension.

The east window and six big ones in the nave come from the fifteenth century; others in the chancel are fourteenth century, and the sill of one is lowered to make stone seats for the priests. A piscina in the nave has a grotesque face over the drain, the old roodstairs still remain, and the old font has four lions supporting it. Among the quaint old bosses on the newer timbers of the roof are angels, birds, deer, and flowers.

Hethel

It lies on the road to nowhere, with a moated rectory, a church prettily set among fields down little-used lanes, and a hawthorn tree growing close by which must be almost unique. Gnarled, twisted, and bowed, the Hethel Thorn has a trunk like twisted cables and arms like an octopus, and is still a very fine tree, though it is believed in the village that its first blossoms

The River Wissey at Hilgay

perfumed the air 700 years ago. Still it wears them every spring, and in winter its propped-up branches bear clumps of mistletoe.

The odd little church with an embattled tower is a medley of centuries not too happily blended, especially on the workaday north side. Much of it is fourteenth century, but the porch, which shelters a holy water stoup, is fifteenth. The chief interest of the church is in the pompous monument of Myles Branthwaite, a lord of the manor of Shakespeare's day, 'freed from the dust and cobwebs of this vaile.'

Hethersett

It straggles along the highway from Norwich to Wymondham. Some attractive houses stand back among woods and gardens, and the Old Queen's Head, a modest inn with red-tiled gables, still stands where the London coaches once changed horses.

A shaded walk brings us from the busy road to the lychgate leading to the church by the meadows, a fine fourteenth-century building entered by a splendid fifteenth-century porch. There are angels in the spandrels of its entrance arch, and among the battered bosses enriching its vaulted roof is a lovely one showing Our Lord and Mary enthroned, with three angels. It is in the centre of the roof. Arches on clustered pillars divide the old nave

and aisles. The chancel was made new at the close of last century after being ruinous for about 300 years. An odd effect is given by a beam, finely carved with trailing foliage and grapes and carrying a gable of painted panels, which marked off the part of the nave as a chancel before the ruined chancel was rebuilt.

Hevingham

Trees fill the entrancing woods on each side of the road where the church stands on a knoll looking across the fields. In the churchyard and the rectory garden oak trees and Spanish chestnuts grow, and round two of the churchyard oaks are seats. Some of the chestnuts are so old that their branches almost sweep the ground, but none rivals the splendour of the tree by the porch, which was planted while James the First was king and has a trunk 19 feet round.

The medieval church has a plain tower, but the fifteenth-century porch has a group of niches and windows over the arch. An old studded door in a fine old doorway lets us into a church with many fine tilings. One is the trefoiled piscina in the splay of a window with stone seats formed out of its sill. Another is a brass candelabra of 1741, for twenty candles. A third is the splendid medieval font like a six-sided pillar enriched with recessed arcading on clustered columns, with Peter among the battered saints and a Crucifixion under the arches. Remarkable for its age and its craftsmanship is the rich carving on some of the choir seats, two of which have their original desk tops. The oak roof of the nave is a modern copy of the old one.

Heydon

It is a little paradise gathered about a green at the edge of a park with great beeches, limes, and oaks sheltering the fifteenth-century tower, and on the walls of the church is a little surprise for the botanist, for here grows a rare fern, the scaly spleen-wort. In the park is a tree called Cromwell's Oak, named by Erasmus Earle, MP for Norwich in the Long Parliament and a Commissioner at the famous Uxbridge Conference, one of the vain efforts of the Parliament to make peace with the King. The medieval chancel screen was given to the church by the lord of the manor in 1480, and the old pulpit has kept it company all the time; it has been reckoned that more than 40,000 sermons have been preached from it. It stands like a traceried wineglass on a flowered stone base, a splendid oak rostrum with a Jacobean canopy and a panel of Flemish carving reach up to it. The panels were painted to match the panels of the screen, but the portraits are fading away. The roofs looking down on all this beauty have cornices enriched with heads and

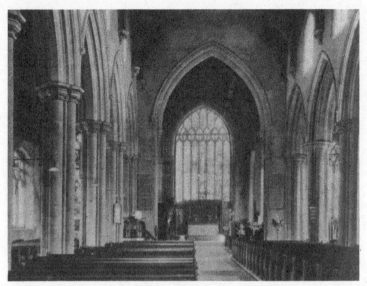

Hingham Church, where Abraham Lincoln's ancestors worshipped

Tudor roses, and there is more Tudor woodwork in the Elizabethan reredos in one of the aisles.

Hickling

It is fortunate in its setting, for heaths and commons fringe it on the north, and to the south is the biggest and one of the loveliest of Norfolk's sheets of water, Hickling Broad.

Hickling has a noble church with hideous gargoyles looking out from its tower, and heads of knights survey the tranquil scene from the two-storeyed porch. The window of the porch is blocked by a huge eighteenth-century sundial, and inside is a medieval door on massive hinges. The font, adorned with acanthus leaves, is 600 years old, and a big stone with a leafy pattern is a century older.

Hilgay

The Fens are at its doorstep, but its narrow street climbs the hill from the River Wissey flowing to the Ouse. Into its view across the river comes the seventeenth-century Snowre Hall, fascinating with secret chambers, and having a link with Charles Stuart, who is said to have sheltered here before his surrender at Newark.

A lovely avenue of sixty tall limes with holly trees and holly hedges, and a lychgate at each end, brings us to the churchyard. The stumpy brick tower just topping the nave comes from the eighteenth century, and from it George Manby is said to have practised firing his life-line. The fourteenth-century nave has a leaning arcade of two tall and two low arches, and the chancel is made new.

Hillington

Rows of old cottages in gay gardens, a few houses, a quaint little post office with diamond panes, the church, and the school run along one side of the great park, through which flows a stream widening into a winding lake. Withdrawn from the busy highway bordering two sides of the park, the church has a sturdy old tower, but the ivied walls and pantiled roof were made new last century.

Hindringham

It is on two little hills. On one stands the fine old church, its high tower rising charmingly over the pantiled and creepered roofs of farm and cottage, looking to the sad windmill on the other hill. Down in the valley between them is the lovely Elizabethan house, Hindringham Hall, with trees and a wide moat.

Most of the church is medieval, though the chancel was made new and the tower was restored last century. The rest is fourteenth and fifteenth century, and to the earlier time belong the beautiful nave arcades and the two arches between the chancel and the chapel. The lofty tower arch is richly moulded, the fine sedilia seats have traceried canopies, the south aisle has a peephole to the altar, the porch has a holy water stoup and an old oak door. The old font, standing proudly on two high steps, has the Four Evangelists and the Crucifixion round the bowl, eight quaint heads under the bowl, and crowns and letters round the stem. In the chancel stands the church's great possession, a treasure rare in the land, for this massive oak chest, carved on the front with stars and interlaced arcading, with its slightly rounded lid opening on pin hinges, and with a simple iron lock, is one of the most ancient coffers in England at least 750 years old!

Hingham

A pleasant little market town, it is rich in story, for it has a notable link with English law and a link with Abraham Lincoln; and it is rich in its church, for it has one of the best medieval buildings in the county.

Here to the lord of one of Hingham's five manors there was born in 1240 a son who was to grow up to be Sir Ralph de Hengham, one of

the founders of our law. Here in the church was baptised in 1622 Samuel Lincoln, the Norfolk weaver who, though it was from Norwich he set out for the New World, has given his native town a link for all time with an immortal descendant six generations after him, the greatest man ever born across the Atlantic.

From Hingham's two greens avenues of cypress and yew lead to the church, its fine massive tower, entered by a lovely west doorway, rising 120 feet high. A modern hammerbeam roof looks down on the clerestoried nave, bounded by splendid arcades of six bays with clustered pillars, and on lofty arches to the tower and chancel. The west window glows richly with the Woman at the Tomb, telling the story of the last scenes in the life of Our Lord. An unusual thing treasured in the chancel is a bushel measure, once used for measuring the tithe grain and chained in an open space in the town. Made of iron, and known as the Winchester Bushel, it is quite a rarity and the only one in a church. Two others are in Norfolk.

Reaching almost to the wallplate of the lofty chancel is a magnificent stone monument which must surely be one of the biggest in any village church. Shields of arms adorn the front of the tomb; in the mouldings of its elaborate arch are figures in niches; angels are in the turrets rising at each side; in the carved gable Our Lord is seated between a knight and his lady; and on the traceried wall in the back of the monument kneel ten men and women, one like a nun and three in horned headdress.

Hockering

On the pleasant road to Norwich the thatched cottages and the farmhouse with stepped gables stand like friends in waiting about the fifteenth-century tower. The oldest part of the church is fourteenth century. The chancel has a new arch with clustered pillars, a new piscina, and new sedilia carved with flowing vines, birds and lizards in foliage, and nuts and foliage with a caterpillar on a leaf. The new bowl of the massive font is on the old stem, round which are men and women saints, St George and the Dragon, and St Christopher with the Child. An ancient coffin stone is carved with a cross.

Hockwold-Cum-Wilton

The two places run from one to the other, both with many flint-walled cottages, and each with an old church.

Wilton has a slender cross on the green near the church of St James, which comes from the fourteenth and fifteenth centuries. Its old porch keeps its old oak roof, and lovely rafters look down on the cream-walled nave and chancel, full of light. The great chancel arch reaches the roof. There are

quaint niches in the splays of two windows, and under one is a trefoiled piscina. The tapering font is old, and there are old glass fragments. The chief charm of the church is in its woodwork, from the roofs down to the oak chest. There is a fine array of richly carved benches, and among their carvings, old and new, are quaint grotesques, a shepherd with sheep, an old woman who seems to be talking to a headless companion, and a man on all fours. There is delicate tracery in the old screen, one side of which has a curious scene of a cross-legged man wearing a crown and two jesters on galloping horses by his side.

Hockwold's church of St Peter keeps company with Hockwold Hall by the wayside. The house has walls of mellowed brick, gables, and clustered chimneys, and has a story centuries old. The church is fourteenth and fifteenth century, with a great array of old windows. The chancel has fine old seats for the priests and in the nave is a patch of ancient wall painting strewn with daisies. Fiddles and flutes, trumpets and cherubs, adorn an eighteenth-century wall monument to John Hungerford and his wife. The glory of the church is the beautiful nave roof, its carved tie-beams alternating with hammer- beams, from which eight figures of saints look down, their hands upraised and some of them wearing crowns.

Holkham

None who has been here forgets the loveliness of the great deer park with enchanting avenues, stately oaks and beeches, and sombre firs. A noble piece of countryside by the marshes and the sea, the park is nine miles round, and has a thousand acres of trees, all grown from the sandy barren flat on which Thomas Coke, first Earl of Leicester, built his fine hall, packed with treasure inside as it is girt with beauty without.

The formal gardens, framed by the lovely trees, are gay with flowers and imposing with statues and ornaments. The house (which may frequently be seen) is one of the stateliest works of William Kent, and the two fronts are nearly 350 feet long, with a Corinthian portico on the south side. There is a magnificent collection of sculpture, and pictures by Rubens, Raphael, Vandyck, Leonardo, Reynolds, Lely, Gainsborough, Poussin, and Claude Lorraine. The library has one of the greatest private collections of books and manuscripts in England.

From the village, which nestles by the north side of the park, a lovely avenue of evergreen oaks leads across the marshes to a belt of fir woods, beyond which lie vast stretches of firm sands. From a great triumphal arch on the south side, a straight avenue runs for a mile and a half to the middle of the park, where an obelisk eighty feet high has stood since 1729. Near it

is a small temple with a portico. On the north side of the hall is a Corinthian column crowned by a wheatsheaf and enriched with reliefs and corner figures of a sheep, an ox, a plough, and a drill. It was set up by public subscription in 1850 as a memorial to Thomas William Coke, who succeeded to the estate in 1776 and was created Earl of Leicester in 1837, the title having become extinct with the death of his uncle (the first earl who built the hall) in 1759. Popularly known as Coke of Norfolk, Thomas William Coke became Father of the House of Commons and was a great agriculturist.

Half a mile from the house, still within the park, the spacious flint church stands high on an ancient mound near which bones and iron armour have been found; a road leading from the church lodge to a camp in the marshes may have been used by the Romans, the Saxons, and the Danes.

All that is old in the church is fifteenth century—the tower, some windows, and the arcades with their odd arches and pillars, continuing into the chancel. A new doorway under a wide medieval arch in the tower lets us into the church, where the striking feature is the richly carved oak of traceried screens, with birds pecking flowers and berries in the spandrels, in the lectern, and in the fine array of benches, which are in themselves a great nature galley. In the amazing variety of carving on their backs, ends, and arm-rests, are newts and birds, seaweed and shells, and flowers and fruits of field and garden, one of the most cunningly carved flowers being a dahlia.

The Grammar School at Holt

Holme Hale

Its houses straggle round the lanes, going nearly to the park with its big house, and cluster thickest about the rectory and school, almost hiding the church with its imposing 500-year-old tower. One boy and girl here are for ever at their lessons, for they are part of the attractive metal weather vane on the school, which shows a master explaining to them the globe of the world.

Built late in the fourteenth century and through the next, the church is lofty inside, where an arcade with bell capitals divides the clere-storied nave and aisle, and the nave roof keeps most of its old beams and ten angels with new heads and wings. The restored fifteenth-century screen has some fine tracery tipped with roses, and two lovely roundels of delicate tracery over the entrance. A quaint little Jacobean table in the sanctuary has bulging legs. The chancel has its old sedilia and there are two piscinas.

Holme-Next-The-Sea

Here near the sands and the sea, Henry of Nottingham, a judge of the time of Henry the Fourth, made new the chancel of the church and raised the flint tower in the fifteenth century. It is his monument, rising above the nave and chancel. It has sound-holes as well as belfry windows, and its base, forming the porch, has stone seats, a vaulted roof, and a lovely archway. The chancel has ancient stone seats in the south wall and a double piscina in the east wall.

Holt

Old houses are huddled haphazard in the heart of this little market town, which is clothing itself more and more in modern dress. It breathes the breezy air of rising ground, and looks out on the wooded countryside which gave it its name in Saxon days.

It was held as a royal demesne by Edward the Confessor, and there is a relic of Norman days in the church. It has a school still flourishing after nearly 400 years, founded by a Lord Mayor of London. But most of the town was burned down 200 years ago, and the fire has left its mark.

A fine avenue of limes leads to the church tower, which once had a spire as a landmark, and tells the time with a one-finger clock. Like most of the church, the tower is fourteenth century, the porch is a century younger, the east window and the windows of the aisles are about 1500, and all is much restored. The roof has traceried gables, and angels along the sides. The altar table is made of local cedar wood and of olive wood brought from Italy. There is a flagon given by a king and a paten given by our first Prime Minister (George the Third and Sir Robert Walpole).

Right: Near Horning Ferry on the Norfolk Broads

Below: A ferry on the Bure at Horning

The best old possession the church has to show is the fine Norman bowl of the font, festooned with fleur-de-lys. The best new possession is the glass of one window, a treasure. The peace memorial window shows the Madonna and Child, St George, and St Martin. A dainty light window with the Nativity and the Shepherds is in memory of two choirboys killed in the Great War. We see the Women at the Tomb in rich colours, and among saints are Forsey as a monk holding a church, Felix as a bishop, and Juliana reading

a book. The window which will captivate all strikes a very happy note; it is by Francis H. Spear. Lovely in itself and in its subject, it shows Chaucer's band of pilgrims, thirty-feet figures and two dogs, jogging along the road winding up to Canterbury, which we see, with the cathedral and a bishop, at the top of the window. Monk and nun, knight and squire, piper and fiddler, bowman and cook, are among the colourful and motley company, keeping green the memory of a doctor who lived and worked at Holt.

It has established for itself a proud reputation, and many good scholars have come from it. There was William Withers, an authority on forest trees; Thomas Girdlestone, the physician who found time to add to his medical works a translation of the Odes of Anacreon; and Richard Newton, a classical and Hebrew scholar who was buried in the churchyard but by his own request has no stone to mark his grave. In our own time the spirit of Gresham's has been nobly expressed in two Everest Expeditions and in the guiding and directing minds of the most powerful organisation in the British Empire, the BBC, for Sir John Reith was an old Gresham boy.

Honing

It has an avenue a mile long leading to its hall and to the church which stands on a mound near by. Most of it has been made new, but the tower and the nave arcades have been here 500 years, and the font 700; the bowl has eight lions' heads on it.

Honingham

Its cottages gather pleasantly round the green on the busy road to Norwich, and under an oak planted forty years ago is the peace memorial. A mile away, still on the main road and above the River Tud, the church stands near the gates of the fine park, which shelters the hall and the lake. The church is 600 years old except for the fifteenth-century porch and the battlements of the tower, at the corners of which stand the Evangelists. The traceried screen is in memory of Baron Ailwyn, who restored the church and gave it new seats near the end of last century. Most of the old poppyheads remain. Two of three brass inscriptions to sixteenth-century Vincents have been used twice. On the reverse side of one is seen part of a woman's skirt, and one of 1556 is inscribed on the other side to Elizabeth Arden of 1530. A curious thing here is a framed sheet of lead which was found during repairs to the tower. On it are footprints, the date 1645, and the plumber's initials. It is not known what the mysterious footprints mean. The best thing here is the beautiful fourteenth-century font, its bowl carved with quatrefoils and set on a stem with a cluster of eight shafts.

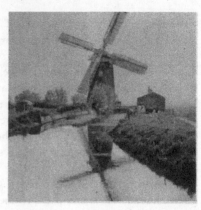

The windmill near the Mere at Horsey

Horning

It is a great name in Broadland, its ferry a stopping-place for yachts and wherries on their way to the Broads. The River Bure is its highway, and the marshland its country. A delightful village of old and new, most of what is new is charming. We remember it as like a little Venice in the heart of Broadland, where waterways wandering from the river into the gardens are crossed by tiny bridges. The river winds in and out till it nears the old church, which looks out on the shining water through a mantle of trees and on sails like white wings among the green. Lovely lanes bring us to it, and to the charming thatched house with gables and dormers keeping it company. Opening to the churchyard is a lychgate enriched with arches and beams carved with grapes, holly, oak, and berries.

The fine tower with traceried sound-holes as well as belfry windows has four figures sitting at the corners of the battlements, and is fifteenth century, like much of the old work here. The arcade which led to a vanished north aisle is seen now inside and out of the nave wall; it comes from the thirteenth century, as does the chancel arch and the priest's doorway, by which is an ancient engraved sundial seven inches square.

The fifteenth-century font is on an older base. The old rood stairway is quaintly set in a pillar of the chancel arch and one of the south arcade. Ballflower covers the drain of the piscina in the chancel, and from the vestry, which has replaced an old sacristy, is a peephole to the altar. There are eight consecration crosses, six on the walls of the chancel and two on the south aisle, all showing a painted cross in a roundel nearly a foot across. So many consecration crosses are rare in a village church, and these are remarkable also for their size; they mark the places where the bishop placed his hand hundreds of years ago.

A crumbling dugout chest has ironwork wrought 700 years ago, and some old poppyhead bench-ends in the nave have set the pattern for modern ones. In the carvings on four old stall-ends we see a demon pushing a man into a dragon's mouth, a dragon with a foot held in the stocks, a man struggling with a two-headed serpent, and a quaint scene of a brawny little fellow holding another by the neck and forcing open his mouth.

About two miles east of the church are the remains of St Benet's Abbey, founded by Canute, who replaced the building his forefathers destroyed in 870. Two arches remain of the king's penitential offering, one inside a mill. We cannot walk up to it, for the marshes guard it closely and the encroaching rush-fringed river sweeps past; but we can walk along the old green causeway the monks paced on their way to the hospital, of which time has left little more than of the abbey. Only the thatched chapel, now used as a barn, recalls the hospital's chequered history. The abbey, strongly fortified, held out for a long time against the Normans. The story says it was at last betrayed into their hands by a monk on condition that he should be made abbot. The Normans kept their pact, made him abbot, and hanged him. The abbey gatehouse still stands among the marshes, picturesque with its corner turrets.

Horsey

Secluded among the woodlands, it is part of the flat Broadland where willows fringe the canals and the sails of the windmills race in the breeze as they pump water from the dykes. Horsey Mere's many acres, shut in by tall reeds, is close by, and a mile and a half over the sandbank the sea comes rolling in.

Yet, remote from the world though it seems, men have called it home for unnumbered years. In the days of Boadicea the Icenians knew it as an island, and Romans made it a settlement, leaving as witness of their occupation coins of Vespasian and querns for grinding corn. Of the annals of that distant day only relics such as these remain below the ground to be now and then brought to light by the plough.

The Normans left us the round tower of the church and the fifteenth century added the octagonal belfry. The thatch covering the continuous nave and chancel is seen through the timbering inside. Except for two fourteenth-century windows, the rest are a century younger, and one frames an arresting portrait of Catherine Rising of 1890, showing her in a vivid red dress standing at her easel with palette and brush, a little sailing ship below her. The old roodstair is by the fine fifteenth-century screen with its graceful carving of roses and traces of red and gold. The font and some of the poppyheads are medieval.

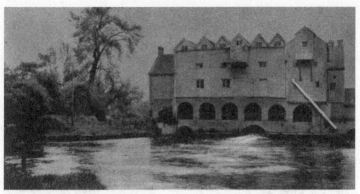

A mill on the Bure at Horstead

Horsford

Trees shelter the church, which stands on a hill, looking over the fields to the clustering red roofs of the village. Facing it is the hall, and though they are centuries apart there is a pathetic link to join them. A fifteenth-century tower with pretty sound-holes crowns the simple flint church, which may possibly have Saxon work in the nave. Under the arcade stands the massive Norman font, its square arcaded bowl resting on a stout central column and four corner pillars. The small thirteenth-century chancel, lit by candles and roofed with thatch, has a simple piscina, and a triple lancet east window showing Our Lord and figures of Mary and Thomas.

Half a mile away is a mound with ramparts and water in the inner ditch. It is said to have been the site of a Norman castle.

Horsham St Faith

It has lost its market and one of the biggest fairs in England, but it keeps the memory of poor Catherine Howard, whose ill fortune it was to become the wife of Henry the Eighth. She spent her childhood here, living with the Dowager Duchess of Norfolk, her father's stepmother, and came here many times afterwards, before her ill-fated ambition led her to become the queen of Bluebeard. Behind the church, built into a farmhouse, are an arch and some windows of a twelfth- century priory, of which the seal is in the chapter house at Westminster.

Now it is a pleasant village with a fine fifteenth-century church which is a shrine for lovely things. It is attractive outside with its lofty tower, the east wall finely chequered with stone and flint, and the porch with a fine niche and an upper room. The vaulted roof has a central boss showing St Andrew

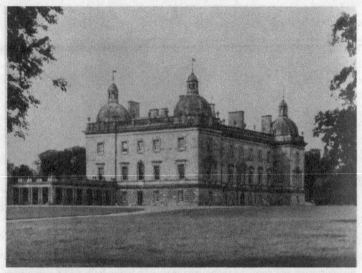

The Hall built by Robert Walpole at Houghton

bound to the cross. A beautiful modern door of linenfold lets us inside, where a striking feature is the delicate grace of richly moulded arcades, with thirteen arches between them. Striking too is the 500-year-old font, carved on the bowl with angels in traceried panels, with four queer animals at the foot, and crowned by a Jacobean cover rising nearly as high as the arcades. The chancel has a double piscina and there is a peephole in the south aisle. Old and modern benches have poppyheads carved with fruit, flowers, and pelicans. Birds are climbing pinnacles in the oak reredos, which has niches and dainty tracery, and is in memory of a friend of the church killed by a buffalo in Africa.

A rare medieval oak lectern is complete with pedestal, and the thirteenth-century oak pulpit has gold leaves over traceried arches and a gallery of paintings of saints and the Madonna. The screen has been restored above the arches, which have double edges like lace.

Horstead

It goes with Stanninghall, where the church has been long in ruins; Horstead's, looking across the River Bure to Coltishall on the hill, has been preserved since the fourteenth century when it was a place of pilgrimage. Here still is the shrine to which pilgrims came, a niche in front of the tower, empty now, but then with a statue of the Madonna. The church has a 700-year-old font

and fine modern glass in the windows. It is rare to find a Jesse window in a village, but here is one with all the figures in David's royal line arrayed in splendour. The east window has Adam and Eve, Joseph and Mary, and the Norman Bishop who founded Norwich Cathedral soon after the Conquest, Herbert Losinga.

Houghton

A lovely avenue from Harpley ends, after nearly a mile, at the rows of white cottages by the white iron gates of the park in which noble trees spring from the deep bracken which perhaps gave Houghton its name, Houghton-on-the-Brake.

Set in the great deer park is Houghton Hall, the biggest country house in Norfolk, which our first Prime Minister took thirteen years to build and completed in 1735. The Walpoles were here in the time of King Stephen, and Sir Robert's great stone hall is the third of their Houghton homes. Colonnades, balustraded parapet, domes at the corners, and a frontage of 450 feet are its striking features outside, and among its treasures are fine tapestries, sculptures by Rysbrach, Kneller's portrait of George the First, and a bronze cast of the Laocoon.

The Slipper Chapel at Houghton St Giles

The chancel keeps its thirteenth-century arch with bell capitals, a simple piscina of the same time, and the east window with flowing tracery 600 years old.

When Sir Robert built his mansion and planted the park with trees he pulled down the houses round the church and built the cottages near his gates. Some have thought that this gave Goldsmith the theme of his Deserted Village.

Houghton-On-The-Hill

Just above the Peddar's Way, the ancient track running from the sea to the Suffolk border, is the sad and lonely old church on a green hilltop, its only companions a cottage and a farm over the fields. Its chancel was destroyed in the eighteenth century to save repair, and the top of the fourteenth- century tower is open now to the sky. One or two old windows are left, and two small splayed windows, one blocked, are thought to be relics of the Saxon building.

Houghton St Giles

A small village on the hill above the River Stiffkey, it has a lowly flint church with a red tiled roof and a square tower with a little pyramid cap. It was made new last century, but within the narrow walls is still the old screen with paintings of saints, their colour dimmed by time and their faces scratched out by man. The best of them are the women saints (including the Madonna) on one half of the screen, the others being the Four Latin Doctors. We see St Giles with his hind and a dove by a grotto in a thirteenth-century lancet. There is a plain old chest and a plain old font, and old bench-ends with poppyheads. A brass plate marks the resting-place in the chancel of John Gunne, who was vicar from 1495 till his death.

The village is on the last stage of an old pilgrim's way to the Shrine of Our Lady of Walsingham, and beyond the ford over the river is a charming wayside chapel with gabled roof and fine windows. There is a niche at each side of the west window, and under the roof are fine bands of quatrefoils. Coming from the fourteenth century, it has been restored by the Roman Catholics, and has an altar shining with gold. It is known as the Slipper Chapel, for here the pilgrims would stop to rest, and to remove their shoes before going on barefoot to the famous Shrine.

Howe

The most historic possession of this small place, with a few thatched cottages scattered about its green and a pond with a weeping willow, is the crude

round tower of the church, for it was built by the Saxons and has a typical double-splay opening. It has some brick in its flint walls, a rough lancet and two bull's eye windows, a round-headed west doorway, and a chimney sticking out of its conical roof, which just tops the nave. A 500-year-old porch leads to an older nave and chancel, where the oldest window is Norman. Winged angels hold shields at the end of the nave roof, and one of the few worn old poppyheads on the choir stalls is carved with a woman growing out of foliage.

Hunstanton

Part of our east coast, but looking west, its people have for their delight the wonderful sunsets over the Wash and the long views to Lincolnshire and Boston Stump on a sunny day. Its wide stretch of fine sands, which have brought it great popularity, is sheltered by cliffs rising 60 feet above the sea, famous among geologists for their curious formation, a band of red chalk coming between the white chalk of the top and the brown and yellow stone of the base.

Old Hunstanton, creeping towards the edge of the cliff, is a lovely retreat in quiet lanes, with creepered cottages, trees, and a pond all in company with the fine old church at the gates. New Hunstanton comes up to the cliffs and down to the sea, and gathers round a green, from the middle of which the ancient cross looks out.

Between the Old and the New, near the lighthouse at the top of the cliff, is the Garden of Rest where flowers keep green the memory of all the men and women of East Anglia who lost their lives in the Great War. We found it a glory in June, its walks a mass of white flowers (as if covered with snow), dotted with marigolds, scarlet poppies, and French lilac. In the midst of this haven are the scanty remains of St Edmund's Chapel, where pilgrims offered their prayers on the way to seek Hunstanton's healing springs. The chapel takes its name from the legend that Edmund, Saxon king of East Anglia, landed here when he came from Germany to be crowned. He fought the Danes and was captured by them, and refused to save his life by forsaking his Christian faith.

Modern Hunstanton has set its spacious new church in a garden. Built in medieval style, it is dedicated to St Edmund, whom we see under a gold canopy by the chancel arch, wearing a scarlet cloak lined with ermine. Lovely glass shows him in a golden ship sailing for East Anglia; and again, crowned and in rich raiment, coming down the gangway of a quaint ship with a company of men and women and a dog sitting in the stern. The pulpit, richly carved with arches and pinnacles, has come from Peterborough

Cathedral, and the old font bowl from a chapel in Suffolk; it has a new lead border enriched with fishes and water lilies on a gold ground.

The old village had a church at the time of Domesday Book, but almost all the old work in the church today comes from the first half of the fourteenth century, when it was made new by Sir Hamon Le Strange and his son. The family has held the manor for 800 years, a remarkable example of continuity which has been rarely paralleled in England.

The church was much restored and enriched in the middle of last century by Henry Le Strange, who gave to it the skill of his own hands and most of the cost. It was he who designed the paintings on the roof of the tower and nave of Ely Cathedral, working on it four years but dying before it was completed. He sleeps here in the old churchyard, and the glass in the east window is his memorial, showing scenes from the Passion and Old Testament scenes of suffering and sacrifice. Many of the windows were made new during the restoration, when the clerestory was added. The buttressed tower stands at the west end of the north aisle. The old porch has lost its upper room, and its gable now rises oddly above the roof of the aisle. The entrance arch has tracery tipped with leaves, and charming tracery fills the two round windows in each side wall. The door is magnificent with a mass of ironwork in fine scrolls ending in leaves.

In this stately and gracious place the fine arcades have stone seats round the pillars, and nineteenth-century roofs made, like the benches, from oaks grown on the Le Strange estate. The fine roof of the nave rests on corbels of angels and apostles. The font is Norman and a piscina now in the vestry was fashioned from a Norman capital. The battered medieval chancel screen has a new vaulted canopy, but the original paintings of Apostles are still clear, their robes reminding us of the magnificent work on the Ranworth screen; those of St Paul and St John are adorned with hares and falcons and a dog with bells on its collar.

The house the Le Stranges built is in a thickly wooded park, long and low, with a wing at each side of the gatehouse and stacks of clustering chimneys. The lawns and gardens have not much changed since Tudor days; the terraces and avenues and flowering borders are as trim and perfect as if they had been painted; water at a distance encircles the house like a moat. This has been the domain of the Le Stranges (according to Sir Roger's family tree) ever since one of them married a Saxon lady. The earliest part of this storied house was built by Sir Hamon Le Strange when he came home from Crecy. Sir Roger made the central brick gatehouse about 1500. Inigo Jones designed the archway of the forecourt about 1618. On an island is an odd seventeenth-century building, built (the story goes) by one of the heads of

this great house so that he might retire to it with his viol, the playing of which had wearied his wife.

Hunworth

It lies among lovely wooded hills and is a pleasant place with a big green and red-tiled farms. The church tower has stood 500 years, and for 400 years the quaint gargoyles have been looking down from the transept. In the doorway are the deep holes which were used in medieval days for fastening the door with a great closing bar in times of strife.

Ickburgh

It is believed that a trackway older than the Romans may have linked it with the Icknield Way, but much that attracts us here is new. Thatched cottages, charming with creepered walls and flowers are strung along a byway, ending at the church and the almshouses. The homes of the old folk are attractive with gables and a garden bright with flowers, and across them is written, Abide with us, for it is towards evening, and the day is far spent. At the other end of the village is the white figure of a girl with a shawl over her head, resting on a rock with a wreath of remembrance for those who did not come back. It is an unusual monument to come upon by the wayside.

Except for its fourteenth-century tower the church was made almost new last century. It is all very neat, lit chiefly by candles, of which some are hanging and many on long sticks among the pews. There are some good modern carvings. Two bishops look out from the sedilia, and a chained bear is carved in oak on the hood of the north doorway. Eight minstrel angels look down from the ends of the roof beams, holding harp, fiddle, tambourine, bagpipes, guitar, trumpets, and organ. Very fine are two stone corbels most cunningly carved to support short clusters of shafts below the end arches of the arcade. One has a Nativity scene with ten figures; the star is shining on the stable, angels and shepherds are adoring, and the ox and the ass are looking on. The other is a canopied Temple scene, with Simeon holding Jesus, Mary and Anne kneeling, Joseph with a basket of doves, and a priest at his desk.

Ingham

Here 600 years ago Sir Oliver Ingham and his daughter built one of the striking churches of the Broads, and here it stands proudly still with a lofty but rather dark nave and a pinnacled tower that can be seen for miles. There is a marble font with panels cut 700 years ago, and on the walls are engravings of vanished brasses. One shows Sir Miles Stapleton, founder of

a priory here, with his wife Joan, daughter of Sir Oliver Ingham; another shows Sir Brian de Stapleton with his wife, under a lovely canopy, a lion at their feet with a dog called Jakke, who is famous among our church antiquities, for he is one of the only two pets whose names are inscribed on English brasses. The only dog remaining on a brass that we have seen is Tirri, at Deerhurst in Gloucestershire.

Ingoldisthorpe

It has lovely trees and pretty gardens, and climbs from the highway to a hall standing proudly on the hilltop among beautiful cedars and oaks. Here also is the attractive flint church with the manor house for a neighbour, leaving the Old Hall, and a row of cottages with a big clock, to their lowlier place.

A path between yew hedges leads to the church, and by the porch is part of the shaft of an old cross. It is said to be the third church on this site, and, though much restored last century, has still something to show of Norman days and of the three medieval centuries. The Norman relic is the octagonal font, which was originally made square. The nave is partly thirteenth century, the tower is fourteenth century, and a fifteenth-century screen with fine tracery divides the nave and chancel, which are crowned with modern roofs on corbels carved with angels and figures from the Bible.

Ingworth

Its quaint little wayside church, and the houses clustering about it, look out over the millstream to the oak woods and the meadows. Tall elms keep company with the church, which restoration has not spoiled. The whole of it is thatched: nave, chancel, the pretty red porch with the stepped gable, and even the short round tower looking like an apse at the west end. It is all that is left of the Norman tower which fell in 1824, and is now a vestry. Rosemary bushes grow on each side of the 500-year-old porch, which has a mass dial, a niche with a bishop's head, and a pretty little window in its upper room. An old door lets us into a white interior of great simplicity, lighted by medieval windows. The fifteenth-century font has a fine carved pillar supporting a bowl adorned with shields, and near it is an old coffin stone with a cross. Other old relics are box pews, an ironbound chest, an hourglass stand, and the base of the fifteenth-century screen, which has now a Jacobean top brought from Aylsham church two miles away.

Intwood

It is all charming here, where pretty thatched cottages, a quaintly thatched lodge, and a tiny church hide in lovely trees and quiet lanes. All around

are woods and meadows. Three tall oaks shade the green, where the ways meet by the church, and another fine old veteran stands by the Norman tower, which has Roman bricks in the arches of some of its windows. The fourteenth century crowned it with the octagonal belfry, and much of the old work in the church is of this time.

There is much attractive modern woodwork in the dark oak benches: the gallery, the pulpit, the desk, and the stalls. The benches are edged with flowers. Two chancel seats have lovely poppyheads of hops, blackberries, and oak and acorns, and on their arm-rests are the symbols of the Four Evangelists. Two angels are kneeling on the front of the priest's seat, which has two charming poppyheads, one with hawthorn berries and one with trailing vine.

Irstead

Its scattered cottages are by Alderton Broad, and its 600-year-old church with a roof of thatch stands by the River Ant. The church has a rare claim to distinction, for its oak seats in nave, aisle, and chancel are as they have been for 400 years. Interesting seats they are, with carvings of dogs and a bird on the bench-ends and the front pews.

The door which brings us into the nave has a splendid medieval ring like an ornamental cross. The chancel screen has faded portraits of the Twelve Apostles, the fifteenth-century font with men and lions about its pedestal has eight richly carved panels, one of which is notable for showing the handkerchief of St Veronica with the portrait of Our Lord on it, a rare portrayal of a legend which we have also come upon at St Osyth in Essex. The pulpit is 400 years old, and the chancel has a treasure older still—lovely faces of the Madonna, Our Lord, and angels in roundels of fifteenth-century glass.

Islington

There are herons in the fine park of the big house, and a sad little cross-shaped church fast settling down to ruin, weary of the wear and tear of its long life from medieval days. But, if the church has no memories to preserve for us, the village has a claim to fame, for this is the Islington where lived the bailiff's daughter who wedded the squire's son. The tale, set to music, was often sung in Victorian drawing-rooms:

There was a youth, a well-loved youth,
And he was a squire's son,
He loved the bailiff's daughter dear
That lived in Islington.

They were parted by unsympathetic parents, and the youth believed he had lost his sweetheart for ever, but all ends happily at last:

> O stay, O stay, thou goodly youth,
> She standeth by thy side;
> She is here alive, she is not dead,
> And ready to be thy bride.

Itteringham

The church has stood by the slow-moving River Bure for 700 years, and the door into the nave swings on the original hinges. The tower is fifteenth century, and a ruined chapel of the same century still clings to the outer wall of the chancel. Inside the chancel has rich Jacobean panelling, and there is a Jacobean pulpit carved with an angel of a strangely classical type. We noticed in the churchyard that one of the heroes on the peace memorial lies beside it, for Sergeant Gotts came home from the war to die of his wounds.

Near the village is the fifteenth-century Mannington Hall, built of flint and stone, with Elizabethan chimneys reflected in the moat.

Kenninghall

We think here of two women and two reigns of terror, queens with fifteen centuries between them. One was the heroic and terrible Boadicea, the other was the terrible Mary Tudor. It is said that a small moated field at Candleyards, a mile and a half away, was the site of Boadicea's palace; she is thought to be at Quidenham, down a road which is like a lovely bower of trees.

Close by the moated field is a farm on the site of another historic house, the palace built by Thomas Howard, third Duke of Norfolk, in which his poet and soldier son Henry, Earl of Surrey, was probably born. It was here that Mary Tudor called in the thrilling week after the young King Edward died, and here she wrote the famous letter to the Privy Council asserting her rights to the Crown. The letter reached the Lords of the Council as they awaited news of Mary's arrest, hoping thus to be able to proceed safely with the investment of Lady Jane Grey, whom they had just proclaimed queen. The lords promptly arrested the bearer of the letter and gathered round while one of them read it aloud. In the next room, as he read, was Lady Jane Grey herself, trying on the crown she did not want.

The church of this historic village has a sturdy fifteenth-century tower buttressed to the battlements; the chancel and the nave are 600 years old.

The nave has quatrefoil and clerestory windows, a quaint piscina, and on an arm-rest of one of its old pews is a lion with curly mane standing on its hind legs and holding on to a tree trunk. By two medieval brackets on a wall are two groups of brass portraits showing five girls with long hair and five boys in flowing gowns, all unknown. A fine old door with its ancient ring still swings in the Norman doorway, on which is a fragment of a mass dial, and by the pillars of the doorway are carvings of a prancing horse and a lion trying to catch its own tail.

Ketteringham

It houses a treasure the proudest museum in France would be proud to have, one of many in a great house; it has a church with memorials of lords of the manor whose names are links in history; and it has delightful cottages in its byways.

One of these cottages, near the pretty well at the cross-roads, has a layered thatch which is a veritable work of art, with a pair of dormer windows poking out of the roof like the bonneted faces of two old ladies. Another is a mass of tangled jessamine and honeysuckle and thatch. The church for which these cottages have been companions so long is charmingly set in the park, where a stream feeds two lakes and hurries on to join the River Yare. By the church, but hidden from it by glorious trees, is the hall.

Of all its treasures, it is one brought here by this family of French Huguenot descent that stands alone—a long, plain, and workmanlike sword, its guard finished with bold scrolls of ironwork, *none other than the sword of Bayard,* the knight 'without fear and without reproach,' a true warrior's steel like that 'which ornament had none Save the notches on its blade.'

Much of the aisleless church is fifteenth century, though there are thirteenth-century lancets, and the tower has been rebuilt. The beautiful hammerbeam roof has fourteen angels holding coloured shields. The font was richly carved with roses, symbols, and trailing grapes 400 years ago. Among what is left of the old glass to the Greys are many headless figures, saints, shields, a crowned Madonna, and a bishop.

Lady Jane Grey is here in brass, though the portrait of her husband Sir Henry is gone. She is a charming figure in her long graceful robes and horned headdress. Near Lady Jane's brass is another of John Colvyle, a surprised-looking baby in sixteenth-century swaddling clothes.

Kettlestone

At a corner of its crooked street stands the flint church with a fourteenth-century tower, quaint with its eight sides, a door halfway up, and quatrefoil

sound holes between the belfry windows and the parapet. The rest of the old work is thirteenth century. The chancel and its arch and the porch were made new in the restoration of 1871, but fragments of Norman stones are built into the porch, and the chancel keeps its east window with butterfly tracery. The 500-year-old font has shields showing the lion and fleur-de-lys of England and France, the keys of Peter and the swords of Paul, the arms of the see of Norwich, and the emblem of the Trinity. Nine seats have old poppyhead ends carved with flowers.

Kilverstone

It is only small, but is all delightful in its seclusion, reached by a lane of stately trees. A group of four gabled dwellings under one roof stands by the green, on which is a fine maple by a fountain and a shelter. It is the village peace memorial, and on it are the words:

> *There is some corner of a foreign field that is for ever England.*
> *The grief that lingers and the pride that burns,*
> *All that love means and honour can express.*

From this green a grassy track leads down to the small church where Admiral Lord Fisher was buried with his wife.

A beautiful lychgate with dormer windows in its shingled roof has a cornice of vines under its eaves and squirrels eating acorns in the spandrels of its arches. That is twentieth century, but the trim little church to which the lychgate leads us has a story and something to show of about a thousand years ago. Its round tower was perhaps built by the Saxons, though its battlements are fifteenth century. A fine little Norman doorway, 3 feet wide and 7 high, its arch of roll and zigzag mouldings resting on pillars with carved capitals, leads us inside, where restoration has given a new look to the fourteenth-century nave and the fifteenth-century chancel. But there is beauty in the modern work.

Lovely glass glows richly in a window, showing a priest, a labourer, and two mothers with children. The reredos of stone and marble has a mosaic head of the Good Shepherd with a sheep on his shoulder. The oak pulpit has carving and a panel showing Christ ascending with cherubs round Him and two disciples at His feet. At the foot of the pulpit stair rail, on the ends of the choir seats, and on a chair in the sanctuary, kneel musical and praying angels.

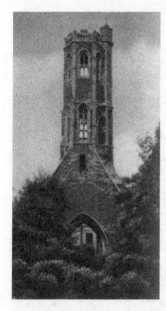

Greyfriars Lantern Tower in King's Lynn

Kimberley

Gathered round the green with its stately trees are the church, the old cottages with thatch and cream walls, the farm with its long barns, and the forge with its ringing clang of hammer and anvil. The villagers drawing water from the pump on the green complete this charming country scene.

It is all on the edge of a great and beautiful park, with deer, a lake, and gnarled old oaks hiding the brick house with the Queen Anne towers. In the park are still some remains of the manor house to which Sir John Wodehouse came home from Agincourt; the sword he unsheathed on the field and the rosary given to him by Henry the Fifth's Catherine, the grandmother of the Tudor dynasty, are now at the great house in the keeping of John Wodehouse's descendant the Earl of Kimberley.

Queen Elizabeth entered the old house in state, and sat on a canopied throne of red velvet and gold embroidery to receive the nobility of Norfolk. The throne, which was made for her visit and is the only one of its kind in existence, was brought to an exhibition in London some years ago, when Queen Mary sat on it for a few moments and laughingly remarked that it was 'not very comfortable without a footstool.' Among the treasures that came to light in three old family chests was the gold bodice of one of the dresses worn by Elizabeth during her progress through England, a thrilling relic of

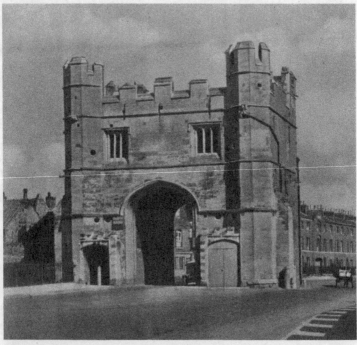

The fifteenth century South Gate in King's Lynn

our romantic queen, wrapped in a copy of the Morning Post of 1839.

The trim little church stands at the park gates. What is old is fourteenth century, but restoration early this century made much of it new within the old walls. The upper stages of the tower are dated 1631 with figures patterned in brick. There is a fine sycamore by the porch, and the door opens to the simple interior of nave and chancel, where a fine new massive roof looks down, enriched with carved hammerbeams and wall-plates, tracery, and floral bosses. Fine tracery adorns the screen, and fleur-de-lys poppyheads are on the pews. The font is 600 years old. A stringcourse runs round the chancel, where fine old windows have moulded tracery under hoods adorned with heads. In the old glass filling the east window are angels, saints, and a small Crucifixion scene, and old glass in another window shows Jesus upsetting the money-changers and a scene of general resurrection.

The family vault is in the churchyard, but their memorials are in the church. We see Sir John Wodehouse of 1465 and his wife in brass, he a knight in armour, she in kennel headdress and a girdled gown. Above them

kneels Dame Elizabeth Strutt in her alabaster monument; she was the pretty daughter of Sir Thomas Wodehouse, and died in 1651. Below the sanctuary step a brass inscription without a date tells us that 'Here lyeth Sir Edward Wodehouse, knight, and Dame Jane his wyffe; all good Christen men that rede thys same of your charyte to praye for their soules.'

King's Lynn

It has had a life of a thousand years, and still - as we walk about its ancient ways and its old harbour we feel that we are far down the centuries. Perhaps we may think of this old East Anglian port as a stout Norfolk burgess keeping watch through the centuries over the mouth of the River Ouse. He would see the Saxons sailing in with their treasure, and as the treasure (never easily come by) must be well and soundly kept he obtained a charter from King John and Saxon Lynn became Bishop's Lynn. He built a wall about the town, set up churches, collegiate house, and charities within the walls, and as time passed and prosperity grew he added a Guildhall, and with the Reformation and the dwindling of the bishop's power he changed the name from Bishop's Lynn to King's Lynn.

To this day part of the old wall stands, and one of the gates. There are traces of four monasteries: Greyfriars Lantern Tower in the heart of the town, the gateway of Austin Friars and the gateway of Whitefriars, and the mere name of Blackfriars in one of the streets. The old churches remain, and the memory of the famous men of the town is imperishable.

If the years and the silt of the slow old Ouse have robbed the town of some of the glory of the Middle Ages, there are fine new docks and a modern fishing fleet, and to the harvest of the sea has been added a never diminishing harvest from the fields, the pastures, and the orchards which deliver their produce to this market town. King's Lynn is the nearest coast town for Birmingham and the industrial Midlands, their natural gateway to the continent, and the harbour is a fine sight with its ships, and appropriately set among the great towers of the church is the attractive little Custom House. There are two marketplaces for two days of the week, old streets and new ones side by side, and avenues of fine old trees laid out 200 years ago called the Walks (partly on the old fortifications) add to its charm as a country town.

It is good to enter an old town by a gate. Only a stone marks the site of the East Gate of Lynn, which was pulled down in 1800, and the arms that adorned it are now on the wall of an office; but the strong fifteenth-century South Gate, with its turrets and battlements, still stands on London Road. Guanock Terrace close by indicates the line of the old wall, parts of which we see in the Walks and in Kettlewell Lane.

Facing St Margaret's Church in the Saturday Marketplace is the Guildhall, with a handsome front of chequered flint and stone, a fine fifteenth-century window, and on the porch the arms of Edward the Sixth and Elizabeth. Built 500 years ago, it was originally the hall of the Trinity Guild, a wealthy merchant guild existing before John gave the town its charter. Nearly a score of charters beginning with his time are in the strong room here. Here too is the Red Register, said to be one of the oldest paper books now known, in which are written the municipal records from 1204 to 1392. There are four silver maces of the time of Queen Anne, a sixteenth-century mayor's chain, the town's seal of 1300, the handsome State sword carried before the mayor (of which the blade may have belonged to one given by King John), and a magnificent cup of about 1350 enamelled and set with stones and jewels, called King John's Cup through his association with the town and his visit to it about the time when his fortunes were sinking in the Wash. Among the portraits on the walls are those of Sir Robert Walpole (MP for the town) and his son Horace, and those of Lord George Bentinck, Captain George Vancouver, and Fanny Burney, who were born here. She lived as a child in the house now the vicarage, facing the west end of St Margaret's Church, where her father was organist; the birthplace of Captain Vancouver is now the Friends' Meeting House, from where he set sail as a happy boy of thirteen with Captain Cook.

The town has a wonderful company of fine old houses. In Queen Street, near St Margaret's, is the seventeenth-century Clifton House with seventeen twisted pillars at the entrance, an older brick tower in the courtyard, and cellars older still. Sir Walter Besant brings the house into his book on The Lady of Lynn. The old house on the north side of St Margaret's vicarage was the home of the Thoresbys, one of whom was mayor of Lynn and founded the college for priests which stands at the corner of Queen Street; it has a fine doorway, and a door carved with fleur-de-lys and vine. An old house with a Gothic doorway in Nelson Street was the home of Thomas Bagge, of whom we read in Fanny Burney's diary. Close by is the fifteenth-century Hampton Court, where hangs a cannon ball fired by the Parliamentarians when besieging Lynn; it struck St Margaret's but did little damage. The siege was the most important event in the history of the town, and, though the Royalists held out bravely against 4,000 horse and foot, they had to capitulate. Not far from Hampton Court is the timbered warehouse of the old Hanseatic League, held by them from the thirteenth century to the eighteenth.

In King Street stands the charming little Custom House which Henry Bell, twice mayor, designed in 1681, loyally placing the statue of Charles the

The Guildhall in the Saturday Marketplace in ancient King's Lynn

Second over the entrance; it is quaint with its pyramid roof, its dormers and gallery, surmounted by a dainty cupola. Near the other end of the street is a warehouse with less architectural pretension, but is suffused with a glory of its own, for, originally St George's Guildhall, it became a theatre, and in it Shakespeare's travelling company played, the poet himself probably being among them. It is one of the rare places in the provinces where we may believe that he appeared on the stage.

King Street brings us to the Tuesday Marketplace, a fine square of three acres in a quiet corner near the waterside. Here we find the Corn Exchange and more houses of old merchant princes. Here stood the pillory; here witches were burned; here the pleasure fair begins on St Valentine's Day and continues for a fortnight; it has been held for over 800 years. From Tuesday Marketplace it is only a little way to the town's second fine church, St Nicholas.

Gardens and promenades add much to the charm of the town. Two fine avenues of limes and chestnuts, planted at right angles to each other in the middle of the eighteenth century, are known as the Walks. They are partly on the old fortifications, and where they meet is a gateway made of stones from the old town wall. In the Walks stands the Red Mount Chapel, a quaint brick building set on a mound about 1485 by Robert Corraunce. Within it, rising above the octagonal brick shell, is one of the smallest and loveliest

stone chapels in the land, a veritable gem, shaped like a cross and crowned by a beautiful roof of fan tracery resembling that of King's College Chapel. This Chapel of Our Lady of the Mount is as nearly perfect as can be, a chapel in miniature (it is but 17 feet from west to east), with delicate detail. From the corridor round it those who could not get into the chapel would have a view of the altar through three peepholes. The stone chapel is at the top of three storeys in the building; part of a brick handrail to the stairs leading up to it remains as a rare relic. The middle storey was perhaps the living- room and the private chapel of the priest, and on the ground floor is yet another chapel which may be thirteenth century. Many pilgrims of olden times came here on their way to the Shrine at Walsingham; now once a year a pilgrimage is made to it from the Roman Catholic Church in Lynn. It is said that Red Mount Chapel was connected underground with Greyfriars monastery, of which the graceful lantern tower (once the middle of a cross-shaped church) still stands near the peace memorial in Tower Gardens.

St Margaret's Church, founded 800 years ago by the first Bishop of Norwich, and attached to a priory of which there are remains in cottages is a stately place in the shape of a cross, with western towers 82 feet high. It is 240 feet long, but was once much bigger, and had a central lantern rising 132 feet. Today it has an original cross on the west gable. The fine old handle is still on the door, and on the doorway is the mark of high water in 1883, reminding us that Lynn has suffered from flood and storm. Little is left of the Norman building except for the base of the south-west tower, with leaning arches on clustered pillars; its middle stages are thirteenth century, and the top storey is fourteenth. In the tracery of one of its windows are remains of a very rare copper dial for showing the phases of the moon, once operated by clockwork. In front of the windows of this tower is a passage leading to the fifteenth-century west window of the nave. The spire which once crowned this tower fell in a storm 200 years ago, greatly damaging the nave and aisles. The northwest tower was made new in the middle of the fifteenth century, but one arch is original.

It was in the thirteenth century that the Norman church was transformed, and of this time there remain the four lofty central arches and much of the beautiful chancel, which is the glory of this place. Arcades of richly moulded arches and fine capitals lead to its south aisle and to the Trinity Chapel, and above them is the lovely fifteenth- century clerestory, a lantern of light with a gallery walk.

In the east window are figures of Our Lord with the Cross, Mary and John, and a score of saints and angels. Under it is the colossal reredos of red and gold with carvings representing the Annunciation and the Crucifixion, and figures of Our Lord in Glory, the Four Latin Doctors, St Felix, and St Hugh

of Lincoln. The most interesting glass fills the west window with figures of Christ, angels, saints connected with the parish, angels bearing Passion emblems and coats-of-arms, and scenes in the town's history. We see King John granting the charter and presenting the sword to the mayor, Cardinal Wolsey visiting Lynn, and Henry the Eighth granting a charter.

The high altar is made of cedar wood from Lebanon, and in the Trinity Chapel is an Elizabethan altar table. The pulpit is eighteenth century, and its old sounding-board is preserved at the west end. The brass eagle lectern is fifteenth century. The fine misereres of the fourteenth-century stalls are carved with heads, among them those of Henry Spenser (Bishop of Norwich), the Black Prince, and Edward the Third. The side screens of the chancel are 600 years old, and in front of the organ is an Elizabethan screen, with heavy arcading, which was once the chancel screen and was altered in the time of James the First; on it is the Latin inscription 'Henry united the Roses, James united the Realms,' the words used by James in his first speech to Parliament. They appeared also on his first gold coinage. The screen facing this is a modern copy. A few relics of other days are two Elizabethan chalices, several seventeenth-century flagons, an illuminated Sarum Missal, a stone coffin, and an ironbound chest.

The porch of St Nicholas at King's Lynn

Two treasures St Margaret's has which would bring us here if it had nothing else to show. In their original stones in the chancel south aisle are two great brasses which have no equal in the land, both fourteenth century and both to mayors. That of Adam de Walsoken comes from 1349 and is nearly ten feet long and six wide; Robert Braunche's brass is 1364 and about nine feet long. Huge as they are, both are crowded every inch with beautiful engraving, and both have unusual picture strips at the base.

Adam de Walsoken is with his wife Margaret, he wearing a plain loose coat with sleeves and hood with a dog at his feet, she a gown beautifully embroidered, and with a dog at her feet. They stand under finely ornamented arches, both at prayer with angels at their shoulders. Around them are angels with musical instruments and apostles, all in canopied niches, and below are two panels with pastoral scenes—the gathering of apples, and a man riding with a sack of corn on his back towards a windmill, in the doorway of which stands a little man. This is said to be oldest illustration of a post windmill. Elsewhere there are shields, singing angels, odd animals, and odder little men; there are at least a hundred figures, relieved with every kind of foliage and scrollwork with which the assiduous engraver filled the spaces.

With Robert Braunche are his two wives Leticia and Margaret, all under canopies, with angels at their shoulders. Robert himself, with ringlets and moustache, wears a loose coat and has an eagle at his feet; his wives wear wimples and each has a dog at her feet. Margaret's gown is enriched with heads of dogs, and Leticia's with doves. At the sides are men and women in fourteenth-century dress, perhaps friends or relatives; above is an angel choir, and below is a worldly feast which has caused the brass to be known as the Peacock Brass. It is said that the panel at the foot pictures the peacock feast supposed to have been given to Edward the Third when he visited Lynn, and indeed nothing is absent which might add lustre to the banquet. There are the guests at the table (laden with delicacies), musicians, and a procession of distinguished ladies who served the meal.

St Nicholas is an old chapel-of-ease belonging to St Margaret's, striking in its size (200 feet long and 70 wide) and with a great window nearly filling the west front. The chapel was rebuilt about 1420, except for the thirteenth-century south-west tower, which is crowned by a modern spire, covered with lead. The old spire fell during the storm which destroyed the spire of the mother church in 1741. The lovely porch has an upper room and a front enriched with tracery and canopied niches, and its fine vaulted roof has quaint heads and many bosses, carved with figures of Christ in Glory, angels, a king, a queen, a bishop, and grotesques. At each side of the inner doorway is a woman in draped headdress and a boy in a broad-brimmed

hat, and in it hangs a fine door covered with rich tracery, pinnacles, and niches, with six seated and kneeling figures over the wicket.

The chancel and the nave are in unbroken line, and the soaring arcades are of ten and eleven bays. Between the windows of the fine clerestory are double niches, and the splendid old roof is enriched with open carving and lovely angels with outspread wings, holding books and playing instruments.

The seventeenth-century font has a modern cover copied from the old one, and there is an older font bowl on an oak stem. Six angels peeping over three canopies are all that is left of the old sedilia. The splendid lectern is a bronze eagle with four lions at the foot. The old seats left in the chancel have fine carving of animals, and wreaths of flowers among which are saints, a man in a cockle shell, a man and an animal by an altar, a man with a pig over his shoulder, and the Madonna. Some of the carving belonging to this group is treasured in the Victoria and Albert at South Kensington.

On a big classical monument is a medallion portrait of Sir Benjamin Keene, a grammar-school boy of Lynn whose portrait hangs in the town hall; Sir Robert Walpole made him Spanish Ambassador, but Horace Walpole thought him 'fat and easy,' though with universal knowledge. Three seventeenth-century memorials show Richard Clarke (a mayor) with his wife, and their son with his wife and children; Thomas Snelling (who died while he was mayor in 1623) with his wife, three children, and a babe in a cradle; and Thomas Green (a merchant) with his wife and their nine children.

Among the other churches and chapels in the town is All Saints at South Lynn, with its fourteenth-century nave, its chestnut roof, and remains of the old screen and the roodstairs.

At Gaywood, a suburb of the town, are the fine modern buildings of the old grammar school, and next door to them is the Hospital of St Mary Magdalene—no other than the foundation of almshouses which first appeared here in the twelfth century, the present building having been erected on the same site in the year Charles Stuart died. Twelve dwellings and a chapel stand round a quadrangle, and in them live widows of Lynn. There are other old houses here, a clock tower in memory of the Gaywood men who did not come back, and the church of St Faith, neat and trim, sheltered by trees off the main road. The church is much restored since the old days, but there are still many fourteenth and fifteenth-century windows, the fifteenth-century tower, and a Norman doorway. A fine chair is Jacobean, and a beautiful Elizabethan altar table has a front panel of rich embroidery. Among the modern woodwork is the canopied pulpit with carvings of George and the Dragon, the Good Shepherd with the sheep, Nicholas with a boy, Walstan

with his dog, and Dunstan with pincers, birds fluttering round his shoulders. The Four Evangelists are on the priest's seats, and in the reredos we see the Entombment, saints in niches, the Madonna and the Archangel Gabriel. Rich glass in the east window shows Christ in Glory with saints and angels. A window with a fallen soldier by a crucifix is in memory of one of them who died for us in the third week of the Great War. The most interesting possessions of St Faith's are two quaint old Dutch paintings hanging in the nave. One is of Elizabeth at Tilbury, the queen on horseback with a troop of soldiers, while in the background is the English fleet in full sail and the Dutch ships all ablaze. The other is of Gunpowder Plot, and in it we see the king and his red-robed counsellors, Guy Fawkes with a companion and a demon with a torch in the cellar below, and searchers approaching from the other side.

King's Lynn has two museums, one with a little art gallery. In a beautiful timbered house in Bridge Street, the home of a mayor in the seventeenth century, with a lovely overhanging front, a balcony, and oriels on carved brackets, is housed what is called the Greenland Fishery Museum, where we may see old drawings and maps, medals, coins and seals.

For the museum with the art gallery we must go to Market Street, where pictures hang by Norfolk artists, and others by such famous painters as A. J. Munnings, Amesby Brown, Walter Dexter, and Frank Southgate. In the museum is a pedestal memorial to Captain George Manby, the Norfolk man who invented the rocket life-saving apparatus, and among the exhibits are mantraps, the old ducking stool, and a fine collection of birds, butterflies, and insects.

The interesting group of notable people born in this old town includes two immortal names and two less familiar. The African explorer Thomas Baines was born here in 1822, and, having a taste for the life of an artist and the life of the sea, he went to the Cape and joined an expedition for exploring Australia. Afterwards he joined the Zambesi expedition, under Livingstone with whom he went half way and then went on to the Victoria Falls to make sketches. In 1587 there was born here the little known Sir Francis Bacon, a judge who came of the same stock as his immortal namesake. He lived through the Civil War, and after the execution of the king, when the judges were called to take the oath to the people instead of the king, he was one of five who refused, and resigned. He lived in retirement and died at Norwich, where he was buried in St Gregory's. He was the fifth member of his house to become a judge.

One of the two immortals born here, George Vancouver, sailed as a boy of thirteen with Captain Cook, and years afterwards, in following the course

of Cook, he rounded the Cape, surveyed the south-west coast of Australia, naming harbours and headlands, and crossed to New Zealand entering Dusky Bay, which Cook had marked on his map *Nobody Knows What*. He carefully mapped it and marked it on his chart *Somebody Knows What*. He sailed round the west coast of North America, exploring tiny inlets and discovering the Gulf of Georgia, then sailed round the island which now bears his name. Renewing his work to the north, he for the first time correctly mapped the coast beyond San Francisco, reaching England in 1795 after a voyage of four years, rich with results. Bred to rigid discipline at sea, he was himself a strict disciplinarian, and there was an outcry over his having flogged a midshipman (Lord Camelford), put him in irons, and discharged him from the ship. His voyage completed, he settled down at Petersham to write its story, and had just finished it when Death ended his voyage through this world.

It was in the house of an organist at King's Lynn that Fanny Burney was born in 1752, and from her time to ours there has probably been no day when somebody was not reading of her in one of a hundred books. She was a backward child, and could not read the alphabet when she was eight, but started scribbling before she was in her teens, burned all that she had written, and then secretly wrote her first novel, Evelina. It had been her good fortune to sit silent in a corner of a drawing-room filled with the talk of such men as Edmund Burke, Sir Joshua Reynolds, and Dr Johnson, and when Evelina appeared, published anonymously by a man she had not met, her father who had laughed at her, and the publishers who had refused to consider the manuscript, were agog with excitement as her identity was revealed.

All the boys of King's Lynn know the name of Frederick Savage, a clever young engineer of the town who invented a winnowing machine and tackle for ploughing, and when a travelling show came round he invented a steam-engine to turn it round instead of being pushed by hand. Then he invented the switchback, and out of all this grew up the great fair at King's Lynn, where regularly there is a little ceremony at the foot of a monument set up to him at the corner of Guanock Terrace, with a sculptured figure of him in his municipal robes. He was an alderman and a mayor, but he is remembered chiefly as the man of the fair. AT King's Lynn was born a woman whose life is the first known autobiography in English literature. She was Margery Kempe, daughter of John of Brunham, five times Mayor of Lynn. She was born in 1364, and married at twenty to John Kempe of Lynn, to whom she gave fourteen children before she went out of her wits, had a vision like Paul's on the road to Damascus, and made a bargain with her husband that she should go on pilgrimage. She wandered weeping and

sobbing over England and Europe, and even to Holy Land, so depressing with her groanings that every other pilgrim avoided her.

When at the end of her days she tramped to London from Canterbury clad only in a sackcloth apron folk made mock of her. Her loud sobs drowned the voice of many an exasperated preacher, and made her companions heartily sick of her; but they are all gone, and it is the weeping Margery we remember in these days. AH that was known of Margery and her book was an extract from it in the University Library of Cambridge, a little book of eight pages printed by Wynken de Worde about 1500. The contemplative beauty of this extract led people to think that Margery Kempe was an anchorite, one of those solitary medieval folk whose cells still cling to a few of our village churches.

But now we know her for a sturdy mother of fourteen children, the wife of John Kempe, whom she persuaded to give her up to a religious life while she stood beside him under a cross on the York-to- Bridlington road, vowing that she would pay his debts before making a pilgrimage to Holy Land.

In 1414 she began her pilgrimage, and her sobs doubled in volume as she stood in the Temple and made her way to Mount Calvary. 'She could not keep herself from crying and roaring though she should have died for it,' she confesses in her autobiography.

She returned to King's Lynn and her husband, but two years later sailed from Bristol to visit a saint's shrine in Spain. Back again to preach in England, she then went to Danzig. She was getting an old lady, but the difficult journey back through Germany to Calais and Dover had to be made mostly alone, for other travellers would not put up with her ways and were ashamed to be seen with her. She tramped to London, and, standing in the streets in her sackcloth apron, slashed with her tongue at the vice she saw around her, and 'her speaking profited right much in many persons.'

Then she dictated her story. Because Margery did not know Latin or French she wrote in English, and it is the fact that her book is in English that makes it so remarkable for us. This is the book which for generations lay in the library of Pleasington Old Hall, the Lancashire home of a Roman Catholic family who may have received the book from the monks at the Dissolution of the Monasteries, the monks thinking it would thus be saved from destruction.

Occasionally someone picked it up and looked through it as it lay on the shelves; but all the way through Margery refers to herself as 'this creature,' and only once is her name mentioned, so that the book remained unrecognised till Lieutenant-Colonel Butler-Bowdon took it to South Kensington. There it was recognised as the hitherto unseen story of Margery Kempe, and it is

now available for all who will in two editions, one for the expert in the old language and one in a modern version which anyone of us can read.

Kirby Bedon

In a little group on the hill stand the big house and the thatched cottages, the trim flint church of St Andrew, and the ivied ruins of the round tower of St Mary's church across the road. St Andrew's church has a simple nave and chancel with a nineteenth-century tower and porch, but the doorway is Norman and frames its original door, with a wooden lock and a quaint array of ironwork in feathered bars and bands like horseshoes. At one side of the doorway is a mass dial. The fifteenth-century font is carved with tracery on the bowl and stem, and the flat Jacobean cover has a carved border. There are two Jacobean chairs, an old pulpit and altar rails. Ancient glass fragments show an angel with yellow wings and a man's head in yellow and brown.

A celebrated mathematician and astronomer was rector here in 1784. He was Samuel Vince, son of a Fressingfield bricklayer, who worked with his father till he was twelve, when the parson sent him to Harleston school, where he became usher, eventually being assisted to a university education at Cambridge. He wrote monumental books which established a great reputation in his day.

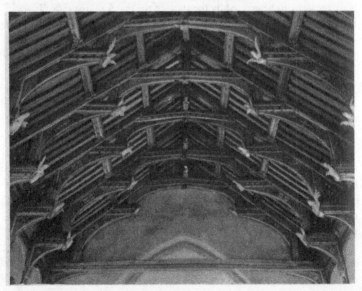

One of Norfolk's finest roofs in Knapton

Kirby Cane

Lying between two main roads, but far enough from both to escape their noise and bustle, it is ages old, so old that Saxon urns and a Roman kiln have been found. The church and the great house are wayside companions among the trees, the house with a charming garden and a pool, the churchyard shaded by spreading cedars. The round tower is Norman except for the battlements, and the Normans built the south doorway, with its zigzag and flowers and a grotesque head which has been looking out for 800 years. An ancient door with strap hinges lets us into a nave where all is trim and quaint with golden walls, the light falling through windows coming from Norman to fifteenth-century days. The rood- stairs are in the splay of a fourteenth-century window. A stout arcade with massive pillars divides the nave, with its old black and white roof of trussed rafters, from a wide aisle on which an old roof looks down. The bowl of the 600-year-old font, resting on clustered pillars, is carved with heads of lions and men and woman.

Knapton

Its road leads uphill past scattered dwellings, a mile - and a half from the sea, and the tower of its fourteenth-century church is a landmark and a magnet, drawing us to one of the finest treasures of its kind in the land.

A beautiful old porch with a triple niche over the arch leads us in, and we open the door to be greeted by the sight of the fine font, majestically set in the bare nave and looking like a pyramid with its three high steps. At least seven centuries old, it has a bowl of marble on nine shafts and a canopied Jacobean cover on which is the Greek inscription reading curiously the same either way, 'Wash my sins and not my face only.'

The tower is oddly set at the north-west corner and has a doorway to the nave. Here are old coffin-lids, Jacobean chairs, a Jacobean relic of a three-decker pulpit, and a fifteenth-century screen spoiled with paint and hung with Jacobean gates; but the glory of Knapton is over our heads as we stand in this nave. Even the oak eagle of the lectern turns his head in admiration of the magnificent double hammerbeam roof which John Smithe gave to the church in 1503. It is one of the finest roofs in Norfolk, and in its design and construction, as well as in its beauty, has few equals for its time. The beams and spandrels are richly carved; three tiers of angels have wings outspread, and angels are on the wallplates. Figures with scrolls, shields, symbols, or playing instruments are in niches on the wall supports, and below these are modern angels, the only unpainted figures among 140 enriching this wonderful roof.

Lamas

The River Bure flows slowly by, by the splendour of the j beeches in the meadow, by the medieval church and the farm. It is one of the most delightful scenes on the Broads.

The river has been flowing past the church for 700 years, and sheltered in the medieval porch is the door the village folk have been opening and shutting since the days of Magna Carta. It has an oak lock with a huge key, and over it a thirteenth-century coffin lid forms a lintel. On the tower arch are two cowled and bearded heads, and on the wall is a cross in red and black marking the place where the bishop put his hand on Consecration Day. The font is 500 years old. Norfolk has a remarkable record of long service in its pulpits, and in the chancel is a tablet to Philip Candler, rector here for sixty-eight years, one of the longest records we have come upon; both he and his wife, his devoted helpmate for sixty years of his ministry, died in 1832. A much earlier minister, one Peter, who served here 650 years ago, is said to have killed a man who was stealing his beans, and then to have buried him, a strange story to have lived through the ages.

At Little Hautbois, about a mile away, is a beautiful Elizabethan hall with fine windows and ornamental gables, now a farmhouse. In the Quaker burial-ground lie a mother and daughter who both won fame in books, Mary and Anna Sewell. The mother came of an old farming family, her father turning shipowner at Yarmouth. She was educated at home and became a governess before she married; not until she was sixty did she begin to write, and then, being a Quaker, she produced little ballads and simple talks for children. The daughter Anna, born at Yarmouth, inherited her mother's gift for writing, and, being confined to the house by a severe injury which crippled her in her teens, she developed her writing along with a wonderful feeling for animals. All the world knows of a book she produced in 1877, a year before she died, for it was Black Beauty, the autobiography of a horse.

Langford

Hiding away in a valley where the River Wissey flows are its few farms, a tiny church with one of them for company. We see it from the river through an arch of tall beeches, lowly and trim, with a mellowed red roof and a turret for its bell. A fourteenth-century church much restored, it has two surprisingly fine things taking it back to Norman days.

One is the splendid doorway, its arch, with mouldings of zigzag and bobbin ornament, resting on two shafts at each side, all in perfect preservation; the other is a noble chancel arch as wide as the nave, impressive with its bobbin-and-roll mouldings, and shafts with cushion capitals. There are two

blocked Norman windows in the nave, and the east window is 600 years old. By the window-seat sedilia is a trefoiled piscina, and the massive font is fifteenth century.

Another surprise in this small place is the ponderous marble monument against the chancel wall, set up in the time of George the First by Dame Cecilia Garrard in memory of her husband Sir Nicholas and his ancestors. It is overpowering, and almost comic in its absurd array of lifesize figures of three baronets, all wearing Roman robes and sandals. The first was Sir Jacob, who was honoured for his service to the Stuarts and died about 1666.

Langham

Under the trees which bury the church by the cross-roads on the hill, catching the sea breeze from the salt marshes two miles away, sleeps a writer whose name is dear to every schoolboy, for Langham churchyard is the resting-place of Captain Marryat, who created the immortal Midshipman Easy, Masterman Ready, Peter Simple, Jacob Faithful, and a host of characters as alive to us today as when they sailed in the wooden frigates of the Navy.

Like most of the church which it crowns, the fine lofty tower, with big belfry windows and sound-holes, is fifteenth century. A leaning arcade divides the nave from its aisle, and the old roodstairs are still here. The chancel reredos, picturing the Annunciation, is unusual, for the figures are made of silks and brocade, and outlined in coloured and gold thread. Paintings on the traceried oak panels of the reredos in the chapel show the Visit of the Wise Men, Christ walking on the water, John the Baptist, Mother Juliana of Norwich, St Withburga of Dereham, and St Elizabeth. The font is Norman and has on it an inscription to Alice Nettleton of 1692. Another inscription of the same century records the death of John Palgrave, who 'lived beloved and died bewayled,' and was descended from the 'ancient, virtuos, and worthy family of Palgrave of Palgrave.'

Langley

At one end of its charming little lane, which is turned into an avenue by oaks and lime trees, are the gabled almshouses of last century; at the other end a gate opens to a wooden path leading over a field to a church nestling delightfully by the wood in company with a farmhouse and fine barns. In the 800-acre park, with its oaks and cedars and its spring carpet of snowdrops and daffodils, is the eighteenth-century Langley Hall, and not far from it is a tall cross with statues of saints on its tapering shaft. It marks the place where four villages meet, their names on a stone. It was brought to the shelter of the park from its old site near Langley Abbey, now in ruin on a

farm a mile away. The old abbey was founded as the twelfth century was closing, and we found ivy and wallflowers growing on what is left of it, close by a thatched barn.

A thirteenth-century doorway leads us into a fourteenth-century church with a fifteenth-century tower. Indoors it is exceedingly long and rather barnlike, with no arch between nave and chancel. The nave is filled with high-backed and horsebox pews, and from one of them rises a three-decker pulpit. The font is 600 years old. An interesting possession is the glass in some of the windows, precious because it was saved from the French Revolution, brought from Rouen Cathedral. In the east window is St George brandishing his sword, Christ enthroned and again before Pilate, and a fine Nativity with the Wise Men in rich robes. A saint in red and gold mantle with a purse on his belt is looking up to an angel in a cloud, and by him in golden fields sit two shepherd boys, one with bagpipes and a dog at his feet. The peace memorial is a beautiful oak panel with two doors, and paintings in medieval style of St George, St Michael, and their dragons. It is to six men who did not come back.

Larling

It has a pretty spot where a bridge spans the River Thet flowing through, with willows growing by the water and a timbered inn. The church stands alone in a field, with no road to bring us to its tranquillity. It has willows and iris growing in the marshy ground about it, and only the distant hum of traffic disturbs the song of its birds. Much of this simple flint building has stood here 600 years; the buttressed tower and some of the windows are fifteenth century. There are fragments of old glass, and the old altar stone, found last century under the floor, is now in its place. At the end of the south aisle a flight of steps leads to the doorway of the roodstairs, and here, at the side of a window with stepped seats and arm-rests in its sill, is a piscina carved with heads. There is a splendid Norman doorway with rich mouldings, one with balls and crosses and little heads of men. The upper halves of the shafts are carved with diamond, zigzag, and pierced bands, and on one of the pillars is a mass dial. At the crude font, with four tapering sides, the children of this village were christened 800 years ago.

Lessingham

Its cottages are grouped on the flat lands near the coast, and the 600-year-old church is in the fields behind. The font is a century older than the church and has carved trefoiled arches, unusual in this part of Norfolk. There are fragments of a medieval screen with the portraits of twelve saints fading

away; we can still recognise St Catherine with her wheel, and St Apollonia, who is holding a tooth in an enormous pair of pincers, he having been the saint to whom our ancestors appealed when they had toothache.

Letheringsett

Down through the woods of a valley the Saxons found, in the heart of a forest, tumbles the River Glaven. We may cross it by a bridge near the hall, and come by it to the houses and the church. The old hall is now a farmhouse. It is a charming spot, though on a busy road, and is embowered in lovely trees. Here Hamon Grimbaldus built the church when he was lord of Letheringsett, and made his youngest son its first rector early in the twelfth century. It seems likely that he was Grimbaldus Medicus, physician to Henry the First, and from him we inherit the Norman round tower which has an original window deeply splayed and belfry windows from the fourteenth century. The font, its bowl on nine pillars, is almost as old as the tower. Over the thirteenth-century arcades is the fifteenth-century clerestory. An old almsbox has iron bands and two locks. The lighting is from candles in fine hanging candelabra Angels adorn the cornice of the modern roof, and in the extraordinarily elaborate alabaster reredos are figures of the Madonna and Child, John the Baptist, and the Twelve Apostles.

Litcham

There is an air of other days in the hooded doorways of some of its houses, and it is believed that the house called the Priory, by the bridge over the youthful River Nar, was once a house of rest for pilgrims. What is old in the church is chiefly fifteenth century, and in the brick tower which Matthew Halcot built in the time of Charles the Second some of the old stones were used again. The fifteenth-century font has tracery and shields, and the pedestal pulpit of about 1500 has traceried panels. A massive old chest with tracery and buttresses has a huge lock. The chief interest of the church lies in the 500-year-old screen, adorned with beautiful tracery, newly painted and gilded. Of the gallery of original paintings on the panels some are gone, some almost gone, and the rest more or less worn. We can see St Gregory holding a cross, St Edmund with the arrows of his martyrdom, Edward as king as well as martyr, the boy William of Norwich (whom a false tradition declared to have been martryed by the Jews in the twelfth century), Hubert the hunter kneeling before the white stag of his conversion, and Henry the Sixth. Among the women saints are Margaret and Ursula.

Little Fransham

Queen Elizabeth is said to have slept for a night at the Old Hall, but its glory has departed, and now the whitewashed front and the huge chimney stacks shelter a farmhouse. Something of the glory has departed also from the church, for the old tower fell down 200 years ago. Today its great possession is the massive Norman font with three sides carved with little arches, and the fourth with flowers. The church is mostly 600 years old, and has still its medieval roof looking down, the most impressive thing here. There are old carved panels in the pulpit and the lectern, and fine old woodwork in the chancel seats which have traceried backs and ends with poppyheads and animals.

Little Melton

As we leave the rambling village, an old windmill bereft of its sails points the way to the red-roofed church in the trees, its square tower whitening in the sunlight. The bright little building has a fourteenth-century chancel and two relics of the church of 1180 in the stone altar on the Elizabethan table and the very low font, its nine pillars supporting the bowl. There is a mass dial on a corner outside, and heads of King Edward and Queen Eleanor guard the hood of the doorway. The chancel keeps its old sedilia and a fine double piscina, and there is a little piscina on a pier of an arcade. The roodstairs have their old oak treads.

In the 600-year-old wall paintings which have come to light in our time is a patchy group which may be St Christopher and St Catherine. Another shows two seated women in graceful robes holding rosaries, with evil spirits above them; and at each side of the east window are the figures of Gabriel and Mary. There are neat benches of grey oak, and a pulpit with traceried panels 400 years old. Against it the green and white and gold of the fine fifteenth-century screen shows up vividly. On the screen is an hourglass stand of 1650. The altar rails, also grey with age, are a little restored, and have tracery like that on the base of the screen, as well as a border of Tudor flower. They seem to be part of a screen, and similar work is in the stalls. An ancient chest has two locks.

We noticed that Little Melton had three parsons in 1349, when 800 parishes in Norfolk lost their priests through the Black Death.

Little Plumstead

It is proud of its oaks, and with just cause, for they line the roads to the church, which stands on the edge of the park of Little Plumstead Hall. Beech and yew, a fine cedar, and a magnificent oak are among the great trees sheltering

the venerable church, which was old when the trees were young—so old that the Saxons may have built the round tower. The twin brothers Protase and Gervase, martyrs of the first century, are its patron saints. Far away in Milan, relics of these brothers lie in a crystal shrine at the church where St Ambrose blessed them.

Much of the building is fifteenth century, but we come in through a doorway with a Norman hood, sheltered by a patched-up porch, and the blocked north doorway has an old round arch. In bright panels of foreign glass we see the Four Evangelists and their signs, St Luke painting and the others writing.

Little Snoring

Its name is odd, and there is much that is odd in the church, which stands on one hill while the cottages climb another. The round Norman tower has a curious red cap with four tiny dormers, and stands a few feet from the rest of the building. The Norman arch on its eastern side suggests that the tower was once attached to a nave, and under the arch is a face with open mouth.

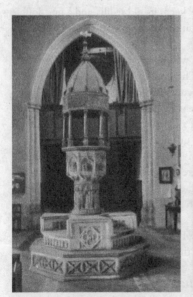 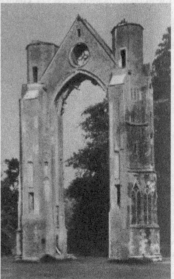

Above left: The canopied font of the church at Little Walsingham

Above right: The east window of the priory at Little Walsingham

The rose-bowered porch has stone seats, and shelters a doorway which is part of the church of the Normans. It is one of the most extraordinary doorways we have found among ten thousand, for not only is it of tremendous size in comparison with the carved shaft and capitals supporting it, but the arch has a fascinating display of three orders, all varying in shape. The outer moulding, under a carved hood, makes the arch like a horseshoe, the innermost is a simple round arch, and the pointed moulding between them is adorned with double zigzag and has a lion's head at the apex.

It is all simple and plain within, but here again is oddness. Four wide steps mount at the west end where once there were pews, and below them stands the fine Norman font, its round bowl carved and set on four pilasters round a shaft. A wide thirteenth-century arch leads to the chancel, which has four steps to the altar, and is full of light from a quaint array of windows whose only pictures are of the village and the fields outside. The oldest is the unusual group of three lancets as high as the roof and as wide as the east wall, where their great splays are divided by shafts. Another quaint touch is the big corner piscina in the splay of a restored medieval window, its sill forming a seat.

As well as its surprising south doorway, the nave has a blocked doorway of the twelfth century, and an assortment of windows from that time to the fifteenth century. There are some old poppyhead bench-ends, and the pulpit and the reading-desk are made of old Spanish mahogany.

Little Walsingham

With lovely woods all round, creeping up to shelter it, it is a fascinating little place, with the ruins of a twelfth-century priory, remains of a friary founded two centuries later, and a medieval church with one of the finest fonts of its kind.

For centuries this was the second place of pilgrimage in England, for here was the shrine of Our Lady of Walsingham, to whom kings and queens bowed the knee after walking barefoot down these old streets. Stirring indeed is the thought of the greatness that has come here, of the wealth that has been given in penitence or remorse, of the prayers that have been offered by great and simple folk.

The church stands high at a charming corner, with firs in the churchyard, withdrawn from narrow busy streets about which the past clings graciously in many quaint buildings. Some of the houses have timbered overhanging storeys, and in front of one such block is the old pump shelter looking like a great beehive.

It is believed that there was a church here in Saxon days, but the church we see is chiefly fifteenth century, its tower of about 1200 crowned by a

slender leaded spire which was known as one of England's few twisted spires till it was made new in our own day. The west porch is adorned with stone heads and in it hangs one of the two old doors here, the other by a fine traceried door with original fastenings in the south porch (which has a lovely vaulted roof supporting an upper room). There are two old screens, some old pew-ends in the nave and chancel, a wooden pulpit over 500 years old, a quaint piscina niche, a thirteenth-century coffin stone, an old chest, and the base of a fourteenth-century churchyard cross. A chalice brass is in memory of William Wettsrow, who was priest here early in the sixteenth century. A curious memorial carved with arrows, a snake, and a laughing face is to Robert Anguis of 1590, whose father used to live in the Black Lion Inn still standing behind the main street. Another curious memorial, showing a four-poster bed with curtains drawn, tells us that Edward Fotherbye sleeps here.

On their great alabaster monument lie Sir Henry Sidney and his wife, he in armour and she in black gown and farthingale. Sir Philip was their nephew, and a sad day it must have been for them when his brave spirit fled. Lady Sidney lived till 1638, and it was she who gave the fine cover of the font, its dome resting on pillars and crowned by a golden dove. Seven feet high in itself, it rises twice as high with the font, which is the chief treasure here, though sadly battered; the bowl is carved with representations of the Crucifixion and the Seven Sacraments, in niches round the stem are headless remains of the Four Evangelists and the Four Latin Doctors, and the steps on which it is set are adorned with tracery and flowers, the top one shaped like a Maltese cross.

It is said that some old glass above the sedilia, showing the angels of the Stigmata of St Francis, was given either to the church or to the Franciscan Friary by Henry the Seventh, when he came here on pilgrimage. Of the friary founded in 1346 by Elizabeth de Burgh, Countess of Clare, there are still seen ruined grey walls with traceried windows, enclosing the garden of a house.

A fifteenth-century gateway in High Street, near the old pump, leads to what is left of the priory in the grounds of the great house called Walsingham Abbey, charming with trees, an old bridge over a stream, and a golden meadow. Founded in 1149, the priory was the pride of medieval England and was famous throughout Europe. Now there are only lovely ruined fragments, in and out of which we found a proud peacock strutting about. The noblest fragment is part of the fifteenth-century east end of the church, the majestic arch of the great window a beautiful frame for a group of beeches beyond; above it in a gable is a round window, and at each side are

handsome turrets with niches in the buttresses. The massive bases of the west doorway of the church are still here, and of the refectory there is the lovely fourteenth-century west window and stone steps in the arcaded wall leading to the reading pulpit. A Norman doorway leads to a stone bath, and there are two wishing wells.

Still a place of pilgrimage for devout Roman Catholics is this charming spot, though nothing is left of the old shrine of Our Lady of Walsingham, set up in 1061. Every road had its pilgrims trudging to what was believed to be one of the most sacred spots in Europe, and next to Thomas Becket's tomb at Canterbury there was no shrine in the land so much visited. Here came Henry the Third in 1241, and here knelt the first three Edwards, Henry the Sixth, Edward the Fourth and his queen, and David of Scotland with a score of knights. Henry the Seventh sent his banner to Little Walsingham after his crowning victory over Lambert Simnel at East Stoke, Catherine of Aragon was on her way here when she heard of the victory of Flodden, and Cardinal Wolsey came here four years later. Last of the kings to come to the shrine was Henry the Eighth, who was to destroy it. He started his walk here in 1510 from East Barsham Manor House, stopping at a Slipper House two miles away to take off his shoes. He deposited a valuable necklace on the figure of the Madonna, little dreaming perhaps that the time was to come when the figure would be burned at Smithfield.

Its fame was still undimmed in the time of Erasmus, who tells us that the chapel was of wood with little light save that which came from candles, though it was always bright and shining with jewels and gold and silver. Oliver Goldsmith seems to have founded his ballad of Edwin and Angelina on a quaint old poem telling how a pilgrim found his way here.

The story of the shrine did not end with its destroyers 400 years ago, for in our time a new shrine has been rising and the remains of the old shrine have been revealed by the excavators. The new west front rises from a courtyard and its gable is crowned with figures of the Madonna and Child. The front porch is striking with three arches and has round windows above. Inside are two chapels, north and south, enclosed by fine iron gates, and set in the walls is an interesting collection of stones from abbeys and shrines of medieval England. One stone is from the old church of St Bartholomew built by Rahere the king's jester, close by the site of the fires of Smith-field; another comes from the Saxon church built by the Roman wall at Hexham; a capital is from Lincoln cathedral; some stones are from the tomb of the daughter of Edward the First; and another is from the first Carthusian house in England founded by the king in his remorse for the murder of Becket. There are fragments from St Peter's in Rome, the cathedral at Pisa, the

Coliseum, Bethlehem, and the Hill of Patmos. One little chapel is built as a copy of a house in Palestine such as Christ would have lived in as a boy, and there are tiles from the vanished Boxley Abbey in Kent.

There are fifteen chapels round the nave. The high altar, made up of stones from many cathedrals, has six columns with gilded capitals supporting a painted screen with panels of Joseph's Dream, the Presentation in the Temple, and the Wise Men; the paintings are by Miss Enid Chadwick. Some of the stone heads in the nave, among which are the bishop and the vicar of the time, are the work of a village man, Mr R. Money.

In the garden are the Stations of the Cross, and there also is a sepulchre hewn out of the rock, a copy of the sepulchre venerated in Jerusalem. The Crucifix in the garden belonged to Father Tooth, a priest well known to the last generation, and it figured in the riots at St James's, Hatcham, in 1870. Bordering the garden is a charming old house in which the nuns live, and an elegant red brick tower looks down, crowned with a golden figure of the Archangel Gabriel.

Loddon

It was the birthplace of Ann Bartholomew, who published plays and poems and painted flowers and miniatures. One of her watercolours is in the British Museum.

The great possession of this little market town of a thousand folk, lining part of the road to Norwich where it crosses the River Chet, is a fine flint church, standing imposingly in a churchyard dotted with firs, on the edge of a market square which makes a bay in the road. Built about 1480, almost entirely as we see it today, it is striking in its proportions, and has some rare treasures. The tower has eight bells. The lovely porch has a vaulted roof supporting a priest's chamber. Over the entrance is a niche with a window at each side, and in the niche is a worn group of the Trinity.

It seems all windows and arches as we enter by the inner doorway. Over the lofty arcades running from west to east is a remarkable clerestory of fifteen windows on each side, and from it grow the hammer- beams and arches of the grand old roof, which crowns nave and chancel without a break. There is a Jacobean pulpit, and the base of the medieval screen is still here with fine old paintings of events in the life of Our Lord and a rare picture of the martyrdom of St William of Norwich, and whose shrine in Norwich Cathedral became a scene of pilgrimage.

The ancient poor box is one of the most remarkable we have seen. Carved out of a solid block of oak and standing on short pillars, it is thought it may have belonged to the original Saxon church. One of three old Bibles is 1611,

a Book of Sermons is 1560, and there are two coffin stones older still.

Still clear is a rare old picture showing the kneeling figures of Sir James Hobart in armour and his wife in a heraldic mantle. He was Attorney-General to Henry the Seventh, and founded this church, of which there is a crude drawing in a corner of the picture. Lady Hobart built the bridge at St Olave's, and this is shown in another corner, with a wagoner leading his horse over it. The Hobarts lived at Hales Court two miles away, where part of their old home still remains as a farmhouse.

On a fine tomb are the seventeenth-century brass portraits of Sir James Hobart and his wife, who were married for sixty years and had fourteen children; he has a fur-trimmed gown and she a dress with hooped skirt and a close-fitting hat. A brass on another tomb shows Henry Hobart of 1561, wearing armour. The lifesize marble figure of an old lady resting on her elbow and holding a prayer book is of much interest, for it shows another member of the Hobart family, Lady Dionis Williamson, who is remembered for being the biggest contributor to the rebuilding of St Paul's cathedral. She gave £2,000.

A brass showing two hands clasping a heart is in memory of Dionysius Willys of 1462, and in the chancel is a brass of 1546 showing John Blomeville and his wife in shrouds. A memorial of our own day has the stone heads of two brothers who were born here and died for their country. Francis Cadge fell in the landing at Gallipoli in 1915, and William was killed at Loos.

If the church had nothing else to show the impressive sight of the fifteenth-century font in its charming setting would be enough to bring us here. It stands high on a fine flight of steps, their edges carved with tracery and flowers, and the top one shaped like a Maltese cross. It was a wonderful font in the days of its glory, and is so even now, though its figures are terribly hacked about. The bowl is richly carved with the Seven Sacraments and the Crucifixion, and has tiny angels at the four corners.

Long Stratton

It lies on the Roman road and its story goes back to the Normans, who left the round tower of its church as their monument. It was the fourteenth century that gave it its battlements and the stumpy spire.

The village has a treasure very rare in the land, a medieval Sexton's Wheel hanging on the wall of the church. It is a very queer survival, one of only two known, and consists of two round wheels of ornamented ironwork about three feet across, fixed so that they can revolve either way. Spokes divide the wheels into sections representing the days of the year sacred to the Madonna, and in each division is a fleur-de-lys and a hole with a string. Anyone who

wished to keep the Madonna's Fast (a penance observed once a week for seven years) would try to catch hold of a string as the wheel went round, and so determine the fast day. It is all a little childish, no doubt, but such things happened 500 years ago when this quaint wheel was made. It is the only wheel of its kind now left except one other at Yaxley, in Suffolk.

The church itself is fourteenth century, having been built by Sir Roger de Bourne, who sleeps here with his brother the rector. There is a lovely oak pulpit, a beautiful linenfold door of ancient oak, something of the old chancel screen with flowers, and a chair with winged snakes on its arm-rests. The altar-rails are very beautiful, with posts and balusters of Queen Elizabeth's day. The east window has a row of Flemish roundels in old glass showing the Nativity, the Descent from the Cross, and the Stoning of Stephen.

Ludham

The houses of this tiny Broadland town, old and new, roofed with thatch and tile, cluster about the hilltop, and the gracious old church that rising among them looks out on a green and pleasant land of waterways and windmills.

Half a mile away is Ludham Hall with its memories of the childhood of a poet, for it was the home of Cowper's mother, whose picture stirred him in later years to one of his best known poems:

> O that those lips had language!
> Life has passed with me but roughly since I heard thee last.

Now it is a farmhouse, but was long ago a grange belonging to St Benet's Abbey. When Henry the Eighth gave the manor of Ludham to the Bishop of Norwich, the grange was made into a bishop's palace, and after being partly destroyed by fire in 1611 it was restored, and a little chapel added which is now a granary.

The fifteenth-century church, with a fourteenth-century chancel, is crowned by a sturdy tower which has a clock of 1762. A mass dial that told the time centuries before the clock is on the south porch, which has an upper room with a niche at each side of its window. The east window is lovely for the unusually delicate treatment of its quatrefoil tracery. From the clerestory grows a noble hammerbeam roof, supported by stone angels with shields and showing in the spandrels the wheels of St Catherine, the patron saint. There is rich carving of leaves and an odd company of quaint heads in the canopied sedilia, and over a crude piscina in the south aisle projects a carved closed hand which may have been for holding a taper. There is a peephole from this aisle to the altar.

A quaint little group of three men and a grotesque is carved on a capital of the chancel arch, which is spanned by a fine old screen of 1493. Though bereft of much of its beauty, it still glitters with gold, and on the richly panelled base are twelve paintings, chiefly of saints. The tympanum of the chancel arch is filled up with an old painting of the Crucifixion on one side and the royal arms of Elizabeth on the other. A few battered stalls have their original desks, and some old poppyhead bench-ends are worked up into the pews. A 500-year-old chest has a lid made from half a tree trunk; a gabled lectern may be as old but is not now used, and a decaying almsbox made from the trunk of an oak tree has iron bands and four locks made about 1550; it is one of the biggest we have seen.

In dignified isolation stands the striking font, carved in the fifteenth century with lions and evangelistic symbols on the bowl; round the base are lions and wild men, a tiny bishop, a woman holding a baby, and another with a rosary.

One charming small thing we found here. On the roadside, in a little bay at the gates of the manor house, shaded by sycamores and with a lavender border, is a rough oak seat on which are cut the words, 'Newton's Corner; sit ye down and mardle.' It was put here by the lady of the manor for an old villager whom we found resting at his favourite spot, watching the traffic go by.

Lyng

Not far from the houses and old cottages crowding by the green stands the church, with the River Wensum winding below it like a silver serpent in the meadows. The patched-up old porch has a beautiful fifteenth-century doorway adorned with quatrefoils and roses. The worn font bowl is thirteenth century, and a bronze censer found here was far rarer and much older, having been absorbed by Norwich Museum. A wonderful possession for this barnlike church is an altar cloth nearly seven feet long, made up of three fifteenth-century vestments of red and blue and orange velvet, and now under glass. The material is foreign but the lovely embroidery is English, showing angels with outspread wings and double-headed eagles among flowers, saints, prophets, figures in ermine gowns, and scenes of the Crucifixion and of Our Lord crowned.

The river winds on to a field where an ivied arch standing among the brambles is all that is left of a chapel dedicated to St Edmund.

Marham

A mile from this straggling village the River Nar flows from the hills to find the Ouse, having for allies abundant springs rising from the chalk. The village is dominated by the sturdy tower of its fifteenth-century church, and

has remains of a vanished nunnery and a Norman church. In the garden of an old farmhouse opposite the church is a lofty wall with two round windows in which the tracery remains. They are nearly all that is left of the nunnery founded in 1249, the only one of the Cistercian Order in the county. The plan of the first church, which was standing in 1500, can still be traced in a field near the vicarage.

The church of the Holy Trinity is long and rather bare, but keeps a fifteenth-century font, half an ancient coffin lid, a Jacobean altar table with carved legs, a big chest of 1725, and a fine set of low old benches with foliage poppyheads and backs of open tracery. An odd bit of interest attaches to them for us, for the estates of John Steward's father were managed by an ancestor of Lord Kitchener. The figures are sculptured in local chalk.

Marlingford

The tiny church is tucked away in a charming corner of the park, and its ivied tower, with the stepped gables and the chimney stacks of the hall, and the mill below the River Yare winding through chestnuts and copper beeches is a delightful picture. The red roofs of the village are over the fields. The tower and most of the old work is fourteenth century, but a Norman doorway with zigzag lets us in. The north aisle and the porch were made new last century when the nave was given a new roof and the roodstairs were opened out. The 700-year-old font is adorned with arcading, and there is a holy water stoup in the nave, an old hourglass in its stand, and a poor chest with three locks. Plain oak panelling on the east wall, and an altar frontal embroidered with flowers like clusters of bells, such as we see in many Norfolk gardens, help the neat furnishing of the chancel.

Marsham

On the brow of the hill, in the shade of elms and limes, is a church that has kept nearly all that the fifteenth and sixteenth centuries gave it—hammerbeam roof, painted screen, benches with holes for candles, and sculptured font. The hammerbeam roof draws all eyes to it as we come in; it has carved angels looking down and tracery in its spandrels. The screen remains, but its bright pictures of saints have faded, though we may still recognise St Faith, symbol of the faith that endures. The font is one of that precious group in East Anglia carved with the Seven Sacraments. In the Confirmation panel are babies in arms recalling the fact that before the Reformation children were sometimes confirmed at their christening, as Princess Elizabeth was. Round the lower edge of the bowl is a ring of angels, and there are eight saints on the pedestal. In the east window is brilliant glass in memory of Charles Louis

Buxton, who died in our own century; it shows Our Lord with Apostles in rich apparel, with angels about them.

Martham

Except for the nineteenth-century chancel so unlike the rest, the church is about 500 years old and as fine within as without. The beautiful tower has a graceful arch, and light streams from the great windows of aisles and clerestory over the nave arcades. In the east window of each aisle angels and saints shine in red and blue and yellow glass of five centuries ago; a golden-winged St Michael is weighing three souls against two fiends, while a third fiend falls into space; Mother Eve in blue, with a veiled headdress and a distaff, is spinning; and St James and St John, with St Margaret thrusting a cross into the dragon, and a bearded saint with a staff and book, are all here. We see the Crucifixion, the Scourging, the Annunciation, and John the Baptist kneeling at the feet of the Madonna and Child. Edward the Third and Queen Philippa have with them St Juliana and St Edmund of the arrow, St Agnes and St Margaret, and there are also scenes of the Resurrection and the Ascension.

As old as this fine old glass is the beautiful but battered font, with scenes of the Seven Sacraments and the Last Judgment. Some of the many old poppyheads worked into the pews are carved with fruit, and one has a man's head strangely topped by a tall hat. The fine painted chest may be the oldest thing the church has to show, and looking down on so much that is old is the fine modern hammerbeam roof of the nave, enriched with twenty-two angels and supported between the windows of the clerestory by heads. The east window is a gay mosaic of colour, and is part of a chancel rebuilt last century and adorned with a mass of fine carving on which angels with great wings look down from the roof. Flowers and leaves and vine are in the spandrels of the chancel arch, and the corbels and capitals at the sides are remarkable for their realistic carving of angels, passion flowers, lilies, and little animals. There is similar lavish display in the sedilia and on the cornice of the east wall, but the best and most astonishing thing is the recessed altar tomb of Jonathan Dawson, the vicar to whom the whole chancel is a memorial. Enriched with arcading on the front, it has angels floating from the tips of a lovely arch, sprays of lilies, and a shield of trailing foliage.

Matlaske

Behind its winding street of charming cottages is the wooded fringe of Barningham Park, by which stands the church with a round Norman tower, an old mass dial, and medieval windows. Huge stone heads carved by

medieval masons support a modern roof, the heads striking for their flowing beards; and there are fifteenth-century benches with poppy heads, and a fifteenth-century font with an elaborate traceried and pinnacled cover.

Mattishall

Houses old and new, all comely, surround the church like a congregation. Looking its best outside, with a fine tower and a canopied spirelet seen from afar, the church comes from the fifteenth century, and has great beams in the roofs of the nave and the north aisle. The old chancel screen has painted figures of the Twelve Apostles holding scrolls with texts, making a stately panelled row against a gold background. St Peter is vivid in red and green and white, St Andrew in red and green, and among the tiny gilded carvings in the corners of the panels is a jester crawling along with a pack on his back, a man flourishing a sword at a roaring lion, a unicorn, a winged dragon, and an angel. An old screen across a chapel is carved with vines; and the Jacobean pulpit with a crown, a rose, and a thistle has a sounding board adorned with flowers. There is fine modern carving on the doors and in the wooden lectern, which is a copy of the rare one at Shipdham, made in the time of Henry the Seventh and among the best in the land.

Mattishall Burgh

Like the clustering cottages, the trim little church with a west tower is red-roofed. A medieval church made partly new, it has an old door with a stoup at the side opening to the white-walled interior, crowned with old trussed rafters in the black and white nave roof and with old braced beams in the chancel. An arcade of two bays leads to the transept, the chancel has a pretty corner piscina by the windowsill sedilia, the thirteenth-century font is adorned with simple arcading, and the old barrel organ remains in the little gallery.

Mautby

Set on a little hill among the cornfields the thatched church is sheltered by trees with only one house near it. Near the River Bure, winding through the level marshlands on its last weary miles to the sea, is the old hall, now a farm.

The round Norman tower of the church has a medieval belfry and an ancient arch opening to the nave. The chancel is raised on a high step and its 400-year-old screen has a peephole to the altar which is up three more steps. The font is fourteenth century and there are a few fragments of glass of the same age. Under a founder's arch lies a cross-legged knight in mail,

carrying a long shield and with his hand on a sword. The aisle has lost the monument of its founder Margaret Mautby, who married John Paston, son of the famous judge, and spent much of her time in this village writing many of the Paston Letters. Long after the Pastons the manor became the home of Lord Anson, the admiral who sailed round the world and was a thorn in the side of the French Fleet in the first half of the eighteenth century.

Melton Constable

All is old here, the Astleys, their park, and the church. Their hall, standing near the lake and the deer-haunted glades, is the third home here, and since it was built in 1670 has been enlarged with wings. More of the Astleys than can be named lie in the church, which was consecrated before the end of the eleventh century and still has Norman remains for us to see.

It nestles under the trees, yews and firs and oaks, and is reached by a lovely drive bordered with rhododendrons. Its walls are prettily crowned by a low Norman tower with a pyramid cap, rising from the middle of a cross. Inside, over the massive Norman arch leading to the chancel, are two round-headed openings with a thick pillar between them, and another Norman relic is a window in the nave. A curious arrangement in the chancel is a low window having at its sides a seat cut in the wall and a stone reading-desk for the clerk. The south transept, built in 1681 for the hall pew, is reached by a flight of steps and has a brick vault below. Old glass shows coats-of-arms and odd figures of courtiers and pedlars. The reredos is a triptych with paintings of Gethsemane, the Crucifixion, and the Descent from the Cross.

Between the church and the hall stands a tower known as Belle Vue, which originated in a windmill and has a fine view of Norwich and the sea. North of the village is a fourteenth-century tower with the ruins of Burgh Parva's old church.

Merton

Its few houses are dotted about the fields by the green, and its highway skirts the park where among many old oaks the church looks down on the great house by the lake. Fragments of the older house have survived, but the stately and beautiful house we see, with stepped gables and clustered chimneys is 300 years old. It has a wonderful wistaria on one of its garden walls, throwing out its arms for 30 feet on each side of the stem. It must be nearly as old as the house; the oldest inhabitant told us that he had seen the marvellous sight of it in full bloom every summer he could remember.

The round tower of the church is Norman, and there are Norman shafts in the thirteenth-century belfry windows. It is thought that the base of the

tower may be Saxon. Most of the rest of the church is fourteenth and fifteenth century, and there are still fragments of old glass.

Among the high and low pews that crowd the nave is the great square pew for the hall. On the priest's seats in the chancel are carvings of a parson at his desk and a cellarer with his hammer and three barrels. There are massive old altar rails and a Jacobean two-decker pulpit. The old hourglass stand, now fixed to the chancel screen, is notable for having been set up before the end of the fourteenth century; it has heavy tracery and colour fading away. There is a peephole from the south aisle to the altar. The font is fifteenth century, and its lofty pinnacled cover is a copy of an old one.

Methwold

The medieval church of this quiet little town of 1,200 folk stands finely through the frame of trees, rising high over the red-roofed houses. Its tower is a striking landmark from the fenland, and is fine in itself with a beautiful lantern and a spire reaching 40 yards high.

Opposite the church, on the end of a row of timbered cottages, is an unusual and picturesque wall which is a fragment of a three-storeyed sixteenth or seventeenth-century house. A kind of projecting chimney climbing from the ground to the tip of the many-stepped gable is patterned with ornamental brickwork, and at each side of it are windows. The sides of the wall are stepped-out from the ground to meet the eaves of the adjoining cottage, and are then stepped-in to form the gable, so that the end looks much like a kite in shape.

The clock and the sundial greet us as we come to the clerestoried church, an attractive picture with its flint walls and parapets of brick and stone. Inside a soaring arch opens to the tower and a lower arch to the chancel, which is chiefly fourteenth century. Graceful arcades in the nave have mouldings continuous to the floor, but shafts inside the bays have capitals carved with modern angels and a doubled-up little man.

The finest thing in the church is the fifteenth-century oak roof looking down on the nave, its arched tie-beams alternating with hammerbeams, of which some have fine angels. There is a Jacobean table, and a little chest with iron bands and three locks is said to be at least 600 years old. Of our own century is the lovely oak screen with leaves and flowers in its tracery, and a roodloft reached by the old newel stairway, with its two original doorways.

Metton

Those who come a few miles over the hill from Cromer come with delight on the group of ancient buildings here, the house with the stepped gables, and the medieval church among them. So small is the churchyard that the tower

has had an arched passage made to give room for the religious processions in the Middle Ages. From those days come five queer wooden figures which are high up on the wall, doing nothing. They were part of the support of the ancient roof, and are no more needed, but are characteristic of the grotesque forms beloved by the medieval craftsmen.

Middleton

In the flat country about King's Lynn even so slight a rise as is here to be found commands a wide horizon, and before Middleton had a name or had surrounded itself with its three small dependencies (Blackborough, Tower End, and Fair Green), it had found favour in the eyes of some tribe of the Bronze Age. Here they raised a strange pyramid tumulus which is now covered with shrubs and trees and is the home of a myriad rabbits. That is the beginning of its story; it has a link with Roman days in coins of Marcus Aurelius that have come to light in our own time.

The Middleton we know stands pleasantly on the busy highway, the tower of its lofty church rising finely at the cross-roads, opposite the village pump under two chestnut trees. There was a church in Norman days, but most of it now is 300 years younger. Three old gable crosses adorn the porch, the chancel, and the nave. As we look from the chancel along the nave arcades we see the modern font set well under the tower, which has massive arches in its north and south walls. Four panels with painted saints are left from the old screen, and an old almsbox is attached to a bench-end. A beautiful chalice is 300 years old. The piscina has holly and berries in its arches and lilies in the spandrels.

A lovely thing of our own day is the striking glass in a window from the Powell workshops, a shining patchwork of colour showing a quaint Nativity scene with the Wise Men offering their gifts. In its fascinating background of a medieval city is a wagoner with a load of straw, an old man sitting in the market shelter, a horse in a stable, a milkmaid with her pails, and a labourer with spade and fork.

A memorial to Major Everard-Hutton recalls an epic story of last century, for he was one of the Six Hundred at Balaclava.

A mile north of the church as the crow flies, at the foot of a little hill, stands Middleton Towers among beautiful trees, a lovely embattled brick pile with approaches through a noble fifteenth-century gatehouse with four turret towers and an oriel window. Part of an old hunting lodge, still almost surrounded by its wet moat, it was restored last century and is a charming picture. At Blackborough, a mile and a half south of the church and overlooking the River Nar, are slight remains of a Norman nunnery.

Mileham

Here the Romans settled and the Normans built a castle; it is a pleasant countryside with proud and lowly houses prettily set among the trees. The British Museum has a treasure of Roman days found here, a silver dish weighing about 60 ounces, into which some Roman general may have dipped his hands. In another hoard of silver that came to light here every one of the articles was found cut in two, and it is thought it may have been the booty of thieves who had shared the spoils, buried for safety and left for eighteen centuries. The fragments of the Norman castle stand above high earthworks with the waterless moat about them. Of the house in which Sir Edward Coke was born nothing is left, but the tomb of this great judge is in Tittleshall church two miles away.

Mileham's old church is part of a charming picture seen from the rectory garden. The thirteenth and fourteenth-century tower, with fifteenth-century battlements, leads us inside, where massive arcades from the twelfth century divide the nave and aisles. The south arcade is supported by wooden props, so dangerously does it lean. The clerestory, like most of the windows, is fifteenth century. The priest's doorway with shafts and scalloped capitals is over 700 years old. A fine coffin stone with leaves growing up the stem lies by one door, and a simpler one by another. The font is fifteenth century, and the bowl of an earlier one has been brought into the church from a village garden. The plain six-sided pulpit was made about 1500, and a pillar almsbox with an iron lid and three locks is dated 1639.

The rare treasure here is the beautiful fourteenth-century glass filling the west window of the nave with figures of John the Baptist, St Catherine, and St Margaret; the upper half of the glass glows with rich heavy colour, the rest is more delicate. Old figures of the Baptist, St Agatha, and a bishop are in the east window; and in a chancel window are kneeling a man and a woman who may be founders or benefactors, with a panniered ass which may suggest the bringing of material for the church.

Morningthorpe

It lies tucked away in charming lanes a mile and more from the Roman road between Norwich and Ipswich, and has fine old Tudor houses among lovely trees. One charming Elizabethan house facing the church has quaint chimney stacks, a spreading cedar in its garden, and a barn with a finely patterned thatch. Another Elizabethan house near the church stands in its park, and was the home of the Howes, whose memorials tell us that John made the world better for his living, that his son John was a merciful man,

that Thomas was rector for fifty-one years of last century, and that Edward was twelve years MP for Norfolk.

Under a recessed tomb in the chancel, with carvings of a spade, pickaxe, hourglass, skull and crossbones, sleeps Martha Garney, who died in 1694. She was the last of the Garneys of Boyland Hall, yet another Elizabethan house which stands in a valley north of the village, the River Tas flowing through its grounds. It is a big grey house with many chimneys, and has over one entrance a bust of Queen Elizabeth.

Small like the village, the church is neat and simple and aisleless, and comes chiefly from the fifteenth century except for the round tower with its uneven walls, which was built by the Normans. Its stout arch is Norman, but the west window and those of the belfry were inserted 600 years ago, and the parapet is modern. A medieval mass dial is in the wall. The old font has lions at the foot and winged angels under the bowl. A pretty fifteenth-century piscina has a pinnacled canopy, Tudor rose and a leopard's face in the spandrels, and a six-leaved drain. Over the tower arch the royal arms are boldly carved out of a solid block of oak, and painted. Modern days have given the church roofs adorned with angels and flower bosses, and enriched the nave and chancel with poppyhead seats, one of which has a fine John the Baptist in camel hair and mantle.

Morston

Its red-roofed houses, and the church with a sorry-looking tower, are among green fields by the vast stretch of marshland going to the sea. The hamlet stands secure on its windswept bank, and though at the spring tides the salt waters creep closely up, and the prospect is desolate and wild, the marshes and the dunes are fascinating in their medley of colour.

We found the people putting their shoulders to the wheel to make good the ravages of time and weather on their much-buffeted church, doing the work themselves with what money they could get. There is a Norman lancet in the patched-up tower, but most of the old work is fourteenth and fifteenth century. Small quatrefoils light the south side of the clerestory, an old almsbox has iron bands and two locks, the old font has figures of the Four Evangelists, and there is a corner piscina in a window-seat.

The lower part of the medieval oak screen is still here, though much battered, and its paintings of the Four Evangelists and the Latin Doctors are recognisable. Remains of fine carving in the spandrels of the panels show headless angels, a saint, and pelicans.

Moulton St Mary

Its lanes twist through the meadows, and the church stands in quiet seclusion in company with great trees, thatched barns, and the old Manor Hall with traces of its moat.

The round Norman tower with a red cap and a big weathercock fallen from his perch only just tops the nave. The simple oblong of thirteenth-century chancel and fourteenth-century nave, with leaning walls and no arch between them, is lighted by windows of all three medieval centuries. On the old brick porch is a battered sundial, and the ancient door is still on its plain old hinges.

At the side of a chancel window with a sill providing stone seats, is a fine and uncommon double piscina with pillars and elegant arches, and a six-foil for tracery. On the opposite wall is a stone seat with a quaint grotesque head on each side. Under a nave window is a curious arrangement of a niche and the brick steps of the rood stairway. The fine font comes from Norman days, and has nine old pillars. The stalls have some old carved panels and poppyheads. The fine Jacobean pulpit has a border of fleur-de-lys, and its desk and canopy are both carved. Of the same century are the altar rails, and the reading desk carved with big leaves, has the date 1619.

Moulton St Michael

It is scattered in the byways two miles from the Roman road between Norwich and Ipswich. Its small church was splashed with crimson creeper when we called, looking charming among the copper beeches. It is mostly 500 years old, with old and new in the fine nave roof, an old font with angels and lions and Tudor roses, a south door with its ancient ring, a chancel arch with the faces of kings, queens, and peasants in its mouldings, and a modern wall painting over the arch with St George slaying his dragon between two angels.

Mulbarton

It has one of the biggest greens in Norfolk, and most of its scattered houses and cottages look on to the common land, of which there is nearly 50 acres. A high tower with chequered buttresses dominates it all from one corner, crowning a much-restored little church.

What is old in the church comes largely from the fourteenth century. Old glass in the east window shows Adam and Eve in the garden, a man in blue digging under a red sky, a knight in armour with a chained demon, a bishop, and a crowned figure in white and gold with a sword; and other old glass in the nave shows musical angels with harp and guitar, an old man in white

and gold with a boy reading beside him, and a crowned man with a sceptre, carrying a cathedral.

Mundesley-On-Sea

It is popular for its wide sands and the sea, which rushes up the beach to batter the splendid cliffs. Down in the dell between the cliffs runs a small stream, flowing by an old wooden mill. Mundesley now is old and new. After immemorial years spent in fishing the hamlet has attracted to itself something of the popularity of its famous neighbour Cromer, and the old church, which till our own time had long been ruinous except for the patched-up west end, has been made almost new. It stands high on the windblown cliffs within sound of the sea, a church without a tower, preserving a few relics of its old days. The chancel arch is restored. A 600-year-old window by the porch is adorned with two quaint figures, one smiling, and one as if crying out in pain. The east window glows with a scene of Our Lord in Glory, and fine glass in the nave shows the Nativity with the Shepherds. The plain font is old, and an old mass dial and fragments of a Norman arch and of Norman mouldings are built into the walls. The finest new thing here is the rich oak screen with a loft in front of the chancel arch. Above the tracery of its bays are birds in a cornice of vine.

Mundham

Pleasant with thatched cottages and farms, it has a lonely wayside church which still preserves the sanctus bell from the ruined church of St Ethelbert half a mile away.

Primroses and violets grow in St Peter's churchyard, and an ugly gargoyle looks down from the parapet of the old tower. In the fifteenth-century porch is one of the county's fine Norman doorways, with rich carving of varied ornament. The simpler Norman doorway on the north has a good horseshoe arch.

It is pleasant and light inside, where two arches divide the north aisle from the nave, which is crowned by its old black and white roof, with some of its original painting on the embattled wallplates. The old hourglass bracket is on the fifteenth-century screen, and fragments of old carved stone are under the tower, with remains of a fine Norman font. There are heads of two boys on the piscina, which has its original oak shelf. A faint painted consecration cross was found on a wall a few years ago, and there is a blurred wall painting of St Christopher, framed in green.

Narborough

The little River Nar is busy turning the mill wheel in the heart of this village, clustered so charmingly on the way to King's Lynn. The road runs between the church in its trim churchyard and the fine old hall in the park. Older than church or hall or mill is Narborough's story, for here begins the remarkable earthwork known as the Devil's Dyke, which stretched southward for about nine miles and can still be traced from the park as far as Beechamwell.

The fifteenth-century church was much restored in the nineteenth, and the tower lost its spire while Charles the Second was king. A doorway with flowers in its arch opens to the bright interior, where there are stone seats round the pillars of the nave arcades, and some fifteenth-century benches. Some fine glass of that time, showing angels and saints, is in a window with shields of the Spelmans, whose memorials are the chief interest of the church.

Narford

Its cottages are hidden in rich woodlands by the River Nar, and the church and the great house are by a lake which becomes a waterfall at a charming little bridge. The hall, a fine house of the time of William the Third, has long been the home of the Fountaines, and once held the art treasures collected by Sir Andrew Fountaine, the antiquarian, who died in 1753. The squat little church, looking its best outside with trim walls and a finely pinnacled tower, is chiefly fifteenth century, and has a yew inside its gate which looks older still.

Necton

From the main road we see the pleasant village clustering at the foot of its fine church, and the rectory among the trees. The church is mostly fifteenth century, but the tower was made new last century. The oldest part of the church is the 700-year-old St Catherine's Chapel, with a very fine Jacobean altar table, and still with the old consecration mark on the wall. The pulpit is 300 years old, a splendid ironbound chest is as old as the Spanish Armada, there are two wooden candlesticks of great age on the altar, and the battered old font has seen the christening of the village children for many generations.

The great possession of the church is the carved and painted roof of the nave, growing from the fine clerestory of eight windows on each side. An enduring monument to the skill and patience of fourteenth-century craftsmen, it has arched beams with bosses and a fine company of angels, apostles, saints, doctors, and bishops, with figures of Our Lord and His

mother, and it is remarkable for having kept its original colour, so that we see it as it was before the Reformation.

Needham

The village sacrificed twelve men in England's darkest hour, and among those who came back were three who won honour for heroic service. It is part of the road from Harleston to Scole with the Waveney flowing by, and has attractive cottages, an inn with a dainty sign, and a flint school looking out from a churchyard where tulips, forget-me-nots, and laburnums grow.

The Normans gave it the round flint tower with its simple and sturdy arch, and the fifteenth century added the octagonal belfry. From this time comes the nave, and the quaint brick porch with stepped gable, a turret at each corner, and an old roof; St Peter with his fishing net and his keys, in a niche over the entrance, is modern. The fifteenth-century font has worn lions at the foot and worn angel heads under a bowl adorned with roses. There are two old chests, and the ends of a dozen old benches have poppyheads of flowers. Along a bench with an embattled top is carved the solemn admonition from the past, 'Use well thy time, for death is coming; the sentence of God Almighty is everlasting.' The glory of this simple aisleless church is in its grey oak roof with its stout old tie-beams, splendid arched beams, and embattled wallplates.

Newton Flotman

Thatched cottages straggle pleasantly along the road to its seventeenth-century bridge across the River Tas. The smithy and the gaunt mill by the bridge belong to neighbouring Saxlingham. From the bridge the old church at the other end of the village comes into the picture outlined against the sky, looking down on the winding stream. Like its embattled tower, most of it is fifteenth century, though fourteenth-century windows light the nave. The west window of the tower glows with rich glass. There is fifteenth-century tracery on the front of the pews, some of which have foliage poppy-heads; we noticed a modern dog on an arm-rest facing an animal which has been here 500 years.

North Burlingham

Sheltered by fine oak woods on the road from Norwich to Yarmouth, it has a church at each end and a fine thatched forge between them. The round Norman tower of St Peter's fell in the early years of this century and has not been rebuilt, the oldest work in the church being fourteenth and fifteenth century. Here still is the old mass dial from the days before clocks, but the

three medieval bells, which long rang the people to worship and the children to Sunday School, have gone into the safe keeping of a museum in Norwich, and its four sixteenth and seventeenth century brass inscriptions have been taken across to St Andrews together with the old roodscreen, now set up at the west end of the church.

Within sound of the ceaseless traffic running past, St Andrew's church hides in the woods, in a churchyard starred with primroses in springtime. The tower, like most of the building, is fifteenth century, with St Andrew's crosses in diamond panels and a medieval mass dial. Earlier remains are seen in a fourteenth-century doorway, a thirteenth-century low window in the chancel, and a hood of twelfth-century star pattern on the porch. The font is 500 years old, and a chest comes from 1664. The old roof is adorned with painted angels and rests on wooden heads, a jester and a man with his tongue out among them.

It is 400 years since the screen was first set up, but only the uprights and the battered panels are old. In its gallery of painted saints, all of whom have lost their faces, we see St Benedict holding a book and a crozier (one demon peeping round his green cloak and another running away), St Edmund holding a ring, St Cecilia holding a wreath of flowers and a sprig, St Walstan with his scythe, St Catherine with her wheel, and St Withburga with fawns nestling against her gown.

North Creake

It lies in the peaceful valley of the Nelson country through which flows the little River Burn. In a sheltered corner by the stream, on the way to Nelson's birthplace, are some ruins among the trees. They are all that is left of Creake Abbey, but there is still a haunting sense of the beauty this place must have had when Sir Robert de Nerford founded it seven centuries ago.

Under the woods stands the wayside church, on which roses climb in summer and a sundial marks the summer hours. Some of it is 600 years old and most of it fifteenth century, the age of the clerestory and the hammerbeam roofs. White-robed angels with shields and apostles with scrolls adorn the chancel roof; the coloured nave roof has angel bosses, thirty-six angels on the richly carved wallplates and twenty saints supporting the hammerbeams. In the west doorway hangs an old door with rich tracery made new, and four old panels are preserved in the organ case.

The fourteenth-century chancel has fine stone carving in the sedilia and piscina and in the Easter Sepulchre; and much rich modern carving in wood is in the panelling of the chancel walls, the screen, and the seats. In the wealth of carving in the altar and the reredos are tiny saints and angels in niches, and

under the reredos canopy are three painted Bible scenes. The tale of modern craftsmanship is carried on by the traceried ends of the benches, the gabled lectern with canopied figures round the stem, and the richly pinnacled cover of the medieval font. The cover is like a tower with a delicate spire, opening to show paintings of the Baptism and Our Lord with the Children.

North Lopham

The village runs along a road lined with trees, and chestnuts grow by the big pond where witches are said to have been drowned in the bad old days. The old forge is still here, and cottages with thatched roofs face the church. Swallows were building in the old timber porch when we came to the church, where things appeared a little awry with leaning walls and arches and tilting old windows, most of them fourteenth and fifteenth century. The tower, with huge buttresses almost to its battlements, was built in the hundred years from 1480, and has a fine lofty arch to the nave, which is divided from the aisle by a medieval arcade. The old font has a fluted stem and a bowl with delicate tracery; and winged animals and figures remain on the old bench-ends. There are a few fragments of old glass and an ancient chest with three locks.

Northrepps

This was one of the homes of the Gurneys, and though the church, a mile from the sea, has a history of nearly 800 years, its chief memories are linked with this great Liberal and Quaker family of more modern times.

The church is chiefly fifteenth century, but in the chancel are two Norman windows. The screen was given in 1460 by John Playford and his wife Custance, their names carved on its central band. Some traces of its painting remain on the panels and on the tiny faces so oddly putting out their tongues in the tracery; above it is a new canopy with bright shields and arms. Here also is a medieval font and a window with figures of three angels paying tribute to three Gurneys.

North Runcton

There is leisured grace about this wooded retreat by the road to Lynn, where the gated common at one end comes ablaze with golden gorse, and church, school, farms, and cottages with dormers and stepped gables, gather by the green. At a charming corner is a creepered cottage by the hall gates, from where a fine avenue of limes goes to the grey house with Dutch gables and clustered chimneys, noted for a staircase of old oak and carved mahogany. Built in classical style in the eighteenth century, the little church has a domed

roof supported on four pillars. There are two Jacobean chairs with carved backs and borders, two fine carved candlesticks six feet high, paintings by a Florentine artist of Our Lord and the Four Evangelists, and a striking window showing St George in a motley of blue, silver, and red. It is in memory of fifteen men who did not come back. A window showing St Catherine, with this church in the background, is to Sir Somerville Gurney and his wife.

North Tuddenham

The village is scattered, and in a sequestered spot in the fields near the River Tud is the fifteenth-century church and the rectory which has succeeded one where the poet Cowper lived. We may fancy his stooping frame and his kindly face among the worshippers in the church, which is much as he would know it. It has huge buttresses, a tower as old as its one bell (1380), and a door with fine tracery opening to the candle-lit interior, where the chancel arch reaches the roof of the wide lofty nave.

Glowing red, blue, and gold in the tracery of most of the windows is fine fifteenth-century glass showing saints, angels, and bishops. In the windows of the porch are small figures peeping out of a medley, the head of a saint, a bishop, a tiny figure on a throne, lions, eagles, dogs on leash, and a Catherine's wheel. The old glass was bought from a neighbouring church. Only the lower part of the chancel screen remains, adorned with a company of painted saints. St Geron, who is among them, is said to be represented in only one other painting, at Suffield in Suffolk; he was a missionary to Holland who was killed by raiding Danes in 856. On some screen panels under the tower arch are perfect paintings, though dim with age, of four saints—Gregory and Augustine, Matthew and Mark. They come from about 1390 and were bought from a lumber shop.

A curious collecting box of Queen Elizabeth's day hangs on the wall, and though it collects no more it still exhorts us thus, 'Let not thine liande be open when ye shouldest receive nor shut when ye shouldest geve.' A big fifteenth-century chest has three locks, and a smaller one on legs is older still. There are monuments to the Skippes of Jacobean days, and a curious memorial showing the bust of a man in a circle of books may be to one of the family.

North Walsham

If the Battle of Waterloo was won on the playing-fields of Eton, it must be equally true that the Battle of Trafalgar was in some measure won at the Paston Grammar School in North Walsham, for it was Nelson's school,

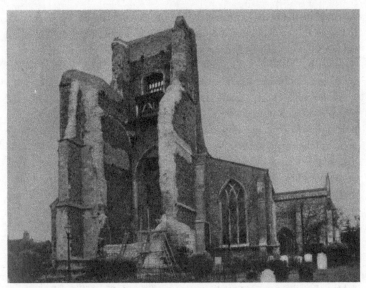

The medieval church with its ruined tower at North Walsham

where he spent three vital years, coming as a boy of ten, and leaving in his teens to go to sea.

Nelson's school has been rebuilt since Sir William Paston's day, but it is a delightful place, looking as if it had a great tradition. It was rebuilt just in time for Nelson, and the old building stands today on one side of the market square much as young Horatio would see it, a pleasant Georgian place of red brick, with the walls of the playground and the walls of the master's garden as in the days when Nelson stole the pears by night. The school has a proud record, for it sent out into the world not only our chief sailor but an Archbishop of Canterbury and the famous Rider Haggard.

The quaint market cross, set up by a Bishop of Norwich in 1550, is still the hub of this little town. It stands in the market square sheltering an old fire engine, which we may find it hard to believe was ever used, and dominating the whole scene is the gaunt ruin of the medieval church tower, 150 feet high, but like a ragged warden of the fine church under its wing. Supported by this tower that has seen better days is a little Saxon tower which keeps one of its thousand-year-old windows.

The rest of the church is much as the fourteenth-century weavers made it when they spent their wealth without restraint to crown the little town with splendour. The nave and chancel, with their glorious arcades, were built a few

years before the Black Death swept through England and cut the population in two, and the tall pinnacled porch, with the arms of Edward the Third and his son John of Gaunt, is only a few years younger. The magnificent vista of the church is unbroken from east to west, for only the lower part of the old screen remains between the nave and the chancel. This medieval fragment of a masterpiece has twenty panels on which were painted apostles and saints, and we may still see St Catherine with her wheel, Margaret and a dragon, Barbara holding a tower, and the Madonna receiving the messenger from Heaven. In a corner of the chapel are two medieval misereres carved with a king and a wild man of the woods, and near them is a Tudor table which has been repainted. In the Warrior's Chapel is a Jacobean table carved with grapes, ears of corn, and a chalice, and on it was found an album with photographs of all the men who went from Walsham to the war and did not come back, their names being on an oak panel. The most remarkable piece of craftsmanship in the church is the fifteenth-century cover of the font; it is suspended from a painted beam and rises like a hymn of praise in a series of arches, balustrades, and pinnacles, until it reaches a pelican feeding her young.

Here lies the founder of the Grammar School, Sir William Paston, an armoured figure among the columns and obelisks of a marble and alabaster tomb in the sanctuary. He put it up himself in Shakespeare's day, and must have planned these eighteen painted shields of his ancestors.

It is one of the churches in which the royal arms are of peculiar interest. A bit of painted wood, yet how eloquent of the see-saw of history it is! We can see both sides of it, and from it we gather that it has been felt at North Walsham that, though kings may come and kings may go, the funds of churchwardens do not go on for ever. On this piece of wood Charles Stuart's arms were painted first and the Commonwealth arms over them. This apparently not being satisfactory, the Commonwealth arms were painted again on the other side, and at the Restoration they reversed the board once more and painted the arms of Charles the Second over the other two.

The old ironbound chest is seven feet long and has a lock for every foot, so that seven men with seven keys were summoned to open it in the days when it was the town's safe, 500 years ago.

Out in the fields we found a curious structure overgrown by foliage which proved to be the skeleton of a windmill; and on Walsham Heath, a mile away from the town, is one of several wayside crosses hereabouts, the melancholy memorial of the Rising of the Peasants 600 years ago.

Northwold

It lies off the highway, and has many old houses with cream walls and roofs of rich red tiles, a medieval church with flint walls and a fifteenth-century tower, and the shaft of an old wayside cross. The tower rises in four stages to a handsome crown of battlements and eight pinnacles. A fourteenth-century porch and a thirteenth-century doorway leads us to an interior spoiled by galleries along the aisles. The nave arcades are thirteenth century, the chancel fourteenth. Crowded with closed pews, the nave looks up to a lovely old oak roof adorned with angels, and resting on stone corbels of angels and grotesques. Its medieval colouring is renewed, the bosses shining with gold, the rafters painted with leaves, and barber's pole pattern outlining the panels.

The great possession of the church is the fifteenth-century Easter Sepulchre, among the biggest and best in the land. It is 12 feet high and 9 long, and though sadly battered is still beautiful with a mass of delicate carving in niches and tabernacle work. Its three canopies have lovely traceried vaulting, and below the tomb are sleeping soldiers, battered and broken but recognisable as having been armed, and leaning on trees.

Norton Subcourse

It rubs shoulders with Thurlton, and the towers of both villages greet each other across the fields. Norton's round tower is Norman with thirteenth-century belfry windows and a brick top, crowning the west end of a church which makes a pretty picture from the gate, with the long continuous roof of nave and chancel and a beautiful five-light east window with fourteenth-century tracery. Among the stone heads at many of the windows is one like a jester, and others which seem to be portraits; among old glass fragments is a figure by a wheel, a shield with lions, and heads of bulls. In the rose-coloured walls inside (oblong with no arch between nave and chancel) are many odd niches, and in a chancel recess is the tomb of Sir John de Norwich. The bowl of the medieval font is carved with crude arches and set on nine pillars; but perhaps the best thing here is the fine fourteenth-century group of three seats and a lovely double piscina with arches, finials, and clustered pillars.

Norwich

It was on Mousehold Heath, looking down on Norwich, that Jasper Petulengro said to his friend Lavengro, 'There's the wind on the heath, brother; if I could only feel that, I would gladly live for ever.' The wind still blows on Mousehold Heath, and from this noble height we look down on a city of a thousand years to which all travellers must come who would

know England. There are seventeen roads that bring us into it, yet the city blocks us when we come, as if it would not have us go. It has no great road that runs through, no central open space, for in the very heart of it rises the great mound on which the Norman castle stands, with the old moat sloping down as a garden, and the cattle market round it. It is small as cities go, but there is no other city of its size in a radius of 100 miles, and it has been claimed for it that if we take that quarter of England that comes inside a line drawn from Grimsby to Leicester and on to London, Norwich is the biggest town. Be that as it may, it is not size that Norwich has to boast of, but that quality which makes a town enduring and immortal, and a vital part of our English heritage.

Its castle and its cathedral have both their origins in Norman England, and both are unsurpassed. For those who love a captivating walk through narrow streets and winding ways, through alleys with overhanging houses, peeping into old churches by the dozen, touching history everywhere, Norwich has a unique appeal. It may not solve its traffic problem, but it has solved the problem of making a city beautiful and wonderful. It has

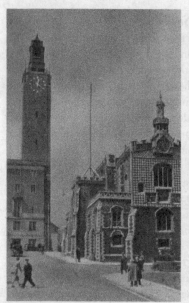
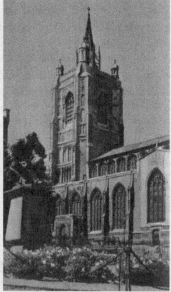

Above left: The City Hall and Guildhall in ancient Norwich

Above right: St Peter Mancroft Church in ancient Norwich

built a twentieth-century City Hall of which any city might be proud, but it has kept its medieval Guildhall, from where the city has been governed since 1407, as a rich American will sometimes keep his log cabin to remind him in his great house of the way he has come. It has more old churches than any other town of its size, and has had the courage to take one of the most charming of them all and give it splendid work to do as a museum. It has given itself a Music House and a Strangers' Hall in which any stranger feels at home. It has made itself a dramatic pioneer with its Maddermarket Theatre. It has done its best to keep alive the spirit of its long past—so old that the man in the moon would not have come down too soon if he had asked his way to Norwich 1,500 years ago, for it was a fishing town then, three miles from the Roman camp of Caistor, and nobody knows how long before that the Stone Age men were living here. It was one of the biggest towns in the kingdom till the Conqueror came, and from then till now it has been crowding itself with history and beauty and wonder. Nothing but coming to Norwich can convey an impression of the remarkable sights of this crowded city.

It is, of course, incomparably the most delightful centre of East Anglia. It is within easy reach of the sea and a few miles from the Broads, and for the stay-at-home there is no more attractive city out of London. It has a river half round it, busy with its shipping and its pleasure boats and crossed by about a dozen bridges—one of them the Bishop's Bridge with three arches, room for only one car, and recesses to prevent the car from running over the pedestrian. It has, below this bridge, the picturesque bridge of Pull's Ferry, built of flint 500 years ago. It has as fine a collection of interiors open to all as we can find in any city of its size, so that not only may we walk about among these old homes of merchant princes, with their ancient gateways, their thatched roofs and timbered fronts and overhanging storeys, but we may sample them indoors. The YWCA has made its home in one of the old houses, and the Archaeological Trust of Norwich has taken over another, now used as a club for girls. Everywhere possible old Norwich is dovetailing itself into new Norwich; it is anxious to preserve its atmosphere and not to lose its high repute as a medieval city.

Lest it should be thought that this old city is half asleep with its sense of the past, let us remind ourselves of its thriving industries employing thousands of people, and of the wonderful civic centre it has given itself in our own time. Old houses and shops, offices, warehouses, and alleys have made way for the City Hall, striking such a fine new note in this city of old things; and with the destruction of so much has come a new dignity for the very heart of Norwich. The marketplace of Norman times has been

repaved, and is gay with an attractive medley of coloured awnings on the stalls. The impressive buildings grouped about it make this central space one of the most striking civic centres of any English city. High on the west side rises the new hall, its great size dwarfing the Guildhall and its bold simplicity contrasting with the medieval grandeur of that attractive structure, with its battlements, pierced parapets, and rich flush-work, rather like a church. Looking to the Guildhall from across the way is the stately fifteenth-century church of St Peter Mancroft. The City Hall looks across the marketplace and the narrow streets to the Norman Keep on its mound, and not far away the elegant cathedral spire is soaring in the sky.

This noble civic hall, designed by Mr C. H. James and Mr Rowland Pierce, houses the municipal departments on five floors. The Lord Mayor's Parlour looks out on the marketplace, and the Council Chamber looks on to a great courtyard to be enclosed as the buildings grow. The walls are of solid brick, faced partly with stone and partly with Buckinghamshire bricks of warm tints, handmade. The floors are carried on steel beams, and the roof is concrete covered with asphalt Engraved on the floor of the entrance hall is a compass, and carved in the marble of one of the walls are the names of mayors since 1403 and lord mayors since 1910, a record of five centuries of civic pride and service which few cities can rival.

The simple severity of the long facade is relieved by a balcony, from the middle of which great columns rise to a cornice. At each side of the entrance is a splendid heraldic lion in bronze, the work of Alfred Hardiman RA; he was the sculptor of the three niched figures on the wall of the Council Chamber, representing Recreation, Wisdom, and Education. There is a wonderful view from the top of the tower on the north side of the hall, rising 185 feet and crowned with a lantern in which hangs a bell weighing nearly three tons. The four faces of the clock are 44 feet round. Norwich has realised the value of floodlighting, and the night view of the tower is one of the impressive spectacles of East Anglia.

The great bronze doors of the hall are enriched with eighteen plaques by James Woodford, in which we glean something of the city's history and its industrial life, which began when the Flemish weavers came over in 1336, expanded two centuries later when weavers and dyers came as refugees from France and the Low Countries, and turned into fresh channels when the old trade left Norwich for the north. We see on these doors representations of the coming of the Danes, the Normans building the castle, the ravage of the Black Death, and the execution of Robert Kett. Here are the old tools of the weaver and the stool he sat on, a girl at a silk loom and another making chocolate, a cobbler cutting out soles for boots and shoes, a man at a machine filling tins with mustard, a man at a loom making wire-netting,

a girl filling bottles with mineral waters, a brewer's vat, and a mechanic with an aeroplane engine. In the plaque showing modern building are walls, scaffolding, and the bucket of a crane. Farming and the great cattle market are represented by an old plough and spinning wheel, and pens in which are a horse and a cow, and a bull, a sheep, and a pig.

Norwich has one of the most valuable collections of civic plate in England, now kept in the City Hall. The magnificent mace has a shaft of rock crystal and silver gilt; its head is crowned and ornamented with precious stones; it is 38 inches long and was made by a Norwich silversmith about 1551. The 1568 Reade salt is equally famous. Over 15 inches high, it is elaborately ornamented and has a high cover; it is almost certain that it was made by Peter Peterson, a Norwich silversmith. Inscribed on one of three Elizabethan cups is *Al Mi Trvst is in God*.

In front of the hall is a fine terrace with flower beds, a setting for the city's tribute to those who fell in the Great War. Designed by Sir Edwin Lutyens, the memorial is a cenotaph with the city arms and a golden wreath, and stood originally by the old Guildhall. Two flag standards at the ends of the terrace have beautiful bronze bases with figures of women symbolising the four seasons (sowing, gathering fruit, reaping) and feeding birds. The memorial to the men of the South African War is a fine bronze figure of Peace with outspread wings, crowning a stone monument by the nineteenth-century Shire Hall, which stands by the castle on part of the old moat,

George Borrow's House

Norwich received its first charter from a Norman king, and when Henry the Fourth made it a city in 1403, with the right to elect a mayor and two sheriffs, the city decided to set up a building worthy of its civic dignity. The thatched tollhouse, built by the Normans and enlarged in the fourteenth century, was pulled down and the present Guildhall rose, much as we see it. From 1412 the basement was a prison, including the crypt of the old tollhouse, in which prisoners were chained to the walls and shut away from the light of day. On the pillars supporting the fourteenth-century vault are still seen marks left by the chains which bound the prisoners, and there remains also the slide from which food was thrown down to them.

The spiral stairway in a corner of the Guildhall crypt was built to give access to the fifteenth-century chapel, the entrance to which can still be seen near the Mayor's Parlour. In the original chamber over the crypt, known as the Council Chamber, over 500 mayors have been elected. Its east front is richly adorned with stone flush-work in diamond and triangular pattern, and surmounted by a nineteenth-century clock-turret. The fine old timbered roof of this chamber has carved pendants, and there is linenfold panelling round the walls. Griffins and greyhounds and a grotesque cock's head are carved about the lord mayor's chair, and beneath the seats of the councillors are contrivances on which the chimney-pot hats of the last century were hung.

There are many portraits on the walls, and the three windows of the east wall sparkle with beautiful old glass, most of it fifteenth century; some is from the vanished chapel and it is all a harmonious medley of fragments, with many figures among them.

A proud possession of the Council Chamber is the sword of the Spanish Admiral Winthuysen, who surrendered at Cape St Vincent and died of his wounds. It was presented to Norwich by Lord Nelson, and we may read the letter he sent with it to the mayor, written from the Irresistible six days after the battle. The sword looks as if it belonged to a fairy story rather than to war; the handle is of mother-of-pearl with silver fittings.

A lord mayor of our own century has given to the city the house built by William Appleyard, the first mayor, who lived in it. It was so damaged by fire in 1751 that the only remains of Appleyard's house are the splendid crypts and the north wall facing St Andrew's church. This wall is a wonderful example of flintwork, the knapped flints being squared and perfectly fitted together, standing as it stood five centuries ago. The fine old staircase has twisted balusters and stairs with carved ends. Its use as a prison from Elizabeth's day till 1828 has given it the name of the Bridewell. Till 1923 it was a boot factory. Now it is a little museum of local industries.

Another twentieth-century lord mayor has given the city the house in which George Borrow lived from the time he was thirteen till he left Norwich in 1824. Born at East Dereham, he came to Norwich as a solicitor's clerk when he was seventeen, being befriended by Southey's friend William Taylor, who taught him languages and so helped him on his way to fame. The house he lived in stands in seclusion off Willow Lane, with his bronze portrait by the passage bringing us to it. Now the house is a Borrow museum. We see the attic where he slept, portraits of people who come into his books, letters and manuscripts, and pictures of Norwich as he knew it.

A place of rare delight in Norwich is Strangers' Hall, the rambling old house of a medieval merchant, which has become a folk museum, with over a score of rooms in which we can read the story of English domestic life for four centuries. The house itself comes from the fifteenth to the eighteenth century, but the fourteenth-century stone crypt over which it stands served as the strong room for the timbered house of Roger Herdegrey, who was Bailiff of Norwich in 1360. It hides behind modern shops in what is called Charing Cross, and the fine old doorway (carved with the lion and the unicorn) brings us to the most charming flagged courtyard in Norwich. Here the hall has oak windows with carved lintels, and a flight of steps climbing to a fifteenth-century porch with beautiful vaulting. The great oak door opens to the fifteenth-century banqueting hall, splendid with its roof of kingposts and tie-beams on carved spandrels, and a screen with linenfold panels, the city arms, and the merchant's mark of the mayor who gave it. One lovely oriel with transoms is as old as the hall; in 1627 the mayor put in the other lovely oriel of brick and oak. The minstrel gallery is also seventeenth century. In one oak-panelled room is a collection of pottery, glass, iron, and pewter; in another are examples of old needlework, an old carved chest, and a fine cupboard made about 1500. The arms of Nicholas Sotherton are carved on an oak beam of the fireplace of the Tudor room downstairs, known as the Sotherton room, with old benches and an old chest, a low timbered roof, and a floor strewn with rush. A passage leads from it to the crypt, where we see a fine sedan chair and a quaint little perambulator with an umbrella canopy. In the goodly array of utensils in the room arranged as a kitchen are ingenious spits, quaint gingerbread moulds, and a baker's mangle for making dough. In the sports room are toys and games of the eighteenth and nineteenth centuries, an early billiard table, and a Punch and Judy Show. Another room has a curious bedwarmer like a cage in an Elizabethan four-poster, and an oak cradle. There is a spacious Georgian room, and in the crowd of ornament in the fussy Victorian parlour are the family Bible and family portraits, cases of birds, and a wonderful basket of flowers made of

shells. There is a captivating display of Victorian and other period dress, patchwork covers and hangings, samplers and sketches, drawings, and maps of old Norwich.

Like a white flower the castle seemed to Norwich people long ago, perhaps because the stone walls glistened white from a distance, rising from the great mound raised in prehistoric times. It is a superb citadel of strength and stately dignity, its front an amazing mass of Norman arches. Of the first stone castle, built soon after the Conquest by William FitzOsbert, nothing is left except foundations. The keep and its entrance tower which still stand, with walls richly arcaded and embattled, are believed to have been built in the twelfth century by the Bigods, several of whom were its constables. One was at the signing of Magna Carta. The keep was refaced outside with stone a century ago, but has Norman work within. The outside stairway to the tower has gone, but the handsome Norman doorway from the tower to the galleried hall of the keep still stands.

From the thirteenth century to the nineteenth the keep was a prison, and there are still grim reminders of those old days. We see remains of dungeons with walls ten feet thick, showing scratchings and carvings by prisoners. We come upon a Norman well, not yet dry, over 100 feet deep. Between the slits in the basement are little tunnels in

The wall through which the archers could speak to one another. High in the keep a passage runs through the walls, and spiral stairs wind to the battlements.

But the gloomy days of this great castle are no more. Since 1894 the keep and the prison buildings (erected early last century and now transformed into galleries) have housed one of our finest museums. The steeped mound is now patched with daffodils, and the moat is now a garden, spanned by a one-arched medieval bridge refaced with flint.

The keep, as part of the museum, is concerned chiefly with the story of Norwich through the centuries, and with the manners and customs of private man in various parts of the world. Rooms typical of different periods are set up on the ground floor, and a fine diorama shows the city as it was about 1720, with its host of churches and gabled houses. The Tudor Room has oak mullioned windows, and rich tapestry made by Flemish weavers in the time of Henry the Seventh; the Elizabethan Room has a moulded ceiling from the house of Dean in Norwich and fine panelling from a house at Lakenham; and the Georgian Room has panelling and roof beams from a house in Fishergate. In this room are several Nelson relics—a piece of hair cut off by Captain Hardy; a letter written from the Victory with his left hand in February 1804, with other letters and portraits, one of his hats, and his

Elm Hill, a quaint street of Old
Norwich

cabin chair. A flagstaff and a festooned ensign of faded green were taken
from a French ship. A splendid door of about 1500, panelled and carved,
has an inscription to William Louth, eighteenth Prior of Walsingham. A long
shovel-board table and an embroidered glove belonged to the Pastons; two
fourteenth-century alabaster tablets show the martyrdom of St Erasmus and
a consecration scene. Here is old English pottery and porcelain, silver, and
plate; a case of eighteenth-century needlework, and a fine collection of coins
from the Norwich mint, dating from 925. Old Snap, a comic dragon with a
long twisted tail, painted scarlet and gold, is a relic of the Guild of St George;
from the fifteenth century to the nineteenth a dragon like this went round
the city in processions and was made to snap its jaws at the crowds.

If we had come upon a butterfly in one of these dungeons it would not have
given us more surprise than did the silk dress worn by Marie Antoinette, hanging
in the ancient keep. This dainty high-waisted dress is striped with pale green on
a cream ground, and has a full skirt and a short train. Hung beside it is a small
inside bodice of the same silk with tabs and ribbons to fasten round the queen's
waist. It is possible that Marie Antoinette may have danced in it.

Most of the pictures in the art galleries of the castle are by artists of the
Norwich School of Painting founded by its great son John Crome, famous

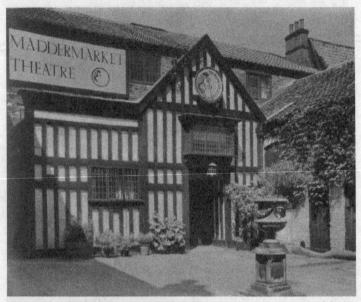

The Maddermarket Theatre of the Norwich Players

the world over for his landscapes. Among his pictures here are Bruges River, Yarmouth Jetty, The Fish Market, and the Boulevard des Italiens. There is a portrait of him by Opie. Joseph Stannard is represented by Yarmouth Sands, and Thorpe Water Frolic. John Sell Cotman, a native of Norwich, has pictures including The Baggage Waggon, and Fishing Boats off Yarmouth. Two other members of the School who have their place in the galleries are James Stark and George Vincent. A lovely Madonna and Child is by Alice Havers, a Norfolk artist who died in 1890. The Estuary and a painting of Haddiscoe Church are by Arnesby Brown, and one of four fine horse studies by A. J. Munnings is Bungay Fair. In one of the rooms is a beautiful tapestry designed by Burne-Jones and woven at the works of William Morris. It shows the first Christmas morning, with the angel holding a star and the three kings with their gifts, in a setting of flowers and a wood.

One of the picturesque old houses of Elm Hill is the Britons Arms, with a thatched and gabled roof and some remains of the fourteenth century. A timbered and gabled house on the east side of the Hill is said to have been part of the town house of the Pettus family, merchants and mayors in the sixteenth and seventeenth centuries, whose monuments are in the church of St Simon near by. Reached by a passage in Haymarket is the attractive

sixteenth-century Curat's House, with turrets and mullioned windows and a room with oak panelling; it was the home of John Curat, sheriff in 1529. There are eighteenth-century houses with classical doorways in Surrey Street, at the corner of which is the Boar's Inn, with one of the few thatched roofs left in the city; it was the home of Alderman Richard Browne in the fifteenth century, but is much restored.

The old Music House in King Street owes its name to having been a meeting-place of the city waits, the town's official musicians, who are said to have been in existence from the fourteenth century to the eighteenth. It has old vaulted cellars, and the fine hall with a roof of trussed rafters is part of the rebuilding of an older house by Sir John Paston. In our own day it has been used by the Norwich Players (a company of amateurs founded by Mr Nugent Monck) till, in 1921, an old chapel, which had been used as a baking-powder factory and Salvation Army barracks, was converted into the Maddermarket Theatre. This model of an Elizabethan theatre, with apron stage and balcony, aided by modern lighting, has become famous for its plays presented as in Elizabeth's day, a pioneer of the drama which has added to the fair fame of Norwich.

The city's Central Library is the oldest public library which has had an unbroken existence since its foundation in 1608. Norwich was the first to adopt the Library Act of last century. In the old block, formerly occupied by the City Museum, is the remarkable ceiling of the Duke of Norfolk's private chapel. One of the branch libraries is at the Lazar House in Sprowston Road, a simple Norman building with gabled roof and two original doorways, standing by a wayside lawn.

On the wooded fringe of the city, between the Wensum and the Yare which meet not far away, is Carrow Abbey, the home of the Colmans, whose works are near by, covering 50 acres and employing 2,000 people. From the road we have a peep of the beautiful house with flint walls and ornamented chimneys, standing where stood a Benedictine nunnery from the twelfth century to the sixteenth. The oldest portion is the house built for herself by Isabella Wygun, the last prioress but one, and includes the entrance hall, the guest chamber, the prioress's parlour, and her bedroom. Isabella's rebus of a Y and a gun are here and there, and old oak panelling, and doors with linenfold still remain.

At the top of Carrow Road is part of the old city wall and one of its old towers—the Black Tower mantled in ivy and roofless now. On the banks of the River Wensum below, near the modern drawbridge, are the two medieval boom towers, now only shells. Where the river turns south towards Bishop's Bridge is the ruined Cow Tower, rebuilt in brick on the old stone foundations

at the end of the fourteenth century. We can follow with ease the line of the old city wall, which was built in the thirteenth and fourteenth centuries. The medieval city enclosed by the walls and the river is about four miles round; now it is a city of 7,923 acres, with 164 miles of streets and 740 acres of parks and open spaces, including Mousehold Heath of 190 acres, Chapel Field Gardens in the heart of the city (an old archery ground with a pavilion shown at the Paris and Philadelphia Exhibitions), Eaton Park of 80 acres, and the old-world gardens and parkland of Earlham Hall, long the home of the Gurneys, where William Wilberforce was always at home.

We walk through the narrow ways of this enchanting city with growing wonder and with unwearying feet, for at every turn is something new and something old, in every street and alley is some vista that is good to see. Crowning it all are three of the most impressive structures of the centuries, the castle of the Normans, the twentieth-century City Hall, and the magnificent cathedral with the majesty of the Normans and the grace of our medieval builders in it. We have looked at the oldest and the newest of these three; we will leave the cathedral till we have looked about the city at its thirty churches, one of them of veritable cathedral splendour, and many of them of historic and architectural interest.

We do not wonder that Norwich is called the City of Churches. Once there were over fifty, and even now there are thirty-three, within the old boundary. Most of them are fifteenth century rebuilding on older sites, and most are of flint; most of them have towers, but the only attempt at a spire (except for the lovely spire of the cathedral) is at the modern St Peter Mancroft.

Second only to the cathedral in size and importance, and ranking among the finest churches of our land, St Peter Mancroft is a handsome building with walls of flint and stone. Begun in 1430 and completed in 1455, it is said to take the curious part of its name from 'magna crofta,' the big croft or meadow which became the marketplace. Shaped like a cross, the church is 212 feet long and 90 feet wide across the small transepts; the nave is 60 feet high, and the west tower nearly 100 feet, its nineteenth-century lead-covered spire rising 146 feet. Owing to the slope of the site, the chancel and the eastern sacristy are raised on crypts and a vaulted passage. There is a vaulted passage through the stately and beautiful tower which is the glory of the church outside, its high walls enriched with panelling, the stringcourses with quatrefoils, and the double buttresses with niches.

The north porch has two stoups, and three niches round the entrance with modern figures of the Madonna, Peter, and Paul. It has an upper room resting on a vaulted roof with tracery and carved bosses, one showing St Peter blessing all who pass below. Attractive without and within are the

two long lines of the clerestory, a lantern of thirty-four traceried windows throwing light on to the lovely old roof and on the delicate stonework of the great arcades. The arches are on clustered pillars so slender that they impede no view, and we can see everything in the church at a glance. There is no chancel arch. The roof of the nave and chancel are splendid, and unusual in treatment; along both sides is fan-tracery in timber, springing from shafts supported by corbels quaintly carved into heads of men and women, some like figure-heads; and above the timber vaulting is a richly carved cornice, the two sides having between them nearly forty angels holding shields and emblems. In charming contrast to the vaulting are the straight lines of the stout rafters of the middle of the roof, adorned with rich bosses. The aisles have good old roofs, their spandrels carved with tracery. The magnificent tower arch, soaring almost to the nave roof, has niches in the mouldings all round. Halfway up is a stone gallery where the ringers peal the twelve bells.

One of the priceless treasures of Norwich is the glass in St Peter's east window, sparkling as if with jewels, and coming chiefly (except for seven of its forty-two panels) from the fifteenth century. Most of it is in its original place; among that gathered here from other windows is some from the chapel in the north aisle, founded by Thomas Elys (mayor three times) and known later as the Jesus Chapel. Some of the panels have fragments, others have scenes from the lives of Our Lord and St Peter. In one Bethlehem picture the swaddling clothes are being warmed in front of a small Dutch brazier; in another angels are removing the thatch from the stable roof so that the rays of the yellow star may shine on the Child. Other windows have shields and many old fragments. The east window of St Anne's chapel in the south aisle has beautiful modern glass with thirty pictures from Bible story and lives of saints, denoting Faith, Courage, Love, and Vision; it is a tribute to the men who fell in the Great War.

The font is arresting, not for itself (for it has lost its figures) but for the rare and elaborate canopy which has sheltered it since the fifteenth century. The canopy has a fine traceried roof, and rests on four richly carved pillars which stand on one of two high steps and are crowned with minstrel angels. The massive dome surmounting this remarkable erection is nineteenth century. The roodstairs and doorways are still here, and two of the stalls keep their misereres. The elaborate reredos is modern.

At each side of the reredos is a doorway leading to the sacristy, which has an oak roof supported by carved heads and a table which was the canopy of an old pulpit. The 500-year-old door by which we enter has through all these centuries been made secure by the same lock, moving a heavy bar into

a slot in the stone wall when the key is turned. Many rich Flemish merchants lived near the church, and it may be because of their piety that St. Peter's is so rich in possessions. Among those which make the sacristy a treasure house are medieval manuscripts, including a 1340 copy of the Vulgate exquisitely written and illuminated, and St. Paul's Epistles with a Commentary, twelfth century and illuminated; a fifteenth-century chest containing the church registers complete from 1538; a ringer's jug of glazed brown Norwich pottery, holding thirty-six pints, used for hotpot when ringing out the old year; an alabaster panel carved with the Evangelists and their symbols; and the magnificent church plate, perhaps the finest possessed by any church in England. Among the seventeen pieces is the superb cup and cover of silver-gilt (richly embossed with a representation of Abigail's visit to King David, the camels laden with gifts) which was made in Elizabeth's day and given to St. Peter's in 1633 by Sir Peter Gleane, mayor in 1615. There is a small pre-Reformation cup shaped like a thistle. One of two sixteenth-century paintings shows the Resurrection; the other is a curious picture of the Thorn in the Flesh, showing a toad-like demon piercing St Paul's leg while he is praying.

St Stephen's church, with fine flint facing, built between 1350 and 1550, attracts us down an alley leading from St Peter Mancroft. The tower (its unfortunate date 1601 referring to restoration) stands on the north side of the church and forms a porch with a low vaulted roof, its bosses carved with such scenes as the stoning of Stephen, an owl, and a grotesque head. There is fan-vaulting in the north chapel, and the lovely old hammerbeam roof above the long clerestory of thirty-two windows has carved wallplates and traceried spandrels. The font has a cover with a big golden pelican, a fine chest is covered with heavily studded bands of iron, and in the sculpture of an old alabaster panel are nine saints. The modern benches have fleur-de-lys poppyheads, and six old stalls have carved armrests. Glowing with colour, the east window has old glass of the fifteenth, sixteenth, and seventeenth centuries, much of it a jumble with figures and faces, and Christopher as one of five figures.

St Gregory's (the third of the four important churches near the marketplace), comes chiefly from the end of the fourteenth century. The platform of the altar is raised ten steps above the floor of the nave, and has an arched vault beneath it. The porch of the tower has a vault with fine bosses, and from it we look through the lacy veil of birch trees in the tiny square to the tower of the City Hall. The church tower has beautiful vaulting; and the clustered pillars of the high arcades have embattled capitals. There is part of a worn pall of crimson velvet, and another old pall embroidered with a design of

angels and fishes. Old woodwork is seen in four stalls with carved arm-rests and misereres, and a fragment of the screen has paintings of saints and an angel, one being Barbara with her tower. A reminder of the days when members of the Guild of St George worshipped here is the great wall painting in the north aisle, showing St George fighting the dragon while the princess stands by and the king and queen look on from a high tower. A great treasure is a brass eagle lectern with three lions at the foot, for it is dated 1493, and is one of about fifty old ones left in England. Another treasure is the brass escutcheon now on the vestry door, its old ring gone; it is the head of a lion with a man's head in its mouth, set in a border of trailing leaves, and fashioned in the fourteenth century. Shields and angels adorn the splendid fifteenth-century font which stands on the heads of four lions and four men. Sir Francis Bacon, who gave money for the repair of the font, has a huge altar tomb. He was one of the judges who resigned after the death of Charles Stuart rather than take the oath in the name of the people instead of in the name of the king.

A quaint alley becomes a vaulted passage where it runs under the tower of St John's, Maddermarket, the name reminding us of the days when dye was sold here. By the tower is the fine old timbered Church House now used by Toc H. The clerestoried church itself is fifteenth century, with some remains of the fourteenth, and the north aisle is on the site of a church built perhaps in Saxon days. The vault of the north porch has bosses of flowers and heads, and the medieval door into the church has its old hinges. The east end of the nave serves as the chancel, with a painting of the Last Supper for the reredos, under an early Georgian canopy on Corinthian columns. A medley of old glass has roundels with heads and a figure of Edward the Confessor holding a ring.

On the wall under the gallery is the finest display of brasses in Norwich. Rich in detail, and very charming, is the family group of John Terry, mayor in 1523. He and his wife and four children are standing on pedestals which rest on the branches of a tree, about which are growing roses, cornflowers, and bluebells, John in a long robe, the mother in rich attire with a rosary hanging from her girdle held by a clasp of three roses. Walter Noneslee and his wife (1412) are small and worn. A mayor and MP of 1431 is with his wife, he in a belted gown, she in draped headdress. John Todenham of about 1450 is a tiny figure in a tunic. Alderman William Pepyr of 1476 is with his wife in horned headdress. John Marsham, a sixteenth-century mayor, wears a fur-trimmed gown; his wife in kennel headdress has a gown with fur cuffs and a girdle with a three-rose clasp. Another sixteenth-century mayor is with his family. Richard Rugge is a sturdy fellow of the sixteenth century, with his

wife in kennel headdress and a girdle tied in a bow. Other brasses are of a woman in kennel headdress, with a rosary and bag; the wife of a fifteenth-century mayor; and a group of five boys of the seventeenth century. Three wall monuments of the sixteenth and seventeenth century show Nicholas Sotherton and his wife in red gowns and ruffs; Thomas Sotherton in red, his wife in black, and six children; and Christopher Layer with his wife and eight children, and figures representing Labour, Glory, Peace, and Vanity. In 1791 a memorial was put here to Lady Margaret Audley, wife of Thomas, Duke of Norfolk, who was executed for treason in Elizabeth's reign. Lady Margaret died at the duke's great house at Charing Cross, near this church, where she was buried in 1563. The house is gone.

St Giles's church, just above the marketplace and the City Hall, was founded in the Conqueror's day, rebuilt at the end of the fourteenth century in fifteenth-century style, and is now an imposing structure of flint (except for the stone porch), dominated by a tower 113 feet high. The highest tower of the old city churches, it was used as a beacon in the sixteenth century, and has among its possessions an old cresset like a wrought-iron basket. The porch is enriched with niches, and a fine cornice of shields under trailing vine and cresting; it is entered by a door with fine tracery, and its upper room rests on a lovely fan-vaulted roof, the only one in the church porches of Norwich. The interior is stately with lofty arcades between the clerestoried nave and aisles, fine windows filling it with light, and old roofs. On the ends of the hammerbeams of the nave roof twelve big angels with outspread wings hold shields with arms. The massive tower arch soars to the roof, and in front of it stands the font carved with flowers, tracery, angels, and shields, the bowl medieval, the rest nineteenth century. Shining in a tiny window in the gable of the chancel arch is the patron saint. The chancel itself is 1866, the old one having been destroyed in Elizabeth's day; there are six angels in its roof. The fine brass of a fifteenth-century mayor shows Richard Purdance of 1430 with a thin bearded face, wearing a robe edged with fur and standing on a dog; and his wife in draped headdress, a dog in the folds of her gown. Two portraits on a brass of 1432 are of Robert Baxter and his wife. That of John Smith, a priest of 1489, has a chalice and wafer. There are many eighteenth and nineteenth-century mace rests, and a loose stone of the Norman church is preserved for us to see. The parish umbrella, 150 years old, is in the Castle Museum.

All Saints stands in Westlegate, facing a square where an old-world air is lent by Georgian houses, and timbered modern ones with thatched roofs and overhanging gables. Chiefly fifteenth century, with a fourteenth-century chancel and some windows made new, the church has fine old black and

white roofs, windows in arcaded walls, and old glass. In striking modern glass St Edmund and Joan of Arc are kneeling by Our Lord on the Cross. A charming effect is given by the low modern screen (to which the pulpit and the reading desk are attached), the neat choir seats, and the gold and purple drapings of the altar. The splendid fifteenth-century font has eight saints in canopied niches round the stem and sixteen on the bowl.

A companion for All Saints is the church of John the Baptist, Timberhill, so called from the old timber market. Built on an older site when the fourteenth-century style was passing, it has leaning arcades reaching the modern barrel roof, aisles with much old work in roofs with floral bosses, modern screens across chancel and aisles, and a porch with a vaulted roof supporting an upper room! The ancient font has a modern oak cover like a tower with a lovely lacy spire of open tracery, crowned with a dove. In the south chapel is a fine old brass candelabra of unusual design, the Madonna and Child standing amid vine branches which support the candles.

St Michael-at-Thorn stands among thorn trees; there are sixteen of them in the churchyard. Except for the tower, which was rebuilt after falling last century, the church is chiefly fifteenth century, but the fine doorway was built by the Normans, its arch of zigzag and carved roll mouldings resting on cushion capitals. The old font has shields and heads of men and women; the chancel has its old black and white roof with angel corbels, and there are old books in a case. The modern chancel screen has rich tracery, and a carved archway of oak leads to the neat little chapel under the organ, where there is a beautiful brass candelabra.

St John de Sepulchre, on a high site just within the old city wall, has a tower of the fifteenth century seen for miles. It stands at the west end of the cross-shaped church, in a green churchyard shaded with trees. The north porch has a vaulted roof supporting an upper room, and a fine fifteenth-century door with traceried panels opens to the nave, its old roof reached by the arches of the tower and chancel. The fine old font, as old as the church, is enriched with angels and lions.

Three old churches and the ruined tower of a fourth are along one side of King Street, a workaday street with many old houses near the river. St Peter Parmentergate is on a green bank, its garden path shaded by thorn trees. Built in the fifteenth century, it has a good embattled tower, and a porch with an upper room reached by a winding stair, now a chapel. The old black and white roof over the wide nave and chancel has embattled tie-beams and traceried spandrels. The panelling behind the old stalls has tracery tipped with roses, and the low screen (old and new) has rich panels with spandrels carved into leaves and flowers, St George and St Michael fighting dragons,

angels, an eagle, dogs, and deer. The medieval font is enriched with angels, demons, lions, and men. There are two eighteenth-century mace-rests, and over the south doorway is a 200-year-old painting showing a quaint figure of Peter listening to the cock crowing.

St Julian's, a simple little place tucked away in an alley, has some of the oldest work to be seen in Norwich churches. Much of the walling is Norman, with fourteenth and fifteenth-century windows, and the greater part of the round tower is thought to have been built for the Normans by Saxon workmen. On its north and south sides is a crude window splayed on both sides, but the belfry windows and the battlements are brick. The vestry hides a Norman doorway, and the fifteenth-century font has angels holding shields. A stone on the south wall outside, carved with a Crucifixion, has an inscription telling that Mother Julian, anchoress of Norwich, dwelt here, and a round depression like a well in the churchyard marks the site of the cell where she spent the greater part of her long life in the fourteenth century.

St Etheldred's church, in a flower garden, is old but much restored. The round part of the tower comes from the twelfth century, its eightsided top from the fifteenth. Norman remains are the carved stringcourse between windows made new, the battered piscina, and the doorway through which we enter, with a scratch dial beside it. The porch and the font are fifteenth century. There is a brass portrait of a sixteenth-century priest, and a wall monument has a seventeenth-century family group; William Johnson, his wife in a high hat, a son, and three daughters.

In St Benedict's Street are the churches of St Benedict, St Swithin, St Margaret, and St Lawrence. St Benedict's, by the old city wall, is a neat little building of Norman and medieval days, the round Norman tower having a later eight-sided top. There are old black and white roofs, two Jacobean chairs with carved backs, and a splendid medieval font with seated figures of saints and women in flowing headdress on the bowl and eight figures with symbols standing round the stem. A curious feature are the exceedingly slender iron pillars supporting three arches of the nave arcade.

St Swithin's has a dainty bellcot replacing the old tower taken down in 1881. Most of the simple building is fourteenth century, but the north arcade is fifteenth century and the south later still. The font is old and old bench-ends now form a book-rack. There are brass portraits of a merchant and his wife, with hands at prayer and bags hanging from belt and girdle; she has a pointed headdress.

St Margaret's has its patron saint carved in the spandrel of the south porch of her church, its vaulted roof supporting an upper room. Most of the simple building is fifteenth century, but there are fourteenth-century belfry windows

in the tower. The interior is bright with cream walls, and standing imposingly at the west end is the medieval font, near a grand old chest carved with buttresses and window tracery. There is also a fine Jacobean chest.

St Laurence's, sandwiched between St Benedict's Street and Westwick Street, built about 1470, is a strikingly long and lofty building, with a chancel up two steps and the sanctuary up eight more. The imposing tower is 112 feet high. Carved in the spandrels of the west doorway are the martyrdoms of St Laurence and St Edmund, showing men feeding the fire on which St Laurence lies, and bowmen shooting arrows at the bound king, the wolf peeping from its lair. The arch of the tower climbs almost to the nave's old hammerbeam roof, of which the shafts are supported by stone angel corbels between the windows of the clerestory. The lofty arches run from east to west, with no chancel arch to break the vista. Two fifteenth-century doors have beautiful tracery, and a charming old door with linenfold leads to the roodstairs. The old font has a seventeenth-century cover, and a window in the north chapel has a patchwork of old glass.

Clustering between the river, the castle, and the cathedral are seven old churches and a great building which was once the church of a Dominican priory. In the street bearing its name is St Andrew's, second in size and importance only to St Peter Mancroft. It comes from an ancient structure rebuilt in 1506, except for tire tower, which was made new in 1478. Great windows fill it with light. Lofty arcades run from east to west, and over them is the clerestory with eleven windows on each side. Oak angels support the shafts of a roof with original moulded beams and carved wallplates. There are three sedilia with rich canopies: a chest, a chair, and the font cover are seventeenth century and all carved; the tower screen has much of its old work; the old glass in the north aisle windows is a colourful jumble with figures and shields and scenes, one having a skeleton standing by a bishop.

There are brass portraits of a man in a fur-lined robe and his wife in kennel headdress; she has a purse and beads, and both are at prayer. Robert Garsett's wall monument of Shakespeare's day shows him in red robe and ruff, and two small kneeling figures in high hats. There is an inscription with the thrilling name of Abraham Lincolne of 1758, perhaps uncle of the American President. In the north chapel (now a memorial to men who fell in the war) is the big canopied tomb of Sir John Suckling of 1613 and his wife, parents of the poet Suckling. Sir John reclines in armour, his wife lies in Elizabethan dress, and one son kneels at their head, another at their feet. Four daughters kneel on the front of the tomb, the top of which is raised on four skulls to show the shrouded figure lying within. On the canopy are women playing fiddles. Robert Suckling of 1589 kneels with his wife in a

wall monument, their children behind them; in the spandrels are Father Time and cherubs playing cup-ball.

The Sucklings were ancestors of Nelson, who came to this church when a boy at the grammar school. Suckling House, their old home near the east end of the church, where the poet's father was born, was built perhaps before the Black Death which took away most of the population of Norwich. It has been much restored, but the hall has its fine trussed roof, and a door with beautiful carving which was here before Robert Suckling came in 1564. The Suckling motto, Thynk and Thank God, is carved on remains of an Elizabethan fireplace. In the old walling is a fourteenth-century doorway opening to the hall from outside, and a vaulted passage leads to a small courtyard. On a tablet outside are names of people who have lived here, from William de Roolesby of 1285, and in one of the modern windows are some of their arms. Used now as a public hall and offices, the old house was given to the city by the Colmans in memory of a sister, together with the modern Stuart Hall joining it. Facing Suckling House is Armada House with overhanging storeys, an oak corbel with 1589, and a panel showing a ship in full sail.

It was outside St Andrew's church that Kett and his rebels shot clouds of arrows and were routed by Captain Drury and his harque-busiers. Facing the church are the two halls which were originally the great Dominican church rebuilt by Sir Thomas Erpingham. Since the Dissolution the nave and its aisles have been a banqueting and concert hall, 126 feet long and nearly 70 wide. Known as St Andrew's Hall, it has arcades of seven bays soaring to the fine range of clerestory windows (twenty-eight in all), a great hammerbeam roof, and a gallery of many portraits. The last one for which Nelson sat has pride of place; it is by Sir William Beechey. Herkomer painted Sir J. J. Colman, and two mayors are by Opie. The portrait of Sir Harbord Harbord (Lord Suffield) is by Gainsborough. The choir, now known as Blackfriars Hall, was long used by the Dutch settlers in the city, and in it Sir Thomas Browne was knighted by Charles the Second. Bigger than many churches, it has enormous windows and a fine roof with bosses of angels and flowers. Here, too, is a gallery of portraits. Below a brass inscription to Theophilus Ellison, parson to the Dutch community, are photographs of portraits of him and his wife painted by Rembrandt. Theophilus sleeps in the middle of this old choir.

The fact that the Archdeacon holds his courts in the fifteenth-century church in Queen Street has lengthened its name to St Michael-at-Plea. Its low tower has battlements and leafy pinnacles, and its porch is adorned with niches, the spandrels of the entrance arch having worn carvings of St Michael fighting the dragon. The old door into the church has rich tracery.

There are golden-winged angels holding shields on the ridge of the fine fifteenth-century roof, and the medieval font has a quaint canopied Jacobean cover with a dove perched on the top. There are shields and saints in a medley of old glass, and a stone on the wall is engraved with portraits of an Elizabethan family, parents and ten children, kneeling at an altar. The treasure here is a number of fine panel paintings of the fourteenth century, said to be part of the old rood screen. Seven now in the reredos are of the Annunciation, the Betrayal, two Crucifixions, St Thomas, Erasmus, and St Margaret standing on a dragon. One showing the Resurrection is in a recess over the pulpit.

St Peter Hungate church is at the top of Elm Hill, a narrow cobbled street with old houses, overhanging storeys, gables, and dormers. It is a charming peep of old Norwich. The church is a rare gem with an ancient story, and is unique for the new lease of life that has come to it. It has made history in our time, for, in becoming a museum for treasures of church art, it is the first example since the Reformation of an Anglican church put to secular use.

The ancient church was restored and partly rebuilt in the fifteenth century by John Paston and Dame Margaret his wife. Engraved on a buttress by the north door is a curious pictorial record of their making a new church out of the old, showing a leafy branch growing from the foot of a barren tree trunk on which are three crosses of the Trinity, and the date 1460.

Wearing a tiled cap in place of its vanished belfry storey the low tower stands at the west end of a simple cross. The porch has an upper room. The walls inside are gleaming white, and some of the windows have beautiful glass of the fifteenth and sixteenth centuries. Some of the oldest is in the tracery of the west window, showing Our Lord, the Madonna, and musical angels. The east window is striking with its strips of old glass, rich and bright, showing over a dozen figures. In the tracery are angels with scrolls, a king, and a patriarch. There are two fine doors with medieval tracery, two tiny peepholes from the nave to the chapels, and a fifteenth-century font. But the crowning glory of this little place is the beautiful fifteenth-century nave roof with its richly moulded timbers, oak angels on the hammerbeams, angel corbels, and at the crossing a central boss carved with three figures.

As its congregation slipped away with the destruction of many old houses round about it, St Peter Hungate became one of the unwanted churches, and the splendid idea of using it as a casket for sacred and historic things was carried out in 1933. We found here a collection of musical instruments to which our grandparents sang hymns and psalms—including fiddles, flutes, and a hand organ; a fine collection of church plate; medieval carving in poppyheads and fragments of screenwork and arches; four charming

tabernacle doors, with the daintiest of tracery; a silver cross adorned with amethysts and a ball of Blue John; illuminated manuscripts including Wycliffe's Bible of 1380; and three lovely Books of Hours in brilliant colour, one French and one Flemish of the fifteenth century, the third East Anglian and a century older.

St George's church stands at a corner of Tombland, now a tree-shaded space facing the cathedral gates but once the Danish marketplace, moved by the Normans to its present site. St George's is chiefly fifteenth century, with remains of an earlier building. It has a fine clock tower, a clerestory of patterned brickwork, a south porch with carved bosses in its vaulted roof (the middle one showing St George standing on a dragon), and a north porch serving as a children's chapel. Over the doorway is an old coloured panel with St George fighting the dragon by a castle, the princess clasping her hands at prayer. There is old woodwork in the fifteenth-century roof of the chancel (with twelve angels supporting its shafts), an old roof of the nave with carved borders, and a splendid Jacobean pulpit with a star inlaid in its great canopy. The cover of the font is seventeenth century; the font itself is perhaps 700 years old. There are roundels of old glass, small panels of seventeenth-century glass, and an old chest. A tiny wall monument of 1609 has coloured figures of John Symonds and his wife in ruffs, she wearing a black dress and hood; John left two shillings a week for ever to the poor. The organ hides the monument of William Anguish of 1668, where he kneels with his wife and seven children.

St Simon and St Jude's, standing at the foot of Elm Hill, with its tower almost gone, is one of the sad churches of Norwich; we found it ruinous in and out, with ivy growing through the windows, and walls festooned with cobwebs. It is fourteenth and fifteenth century, and still shelters two fine monuments, one as modest as the other is imposing. In the small one we see Thomas Pettus of 1597 and his wife kneeling, their six children crowded behind them. Sir John Pettus of 1613 reclines on his alabaster tomb which is propped up to save it from collapse, and under the canopy are eight other figures. Carved in the spandrels of an oak doorway in the chancel are three fishes and a serpent, and a quaint St Simon in his rowing boat; the richly carved doorway has a border of roses and quatrefoils. The register tells of four knights who lie in one grave in the chancel; they were killed when fighting Kett and his rebels on Mousehold Heath. Robert Kett was a tanner of Wymondham who, moved to indignation by Henry the Eighth's looting of the churches, raised a protest which gathered to itself thousands of men and eventually grew into a petition of grievances. The men camped on Mousehold Heath and were brought to battle in which 16,000 were slain on both sides, Kett being hanged from the top of the Castle walls.

Many of Kett's men were buried in the churchyard of St Martin-at-Palace, and a tablet on a house near the chancel tells us that Lord Sheffield was killed close by. Standing among trees at the gates of the bishop's palace, St Martin's has the odd distinction of being the only church in Norwich which we can drive right round. It comes from the middle of the fifteenth century, but a far older story is told by the Saxon long-and-short work at the corners of the chancel. Over the fifteenth-century font, carved with quatrefoils, is a fine brass candelabra. Old carving of two angels holding open books is on the desk of the pulpit, and two poppyheads in the chancel have delicately carved scenes from the life of St Martin, one showing him cutting his cloak for the beggar. There is a similar scene on the back of a modern chair. Elizabeth Calthorpe's tomb in the north chapel has much heraldic display.

St Helen's church in Bishopgate is attached to the Great Hospital of St Giles, founded about 1250 by Bishop Suffield. Some of its old poppyhead benches have the lion, angel, and bull of three of the Evangelists, and a woman saint standing on a dragon; and the fine vault of the south transept is enriched with bosses. A tiny unglazed window in the south aisle is a gem of fifteenth-century stonework. The chancel of 1371 has a beautiful wagon roof of chestnut, adorned with 232 bosses and 252 spread eagles. Two of the bosses are of Richard the Second and his Queen Anne of Bohemia, who were visiting Norwich at the time of its erection. The west end of the nave and aisles, and the whole of the chancel, are converted into apartments for old people. The fifteenth-century tower projects into the modern court of the hospital, and the cloisters are round the four sides of the old court, which has almshouses with pantiled roofs on two sides and the church on a third side. There is a famous swannery in the grounds attached to the hospital.

Ten of the city's old churches are in the great loop of the river in the northern part of the city. St James-with-Pockthorpe, in Cowgate, is a small building chiefly fifteenth century. Its tower, with an octagonal brick top, stands in the nave. There are old black and white roofs, a leaning arcade, a little old glass with heads of two saints and a figure of St Barbara with her tower, and four old bench-ends. A great treasure is a set of ten panels of the old screen with paintings of saints. Now in the chancel, they were sold last century for a shilling each in the market, and after being acquired by the Colmans were restored to the church in 1917. The rarest of the portraits shows William of Norwich. Another treasure is the splendid fifteenth-century font under the tower; on the bowl are sixteen figures of apostles and evangelists; and eight women saints wearing crowns and holding symbols are in niches round the stem, under canopies of branches and leaves which grow round the base of the bowl.

A stone's throw from St James's is St Paul's, in a green churchyard fringed with trees. Much of its round tower (one of five in the city) is Norman, with a modern brick parapet. The chancel is an addition, but the rest is medieval. The font may be 600 years old, and two screens are fifteenth century.

Standing where stood a Saxon church, St Clement's-in-Colegate is by one of the river bridges. It is simple and aisleless, with a slender tower, and a chancel with tilting walls and old roof beams on which are angel corbels brightly painted, some with shields, two blowing trumpets. In the churchyard is the tomb of the parents of Matthew Parker, Archbishop of Canterbury in Elizabeth's day, born in Norwich in 1504. St Saviour's church, in busy Magdalen Street, has a window restored in his memory. Except for its fourteenth-century chancel the old work in this plain little building is fifteenth century. Its best thing is the medieval font, its bowl resting on four shafts which stand on heads of demons.

St George's-in-Colegate is among the shoe factories. Once its companions were the houses of the rich, but the church itself is now a fine place with a forsaken air. The lofty tower is of four stages. The porch has an upper room with a niche between the windows, and the spandrels of the entrance arch are carved with the Annunciation and angels girding St George with his armour. The interior is bright and spacious, crowned with old roofs, and there are old pews and a Jacobean pulpit. Mayors and sheriffs sleep in this old church, but one man lying here, whose name will five when theirs are forgotten, is John Crome, who lived in this parish and founded the Norwich School of Artists. His memorial plaque was put in the church nearly fifty years after his death in 1821. A high terracotta tomb, ornate with shields and two bedesmen sitting on a form, is to Robert Jannys, benefactor of the church and city. The younger Bacon was the sculptor of the monument, showing a weeping woman in rich drapery, to John Herring who was mayor in 1799. In a beautiful brass of 1475 we see William Norwiche and his wife standing on a pedestal, he in merchant's attire, she in horned headdress, the tiny figure of their son between them.

Mayors, sheriffs, and aldermen lie in the church of St Michael-at-Coslany, and much of the medieval rebuilding of the church is associated with these public men. Known locally as St Miles, it rises from lawn at a tree-shaded corner of Colegate, with a few old houses keeping it company. The imposing west tower, with a peal of eight bells, has a doorway with a rich arch, and a traceried door with St George and St Michael in the spandrels. The interior is spacious and lofty, with big windows and soaring arcades in the clerestoried nave, which has a great old trussed roof. The striking feature of the church is the Tudor chapel of the south aisle, famous for the charming flush-work,

like window tracery in flint and stone, on its outside walls. In the restoration of 1883 the walls of the chancel were enriched in similar style, making the church a very attractive picture at the east end. In the chapel of the north aisle is the worn tomb of William Ramsey, mayor in 1502 and six years later. On a stone to Alderman Henry Scottowe and his wife (1515) are two figures in brass, tied up in shrouds. We see the symbols again, quaintly carved in wood, on the tower screen. There is a bust of Edmund Hook, lord-lieutenant of the county in the eighteenth century.

A fine round tower with big belfry windows, built by the Saxons and restored in our time, rises at the west end of St Mary-at-Coslany, a cross-shaped church on a green island site. There is thirteenth-century masonry in the nave, but most of the old work is fifteenth century. The porch has a vaulted roof and an upper room, and in the rich doorway hangs an old door. The beautiful old roof of the chancel has restored bosses, and the vault of the crossing has four angel bosses round one of the Madonna. The fifteenth-century pulpit has its old hourglass and stand, and six old stalls have carved arm-rests and misereres. The medieval font has a canopy cover. In their engraved stone under a canopy we see Martin Van Kurnbeck, a doctor of medicine of Elizabeth's day, and his wife, who are wearing fur-trimmed gowns and ruffs. A monument with kneeling figures of a man and wife and three children may be of the same time. In the chancel is a heart cut in brass, a symbol of the burial in 1457 of the heart of Elizabeth Shantlow. Older than any of these (older than any other wall tablet in Norwich) is the inscription in Norman-French to Thomas Lingcole of 1298, telling us that he gave to the altar a wax taper and a lamp.

The spreading oak in the churchyard of St Martin's-at-Oak is the last of several planted in place of the tree which gave the simple fifteenth-century church part of its name. This was a great oak in which there was placed before the Reformation a statue of the Madonna, which many people came to see. Standing in Oak Street by the silk mills, the church has a square tower, an arcade with slender pillars, windows in arcaded walls, a fifteenth-century font, an old hourglass stand on the modern pulpit, and an alabaster wall monument in which Jeremiah Revans of 1727 is contemplating, as he kneels, the quaint figure of his wife in a curious flowered dress and long veil.

St Augustine's, in the street bearing its name, has the only brick tower in Norwich. Built in the seventeenth century after the older tower fell, it rises stoutly above the flint walls of the church, standing in a spacious garden of lawn and flowers. Though most of the old work is fifteenth century, some of the windows and walling are fourteenth. The old roof of the nave has carved spandrels and angels supporting its shafts; a worn panel painting of

Appollonia with the pincers is all that is left of the rood screen; a marble monument was the tribute of 600 weavers to the memory of Thomas Clabburn, a manufacturer of last century. The font is fourteenth century.

Of the many Nonconformist churches in Norwich the most unusual in its architecture is the brick Octagon Chapel of the Unitarians in Colegate Street, built by the Presbyterians in 1756. Standing at the head of a little courtyard, it has a flight of steps and a classical portico bringing us to a comfortable interior, where a gallery runs round the eight sides and eight fluted columns support the dome-shaped roof (which is a low pyramid outside). John Wesley described it as perhaps the most elegant chapel in Europe. Mrs Opie's uncle was minister here for a time, and James Martineau and his sister Harriet (who were born in the city) were among its members. Mrs Opie, wife of the painter, was also born in Norwich, and lies in the burial-ground of the Gildencroft Chapel, together with many friends of Norwich, including nearly a hundred Gurneys and Birkbecks. The first Quaker chapel in Norwich was built in 1679 in Goat Lane, the alley so well known to Elizabeth Fry and her brothers and sisters, who came here regularly from Earlham and gave the place of worship the nickname of Goats. The seven Miss Gurneys, most of whom had auburn hair and wore scarlet coats and purple boots, must have tempted people to turn round to look at them. The Old Meeting House of the Congregationalists in Colegate Street, built in 1693, has an attractive setting and a pilastered front with a sundial, an inscription telling of four parsons who became ministers here after they had been ejected by the Act of Uniformity in 1662. Lollard's Pit, of which the site near Bishop's Bridge is still visible, and commemorated by a tablet on a cottage near, is a reminder of still earlier sufferers for their faith, for here followers of Wycliffe were martyred; here Thomas Bilney was burned at the stake.

At the point where Unthank Road and Earlham Road meet just outside the old city wall, the Roman Catholic church of St John the Baptist rose between 1884 and 1910 on the site of the old city gaol. The gift of the fifteenth Duke of Norfolk, it is an impressive pile of grey stone in thirteenth-century style, and has been described as the finest Gothic building erected since the Reformation. It claims to be the biggest Roman Catholic church in England except for Westminster Cathedral and the cathedral now rising in Liverpool.

The church dominates the hill on which it stands, and its very foundations are level with the top of the cathedral tower. Under the chancel is a vaulted passage. The massive square tower rises from the middle of a cross, and the walls outside are enriched with buttresses, gables, turrets, flying arches, and many strange gargoyles. The east front (reminding us of Ely) is striking

with its three tiers of lancet windows, flanked by buttresses with niches and turrets with pinnacles. The gabled entrances in the west wall of the nave are a charming feature of the exterior, and the north porch and the north transept are notable, for their stonework is magnificently sculptured, while their doors are covered with exquisite ironwork. Two fine rings in heads of lions are on the doors of the porch.

The majesty of a cathedral belongs to the interior of this great place, where dark marble blends with stone. Everywhere are stone vaulted roofs; the aisles have arcaded walls; the nave, the chancel, and the transepts rise with triforium and clerestory over their arcades. The nave occupies 160 of the church's total length of 275 feet, and is 58 feet high inside. Its fine avenue of richly moulded arches rests on massive round pillars with plain and leafy capitals, and bases carved with foliage and fruit and dragons eating berries. It is a noble vista. Under the mighty arches of the tower we look up into a vaulted lantern with eight lancets. The rood across the eastern arch was carved by a craftsman of Oberammergau. Three arches on clustered shafts support a vaulted gallery at the west end.

The chapel in the north transept has glass (by Clayton and Bell) telling the history of the shrine of Our Lady of Walsingham, which was destroyed four centuries ago; the reredos is crowned with a figure of Our Lady of Walsingham, and shows in panels below the Annunciation, the Crucifixion, and the vision which led to the founding of the original chapel at Walsingham. In the mosaic of colour filling the noble group of three lancets in this north transept are Our Lord and His Mother enthroned, queens from the Old Testament, pilgrims adoring, and medallions of East Anglian saints.

At Heigham, a Norwich suburb on the Wensum, is the Dolphin Inn, with a stone-pillared gateway opening to a tiny courtyard. A rambling two-storeyed house with flint walls patterned in stone and brick, it is charming with gables and mullioned windows, and a doorway set between fine double bays with transoms. It was built by Richard Browne, an Elizabethan merchant, whose arms and 1587 are over the doorway, and his initials on a gable, but it has some remains of an earlier house. Between two windows is a lead dolphin, and within are panelled rooms and a plaster ceiling. It is called sometimes Bishop Hall's Palace. The bishop sleeps in the chancel of St Bartholomew's church near by, where his memorial has a gruesome skeleton holding scrolls, and a canopy crowned with a shield and mitre. Thomas Hall of 1630 is very quaint as we see him in brass, wearing baggy breeches and high top boots. The trim little church is medieval but much restored. The walls are of flint and boulders. The fifteenth-century tower has high battlements of flush arcading, corner turrets, and gargoyle heads under a corbel table dotted

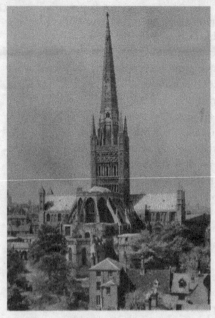

The crown of Norwich

with flowers. As old as the tower are the roofs and the font, which has a Jacobean cover, and in the corner of a window is a charming fourteenth-century piscina with two traceried arches.

Lakenham, to the south of the city, has a new church with walls built of flint and boulders with brick dressings, and the roofs inside are a striking example of the use of concrete, the panels outlined in green and white. The chancel is an apse without an east window. The fourteenth-century font with a Jacobean scroll cover was brought from a deserted church at Knettishall, near Harleston.

We come now to the gem of this galaxy of old buildings telling the romantic story of Norwich, the cathedral, set in a loop of the river. Though it stands in a hollow where the sea once ebbed and flowed, its lovely spire soars so high that it crowns all views in the city. Only Salisbury has a higher spire, the spire made familiar to the world by the most famous artist of East Anglia, and in all England there is not a loftier or richer Norman tower than this from which it springs. The tower itself is 140 feet high, and though the stone of its tiers of arches and windows has been much renewed outside, the interior is perfect. Poised on the top of the spire, 315 feet from the ground, is a golden chanticleer, which flashes on a sunny day against the blue. The

spire is like a finger beckoning us to come to see this exquisite structure rising so graciously into the sky. Whether we look at it from the east or from the west the beauty of its lines thrills us; from the east it rises higher and higher until the eye is drawn as by a magnet to the crowning glory of one of the noblest ancient buildings in the land.

The story begins in 1091 with Herbert de Losinga. Even bereft of all the legends and traditions that have grown up round one who achieved such a monument as this cathedral, the story of this bishop is a fascinating revelation of clerical life eight centuries ago. He was born before the Conqueror set foot on our soil, but where he was born is a matter of dispute. Educated in the monastery at Fecamp, he served so well as Prior that William Rufus made him Abbot of Ramsey and gave him a place in the royal household. It is said that he received a bishopric for paying £1,900 into the treasury of Red Rufus, and that the king made him a bishop without consulting the Pope. Most men acted corruptly then, but only the conscience of one seems to have greatly troubled him. Losinga himself realised that he had been sinful, and he determined to go to Rome to resign in person. Rufus discovered the purpose of his journey and degraded him; but Herbert went on, the Pope accepted his resignation, granted him absolution, and made him Bishop of Thetford again; but as penance imposed on him the duty of removing the see to Norwich and building a new cathedral.

Such was the beginning of Norwich Cathedral. He returned to his diocese with renewed vigour and made his peace with Rufus, who helped him with the building. The foundation stone was laid in 1096, and before Losinga's death in 1119 the eastern portion of the great pile was standing much as it is today—the presbytery with its apse and rare ambulatory, the lower part of the central tower, the great transepts with the eastern chapels, and perhaps four bays of the nave, which served as a choir for sixty monks.

His cathedral is unique in many ways, and has many treasures, but it has nothing of more interest than the painted medallions which have come to light in our time and been restored by Professor Tristram; one shows Losinga passing money across a table, in another he is robed as a bishop in an attitude of prayer, while the third has a picture of a church perhaps meant for the cathedral. Besides the painting of the medallion we see him here in crumbling stone, bareheaded and with uplifted face, his crozier in one hand and the other raised in blessing; so he stands in a niche over a cathedral doorway, facing the garden of the bishop's palace.

Though the palace has seen many changes, and is now largely modern, it still has portions of the stout walling and vaulted basement of Losinga's foundation. The picturesque ruin in the garden is supposed to be part of

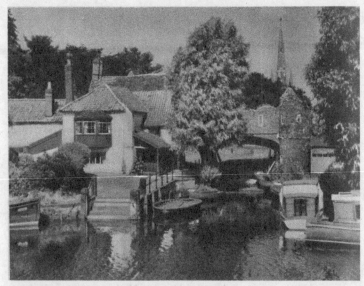

The charming corner by Pull's Ferry in Old Norwich

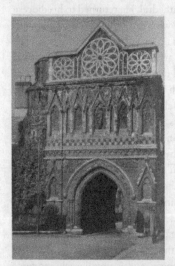

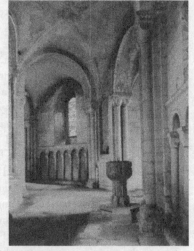

Above left: St Ethelbert's Gate in Old Norwich

Above right: The font in the ambulatory in Norwich Cathedral

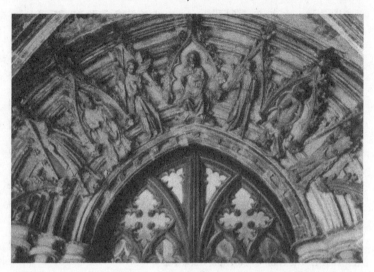

Above: The rich carvings over the East Cloister door

Right: The modern oak pulpit in the choir of Norwich Cathedral

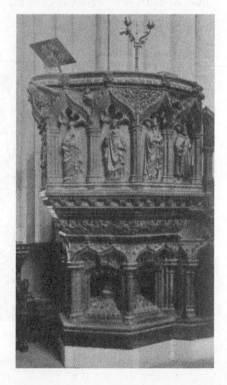

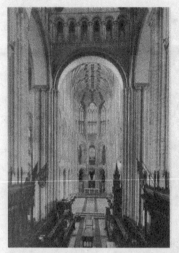

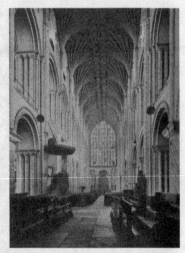

Above left: The choir of Norwich Cathedral

Above right: The nave of Norwich Cathedral

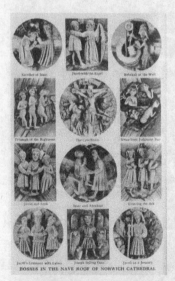

Above left: The boss in the nave of the roof of Norwich Cathedral

Above right: Tombland Alley in ancient Norwich

the entrance to a medieval hall 120 feet long. The private chapel comes from the time of Charles the Second. The approach to the palace from St Martin's Plain is by a two-storeyed gatehouse of about 1430, imposing with a big archway and a smaller archway at its side, a traceried frieze with shields and crowns, and a seated figure in a niche between the windows. It has battlements and vaulting, and its beautiful carved doors were added later in Stuart days.

Green lawns and many old houses cluster about the cathedral. At the south-east comer of the Upper Close is the Audit Room, with fifteenth-century windows in flint walls, and facing it is a fine old house with Dutch gables. A little road close by leads to Pull's Ferry, where the river laps the picturesque old Watergate of the precincts. It was once at the mouth of a canal, which was cut to bring the stone for the cathedral almost to its doors. From the Ferry the cathedral is a charming picture, rising behind the clustering houses with roofs of rich pantiles peeping from among trees. From what is curiously called Tombland (not from any association with tombs but from Toomland, or waste land), lovely in spring with the limes in new leaf, two beautiful gateways lead into the Upper Close. St Ethelbert's Gate was built by the city as payment of a fine for their riot with the monks in 1272, when they set fire to the cathedral. Over its vaulted archway is a chapel; over the chapel is a gabled compartment of rich flush-work in flint and stone.

The lofty arch of the Erpingham Gate, set in flint walls, has old panelled doors, and through them is the lovely view of the cathedral's west front. The gate was built about 1420 by Sir Thomas Erpingham, whose kneeling figure, with his sword slanting at his side, is in the gable. In the rich mouldings of the arch are bauds of foliage canopies sheltering twenty-four saints, and at the top are two angels by a shield with the Five Wounds. The spandrels are delicately carved. The turrets at each side are panelled with shields of Sir Thomas and his two wives; and at the top of each turret sits an ecclesiastic. The word Yenk, for Think, is repeated on the gateway, which some say Sir Thomas built as a penance for his sympathy with the Lollards. It is more likely that he erected it as a thankoffering for coming safely through the Battle of Agincourt, where he led the English archers.

At one end of the Close is a bronze statue of Wellington with his sword; at the other Nelson stands with his telescope, sculptured in marble, looking to his old grammar school just within the Erpingham Gate. Founded as a chapel in 1316, and converted to a school by Edward the Sixth, the fine little building is now the school chapel, keeping its old trussed roof, the gallery with balusters, and the big windows adorned with an array of men and women with golden hair, some hooded, some wimpled, some in netted

headdress. The old vaulted crypt (once a charnel house) is now the school's library, and in it are several old chairs and a quaint list of school regulations. Quaint, too, is the porch added in the fifteenth century; at the top of its steps we can touch the bosses of its vaulted roof, and from it another flight of steps leads to the splendid old door of the chapel, charming with its old hinges of scrolls and leaves and its rich boss with an iron ring. George Borrow came to this school, and that Lord Justice Coke who hounded Raleigh to his doom.

No other great English church has its Norman ground plan so little changed as Norwich Cathedral. Not only does the original plan remain, but most of the Norman work stands.

The great nave and transepts remain, with the Norman lantern of the central tower, and the choir and the presbytery preserve the Norman plan with the projecting eastern chapels which are so attractive outside and in. The central chapel of these three, pulled down in Elizabethan days, has now been rebuilt in memory of the men who fell in the Great War, so that the exterior of the cathedral is as it was, a captivating spectacle with the roofs of these low chapels round the apse, the choir behind them rising twice as high, and the beautiful tower soaring like an eagle into the heavens. The tower is a mass of carving, giving it a striking air of grace which is emphasised by the lightness of the spire. The shafted buttresses at the corners, like fluted pillars, end in spire-like pinnacles above the medieval battlements, and the four faces of the tower have rows of slender arches and windows (probably 100 in all), delicate tracery of ring and diamond pattern, and two tiers of great circles. All this work is Norman, but the elegant spire, pierced with dainty windows, decorated with buds or leaves running from top to bottom at its six angles, and crowned with a cross, is fifteenth century.

The west front, plain compared with many of our cathedrals, has a dignified simplicity with a great window filling the space above the western doorway; it is Norman and medieval. The central doorway, which has been refashioned since Norman days, has still the old traceried door swinging on its hinges, and inside the original Norman arch remains. The aisle fronts are as the Normans left them, each with doorways of three orders, arcading and windows above them, and twin towers with turrets like pepper-pots to match the great gable. The cathedral has a length of 461 feet, made into a simple cross by the great transept, which is 178 feet from end to end.

But, majestic as is the cathedral without, we are spellbound, as we enter the nave from the west end, by the stately grandeur into which this gleaming stone is wrought. The walls rise in three tiers of Norman arcading; the massive strength of the great piers is relieved by their slender shafts, from

some of which grows Bishop Lyhart's exquisite vault, enriched with 329 wonderful bosses shining with colour and gold. The arches of the triforium are framed with zigzag, and those below with other ornament. Norwich is unique in having a triforium almost as lofty as its main arcading. Breaking into the uniformity of the main arches are two enormous round pillars with spiral carving, and two four-centred arches on the south side which Bishop Nykke set up for his chapel. It is an unforgettable scene. When the sun is shining through the windows the triple-arched clerestory is a golden passage, reflecting its light on the vaulting and showing up the sculpture of the bosses, which are only part of over 1,200 in the cathedral and the cloister, an amazing collection unrivalled in the land, containing thousands of sculptured figures. These in the nave are arranged in groups, telling the chief stories of the Bible from Creation to the Last Judgment. Look up, they seem to say, and see written above you the history of the revelation of God to Man.

Seventy feet above the floor, this roof is teeming with life; it has hundreds of figures in animated groups, people and animals carved with directness and vigour. The whole work shows a fine sense of decoration, and remarkable inventiveness. We will run through the fourteen bays of the nave and pick out from the bosses on the roof those that have most significance or beauty, going east to west.

In the first bay a human face encircled by golden rays signifies the Creation of Life like a fancy of William Blake, and the Almighty is raising a hand in benediction. Then comes the Creation of Adam, Eve with an apple in each hand, the coming of fishes and birds (the eagle with beak and claws of gold), and the death of Cain. The second bay has the story of Noah and the Ark with Noah's wife looking out from the windows. The Tower of Babel opens the story of the third bay which continues with the tale of Abraham, Isaac,

Esau, and Jacob. We see Rebekah at the well, a most graceful figure, Jacob deceiving his father, and Esau calling for the blessing his brother has stolen. In the fourth bay the story of Jacob continues and we see him wrestling with the angel, and meeting Rachel; a very curious boss is Jacob's ladder with angels ascending, but the work is not so fine as that of the flocks of sheep and goats. The fifth bay shows us Joseph and his brethren; we see Jacob, with a turban of gold on his head, sending out his son, his brothers stripping him of his coat of many colours (though here it is gold), the merchantmen carrying him to Egypt, and the strange adventures which brought him to power. The sixth bay continues Joseph's story, showing him standing amid sheaves of corn with his brethren, and in this bay we see the Birth of Moses, his rise to manhood, the burning bush, the overthrow of Pharaoh's host in the Red

Sea; and we come to the life of Samson who is rending a lion. In the seventh bay Samson is carrying off the Gates of Gaza, and is seen again losing his power by surrendering to Delilah, who shears his locks and binds him. David succeeds him, and we see him aiming his sling at Goliath and trying on Saul's armour; it is a very graphic boss which shows us David's stone buried in the giant's forehead. We see David crowned in the biggest boss of this bay, and Solomon following him in all his glory, bearing the Temple in one hand.

The eighth bay brings us to the end of the old and the beginning of the new, for Gabriel is bringing the good news to the Madonna, whose hair falls over her shoulders. The Holy Child lies in the manger, the ox and ass bow their heads, the Wise Men bring their offerings, the Shepherds come, Herod's order goes out for the Massacre of the Innocents. In the ninth bay we see Mary escaping with the Child to Egypt, and the sculptures pass on to show us Christ growing up, with the doctors in the Temple, performing miracles, sitting at table with Mary and Joseph, baptised in Jordan, and tempted in the Wilderness. We come to the supper in Bethany after the Raising of Lazarus, and the tenth bay brings us to the Last Supper followed by the Triumphal Entry into Jerusalem. We can pick out most of the disciples at the table; John is Waning forward with the Master's arm resting on his shoulder. In the eleventh bay the hour draws near to Calvary and we see Our Lord in Gethsemane, the Betrayal before Pilate (in which Pilate's wife whispers into his ear). In the twelfth bay the sculptors approach the height of their power and the Crucifixion is in the midst, soldiers crowd the bay, but the lower half is filled with the dawning light of the Redemption. We see the Entombment and the Resurrection, and finally, in the thirteenth bay, the Ascension. The next and last bay shows the Judgment, with angels sounding the summons to the dead, the evil ones being thrown down, the righteous ones rising with the angels; and last of all we see the very modest boss with the portrait of good Bishop Lyhart who built this noble roof 500 years ago.

The bays forming the choir are cut off from the rest of the nave by Bishop Lyhart's stone screen, of which the lower part is original. In the mouldings of its doorway are delicate canopies, and in the spandrels are the bishop's shield and the hart. A blue stone under the screen marks his grave. A piscina at the side of the doorway marks the site of the altar of a vanished chapel dedicated to St William of Norwich, the boy supposed to have been martyred by the Jews. Over the screen is the organ, beyond which we see the arches of the tower on incredibly tall pillars and the windows of the Norman apse shining like a jewelled mosaic.

The bosses of the vaulting in the transepts show the Nativity and the early life of Christ, but the work here is not so versatile as in the nave,

and the same subject is often repeated. Two unusual pictures are the death of Herod and angels receiving the Innocents. In the profusion of star-like bosses adorning the lovely vault of the presbytery are the gold wells of Bishop Goldwell who gave it. Even higher than the roof of the nave this roof grows from finials of the smaller arches between the great ones framing the windows of the clerestory. The Norman arches of the triforium continue towards the presbytery, but the main arcade of the north and south sides is believed to have been altered by Bishop Goldwell. Their four-centred arches have traceried roofs; between the bays are canopied niches; and under the triforium is handsome cresting.

In the arches dividing the aisles from the transepts are stone screens. An old one with beautiful tracery, leading to the south aisle of the vaulted ambulatory, has been immortalised by John Sell Cotman, the water-colourist of the Norwich School, and was the gift of Robert Catton, the last prior but one of the monastery. His initials are on the lock of its old door, through which we come to the fourteenth-century Bauchun chapel, which has a fine original window and a canopied niche, and many bosses in the fifteenth-century roof telling the story of the life and death of the Madonna. We see her in a long cloak, surrounded by rays of gilded light, and again hearing the message of Gabriel and kneeling to receive her crown.

We next pass into Bishop Losinga's little Norman chapel of St Luke, curiously rounded in shape, as is its companion Jesus Chapel on the north side of the processional path. Both have arcaded walls and vaulted roofs. St Luke's Chapel has windows made new in Norman style, but it still has some original painting. It is now the parish church of St Mary-in-the-Marsh, in place of an old church on the south side of the Close which was destroyed 400 years ago, and its sadly battered old font stands near the entrance to the chapel, richly carved on the bowl with the Seven Sacraments, angels under the bowl, canopied figures round the stem, and headless figures and birds round the base.

There is a lovely view from this chapel of the apse end of the presbytery, and of the two 700-year-old arches in the vanished lady chapel. They are exquisite with their clustered shafts, ornament-like chains of flowers, and quatrefoils between the two arches. The ashes of Dean Beeching lie opposite this lovely entrance, and it is fitting that it should be so, for it was his wish that these arches should be opened out again and a new chapel built. Dean Beeching is remembered as a poet of no mean order, and it is to be hoped that every English boy knows his Boy's Prayer. Through these two arches we come to the cathedral's biggest chapel, fragrant with the memory of those who gave their lives in the Great War, Here is the Book of Remembrance

with over 15,000 names, and with the names of the women is that of Edith Cavell, who sleeps outside the wall on what is called Life's Green.

Dedicated to the Holy Martyrs of Losinga's day, the Jesus Chapel has been much restored, and its walls are painted in the old style. Here the body of St William of Norwich is said to have been buried for a time. Here, too, is an old altar stone (marked with five crosses) beneath which relics were kept; and also in this chapel is the only brass left in the cathedral, a Latin inscription to Randolph Pulverton, master of the charnel house in the fifteenth century. Near Jesus Chapel is another of the cathedral's rarities, a curious low archway built across the aisle like a bridge, on the top of which, reached by a spiral stairway, the relics of saints were once displayed. In the painted vault above the bridge are twelve saints grouped round Our Lord in Majesty; the faded paintings on the arch west of the bridge are apparently the Disciples. A round chapel east of the north transept has been restored in memory of Archdeacon Westcott, and is entered by an oak screen.

Rarest of all the possessions here are the remains of the ancient bishop's throne, now under the central arch of the apse behind the high altar, at the head of a flight of stairs. It has been restored in our time, and what is left of the old throne is believed to be part of one built by Losinga on his return from Rome. An oak seat has been placed on the original stone ledge. By the simple altar on fluted pillars are four silver candlesticks richly worked, which, with an almsdish, were given to the cathedral in 1665 to replace those stolen during the Civil War. The altar rails are tiny marble pillars, with a top rail of interlacing bronze on enamel. By them is a rare brass lectern 500 years old with its original pelican, and three modern figures round the stem representing the three orders of the ministry.

The cathedral has a noble array of canopied oak stalls, made by craftsmen who would hear the bells ringing for Agincourt. They are wonderful in the delicacy and infinite variety of their rich carving. The canopies have leafy arches, sometimes carved with eagles, and the tracery of the panels beneath them is tipped with leaves and flowers, dogs curled up asleep, pelicans, faces of men, and a quaint company of girls with expressive faces. The return stalls have exquisite vaulting. On the arm-rests are birds, grotesques, a king, and odd-looking men. The misereres are captivating. Much of the cathedral's rich store of carving is in the roofs for all to see, but here in woodwork superb craftsmanship lies hidden. There are animals fighting, dragons, monks, a squirrel eating nuts, a knight in armour, a man forcing open a lion's jaws, a monkey riding a dog, a mermaid and dragons, a man on a pig's back. A monk is distributing bread to boys whose books are open on the table. An old woman with distaff and spindle chases a fox which is rushing off with a

chicken, and a pig behind her is drinking out of a three-legged pot. Notable among the rest are the carvings of a woman reading, a domestic scene, and a bird's-eye view of a shepherd with his flock.

On the Corporation seats under the tower are twenty-two needlework tapestry cushions presented to the cathedral in 1621 by Thomas Baret, mayor. There were twenty-four, but one is in the Castle Museum, and the other was presented in 1904 to Norwich in Connecticut. These cushions have the arms of Norwich, the castle over the lion with a flowered border worked in red and green, and are still in good condition. At the ends of these seats are the oak pulpit and the bishop's throne, both modern and well worthy of their place, one a tribute to Bishop Pelham, the other to Dean Goulburn. Round the pulpit are eight saints in niches adorned with angels and foliage and beautiful arcading under a border of vine and grapes almost hides the fine pedestal, which grows from the roots of a vine and is entwined with its leaves. An angel stands at the foot of the arcaded stairway. Fashioned like a tower and spire, the bishop's throne is a wonderful mass of carving from floor to finial, with faces peeping everywhere out of the delicate tracery, angels on the arm-rests, and under canopies at each side figures of Bishop Losinga and Bishop Pelham. The old bishop's throne is now in the Bauchun chapel.

The two bishops' thrones have a cardinal's throne to keep them company, for the dean's seat in the nave, near the handsome stone pulpit, is believed to have been the official seat of the Emperor Maximilian over 400 years ago, and is a quaint chair of wood marvellously inlaid with ivory, the back having star pattern and a coloured medallion of a man in a cardinal's hat, set in a frame of delicate ivory filigree.

But the cathedral has no greater treasure than the rare painting on wood now in the south aisle of the ambulatory. Originally a reredos in the Jesus Chapel, it escaped destruction by a miracle in the Civil War. It was stolen from the cathedral and turned upside down to serve as a table till Professor Willis discovered its secret in the middle of last century. Its five panels show the Scourging, the Bearing of the Cross, the Crucifixion, the Resurrection, and the Ascension. The colour is rich and most of the figures are in fine robes. It is believed to be the work of Thomas de Okell, Mayor of Norwich who painted the wonderful Wilton Diptych, one of the most exquisite small possessions of the National Gallery. Both Okell and his son were artists, and it is known that they did painting for Norwich Cathedral. The oak leaves of the background of the Resurrection scene are thought to be a rebus of their name. The arms of Henry Spencer, the fighting bishop, are also on the picture. The Wilton Diptych belonged to a Spencer family related to

the bishop, and it is likely that the bishop commissioned Okell, the chief East Anglian painter of those times, to paint the Wilton Diptych in 1377 to commemorate the accession of Richard the Second, and the altarpiece five years later to commemorate the suppression of the peasants. Most realistic is the Resurrection scene, where the soldiers look sound asleep and might well have been painted from living people; the figure of Christ is impressive and dignified. In the Crucifixion St John holds the fainting Madonna, who wears a dress of red and gold and a blue-green cloak. There is much expression in the faces, and the elaborate background is of vine leaves. The face of Christ has evidently been repainted in the panel of the Scourging; the man with the three-thonged whip has a fearful look.

There are many relics for us to see in the ambulatory. Three carved and painted bosses are very striking, one showing three people lamenting over a king who lies in a bed with a golden coverlet. Here is the big Bible, bound in red morocco and embossed with gold ornaments, on which Queen Victoria signed her coronation oath; a thirteenth century-gold ring, a medieval signet ring cut with the scene of a duck holding a sprig, and the carved oak head of Bishop Lyhart's pastoral staff. With the parchments of grants and charters with seals are a grant by Losinga and a grant by Hugh Bigod, who succeeded William Bigod as constable of the castle when William was drowned with Prince Henry in the White Ship. The fourteenth-century Domesday Book of the diocese is a copy of an older one, and the beautiful writing is probably that of Richard Middleton, sacrist, who gave the book to the Norwich monastery.

Two little Jacobean men of painted wood, with striped trousers, are holding up swords to hit a bell; they once belonged to an old clock, and are known as quarter-jacks or jacks of the clock. Now they stand below the modern clock in the south transept. One of four old chests is sixteenth century and foreign; inside the lid are pictures in a sort of poker-work showing the Last Days in Jerusalem. Two tattered flags hanging in the choir have a thrilling story; they belonged to one of the original battalions of the Norfolk Regiment, which was on its way to India during the Mutiny when the transport caught fire a thousand miles from shore. At the height of the fire two of the men rescued these colours at the peril of their lives.

In the cathedral museum are some Jacobean helmets, an old flint gun about six feet long, and a watchman's box with folding doors. In the muniments room is what is probably the finest collection in existence of 1,500 rolls of the Obedientiars (the twelve assistants of the prior who were at the heads of the various departments), about 2,000 manor and account rolls, and many other documents, with old seals. They are in excellent condition; no other

cathedral has so many dating from the thirteenth and fourteenth centuries. If put together, the rolls of the Obedientiars would make about a mile and a half of parchment. They are from one to ten feet long.

In the old glass we see a beautiful Madonna in golden rays, a smaller Madonna, a saint in a roundel, heraldic shields, and foreign roundels. The painted glass of the great west window shows the Old and New Testament story. Burne-Jones glass in the other transept shows three warrior saints on a heavy background of trees and mountains. A window to Dean Lefroy shows Paul on Mars Hill.

Many of the bishops who sleep in their cathedral have nothing to mark their resting-place; some have simple stones. Bishop Goldwell lies in his elaborate chantry in the presbytery he transformed. His is the only known monument in England that has survived the Reformation with a bishop wearing the processional cope over the vestments. His lifesize figure lies with the feet on a crouching lion. On his broken hands are jewelled gloves. This much-travelled bishop had been secretary of State to Edward the Fourth and ambassador at Rome. His features are defaced, but his robed figure is considered one of the finest of the kind in England.

In the next bay (seen from the ambulatory) are the remains of Bishop Wakering's tomb, with ten figures on pedestals. He was a persecutor of the Lollards, and many of them were martyred in his time. On a pillar here is a monument with the coloured portrait of Bishop Overall of 1619; he has a black cap on his white hair, his ruff gives him dignity, and he has a keenly intelligent face. He was known as the best ecclesiastical scholar in the English nation, and Sir Thomas Browne tells us that he was highly reverenced.

The fighting Bishop Spencer is buried close to the founder in the middle of the presbytery. He died six years after Chaucer. Bishop Corbet, poet and wit, son of a Surrey gardener who became chaplain to James the First, is also buried in the presbytery. There is an eighteenth-century monument on a pillar to Bishop Horne, whose inscription tells us that he had depth of learning, brightness of imagination, and sweetness of temper. Two other bishops here should be remembered for the courage of their opinions: William de Turbe, who was the only bishop to take the part of Becket against Henry, and William Lloyd, who ruled the see of Norwich 500 years later. If his letter had not been delayed in the post there would have been eight instead of seven bishops at the famous trial for sedition. As they did not hear from him whether he wished to sign the petition or not, the Seven Bishops took action without him.

One of the last works of Chantrey is in the south transept, the monument to Bishop Bathurst, who was in his day the only Liberal bishop in the House

of Lords; he wears his robes and a short wig, and sits with folded hands in deep contemplation. Chancellor Spencer's sixteenth-century tomb, on which tenants long ago paid their rents, is under one of the arches of the nave, and in the next bays are the tombs of Bishop Parkhurst, a leading spirit of the Reformation, who fled to Zurich from Mary Tudor's Terror; and Bishop Nykke, who for conspiring with the Pope against Henry the Eighth, was imprisoned and fined a thousand marks. Opposite, under an arch of the north arcade, is the neat tomb of Sir John Hobart, Attorney-General in Tudor days and friend of one of the writers of the Paston Letters. The heraldry on the tomb was broken during the Civil War, when the cathedral was filled with musketeers. Under another arch here is the tomb of Sir Thomas Wyndham and his four wives. Sir Thomas was one of the counsellors of Henry the Seventh.

One of three fine memorials is the brass portrait of George Peilew in his robes; he was dean for thirty-seven years last century. Bishop Pelham, a lifelong friend of Cardinal Manning, is a white marble figure lying on a tomb adorned with mitre and shields. Charming is Violet Morgan's marble figure, kneeling at prayer near Jesus Chapel, sculptured by Derwent Wood, RA. She died just out of her teens at the end of the Great War.

We now leave the cathedral and come into the cloisters. There are slight remains of some of the monastic buildings, and the cloister remains complete, the biggest monastic cloister in England, the only one with an upper storey, and second in beauty only to Gloucester's, while outrivalling that in the wonder of its bosses. It is a lovely quadrangle, with walks 12 feet wide, and a garth 145 feet square.

The Norman cloister was largely destroyed by fire in the riot of 1272. No man who saw the beginning of the cloister we see could have seen its completion, for it was 130 years in building, having been begun in the last years of the thirteenth century, and finished in 1430. There are half a hundred bays with beautiful windows, and their tracery is glazed, showing the development of style as the work proceeded. The eastern walk was the first to be built. We come to it from the south aisle of the cathedral through a beautiful doorway of 1299, its pointed arch resting on seven slender shafts at each side. Across the mouldings of the arch is a splendid series of seven figures in relief under leafy arches, all in colour and gold.

As we stand on the seven steps leading from this Prior's Doorway to the floor of the cloister, we gasp with amazement at the inspiring sight of the two walks in our view, the east and the north. They are like avenues of stone trees touched with bronze, russet, and gold, with clustered shafts for trunks, vaulting for overhanging boughs, and glorious coloured bosses hanging as if

they might be fruit or flowers. By the Prior's Doorway, with an arch which is one of the masterpieces of medieval art, are three big recesses which served as book cupboards. Beyond is the rich arch of a fourteenth-century doorway which led to the slype, and then come the three traceried bays which opened to the vanished chapter house. In the charming south-west corner of the cloister is the doorway which once led to the refectory that adjoined the south walk; and just within the west walk are the two beautiful bays where the monks washed their hands. The two tomb-like tables are richly carved on the front with entwining vines, and are hollowed on top for the water; the arches are carved with figures in roundels of tracery, and all of it shines with colour. In the back of each recess are three battered niches which have lost their old statues, but in two of them are now fine figures of George the Sixth and Queen Elizabeth, both wearing crowns and ermine robes. In niches close to them are small statues of George the Fifth and Queen Mary, finely sculptured by Gilbert Ledward. Very striking are two bosses here, showing Our Lord in Glory with the heavenly host, and a knight at the castle gate, a crowd standing in the battlements, and faces peeping from windows.

The cloister bosses, like those of the nave, are an unending delight. Those of the east walk illustrate the story of the Gospel and the Four Evangelists; those of the south and west walks have scenes from Revelation; and legendary subjects are treated in the north walk, on the wall of which is a great modern display of heraldry.

The Monk's Door leads from the cathedral to the west walk, in which there is a doorway to the choir school. The upper storey of the cloister may have been built for the little studies where the monks did their literary work. One of the rooms has been made into the cathedral library, and here is a collection of rare old books and manuscripts. Among them is the Berners Book, printed on the Caxton press by Wynkyn de Worde, Caxton's clever foreman. The smudgy pictures of heraldry are some of the first examples of colour printing. There is a fifteenth-century prayer-book, brilliantly illuminated. A few of the 7,000 books have original wooden covers.

From the south-west of the cloister is a lovely view of the cathedral, beyond the green garth and the walks; but there is no more attractive near view of it than from Life's Green, the secluded retreat round the east end, hemmed in by old houses and trees, where the birds are singing and the city is lost to sight. It may have been a graveyard for the monks; now it is the resting-place of Edith Cavell. A simple cross marks her grave, and a few words tell us that she gave her life for her country. She lies close to the chapel raised in memory of those who died for us in the Great War, in the shadow of impressive Norman walls with tiers of arches and windows. In this quiet

place, to which her body was brought with the return of peace, the mind runs back to those days in the first year of the war, when she was nursing the wounded, Germans and Belgians, too, and when, driven by the sight of free men turned to slaves, she dared to risk her life by sheltering Belgians from the Army hacking its way through their country. Caught in an act of war, she was arrested and sentenced to death in spite of the protests of the ambassadors of neutral lands, and one autumn night in 1915 she was led into a garden and shot.

Ormesby St Margaret

In this long, pleasant village the woods share the road with the dwellings. At one corner we have a peep through the trees of an embattled house, its gates guarded by falcons. At one end is the fifteenth-century church with a fine tower which has four saints for pinnacles. A porch with an upper room and an old sundial shelters a Norman doorway with four orders of mouldings. There are heads between the arches of the lovely sedilia and piscina in the chancel, and at the ends are a hare and a grotesque.

Oulton

A dial scratched on the doorway of its medieval church was telling the village folk the time 700 years ago, but there is little for the traveller to see in this small Norfolk village. It is said that the stones in the walls of the Congregational Church were taken from two chantry chapels of the thirteenth-century church standing on high ground a mile away, and the Congregational Church is interesting because one of its benefactors was Jeremiah Fleetwood, kinsman of the man who married Cromwell's daughter, Bridget, the widowed Mrs Ireton. The rarest possession of the little church is a paten with the head of Our Lord engraved on it by a craftsman 700 years ago.

Outwell

There are perhaps no longer twin villages in the land than Outwell linked with Upwell, and through the heart of both flows the River Nene. Where the road widens stands Outwell's medieval church, and half a mile away are the old brick walls and clustered chimneys of the Elizabethan home of this family of the Beaupres, the fair meadow standing in the trees.

The thirteenth-century tower was given its top storey when it was a century old. A rich band of quatrefoils runs along the base of the south aisle and the chancel walls, and a porch with a vaulted roof leads us in. The fourteenth-century nave has a roof adorned with angels and is supported

by fine wooden figures. Angels look down from the south aisle roof and from the roof of the Beaupre chapel, where there are also quaint figures in foliage. Shining in the window tracery over the old altar table in the chapel are figures of Christ and saints and martyrs set in clear fifteenth-century glass, and here is the Tudor monument of Nicholas and Margaret Beaupre, their son, and his wife.

The Haultoft Chapel, now the vestry, was built by Gilbert Haultoft, Baron of the Exchequer to Henry the Sixth. The Finchams followed the Haultofts as lords of the manor, and in their chapel, north of the chancel, is a roof with carved beams, and a saint holding a chalice in the old glass of a window. The brass portrait showing a sixteenth-century knight in armour is of Richard Qwadring. The six-sided font is fifteenth century, there are two old chest-like travelling trunks, and a quaint old almsbox carved with faces through whose mouths we slip a coin for charity.

Overstrand

Cromer's little neighbour, it looks out to the all-encroaching sea, and it would seem that the spirit of its church defies the waves, for two churches stand in its churchyard heedless that the angry tides engulfed their predecessor 600

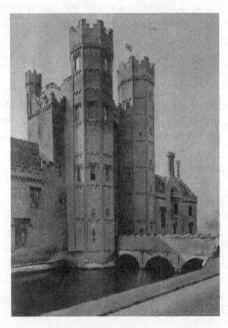

The gatehouse of Oxborough Hill

years ago. One of them lost its roof last century, and the village thought it best to build a smaller church beside it, but in our own time the new church has been closed, and the old one is renewed with something of its ancient dignity. The old font was rescued from a garden. The holy water stoup has still its lovely medieval tracery. The massive walls of the tower have a curious opening in them which was probably an oven for cooking the sacred wafers long ago. The graceful iron brackets for the lamps above the altar have saintly figures on them; they are modern like the pulpit, which was given by Florence Barclay, author of The Rosary.

Ovington

Roman coins and Roman urns have been found on its common, and on the border of the village is what is left of the earthwork known as High Banks, though the ramparts were levelled last century. Yews and pines guard the gates of the rectory and the church, side by side. Begun by the Normans and made new in the fourteenth century, the small church has a low square tower and a nave with Norman walls pierced by a variety of later windows. Among those on the south side is a small Norman window, and one of about 1300 with intersecting mullions. Here too is the fine Norman doorway, its battered shafts supporting an arch with roll and zigzag mouldings under a hood. On one of its capitals is a scratch dial, and at the side of the doorway is an old stoup. The chief interest of the dim interior is in the fourteenth-century font, eight shields in quatrefoils on the bowl, and round the base battered figures of eagles and an angel. There is a simple Jacobean table.

Oxborough

Here were the Romans. From the lane where a little bridge crosses the stream, flowing through the park to find the River Wissey, we have a lovely view of the stately old hall, a superb pile of embattled walls, stepped gables, and patterned chimneys, reflected in the water of the moat. It is built round a courtyard, and from the road we see its fine gatehouse with two towers seven storeys high.

Except for the years of the Commonwealth, when the house was seized and sold by Parliament, it has been the home of the Bedingfelds since Sir Edmund built it at the end of the Wars of the Roses, and it has been little altered since his day. Henry the Seventh came here to visit his supporter, and in the turret of a tower is the brick staircase he climbed to the room prepared for him. It is a kingly room indeed. The walls have their old linenfold panelling, and the coverlet of the bed, the very coverlet on which the king rested his uneasy head, is embroidered in the complicated Tudor

design of birds and beasts. It is said to have been the work of Mary Queen of Scots, of whom there is a portrait in the house.

We pick up some of the story of the Bedingfelds in the fifteenth-century church, which stands where the ways meet near the hall. It is a charming picture, with its fine tower and spire rising high above the trees, and the old sanctus bellcot is on a gable of the nave. The spire was made new last century, after the old one had been struck by lightning, and it reaches the height of 150 feet. The church succeeds one of which ruins are in the rector's garden.

The view of the spacious interior is imposing from the chancel, looking along the wide nave arcades to the beautiful arch of the tower. Old bricks and tiles pave the open space in front of the chancel screen, which has battered tracery and ancient paintings.

On the arm-rests of grey old benches are battered carvings of grotesques, a dog with a cockerel, a pelican, and nine little pigs with a headless sow. There is an old font, and an old altar stone is on the floor of the chancel, where for sedilia is an unusual long seat enriched with quatrefoils, its traceried back under a coved canopy with a cornice of angels and roses. In remains of old glass are angels, the head of a king, and a figure under a canopy.

The old brass eagle lectern with the beak open for putting in pence and an opening at the tail for taking them out, has three lions at the foot, and is one of about fifty that have been in our churches since before the Reformation. Its Latin inscription asks for prayers for Thomas Kypping, a fifteenth-century priest.

Old roofs look down everywhere, all simple except that of the chapel founded by Margaret Bedingfeld in 1513. Enclosed from the chancel and the aisle by Italian screenwork of terracotta, with grilles, like a white cage with elaborate decoration, its only beauty is its fine old roof, with richly moulded beams resting on angels. Here is the canopied marble monument of Sir Henry Bedingfeld of 1583, whose name is more notorious than all the rest. Sir Edmund, his father, had been steward to Catherine of Aragon during the last years of her life, and history records that he was a harsh guardian. He was harsh also to Princess Elizabeth while she was under his care, and Elizabeth did not forget it. When she came to the throne she dismissed him with a 'nipping word.' There are monuments to Sir Henry Bedingfeld, a Royalist who died in 1657, and to another Sir Henry of 1684, the first baronet.

Oxnead

This was one home of the great letter-writers, the Pastons, soldiers, sailors, judges, courtiers, politicians, in the centuries before their name and fame

faded for a while, only to come to life again with the discovery of their letters. Never was a better example of the saying that the written word remains.

The River Bure marches at the foot of their park till it flows past a watermill and is lost in a grove. Across the park an avenue of oaks leads to a farmhouse whose gabled porches and slender capped turrets remind us that this was once the hall of the Pastons where a king and his queen were entertained. The chronicle of those who built the hall in the days when their power and riches were growing up is in the church under the beeches on the other side of the pleasant garden.

Palling

It is a far-away fishing village on a perilous shore, so perilous that two lifeboats are always ready for the storms; yet men have lived here a thousand years and more, for the thatched church has Saxon masonry in its low tower, refashioned 600 years ago. The old door still opens for us as it has opened for the village folk for 500 years, and in it is the ancient key, wearing away. Here are the old benches on which men and women have sat since soon after Agincourt, and the old font at which children have been christened longer still.

Paston

It was the discovery of a bundle of letters which gave it fame; its medieval church, its Elizabethan barn, could hardly have endowed it with significance if the Pastons had not lived here, and if their chronicles of fifteenth-century life had not been saved for us. Their old home is gone, the hall being on its site; but their grand old barn stands by the church, its steep roof thatched outside and fine inside with alternate tie-beams and hammerbeams.

A fifteenth-century porch leads to a plain nave and a bare chancel, divided by a fifteenth-century screen spoiled by the painters. The font, a stoup near the door, the piscina niche with its old shelf, and the sedilia into which a tomb has been set, are 600 years old. A parish chest is 500. Among the old poppyhead bench-ends is one with the Paston arms and crest, and another with the head of a horned demon. The chalice is Elizabethan, and the paten older still. Among a collection of old books in a case is the Paraphrase of the Gospels by Erasmus, which Edward the Sixth ordered to be put in all churches.

Some of the fourteenth-century paintings which may have covered the walls have been brought to light. A giant St Christopher with a benign face and a long beard catches the eye on opening the door. He carries the Child,

no bigger than his own head but holding the orb in one little hand and having the other raised in blessing. On the same wall are the three skeletons and three men representing the legend of the Three Living and Three Dead Kings, which tells how three kings hunting in the forest came upon three skeletons hanging. Another fragment may be part of a Doom picture.

The Pastons lived here till Clement Paston, that 'man of great stomach and courage,' built his fine house at Oxnead, where the monument with his figure is in the church.

There are about a thousand Paston Letters, and they are one of the most perfect mirrors in existence of the social life of an English family before the Tudors ruled and prosperity spread with internal peace. They cover the years between 1422 and 1509, and reveal how the Pastons increased their power and influence by marriage, and by careful choice of sides in the civil strife of the times.

Nothing could be more fortunate for the historian than the preservation of these letters, for the light they throw on their times is unique.

Pentney

A church which has grown from a Norman chapel stands at the cross-roads of this scattered village. Below it is the elegant shaft of an old wayside cross on a buttressed base, pointing the way to the site of a priory two miles away near the River Nar. A farmhouse stands in its place and embodies some of its remains, and close by, a delightful surprise at the end of the long winding lane, is the massive priory gatehouse which does honour to its builders in its stability and shapeliness. Two-storey high and all embattled, it has wide archways, and is flanked by turrets climbing from the ground.

Most of the plain church, with a western tower, is fifteenth century, but we can trace the Norman chapel in the tapering thickness of the walls, in a Norman pillar in the splay of a fifteenth-century window, and in the bold arcading in the side walls of the nave.

Poringland

There is magic in its name, for John Crome made it immortal by his picture of the famous Poringland Oak so familiar to us all in the National Gallery. In Carr's Lane near the village is an old oak which is pointed out as Old Crome's Oak. There are a few thatched cottages here and there, and opposite the church is an old red brick house with a high-pitched roof, a pretty two-shafted chimney stack, and a quaint little room over the porch. The bright church, though much restored, still has something from Norman to fifteenth-century days. The round Norman tower has thirteenth-century windows and

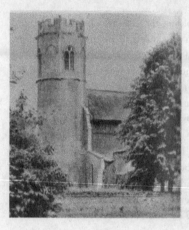

Potter Heigham Church

an eight-sided belfry of the fourteenth, and also of the fourteenth century are the north and south doorways and the chancel. The clerestory is 500 years old, its windows framed by the oak supports of the fine old roof of open timbering. The east window has a niche on each side and one above it, and in its clear glass are old pieces with two saints under canopies, Our Lord with a Crown of Thorns and a blue cloak, and a shield of the Five Wounds. Some old bench-ends have foliage poppyheads, and the 500-year-old font has four lions round the stem, and angels round the bowl.

Postwick

It hides in bowery lanes near a great bend of the River Yare a few miles from Norwich, and all we see of the village from the road is the church tower peeping from fine trees on a steep hill.

The charm of the little medieval church is only in its setting, and in its fine 600-year-old tower with ivy growing round the base. We found ivy creeping over the nave and covering the porch, and white clematis climbing round the east window. The fine font, as old as the tower, has women's heads carved under the bowl; the stone pulpit, the gift of a rector, is interesting for its ornamentation of coloured stones, which he collected on the shores of the Mediterranean.

Potter Heigham

All the world knows its old bridge, carrying the Yarmouth road over the River Thurne, with a rounded arch in the middle and a pointed one at each side. Some of its grey stone may have been here when King John came riding

by, and the main traffic of the Broads passes over it still. In summer it is gay with the spirit of holiday, and the yachts and the wherries draw up to it for the night. There are windmills round about, and old thatched cottages and new red roofs are in the lanes leading to the lovely village church, which awakens more ancient memories than the old bridge.

Standing at a quiet corner by a wayside pond, it has the charm of gracious old age, its outside dress irresistibly attractive with an ancient tower, lovely thatch on the nave and chancel, and a fine array of fifteenth-century windows in the aisles and clerestory. There are few bigger clerestory windows in our English churches than in this row of six on each side.

The Normans built the round tower, which reaches the top of the nave roof and is encircled by a band of grotesque heads. The fourteenth century gave it the handsome belfry, with heads by the windows and under the parapet. The rest of the church is fourteenth and fifteenth century, though the chancel has some windows and masonry a hundred years older. A medieval scratch dial is on the walls. The two-storeyed medieval porch, of flint and brick, reminds us how the village came by its name. It was the village of the potters who made urns and beakers and vessels of clay for the Romans, and not so very long ago a huge mound of wood ash as high as a cottage (the remains of the Roman furnaces) was found here in a field known as Pot-hills. In a niche over the porch entrance is a crude stone figure of a wild man with a club; he was dug up in the churchyard and given this place of honour in the mistaken belief that he was St Nicholas.

The lovely old roof of the nave, springing from stone angels, has embattled hammerbeams and is enriched with tracery. Modern angels support the old beams of the aisles, and on an old beam over the chancel arch is a Crucifix carved in the Black Forest early this century. The fifteenth-century screen, with battered bays, has paintings of saints (their faces gone) under carved and gilded canopies. There are five old bench-ends, seventeenth-century altar rails, and a Jacobean chest with three locks.

Several medieval wall paintings have been revealed here and made clear in recent years. In the north aisle, opposite the door, is a fifteenth-century St Christopher with a yellow sapling for a rough staff and a sailing ship in sight. Near this is a group of fourteenth-century Nativity scenes, including the Annunciation, the Visitation, and the Three Kings at the stable; there is also a graphic portrayal of the Massacre of the Innocents. In the south aisle is the pretty head of a young girl in red outline and also two scenes of Mercy showing Visiting the Prisoner and Sheltering the Homeless, all fourteenth-century work.

The fifteenth-century font is an unusual but pleasing treasure, for it is cleverly made of small bricks shaped from the native clay.

Pulham St Mary

It is a pleasant place, with thatched cottages among chestnuts and limes, and a stream flowing near by on its way to the Waveney; and it has an imposing church.

The porch walls are panelled with traceried stone between bands of quatrefoils, and pinnacles rise from its parapet, which is adorned with curious carvings. The front is enriched with small windows, canopied niches, and angels, and the old roof has embattled beams. Between the nave and the chancel is a graceful old screen, its vaulted canopy with golden ribs and roses, and gilded leaves and flowers trailing over the arches, which are lined with dainty edging like gold lace. The original paintings of saints on the panels are still here for us to see, though now faded and patchy.

The fifteenth-century font is a mass of colour. The bowl has symbols and gold-winged angels; angels in red, blue, and gold are under the bowl; and the Four Latin Doctors and the Four Evangelists stand round the shaft. The cover of gilded oak has eight arches round a central pinnacle. In medieval glass still treasured here are small blurred figures of the Apostles, Christ in Majesty, and twelve saints. The oldest possession of the church is a fine Norman piscina.

Pulham St Mary Magdalene

It is known to its familiars as Pulham Market, but is small enough to be like a big village. It has thatched cottages about the green and at the gateway to the church, and an old hall where the Bramptons lived behind an embattled wall when Kett's Rebellion shook the county. Like its high embattled tower, the medieval church is lofty and spacious, but is not inspiring. In a niche on each side of the west window is a faceless old figure, and in the arch of the doorway below are crowns and flowers. The porch has crowns and mitres in its arch and roses in the spandrels. In a porch window are fragments of ancient glass. A low and a high arcade divide the nave and aisles, the south having short clustered pillars. The medieval painting of the roof above the chancel arch, of angels with trumpets and censers, gilded bosses, green leaves, and gold grapes, was made new last century, when the Ascension was painted on the wall. There are a few old bench-ends in the choir seats, an old chest has simply carved panels, and the medieval oak screen of the tower arch was made new by a craftsman of our own time.

Qidenham

It nestles in the heart of lovely woodlands, a charming setting for the home of the Earls of Albemarle; but it lives in legend or in history for something

older than any earldom in the world.

On the edge of the park the shingled spire of the little church looks across the road to a mound crowned by a group of firs by the River Wittle. Under this mound is said to sleep that first known woman in our island story, Boadicea. We do not know, but she is supposed to have had a palace at Kenninghall, the village reached by a beautiful mile-long avenue of fine trees, and it is thrilling to feel that we may here be in the presence of all that remains of this heroic woman of our race.

The tower and spire which look across the fields to what is believed to be her grave are the best part of the church. Boadicea fought our first great conqueror; this tower was built by our only conquerors since her day, the Normans.

The plain arch opening into the nave, the north wall of the nave itself and the doorway which leads us in, are also Norman. Over the thirteenth-century south doorway, on which are heads of a woman and an anxious-looking man, is a medieval porch with a charming sundial on which are six small carved figures of bishops and quaint hooded men.

Under the tower arch is a Tudor screen, and there are medieval stone seats, an ancient aumbry and piscina, an old font, and something far older than all this set into a wall—relics of three Saxon pillars, each about three feet high with scroll capitals. They may be part of a font at which were christened children only a few lives removed from Boadicea.

Ranworth Church on the Broads

Rackheath

Many will think the most beautiful things it has for all to see are the iron gates leading to the hall in the richly timbered park on the hill. They have a gracious dignity and came here from the Great Exhibition of 1851 which it was hoped would usher in the peace of the world, but which left behind for us instead the Crystal Palace, which now itself has gone. But it may be that Rackheath has something nearly a thousand years older than these gates, for there is probably Saxon work in the north wall of the church among the cornfields.

Our eyes fall on a mass dial as we enter the porch of this little candle-lit place, which is chiefly fourteenth century and still uses an Elizabethan almsdish every Sunday. A font a little older than the Civil War has on it the arms of a Sheriff of Norfolk who sleeps in the chancel.

Ranworth

On the edge of Ranworth Broad, it is alive with boats and sails where the Broad comes up to the inn. This stretch of 90 acres of water is in a delightful setting of woodland and marsh, and a haunt of wild birds. The stately fifteenth-century church is one of the finest in this countryside, partly due to the generosity of the Flemish weavers when Ranworth was a centre of their industry, and partly because it has so long been a shrine for one of our church treasures.

If we climb about a hundred winding steps to the top of the great tower we have an extensive landscape and a compact view of the village. We can follow the winding course of the Bure from Acle Bridge to Wroxham, and look over Ranworth Broad and see the sails flitting over other broads in and out among the trees. On a clear day Norwich Cathedral's spire comes into view, the spire of Yarmouth's great church, and a glimpse of the sea at Cromer. Nearer to us is a fragment of St Benet's Abbey in the marshes, and the tower marking South Walsham's two churches in one churchyard. At Ranworth itself we look down on an Elizabethan manor house, attractive with yellow walls, creeper, and thatch, which the lord of the manor left when he built the new hall nearer the church. From the other side of the tower we see an old thatched house that has grown from a priory, and the long low roof of the barn. Coming down from our survey of the landscape we found a rough nest of sticks on one of the hundred steps, laid there by a jackdaw, which had found the only hole available for him in the wall of the tower.

Arresting outside, with fine oaks for company and a rose-bordered path in the trim churchyard, the aisleless church is full of light. We come into it by an ancient panelled door. Arches soaring to the roofs lead to the tower

and the fourteenth-century chancel, which has a thatched roof seen through the old rafters, a good corner piscina by a window-seat, and seventeenth-century altar rails. Other old remains are a few fragments of glass, a plain chest 600 years old with wooden hinges for the lid, Elizabethan panels of linenfold in the pulpit, a cope of faded red velvet which may be fifteenth century, a pitch pipe which may have been used in the church band, and some medieval poppyhead bench-ends. On the four carved miserere stalls we see a head with a tongue out and a flower, a man with knees hunched up to his shoulders, and the tiny head of a demon. A quaint little man, a bear, and a man with his tongue out, are carved on the arm-rests.

A unique possession is an oak lectern of 1500 which was used on the roodloft in the days before the Reformation. Four feet high, it has a slender stem supporting two desks, one above the other, one painted with the plain-song setting of the Gloria, and the other with the eagle of St John.

An oak panel recalls the men who served and the fourteen who did not come back from the Great War. Painted in medieval colour, it shows St George as we see him on the fifteenth-century screen, which is the proudest treasure of the village and perhaps unsurpassed in the land for the fine detail of its painted decoration. It was set up between 1470 and 1500. Now in this twentieth century as many as 20,000 people in one year have come to Ranworth church to see this screen for the wonder of the painted decoration which came to light last century, after long being hidden under whitewash. Delicate flowers and leaves in red and green and gold on a white ground adorn the fan tracery of the canopy, and there is exquisite painting in its gallery of nearly thirty saints, though the faces are more or less defaced. In the remarkable detail of their patterned robes we may pick out falcons seizing hares among trees, dogs chasing ducks, dogs in trees, dogs after swans, and lions.

In addition to forming a screen for the chancel, this masterpiece has an extension at each end serving as reredos for two nave altars, and two wings east to west shut off these chapels. There are eight bays in the central portion, two forming the entrance, but the delicately carved edging of the arches is much battered. On the panels below are painted the Twelve Apostles with their emblems, and over the altars are more saints. Two holes have been cut on the north side of the screen to give a view of the altar in the chancel.

Another of Ranworth's treasures is the Sarum Antiphoner, bequeathed by William Cobbe in 1478. It was written on sheepskin by the monks of Langley Abbey and has 285 leaves. Illustrating the text are a score of fascinating pictures, their colour as bright as when the monks made the vegetable dyes and put on the gold with white of egg, burnishing it with

an agate. One picture showing Jonah in the whale's mouth, a king, and a jester brightly dressed in a striped suit of red and blue, illustrates the verse: The fool hath said in his heart, There is no God. In the reign of Edward the Sixth, the Antiphoner was removed from the church and all trace of it was lost till the middle of last century. Then it was bought for fifty guineas by a collector, and at his death passed to a Bond Street bookseller, who informed the vicar of Ranworth of its existence and asked £500 for it. In eighteen months the sum was raised.

Raveningham

Hiding by the fine Georgian house, in a lovely park of beeches, oaks, and elms, is a church surprisingly spacious, a charming autumn picture with its leaning walls clothed in the mantle of a flaming red creeper. Its round Norman tower has a fourteenth-century belfry with fifteenth-century battlements. Two doors in one doorway lead us in, a plain one sheltering a finer old one, a veritable treasure for its ironwork. There are the quaintest of crosses between its splendid strap hinges, one fascinating with scrolls, interlacing bands, and plaited work. The medieval windows fill the church with light, and an oak roof with floral bosses looks down on a low medieval arcade, with capitals only shoulder high.

Another village treasure is the font, which has been here since the church was new, with lions round its stem, eight angels under the bowl, and on the bowl four figures seated on richly carved thrones. One more fine possession the church has—a charming fourteenth-century recess in the chancel, a riot of rich carving in its exquisite cinquefoil arch and its pinnacled gable.

Reepham and Whitwell Churches

Reedham

It was a North Sea port and has been a battlefield - For Romans, Danes, and Saxons. The River Yare runs by its streets and it has a farmhouse with traces of an ancient castle. The church stands high, keeping company with the hall built by Henry Berney in the sixteenth century. Its 500-year-old tower, with huge buttresses, is a familiar landmark across the marshes, in which grow the reeds which give Reedham its name; an attractive picture they make like a green sea, with windmills dotted here and there. In a wood not far away we found hundreds of rooks astir, and many herons on their nests.

A fifteenth-century porch brings us into a fourteenth-century nave and chancel, with a great span of roof crowning the leaning walls. The interior has an odd effect without an aisle and with big and little chancel arches. There are old horsebox pews round the walls, and the battered bowl of a Norman font lies on the floor.

Reepham

Along one side of the market square, which becomes wide awake only on a market day, runs the wall of a churchyard in which stand two churches and something of a third. They were built in the pride of prosperous days for the three villages which have now become one, combining to make the town of Reepham. Hack-ford church was burnt in 1543 and only an arch remains of it, but those of Whitwell and Reepham still stand in good companionship.

Reepham's is 600 years old and was long the Mecca of pilgrims who came to worship at the shrine of the Madonna here. Its treasured possession is the altar tomb of Roger de Kerdiston, who died in 1337.The same fine workmanship is seen in the woodwork of the church, on benches. On one of the arm-rests we see the Evil One looking direfully at his forked tail, and on another is a contrasting bird with a long beak possibly intended for the pelican. On the bench-ends in the chancel are a number of tiny statues, including one of the Madonna crowned. They are all encircled with designs of foliage as varied as they are ingenious, and the same grace is shown in the slender spirals on the ironwork of the door into the tower.

Whitwell's church is more modest, but may well be proud of its pinnacled tower, with shields on its battlements. Its outstanding treasure is the pulpit, a superb example of the Jacobean wood-carver's art. There are Tudor roses in the spandrels of the panels, a fir cone hangs from one of the supports of the book-rest, and vine tendrils are woven into an arch on the panel supporting the rich canopy.

Repps-With-Bastwick

Repps of the byways has the old church of St Peter. Bastwick, on the busy road, has only the square fifteenth-century tower of its deserted church. From Repps's prim church with its ivy-patched walls the chimes tinkle ding-dong-bell over the wide fields, reaching the windmills and the farms and cottages among the trees. The lovely octagonal belfry was added about 1275 to the round Norman tower, which has still its small original round arch to the nave. Some of the masonry in the base of the tower and in the walls of the church may be Saxon. The nave and the chancel are fourteenth century, as is the fine font, the church's best possession. The porch has its old roof beams and rafters of about 1500, but of the chancel screen only the framework is old.

Reymerston

It is pleasant with old thatched and tiled cottages about the fields and lanes, and the trees so profuse about the big house and the farms gather thickly about the low red-roofed rectory, aligning themselves into a stately double avenue leading to the church. Most of the church is fourteenth century, though the tower has a tiny arch which may be older. In the wall of the arch on each side is an unusual little cupboard. Between the spacious nave and aisles are medieval arcades of mixed styles. The lovely old font with a lion at the foot has vines growing from the panelled stem to the bowl, on which are carved four seated figures. Flemish glass fills the east window with bright masses of blue, red, green, and gold, and the Flemish altar rails are a surprising and extraordinary possession. Their carving is of elegant scroll pattern of leaves and flowers, and scenes of the Holy Baptism and a figure preaching to a group of men. On the gate are cherubs among wheat and vine at each side of a chalice. A plain old roof looks down on the nave, and an old pillar almsbox has three locks. There are square pews with some Jacobean carving, a tall three-decker Jacobean pulpit, and high pews with red panels serving as choir stalls.

Ringland

Delightful ways bring us to this pretty spot in the curving wooded valley of the River Wensum, where a fifteenth-century flint church, looking over the village to hills crowned with trees, treasures a rare old roof. The buttresses and the tower battlements are panelled, and angels with outspread wings bend over us as we enter. The old door leading to the tower inside the church is latticed with iron and is opened by a sliding panel. The fifteenth-century font is carved with angels and roses and has lions round the stem, and on remains of the old screen by the tower are paintings of saints with their faces

gone. Some old bench-ends in the chancel have poppyheads carved with flowers and leaves and blackberries, and on one arm-rest is a lion.

Arresting in its beauty is the lovely old roof of the nave, seeming part and parcel of the fine clerestory, which has rich old glass glowing with figures of men and women, the Madonna and the Angel of the Resurrection, the Crucifixion, and John the Baptist. There are carved bosses on the moulded beams, and over the rich vaulting on each side is a lovely embattled cornice of quatrefoils and Tudor flowers enriched with angels and figures. Other angels support the shafts between the windows, from which the vaulting springs. It is one of the best of the old roofs of Norfolk.

Ringstead

At the end of a charming valley where the flat coast country of the Wash rises to the wind-swept downs are Ringstead's cottages, the fine old rectory, and farmhouses, climbing to the church on the hill. A round Norman tower in the grounds of a house at the foot of the hill is all that is left of St Peter's church, pulled down in 1771. St Andrew's fourteenth-century church has a tower much restored with brick, crowned by a short spire, and opening to the nave with a narrow arch. The chancel has a fine corner piscina niche with rich arches and heads of a king, a bishop, and a lion; and in a low window is a figure of St Augustine in jewelled robes. The tiny doorway in the opposite wall is only five feet high. The font is as old as the church, and the fine brass portrait on the floor is of a priest in rich robes whose twenty years here ended in 1485.

Rockland All Saints

Above this neat and orderly village at the foot of the hill is the plain little church of All Saints. Near it is the ruined tower of the old church dedicated to St Andrew. Much of All Saints, with its square tower, is 500 years old, but the herringbone masonry in the north wall, and long-and-short work at some of the corners of the building are Saxon. The treasure of the church is sheltered inside, a tapering Saxon coffin stone with a cross-head at each end and plaitwork between them. There is the cracked bowl of a Norman font once buried in the churchyard, a few old poppyhead pews, and an Elizabethan chalice. Very quaint is a quatrefoil window in the sanctuary, set back in the thick wall as if at the end of a telescope

Rockland St Peter

Neighbour of Rockland All Saints, it has a pretty group of farm and red-roofed barns and a small church with a round tower and a thatched roof.

The Normans raised the tower, and the fifteenth-century builders gave it the octagonal top. Most of the windows are of their time, but some are a century earlier. The brick and flint porch, with a stone tablet in the gable and the date 1624, has a stout medieval arch, and across the lancet arch of the tower is part of a fifteenth-century screen. The chancel, once in rums, has been made new. The best thing inside is the big medieval font, with varied tracery adorning its bowl.

Rollesby

Our Scandinavian invaders found Rollesby Broad XV so convenient for fowling and fishing that they built their huts in this pretty spot. Now there is a fine old church among trees where the ways meet, with thatched houses and barns.

We found lilac filling the air with its fragrance by the porch of the church, which inherits a round tower from the Normans The fourteenth century builders raised it two stages, and other remains of their time are the doorways and the stout arcades (which lead to odd-sized aisles). There is also a medieval mass dial. The clerestory is also fourteenth century. The chancel, wider than the nave, was made new in the fifteenth century. Dogs crown its pinnacles outside, and an effective roof of dark beams and golden stars on a blue ground looks down within. The old piscina is by a curious little walled enclosure like a small cell. The rood stairway remains, and there is a peephole from the end of the north aisle.

Rougham

There is a pleasing air about this pretty woodland village of the byways, which has a little medieval church. Fine trees, especially elms, are planted in avenues, and rooks caw in the park. Near a cypress hedge is a dovecot with a fine thatched lantern, which is older than the red-roofed gabled hall. The hall and the church stand a little apart from the green and the village well. The tower of the church is 600 years old. Over the west doorway is a battered Crucifixion with figures of Mary and John. There is no chancel arch, but a thirteenth-century arcade of seven bays, with slender pillars and capitals dotted with flowers, runs from east to west, opening again to a north aisle. St Catherine with her wheel is in old glass, the font is thirteenth century, and an old woodcarving on a wall shows six Apostles with archangels between them.

Roughton

It is an age-old home of man, for on the great heath above its cottages are prehistoric burial mounds, and on the rising ground is a church with a 1,000-

year-old tower. Except for its Tudor battlements, it is entirely Saxon, with double-pointed windows above and two little round ones below through which arrows could be shot at marauding Danes. The chancel, nave, and porches are of the fourteenth and fifteenth centuries, and many of the windows are excellent examples of the later period. Inside is a gallery of sixteen word sculptures adorning the walls of the nave, here a toad and a hon, there a dragon or a man pulling a face. More pleasing are the queens on the roof corbels. The traceried font is 600 years old.

Roydon

The road on which it lies, a mile or two from Diss XV becomes here a lovely bower with beeches meeting overhead. Roydon Hall, home of the Freres, stands on one side of the road with the inn and the church on the other. The peace memorial cross stands by an old oak outside the churchyard, and inside is a great cedar, a double row of clipped yews, and a fine chestnut rising above the church tower. The tower is Norman with a nineteenth-century octagon or the bells. The fine old porch has five niches on the front. The Jacobean pulpit is heavily carved; and the nave has an old hammer-beam roof.

Roydon

One of a cluster of villages where the heath gives way to fields, Roydon (near Lynn) has a common with many ponds and cottages going down to a small church in company with a farm. The medieval tower of grey flint rises above a red stone nave and chancel refashioned in Norman style last century. Lighted by narrow windows (and by candles in the dim hours) it has a nave roof of open timbering with turned kingposts and a fine chancel arch which only needs time to mellow its zigzag mouldings and the richly carved capitals. Its old remains are two benches with traceried backs in the

Runton Church

chancel, and two beautiful Norman doorways with arches of rich zigzag mouldings on the shafts and carved capitals. The only memorial is to six men who died for peace, a painted panel of teak wood with a fine angel, the Crucifixion, and two soldiers.

Runcton Holme

Its few houses are by the wayside, and the small church is charmingly set in the fields. It is a patch-work of brick and stone. A brick top crowns two Norman stages of the tower, which has a plain Norman arch with a big Norman window above it. There is a blocked Norman window in the nave, and a neat Norman doorway, with a carved arch on each side, lets us into the simple interior. The big pulpit is Jacobean, and the old screen is preserved under the paint. The lovely thing here is of our own day, a fifteenth-century window glowing with Christopher Whall's glass showing the scene at the Tomb, the angel with red and gold wings, and the two women in brown, purple, and red.

Runton

In the days when England was covered with ice the glaciers came down to the cliffs of East and West Runton and the icebergs fell with a crash like thunder into the sea; and today there are two gaps in the sandy shore, strewn with chalky fragments from the Midlands to witness if we lie. Runton comes again into the annals of our land with its medieval church, the tower begun in the thirteenth and finished in the fourteenth century. The nave and chancel, the traceried font, the mass dial, the richly carved piscina with a recess for the sacred vessels, are all 600 years old, and from these far-off days come two saints in vivid red and blue in one of the windows. Ten old seats have poppyheads by fifteenth-century woodcarvers, and there is a medieval paten among the altar plate. Another saint has been added to the east window of the aisle, Francis of Assisi, preaching to the birds at a fountain.

Rushall

The narrow Norman tower of the church has a 500-year-old belfry looking down on a view which a Government Department has spoilt by not thinking enough about the position of one of its buildings. If we turn our backs on what our Government has done for us we look out across fields with elms and chestnuts.

The church is in the middle of the village, with a thatched cottage on the edge of the churchyard, and near by is the old Hall, now a farmhouse, with a wet moat round it overhung with trees. Beyond is Langmere Green, a pretty common.

The thirteenth-century chancel has sloping walls and two lancets at the east end. The porch and the nave are 500 years old. The roodstairs were found in their perfect state in the middle of last century, and four painted panels found at the same time behind a pew are now worked into a desk in the sanctuary, the desk being carved with leaves and flowers and a black and gold shield.

Rushford

It is only small, but the Little Ouse flowing through divides it between Norfolk and Suffolk. The mounds on its heath across the border take its story back to Saxon days, for they are said to be where Edmund was defeated by the Danes. In a beautiful park between the village and the River Thet is the fine modern house called Shadwell Court, taking its name from St Chad's Well close by, once a shrine for pilgrims. The group scene from the lychgate is a charming picture, made by the church with its thatched nave and medieval tower, and the old rectory with flint walls. Of the original cross-shaped church only the nave and tower are left. Huge buttresses strengthen the tower, which has stood firm for 600 years, having apparently been a tower of refuge in time of raids. It has only two slits of windows for 50 feet from the ground, and a doorway opening to the nave. In the nave are remains of slender arches on the walls. The porch of brick and flint is built of fragments of the old church and an old college. The treasure here is a small and oddly shaped oak chest, wider at the top than at the base, with a handle to carry it by. Its sides are latticed with iron bands, and the top is a mass of ironwork scrolls ending in heads.

Ryston

There is an oak here more important than the beautiful park to which it belongs, for it is Kett's Oak, one of several associated with the ill-fated rising of the peasants under the tanner of Wymondham which was so cruelly crushed in 1549. Other such oaks have been called Oaks of the Reformation, because Kett's followers were believed to have met under them. Ryston's Oak, still vigorous, is authentic.

The hall was built in the seventeenth century by Sir Roger Pratt, and is still the home of this family, whose many generations here extend beyond the time of the Reformation. The same Sir Roger, sleeping in the chancel, gave the nave of the church a tiled roof for its thatch. Their arms and crest (a little man in red and gold) are on the marble tomb where Lady Pratt, with curled locks, lies in an embroidered nightdress.

The church is by the wayside across the park from the Oak. Great trees keep it company, and a splendid cedar overtops the brick saddleback tower

which, though made new after being long in ruins, has still its low Norman arch and three Norman windows. Old doors open to the simple candle-lit interior, and black and white roofs look down on the nave and chancel, the nave roof modern and the chancel's fifteenth century. There are two low windows, a pretty corner piscina, an aumbry with finely carved doors, and a font which may be sixteenth century.

Saham Toney

Trees give charm to this pretty village, which takes the first part of its curious name from its round lake of 13 acres. It was Roger de Toni, lord of the manor, who added his name to the Saxon Saham, town of the lake. Looking over the village from a bank by a small green is the fine flint church, crowned by a noble tower with pinnacles, sound-holes in quatrefoils, and stone panels showing the letters G and M for St George the Martyr. We see him with the dragon in the spandrels of the west doorway.

Like most of the church, the tower comes from the middle of the fifteenth century. The nave arcades (with bell capitals on the pillars), the clerestory, and part of the chancel are fourteenth century. In a corner of the two-storeyed porch is a beautiful canopied niche enriched with arcading and crowned by a traceried turret. The piscina is carved with arcading and traceried vaulting. The old chancel screen has been newly gilded. Some old poppyhead seats are adorned with lions. The fifteenth-century font has a domed cover with eight pillars, and an inscription telling that John Ives gave it in 1632. It opens with a sliding panel, and was found in the rectory cellar by Coker Adams, a nineteenth-century rector who was also a writer and a musician, and lies in the churchyard. Over the doorway of the rectory, by the church, is the Winchester motto, Manners Makyth Man.

Salhouse

Of all Broadland's spreading waters we may wonder if any is more lovely than Salhouse Broad, with its neighbour Salhouse Pool, sequestered among trees and reeds in the winding vale of the River Bure. It is delightful country. Away up the lane is the church, its sturdy tower rising at the end of the long thatched roof, and in its park is the Elizabethan hall, with a fifteenth-century door opening every day.

The churchyard is shaded with firs and elms, and a great oak keeps guard by the fine lychgate. By a hedge of box and cypress and a border of golden flowers and forget-me-nots we come to the porch with a dainty niche over its arch, and a wreath of roses in modern ironwork keeping company with the old strap hinges of the door. The base of the tower is 600 years old; the

upper stage, with quatrefoils in charming sound-holes guarded by quaint heads, is a century younger.

Rare in this part of the countryside are the carved capitals of the old nave arcade, all enriched with wreaths of foliage except for one which is quaint with eight faun-like faces. The font is medieval; the seats for priests are fashioned out of the sill of a window. The oldest relics are two coffin stones under the tower, 700 years old. There is an odd little niche in the tower, framed in oak.

An old stall has a miserere carved with a fine bearded head; and there are also old panels with fascinating tracery in the pulpit, near which is one of the most charming hourglass stands we have seen, its graceful ironwork fashioned into a pattern of lilies; a lamp has taken the place of the old glass. Attached to the chancel screen, which has its original tracery and part of its old frame, is a small sanctus bell. The glass in a window showing the Women at the Tomb, in soft colour, came from Bruges.

Sall

It was the home of the Boleyns five centuries ago, and the ancestors of Queen Elizabeth appear to have bequeathed something of their lordly splendour to their ancient church. Its medieval glory draws all travellers to it in Norfolk, and those who climb the 129 stairs of its tower are rewarded with a wonderful view of the broad acres of the garden of Norfolk with the spire of Norwich Cathedral on the horizon. The pinnacles, the rich parapet, and the splendid doorway with the feathered angels in the spandrels, all enhance the grandeur of the tower, in which hang the original doors.

The nave, the transepts, and the chancel all have the dignity of height and roofs with lovely mouldings. The nave arcade is impressive with its splendid piers. The lovely chancel roof has oak bosses with rich carvings of the Annunciation, the Adoration, and the Entry into Jerusalem. The chancel stalls have handsome misereres, and there are still paintings of the Apostles fading away on the fifteenth-century screen; the Four Doctors of the Church are recognisable on the doors. Another fragment of painted woodwork from the Middle Ages is a carved bracket on the ringer's gallery, from which hangs the lovely pinnacled cover of the font; the font itself is fifteenth century, and is set on steps carved with the name of Robert of Luce and his parents. The font is one of the small group still left in this country with the Seven Sacraments carved on the panels, and to these subjects the carver added some delightful touches, for each scene has its own emblem, such as a casket for the oil in the Baptism. In the eighth panel is the Crucifixion scene.

Salthouse

Flint houses and farms climbing a little lane to a church so high that it seems to be on the top of the roofs as it looks proudly out to sea; wide bird-haunted marshes to seaward; Bard Hill with fine views, and the Heath with many burial mounds to landward—so we may sum up this hardy old outpost of the Norfolk coast which for so many centuries has braved the battle and the breeze and the encroaching sea. It is a charming picture from the lonely pebbled shore.

Sir Henry Heydon made the church new in the time of Henry the Seventh, and made it a fine church, keeping the old tower with fourteenth-century windows. A weather-worn porch with stone seats leads us into the impressive interior, ablaze with light. Graceful arcades run west to east, leading to aisles almost as long as the church, their graceful windows all in pairs, with stone seats below them. Over twenty clerestory windows and fine long roofs add to the dignity of the nave, the continuous roof from west to east having fine borders with shields in tracery. The fifteenth-century font stands nobly on two high steps, carved on the bowl with flowers and symbols, angels under the bowl, and four smug lions round the base.

The heath, gay with gorse, was a British settlement before the Romans fortified the coast against North Sea invaders. There was a burial ground here, and urns with the ashes of the dead have been found in barrows. Both Roman and Briton and all later colonists had a defence already made by Nature in the great marsh that stretches seaward. For generations it has been the haunt of sea birds, wild geese, plover, duck and widgeon, tern, and the hooded crow, but in 1897 the tide broke through the sandhills and came up to Salthouse, destroying some of the houses. It was an invasion typical of many this crumbling coast has suffered through the centuries, more ruthless than armed men.

Sandringham

It is his own piece of our beautiful countryside, 14,000 acres of meadows and villages and woods, all as neat and clean and fair as could be wished. When George the Fifth broadcast his first Christmas greeting to his people all over the world he told them that he spoke from his home to theirs, and that is how we think of Sandringham. It is the King's country home, and it is a symbol of the link between the people and the throne that, just as the public walks every day through the courtyard of St James's Palace, so we may walk through Sandringham Park with its great stretches of heather, deep woods, and grassy levels where deer roam at will.

The King keeps his countryside as his people should keep theirs. We drive along roads fit indeed for kings, so beautiful that we must linger. Here are

no litter louts, no spoilers; always the roads are beautiful, winding through woods carpeted with bracken and shaded by beautiful trees of every kind and shape and hue. If we come in June we shall find the emerald of the grass verges enriched with the purple of rhododendron borders and the red and white of may trees, running for miles. We shall find also at any time the signposts set up by George the Fifth, all designed, carved, gilded, and painted on Sandringham Estate. The post at Wolferton illustrates the legend of Fenrir the Wolf and Tyr; that at Flitcham shows St Felix, founder of the church, in a boat. And whenever we come there is a view through the fine iron gates by the wayside of a magnificent pergola bowered with roses in due season; if we come on the right days the gates will open for us, and we may wander through the King's garden, with flower beds of massed colour and fruit trees and vegetables growing in such neat array that the kitchen gardens rival the flower beds as a delight to the eye.

The magnificent gates into the park itself (called the Norwich Gates) are a veritable splendour of craftsmanship, made in Norwich and shown at the International Exhibition of 1862. The ironwork is fashioned into roses, shamrock, and thistles, and it was meant that the gates should be as fine as any in Norfolk, for they were the wedding present to the Prince of Wales and the sea-king's daughter from over the sea. The grounds are laid out in terraces and lawns with a stream running through a dell and under bridges to form a lake.

It is like a fairy-tale come true to come to the little church at the corner of the park, for it has silver and gold and precious jewels all fit for a king. The church is an exquisite picture in June, with its creepered walls blossoming red, white, and blue. It has been refashioned in medieval style, and has an inscription in the porch to William Cobbes who restored it 400 years ago. It was restored again in the middle of last century, again in 1890 when the transepts were added, and yet again in 1909. The chancel arch, resting on sixteenth-century capitals, may be part of the earliest church.

It is the simplicity of the nave and the glory of the chancel that strikes us as we come in. The chancel is a royal splendour, crowned by a richly painted roof, the sanctuary gleaming with silver gilded like gold. It was made as we see it in memory of Edward the Peacemaker, who sat in the royal pew whenever he was at Sandringham for forty-seven years.

One precious possession of this shrine of great devotion we have left until the last. It is the 400-year-old Processional Cross. It is of great beauty and it stirs a great memory. The cross is Spanish, and has on one side the figure of Our Lord on the Cross, and on the other St Andrew with his cross. Four quatrefoils in front have small figures of the Four Evangelists, and on the

reverse side are the Madonna and St John, the pelican feeding its young, and Our Lord rising from the tomb. This beautiful cross was given to the church a few years before she died by Queen Alexandra, in memory of the men of Sandringham who fell in the Great War.

Saxlingham

It is part of a sylvan neighbourhood, and oaks, chestnuts, and beeches shelter the flint church by the wayside. It was chiefly fifteenth century till restoration made it look almost new. Its tower has a chequered parapet, there are two old piscinas, a quaint man's head peeping from a wall, and a fine old ironbound chest with a lid cut out of a tree trunk. Kneeling on a tasselled cushion in a canopied niche is the alabaster figure of an Elizabethan lady. She was the daughter of Sir Christopher Heydon, and wears an embroidered gown. A band of flowers adorns the tiny hat set daintily on her hair, her ruff might have been laundered yesterday, and her pretty hands are together as in prayer. A memorial centuries later is the glass of the east window, where Our Lord speaks from a boat to a crowd of men and women and boys. At each side are the Sower and the Reaper, their presence accounted for by the dedication of the window to Thomas Barlow Wood, Professor of Agriculture at Cambridge, whose ashes are in the chancel.

Saxlingham-Nethergate

In this hollow men have been shaping this village for ages; here are Roman bricks in Saxon walls, and a medieval church with much fine craftsmanship. There are charming houses with lovely roofs of thatch and tile, a three-storeyed group of cottages with eyebrow thatch over dormer windows, a manor farm with a step-gabled porch, a village hall with a thatch roof, an old school by the green with wistaria creeping up its walls, and a seventeenth-century hall shaped like an E in honour of Queen Elizabeth, in a crescent of yew hedges. A one-handed clock and a sundial to help it mark the time together on the fifteenth-century tower, and much of the church goes back 700 years or even to days long before English building had begun, for it is in these walls that we find the Roman bricks, put where they are by the Saxons.

An ancient door with iron grilles brings us into a nave with lofty arches. The old tie-beams of the roof rest on stone heads of lions, men and women, a king and a queen, a man with a cup, and an angel playing a guitar. The 500-year-old font bowl is carved with lions and angels, and the reredos seems to be part of a medieval screen.

A medley of medieval glass shines in some of the windows. In the east window with its roundels and canopies are saints and bishops, flowers and

shields, a man kneeling at prayer, two men in brown and green robes, a king with a sceptre, and a bowman shooting a man tied to a tree (perhaps St Edmund). Other chancel windows show roses, crowns, saints, and angels playing a fiddle and a guitar. One window has bright modern glass showing St Edmund in armour and a green mantle, the Madonna and Child in purple and white, and St Withburga in red and white with her crook and a book. Below them are three small scenes associated with these three saints: St Edmund bound to a tree and the three archers ready with their arrows; the Annunciation; and a group of people by a spring near the wall of a Saxon church.

Scarning

One who lived here called it his Arcady, because to him it comprised all that he most liked in Norfolk. He was Dr Augustus Jessopp, who, after being for twenty years headmaster of King Edward the Sixth's School at Norwich (which he transformed into a modern school of high repute) became rector of Seaming for over thirty years. Here he wrote books on life in England in the Middle Ages, the best remembered of which is called The Coming of the Friars. He died in 1914, and sleeps with his wife in the churchyard, a granite cross marking his grave.

He loved the fine views of the countryside from the hill on which the trim houses, the inn, and the cottages stand. The church he restored is with them, looking its best outside. Except for the fourteenth-century doorway and its porch, most of the church was built in the fifteenth century. The dim chancel is earlier than the nave, which is plain like a barn, and the tower, later still, has sound-holes filled with tracery, and is adorned round the base with flint arcading. South of the chancel is a chapel founded in 1576 by Michael Denby, who left his initials and the date on its wall. He lived as curate and rector in a room above it. There is a carved Jacobean chair, and the font has a bowl 700 years old. The lovely fifteenth-century chancel screen has splendid tracery above its arches, more tracery on the base, and some original painting. Its exceptional feature is the small sanctus bell, which has kept it company all the time, attached to the screen in its old wooden frame.

Scole

It has grown up round the crossing of two highways near Diss, one of them the Roman road between Norwich and Ipswich, crossing the Waveney as it flows between the two counties. The thatched houses and the old inn (an imposing place) are delightful at the cross-roads, which have always been a

scene of bustle, yesterday with the jingle of coaches and horses, today with the speeding of cars and the tooting of horns.

On a high bank among the limes and chestnut trees, stands the church. It has stone angels supporting the old beams of the roof, and a fifteenth-century font with angels around the bowl and under it lions sitting around the stem and a Jacobean pyramids over all. The alter table is Jacobean, and on the chancel walls are paintings of scenes in Bethlehem, with all our patron saints. A quaint piscine is cut into a splay of a window in the aisle, and in the east window of the aisle is a fine modern glass of Christ Risen, the meeting with Mary in the garden, and the meeting on the road to Emmaus.

Coming to Scole from Billingford, we see an old tower which is all that is left of Thorpe Parva's church, deserted for centuries.

Scottow

Its cottages are on the wayside, but the church lies secluded in the glorious woodlands around the hall. It has a lofty tower and slender columns in the nave and chancel, which both have medieval roofs. The alter stone has its five consecration crosses, the thirteenth-century font has a remarkable Jacobean cover supported by red and green dolphins, the lovely lectern is Jacobean (brought from a London church), and fading away on the walls is a big fifteenth-century painting of st Christopher, with fishes still seen in the stream. It is one of the churches where the organ-case is interesting, having seventeenth-century carvings of Bacchus and other pagan scenes, among which is Cupid astride a seahorse.

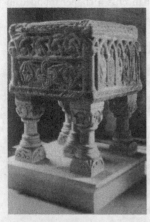

The Norman font at Sculthorpe

Scoulton

The black-headed or laughing gulls know Scoulton well, for to them it is a sanctuary and a breeding place. They have all to themselves the island in the middle of the fine reedy Mere, though they are by no means content with it. It is said that their insistent cries as they wheel over Wayland, the famous Wood of the Babes a few miles away, gave it its local name of Wailing Wood, as well as the ancient superstition that lost souls wailed there. The Scoulton colony of gulls is certainly one of the most curious sights known to English bird lovers.

Nearly a mile away on the Watton road is one of Norfolk's lonely churches, looking to the woods round Scoulton Mere. Most of it is fourteenth century, with an east window a century younger. The tower has a stunted belfry with eight sides, and the nave is roofed with thatch. We enter the bare place through an ancient doorway to find a plain old font, a Jacobean pulpit, Jacobean panels in the front of the stalls, fifteenth-century tracery round the chancel's stone seats, and an old chest with elaborate ironwork.

Perhaps we may say that its most interesting thing is a set of five deep holes in the sill of a round-arched recess in the chancel. It is thought that they were made seven centuries ago for cresset lights.

Sculthorpe

From the road between Fakenham and North Creake we see the mellowed walls of Cranmer Hall over the other fine park carpeted with gold in spring. It is a mile from the straggling village, and has a charming thatched lodge at its gates. The church stands apart by meadows and cornfields, with a background of woods. A rose-bordered path leads to the 600-year-old tower, guiding us to the pretty door carved with flowers of field and garden and birds in apple-blossom and hawthorn.

In this place lives the memory of two men famous in our wars with four centuries between them, for the church was rebuilt by Sir Robert Knollys, who fought in the Hundred Years War, and the chancel was made new in memory of the son of one of Wellington's men.

Sculthorpe is another of those heirs of the ages which have inherited the four great Norman fonts of Norfolk, a group unsurpassed in the land. On this one four lions are holding in their mouths a rope of plaitwork round the rim of the square bowl, which has fine interlacing on three sides, and one panel with five figures representing the Visit of the Wise Men to the Madonna and Child.

Sedgeford

A battered old windmill stands on the hill, and down in the valley is a beautiful old church with a round tower growing quaintly out of the gabled roof of the nave. The Normans built the tower, and the fourteenth century gave it its eight-sided belfry, which is reached by an ancient ladder. Much of the old work left in the church is as old as the belfry. There are stone seats in the spacious north porch, and round the base of the pillars supporting the sturdy arches of the nave arcades, above which are the twelve fine windows of the clerestory. We get the best effect of the arcades from the chancel, which is chiefly thirteenth century and has a charming window of about 1250, showing in the richly carved capitals of its pillars, inside and out, the wimpled head of a woman in foliage and heads of two men among oak and acorns. Geometrical glass touched with red, green, blue, and gold enhance the charm of this window, and in an old jumble in another window are two angels and parts of two crowned figures. The east window glows with rich glass showing Our Lord in Glory with an angel host, Mary and John, and the Nativity. Of two old chests, one is plain and the other has fine poker-work showing scenes in panels and lions and warriors in the decoration. The old newel stairs are here, though battered, and on two worn steps, with an old flight of three for the parson, stands the fine Norman font.

The churchyard gateway, with gabled stone pillars, is a memorial to those who succumbed to an outbreak of typhus last century.

Seething

It has had a few red roses for about 600 years fading on the wall of the church near the chancel arch; they are remains of paintings which have been covered up with whitewash. It has a few green mounds that are older still, for they are part of a Saxon burial place in the grounds of the old hall. Here, too, is a stone pillar, a copy of an older one standing on the site of a church which is said to have been destroyed thirteen centuries ago. Certainly this is an ancient place, for something of Norman England remains in the church, standing among houses and barns with roofs of pantile and thatch, looking to the tower of Mundham among the trees. The Normans built the simple round tower.

We come into the nave through a stout weather door which has been swinging for centuries and is still sheltered by the porch built to protect it 500 years ago; the old roof timbers are still where the Tudor craftsmen put them. Most of the chancel is fourteenth century; the lower part of the oak screen, with its carving of gold leaves and painted panels, is fifteenth century. Much treasured in the village is the fifteenth-century font, its bowl carved with the Baptism in Jordan and the Seven Sacraments.

Sharrington

It has a few cottages and farms, a fine old E-shaped farmhouse, and a small restored medieval church near which is part of an ancient cross with a later top. The tower, through which we enter, has fourteenth-century belfry windows and a low sturdy arch. In the walls of the nave are the blocked thirteenth-century arcades which led to vanished aisles, and supporting its black and white roof is a fine gallery of stone corbels with weird grotesques.

Shelf Anger

In the heart of this small red-roofed village is a farmhouse with the loveliest of old doors. We can see its six panels of linenfold and its carving of leaves from the road, and it is said to have come from the fifteenth-century church across the way. The church has an embattled tower and looks its best from the outside, standing prettily by the road with a line of spreading chestnuts. The charming timbered porch with its fine old roof of moulded beams is over 400 years old and has still a holy water stoup in the wall. The nave roof and the oak screen are both fifteenth century.

Shelton

It tempts us from the Roman road, for it has a church with a beauty of its own, its flint tower well buttressed in the fourteenth century, its impressive array of windows coming from the fifteenth, its clerestory rising high above elegant arcades with niches between the arches. The brick walls, latticed in red and blue and crowned by the clerestory in stone, are a refreshing change in this county with hundreds of flint churches. There are twenty stone angels above the clerestory windows, and angels with lions on the fourteenth-century font. It was odd, when we called, to hear bees humming in the roof, and to be told that bees were known to have been humming there a hundred years ago.

The church was mostly built from a legacy of Sir Ralph Shelton, whose family were here four centuries. Their old hall has still the wet moat and the foundations of their earlier home, and their monuments are in the church.

Sheringham

This seaside resort has grown up round an ancient fishing hamlet lying between high cliffs, from which are magnificent views. The old houses, now being squeezed out by new ones, are huddled together on the steep banks by the sea, where there are many breakwaters and many little boats, and the cottages and the pebbly beach are in quaint contrast with the modern streets.

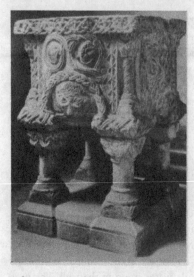

The Norman font at Shernborne

St Peter's church was built as last century was closing, and is big enough for the crowds flocking here in summer. Two angels guard the low oak screen, which has a border of shells and seaweed. The east window, a group of seven lancets, is a glow of colour with a great scene of the Ascension, the Disciples below.

St Joseph's Roman Catholic church has a striking and lofty nave with unusual arches, and a fine modern carving of the Annunciation on the altar of a chapel. Its best possession is the font, within iron rails, a splendid copy of one of the medieval fonts in which Norfolk is so rich. Round the bowl are carved the Seven Sacraments, angels are under the bowl, and round the stem are four saints and the four Evangelists. It is a perfect font in fifteenth-century style.

Shernborne

Cottages with pantiled roofs are dotted by the green where the ways meet, and a knight is galloping in the lists, while his wife sits with clasped hands behind the tournament barrier, on the charming painted sign given by George the Fifth to this byway village of his Sandringham estate. The knight was Sir Thomas de Shernborne, who went from here to become Chamberlain to Henry the Sixth's Queen, Margaret of Anjou. He seems to be galloping towards the church on the green, with yews, red may, and roses overhanging the churchyard wall, where we see him again with Dame Joanna in the fine

brass portraits on the chancel wall. Sir Thomas is in fine armour; his lady, still with her hands clasped, wears horned headdress with her mantle and gown, and a little belled dog in her drapery is looking up at her husband.

The old church was made new at the close of last century, but the trim little place, with its bell in a turret, is on the old foundations, and there is old stonework in the doorways and windows, and in the arcade. Its rare treasure is the font, a magnificent relic of Norman England. Four sturdy pillars support the square bowl, which is a mass of rich carving and has slender carved shafts and capitals at the corners, the sides adorned with interlacing work between the plaited band round the top and the four grotesque animal heads at the foot. It is perhaps the best of the four remarkable fonts in north-west Norfolk which were sculptured by a great artist in stone whose name is unknown, the others being at Sculthorpe, South Wootton, and Toftrees. There is no other font like this at Shernborne. The old home of the Shernbornes is now a farmhouse, standing aristocratically aloof from the village, the water in its moat reminding us of its ancient days.

Shimpling

Charmingly set among fields as it stands back on the Roman road to Norwich, it has red-roofed and thatched cottages dotted along the lane, an Elizabethan house called Shimpling Place, and a small church hiding away. We find it down a road by a moated house, with four chestnuts on one side and an orchard on the other, ending in a broad grass track leading to the gate. The church has a simple charm, with a great beech and a spreading oak in the churchyard. Its round Norman tower has an eight-sided top of the fifteenth century with short spire. The delightful porch of red brick and old timber has flowers in its arch; indoors fine roofs of grey old oak look down on cream walls. We noticed an old head on the tower with curled lip and a turned-up nose, a figure of disdain.

There is no chancel arch. Among many old glass fragments are a number of angels, two with harps and two with violins; red borders, green borders, pinnacles and towers, and shields on which we noticed three black pigs. The striking old font has lions and roses on the stem, and angels spreading their wings under the bowl. The old poppyhead pews have lost some of their figures, and a chest shaped like a trunk is crumbling with age.

Shingham

Ringed round with woodlands, it has a sad little church in a field, the only road leading to it guarded by a fine group of pines. By the efforts of its few scattered folk a corrugated iron roof has made the long ruined nave of the

church fit for use again. It is only nave and chancel, with a 200-year-old bell in a wooden frame, and the leaning walls are lighted by one Norman and three medieval windows. The shafts are gone from the leaning Norman doorway, but its fine arch is adorned with zigzag and stars. Among the battered carvings on the worn old bench-ends are roses, and a man with a crook sitting with his dog beside him. He is the only complete figure left. The two-decker pulpit is Jacobean.

Shipdam

It has among its possessions one of the finest things of its kind in the land. Half a century ago much of the outside masonry and many windows were renewed, but the tower, crowned by a wooden cupola and spire, is fifteenth century, as are the nave arcades and the clerestory above them. From the close of Norman days comes the priest's doorway, and the chancel into which it leads has two unusual stone seats and a pillar piscina. The traceried font and an ironbound chest with five locks are fifteenth century. Lying on its fallen pillars is a Norman font rescued from the rectory garden and there is another old chest. Sorrowful memorials of our own day are two wooden crosses from Flanders.

The pride of the church is the wooden lectern, which has perhaps no equal for its age in England. As old as the Tudor dynasty it has a richly carved desk resting on a shaft of three buttresses with rows of tiny quatrefoils between them, and at the base are three lions.

Shotesham All Saints

It has one of the best natural greens we know, like a miniature valley with its humps and hollows, and a stream winding through it among the elms. On a mound at one end the old church stands proudly among the trees, and by the churchyard wall is a high cross with the names of eighteen men who did not come home again. It is a medieval church with five bells in its tower and a stone vulture on its bellcot. The holy water stoup has kept the old door company for centuries, and the fine font with lions and angels, has been here 500 years. In old paintings on the walls we recognise a Crusader with his sword, and the head of Edward the Second with a feather in his cap. Another scene shows a martyr bound hands and feet in the flames, and above her a woman praying for her soul. The altar table and the altar rails are Jacobean. The windows are interesting for their unusual glass, patterned with a motley of colour in purple, green, brown, and gold. One in the chapel has a curious kaleidoscopic effect produced by an ingenious craftsman who placed two similar sheets of glass apart with space between; the glass is said to be copied from windows in Milan cathedral.

Shotesham St Mary

The first peep of its towers and trees is a promise of the beauty that lies in wait in this small and tranquil place. Charmingly grouped on a little hill among the fields is the old gabled hall, with red-roofed barns, golden stacks, and a pond overhung by chestnut trees. The old grey church stands with it all, and in memory of a church now gone stands a ruined tower. Half a mile away, in the beautiful park through which the river flows, is the great house of the Fellowes, who have made Shotesham their home for two centuries. An old panelled door with an iron grille and a closing ring leads us into a small and aisleless church of the fourteenth and fifteenth centuries. The old trussed roof looks down on the nave. In one of the windows are fragments of old glass in which we see an angel playing a violin. Old carved stones and the head of an ancient coffin stone are set in the wall. The 500-year-old font has lions round the stem and angels on the bowl; and there is an old piscina.

Shoulditam

Pleasant with its red roofs, a spacious green with an old buttressed tithe barn beside it, and a charming corner where we found a carpet of narcissi under the trees, it was once the seat of a priory of the Gilbertine Order, founded in the reign of Richard the First by the Earl of Essex, Lord Chief Justice, who was buried there. His tomb has disappeared, and a farmhouse stands where the priory stood, nothing being left now save the old barn. A hundred years ago some stone coffins and a painted window were found; and a fine medieval coffin lid with a beautiful cross is now treasured in the church.

From its green hill in the fields the trim church looks down on the village. The fourteenth-century tower has a west door with fine tracery and a lofty lancet arch. A medieval doorway opens to a nave lighted by big fifteenth-century windows and crowned by a fine roof of the same time. The best thing in the church, the roof, has coved sides, carved borders, and hammerbeams on which are quaint men with tongues out. The font is fourteenth century. The chancel, made new in 1871, is up five steps and the sanctuary up three more. Some old bench-ends have tracery and foliage poppyheads, and a window in memory of a vicar from 1850 till 1906 shows the Good Samaritan, the face being that of the vicar himself.

On the edge of the village is the Warren, a tract of land dear to naturalists for its streams, trees, bracken, and heather.

Shouldham Thorpe

Many trees and two ponds add to its charm, and an avenue of limes leads from the churchyard gate to a lovely Norman doorway, pillars supporting

the arch with its rich zigzag mouldings. It is the oldest possession of a church much rebuilt last century. There is a fine font over 500 years old.

Sidestrand

On Sidestrand Cliffs the poppies blow, and it is sad to reflect that the cliffs in all their crimson splendour are being conquered by the relentless waves.

The stones of the old church were taken down during the Great War and carried inland, a new church being built with them by Sir Samuel Hoare the banker, father of the famous statesman.

Sloley

Here in the old church, with a thirteenth-century tower and a fifteenth-century nave, is yet another of the magnificent fonts that are the pride of East Anglia. On seven of its panels the rites of the sacraments from birth to death are shown in bold fashion only equalled by the font at Gresham, and they form an exquisite gallery of fifteenth-century custom and costume. Angels support the bowl, and the lion, angel, ox, and eagle symbols of the Evangelists enrich the base.

Snetterton

It has beauty in its keeping as it lies back from the highway, with a few thatched cottages and a thatched post office, and beeches shading the churchyard, where a fourteenth-century tower crowns a church for the most part as old as itself. The chancel is earlier, and from the fifteenth century come the north porch, the aisle with three soaring arches, and the font. One of Snetterton's lovely things is a charming thirteenth-century piscina with arches resting on pillars and a lion on each side. Cut into the sill of a window beside it are quaint three-stepped seats for priests. Another beautiful possession is a graceful oak screen restored in its medieval colours.

Snettisham

The woods look down on Snettisham, which looks out to sea and lifts its beautiful spire to a height of 175 feet, so that sailors may see it from afar.

The church stands in a lovely corner among the fields, away from the village with its shaded square and its bustling street, and is a picture altogether charming, with its fine west front and the graceful spire rising above the flying buttresses of the pinnacled" tower. Though it has lost part of itself in 600 years, the church is still stately enough to have suggested the style of a modern cathedral (at Fredericton in New Brunswick).

Once the middle of a cross, the tower is now at the east end of the church and serves as a chancel, for the old chancel and most of the north transept had fallen into decay at the time the Tudors left the throne; we see a fragment of their ruins in the churchyard. The shallow west porch, the Galilee, has a three-arched entrance and a vaulted roof supporting an upper room; the door to the room is old.

Above the porch, filling the space between the pinnacled buttresses, is the great west window of the nave, its flowing tracery among the finest in this countryside. The east window was shattered by a bomb in the first January of the Great War and has now a Crucifixion scene in memory of those who did not come back.

The dim interior is impressive in its height and space, four soaring arches supporting the tower, and the stately arcades borne on clustered shafts with stone seats round them. The fine clerestory, with alternate round and pointed windows, carries the eye to the splendid roof, which was lowered 200 years ago but still has much of its medieval timber. The fine old font has nine pillars with capitals forming the base of the bowl, the pulpit has painted panels of saints, and the brass lectern is the work of a medieval craftsman. An old bell which we found resting on a stone seat probably belonged to the earlier church and may have been used as a sanctus bell in this. There is a curious fireplace at the west end of the nave, and in the vestry we found two of the ancient tiles with which the chancel was paved in olden days, one of them with a prayer for the soul of Nicholas de Stowe.

South Acre

Castle Acre in all its frayed magnificence overlooks this modest neighbour which shares its name, hiding in trees in the lovely valley of the River Nar, flowing between the villages. It has only a few dwellings besides the handsome house which was once the rectory, a bright little church with an ancient air, treasuring old memorials in brass and stone and wood, and, for a companion, a big new building for drying crops.

There have been earlier churches on the site, but this is fourteenth and fifteenth century. The oldest relic is the massive Norman font, crowned by an old cover like a pinnacle spire, which has lost much of its glory but asks us to pray for the souls of Master Richard Gotts and Master Godfrey Baker, two old rectors.

South Burlingham

Here among the tranquil fields, with the bustle of Yarmouth road a mile away, is an old thatched church with thatched barns keeping it company.

We see the thatch through the fine old rafters within the church, which has a sturdy fifteenth-century tower crowned by a modern belfry. Much of the walling is Norman and the Normans built the north doorway with its crude beak-heads, and the fine south doorway with zigzag and carved capitals. With the fourteenth-and fifteenth-century windows is a tiny Norman one, less than 2 feet long and 7 inches wide. In old glass fragments are heads and shields, and the bowl of the thirteenth-century font rests on nine shafts. There are old box pews in half of the nave, and in the other half fifteenth-century benches, of which many have plaited rush seats, some traceried backs, and some fascinating carvings on the arm-rests, where we see a little man sitting in a chair, a dog with a goose, and a pig following an elephant with a castle on its back. A serpent with a gaping mouth is climbing up one end after a dog.

The 500-year-old chancel screen is carved with tracery, and its red and green panels are patterned with stars. A rare treasure which is most probably the work of the same craftsman as the screen is the pulpit, still gleaming with its old gold and colour. The red and green concave panels of its eight sides are dotted with flowers, and between them are buttresses adorned with delicate plaster work and painting of flowers and stars. It stands on a stone base and is now part of a two-decker with a Jacobean canopy. An hourglass stand attached to the pulpit is also seventeenth century, as are the altar rails.

South Creake

Here, in a village we found gladdened by hedgerows white with may, a small river comes to life, flowing past the scanty ruins of Creake Abbey, to Burnham Thorpe where Nelson was born, and on to its outlet at Overy Staithe. Nelson played by it and followed it to the sea, and many a village lad has followed in his wake.

Behind a ring of earthworks here the Saxons of East Anglia gathered to watch with wintry glance the Danes marching up from the sea. It was the beginning of the Danish invasion which overthrew King Edmund the Martyr and turned East Anglia into a Danish settlement. The invaders did not make their way past the outpost of South Creake without a bitter struggle. Tradition says the bodies of the slain were piled up to the height of the defences, and after a thousand years the place is known as Bloodgate.

The surprise of this village is the delightful old church, a picture outside of an unfinished-looking fourteenth-century tower, and an old porch with a cluster of pillars at each side and a modern Madonna and Child in the niche above it. As we go down the three steps leading us in we are arrested by its beauty. It has the air of a small cathedral. Soaring arcades with stone

seats round their pillars divide the 500-year-old nave and aisles; the old font, with its carved figures hacked away, stands in glorious isolation in front of the majestic tower arch; and a fine old screen, still showing faded medieval painting, leads to the great chancel, 650 years old, and a blaze of light with gleaming white walls, white windows, and white roof.

Charming splashes of colour are lent by the blue and green of the four altars, and by the little cushions hanging from the chairs. Even the floor has a share in the scheme, for it is all paved with old tiles. Very charming is the effect when the eight candelabra in the chancel, and others in the nave, are all aglow.

The altar is guarded by four golden angels. Angels adorn the canopied sedilia. There is a corner piscina. The fifteenth-century pulpit is a little restored and has had most of its painting scratched away. There are some fragments of medieval glass. A massive old chest, lined with cedar wood and completely covered by studded iron bands, has a fid so heavy that seven men are needed to lift it; it has five locks patterned with leaves and flowers, and a master key and one lock are thirteenth century. The splendid fifteenth-century roof of the nave is adorned with twenty-two angels, carved and painted, and its pillars and arches frame the fine windows of the medieval clerestory. In the spandrels of the south aisle roof are curious carvings of a goose, another goose with a bird on its neck, and a unicorn.

South Lopham

Its supreme possession is its Norman tower, the gift of a lord of Lopham who went down in one of the bitterest tragedies which ever cast a shadow round our throne, the sinking of the White Ship with the son of Henry the First on board as he was returning to England in his father's hour of triumph. The village is charming, with an old forge, thatched roofs, and a pretty row of cottages facing the green. A road through fenland and over a common glorified with gorse, silver birch, and rushes brings us to the source of two rivers, the Little Ouse and the Waveney. They begin their journeys as rush-filled streams on each side of the road, and one flows west and the other east, dividing Norfolk and Suffolk.

Not only is William Bigod's tower the glory of this village church, but it is the best example of Norman architecture in the county except for the cathedral itself. Built about 1110, it rises massive and magnificent from the middle of the flint-walled church, dwarfing the churchyard firs, and four of its five tapering stories are ringed with Norman arcading. There is a Norman doorway in the nave, and high up in the wall is a small round window deeply splayed, certainly Saxon and perhaps the work of the tenth-century

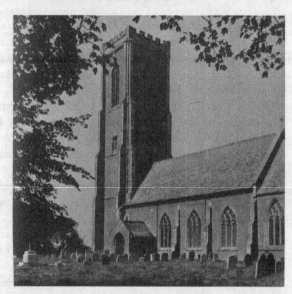

The lofty
medieval tower
at Southrepps

builders. The rest of the church is mostly fourteenth century, but the porch
and some of the fine windows are fifteenth. The clerestory windows of this
time are on both sides of the nave, though there is now only one aisle, with
its arches on clustered pillars. The roof has small hammerbeams and carving
of Tudor flowers.

In the gallery of fifteenth-century carvings on old benches in the tower
is a strange beaked animal with a castle on its back, a headless pelican
with her young, winged animals, a seated figure in a veil, an animal sitting
with another in its mouth, and a woman with a knife and a shoe. Parts
of the medieval oak screen are now at each side of the east window. The
font is old and has a Jacobean cover; the old chalice and paten were made
by a Dutch craftsman, and the dug-out chest is a marvel, shaped out of a
huge block of oak ages ago, eight feet long and probably as old as William
Bigod's tower.

Southrepps

Above its humble cottages the tower of its church rises 114 feet in a splendour
that has survived five centuries. Among the flints round its base are panels
of stone with blank shields and the scallop shell of St James; above its great
doorway (which has copies of its lost medieval doors) are shields of stone
between superbly carved niches. There is more splendour within, and it is

thrilling to stand in the nave and look to the great windows through the lofty arches of the tower and chancel. By the priest's door is a fourteenth-century jester, and an angel looks down from a window in black and gold glass 600 years old. The traceried font is of the same age, and the screen has painted panels spangled with gold five centuries ago.

South Walsham

Oaks line the lanes of this pleasant village, and a fine one on the green keeps company with the pump in its thatched shelter. Beautiful woods divide it from its charming Broad of about 50 acres, linked with the River Bure by the Fleet Dyke. Here grows the rare water fern which was first found in a ditch at Woodbastwick and carried by floods to several other Broads. Its light green summer dress turns brick-red in autumn.

An unusual sight here is the churchyard with two churches less than 20 feet apart, the ruined tower of one of them almost dwarfing the medieval church of St Mary. In 1827 a fire broke out in neighbouring farm buildings, reached the thatch of St Lawrence's chancel, and damaged the whole building, so that now it has no nave. The ruined 500-year-old tower, with ivied walls, is now the home of many birds, and the chancel, which was restored, is used now by the Sunday School.

St Mary's fifteenth-century tower has panelled battlements and traceried sound-holes, and the lovely two-storeyed old porch has the Annunciation carved in the spandrels of the arch, showing a lily in a pot at Mary's side. Under the delicately carved canopy of the niche above it is a group of three figures with battered faces. The chancel is fourteenth century and the nave arcades fifteenth. The beautiful font is 600 years old. The chancel windows are gay with modern glass with many scenes. There is the Nativity with kings and shepherds and a choir of minstrel angels; the Women at the Tomb are here with a curious scene of the Last Supper and the Good Shepherd; gleaming in lovely colour are Mary and Cecilia, both in a frame of lilies, and Etheldreda with her staff. In the aisles we see John, Paul, and James, a striking picture of the Sower and a ploughman, and St Romona among stars set in a window bordered with old glass fragments.

The fifteenth-century screen, with its original gates, has panels painted red and green and patterned with white, and an inscription asks for prayers for John Gate and his wife, who gave it to the church. The ends of the fifteenth-century benches are bordered with leaves, and under some of their fleur-de-lys poppyheads are shields with the names and initials of those who gave or sat in them. Other old relics are a piscina niche, a windowsill with stone seats, two coffin stones said to come from St Benet's Abbey (of which

ruins are to be seen two miles away), and a battered eighteenth-century oak grave slab.

In golden frames on the altar are two ivory carvings of fine craftsmanship, each only about six inches by three. They were brought from Spain. One depicts Our Lord telling the parable of the Good Shepherd; the other shows Him telling the parable of the lord of the vineyard.

South Wootton

Standing in dignified isolation from the modern houses on the road to the sea between Lynn and Castle Rising, yet not so far away that the Wash may not be seen, the old church and the gabled rectory hold themselves apart, like conspirators guarding a precious secret. The secret is the Norman font.

It is one of the four masterpieces in stone which some forgotten sculptor carved for churches in north-west Norfolk, the others being at Toftrees, Sculthorpe, and Shernborne. Each of the group has its own individuality. The carving on South Wootton's square bowl is less elaborate in design than the interlaced work of the others, but it rests on nine pillars, of which four have massive gargoyle-like heads, one with bared teeth, for capitals. The font is the chief ornament of the church, which has transepts giving it the shape of a cross, and a west tower which was renewed in brick after being struck by lightning last century. The nave is fifteenth century, and the chancel has lovely work of the fourteenth century in the east window, the three-stepped sedilia, and the piscina.

Sparham

A belt of trees half hides the church and the clustering cottages, but we do well to find them. An avenue of yews brings us to the medieval church with its pinnacled tower and its charming clerestory windows, and it is a 500-year-old door that lets us in; it has lovely tracery on it. Angels look down from the high nave roof on angels and saints of stone supporting it above the arches. The old wooden pulpit has delicate carving of tiny roses in its arches, and there are two old pews with rich tracery.

Spixworth

It lies hidden between main roads and has a church so small that it seems to have joined in the conspiracy to escape attention. But it is big enough for the few people here, and stands mantled in trees by the small green, looking over the meadows, where there is a dovecot. Its tiniest of towers is only seven or eight feet square inside. The east window has curious leaf tracery, and a low window frames a figure of St Peter, the patron saint, with his keys.

The fourteenth-century sedilia and piscina and the old rood stairway are still here. An old chest has iron bands, and the Norman font has a simple bowl on five pillars.

Sporle

It has a long line of red-roofed houses and farms, and the stream that so waywardly crosses the main street from side to side flows past the old vicarage, which has a tablet on its wall exhorting us to search the scriptures. A bridge and an upward path bring us to the church, and in a field near by are a few stones telling of a Norman priory founded here.

The 600-year-old tower has a fine niche over its recessed doorway, with three shafts on each side. Except for two chancel bays and the graceful nave arcades with bell capitals (which are thirteenth century and the best feature of the church), the rest of the old work comes chiefly from the fifteenth century. One of several piscinas is a piscina between the vestry and the sanctuary. The thirteenth-century font is finely set, its bowl resting on nine pillars and a high base, at the corners of which are four sets of two steps. A carved chair is Jacobean, and t of an old screen. The stone pulpit, projecting he wall, is modern, but is entered by the old rood stairway.

Sprowston

In Mousehold Lane, facing the Heath, are a dozen cottages built in memory of men of the Norfolk Regiment who did not come back, and disabled men live in them now. In the grounds of Sprowston Lodge is a willow grown from the branch of a tree shading Napoleon's grave at st Helena. In an old flint building, now part of a library on the roadside, almost in Norwich, are two Norman doorways which are all that is left of the Hospital of St Mary Magdalene, built for lepers by Bishop Herbert de Losinga. On the Wroxham road Sprowston Hall stands in its park, a fine house made new last century, and in a quiet corner by the fields not far away is the fifteenth-century church of flint and stone, crowned by a brick tower. It was much restored near the end of last century, but has a few old relics and some interesting memorials. The Jacobean pulpit and seventeenth-century altar rails are kept but no longer used. Old glass in one of the windows has an angel playing a violin; the base of the old screen has a richly carved border.

Stalham

On a busy highway close to Stalham Broad so prodigally adorned with tail rushes and white lilies, stands old Stalham town. In its market street, close to the old tithe barn, stands the fifteenth-century church, possessor of one

of the finest fonts in the land. As old as the church itself, it is raised on three ornamental steps, so that it stands over six feet high. An exquisite tendril dines to its base, lovely figures of the Madonna and saints stand in niches round the pedestal, and the bowl has sculptured panels of the Baptism, the Trinity, and the Apostles. Even in a county so richly endowed with medieval sculpture this font is remarkable. The medieval screen has been less fortunate than the font, and we found only five loose panels remaining, their paintings fading. One of them is notable and curious, for it portrays St Roch, the Italian saint who stayed the plague, and the medieval craftsman has shown him pointing to the scars of his affliction.

Starston

It has in its fine little flint church, standing so charmingly at a tree-bowered corner above the willow-fringed stream, a most historic chalice. The silversmith wrought it in the reign of Queen Elizabeth, engraving it with a broad band of leaves round the top and a narrow band on the lid. Long afterwards it passed into the possession of William Sancroft, Archbishop of Canterbury, and one of the Seven Bishops who struck the final blow at the Stuart dynasty.

There are still traces of a Norman church in the nave, but most of the church is medieval. The porch, with an entrance arch adorned with flowers and upside-down faces, is 500 years old. The lofty old chancel arch is all aslant. The nave roof is partly new but has original bosses; and let into the altar table is an old carving of the Last Supper, with Judas holding the bag. A quaint little chest has three locks. The medieval font has lions at the foot and angels under the bowl.

In the vestry is a copy of a remarkable medieval wall painting which has crumbled away. It shows figures mourning round a deathbed while a soul in a winding sheet ascends to heaven. Beck Hall is called after the stream that winds to the Waveney; Starston Hall may claim to be a moated Elizabethan grange, with fine chimneys and round clipped yews to support its dignity, though it is now a farmhouse.

Stiffkey

In the charming Vale of Stiffkey, where the road and the river are close companions, making a big sweep between the sloping woods, the old church stands delightfully by the green, rubbing shoulders with the Old Hall. The church has a square tower and an eight-sided turret to loft and roof; the hall has round towers and gables; and trees ring them round like a bower.

Alone in the churchyard since its companion church of St Mary disappeared half a century ago, the church of John the Baptist comes chiefly from the fifteenth

century. A porch with mosaic of flint-work leads us inside. The chancel has a thirteenth-century piscina. Two or three old stalls now under the tower have misereres carved with flowers, and one of the poppyhead priest stalls is adorned with seaweed and shells. Old glass fragments show five golden heads, and there is a silver chalice given by the Bacons. The Crucifixion scene with Mary and John, carved in white stone, is the peace memorial, and by each of the names is carved the regimental badge of the man who did not come back.

Stockton

With lovely woods all round, its charming little church, with a delightful thatched roof, stands in a lane with haystacks and old red-tiled houses for company. Much of it is fifteenth century, but the Normans built the round tower, to which the thirteenth century gave belfry windows and brick battlements. It has a short lead spire. The porch, with a Dutch gable, has a wooden sundial and seats of massive and roughly cut oak beams. It shelters and old oak door with strap hinges and a ring.

A fine old steep roof with moulded beams and embattled wall-plates looks down on the long narrow interior of white walls, most of them old and some having ancient glass fragments. An old chest has two locks; a Jacobean chair has an arcaded back; and a Jacobean cover crowns the medieval font.

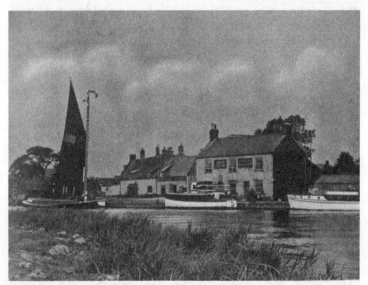

The River Bure at Stokesby

Stoke Holy Cross

It is a modest place of farms and cottages, and its little church, set on a high bank on the edge of the park and away from the village, has grown from the church the Normans built. Its tower is fifteenth century; the south doorway is Tudor with an arch of bricks. In the chancel is a double piscina, a Breeches Bible, two seventeenth-century almsdishes, and three old bench-ends making a poppyhead seat with carvings of queer animals.

Stokesby

It has changed much since its Norman lord looked over the great marshlands and over the River Bure winding among them. Now red-roofed and thatched houses see the traffic of road and rail and of reed-fringed river with flitting sails, many a busy windmill comes into the view, and many cargoes tie up to the wharf.

The church stands trim and plain on the hill above the village, and in its small thirteenth-century tower is masonry of the church the Normans built. On the door is a fine fourteenth-century ring with a plate of ironwork wrought into a pattern of feathers. A few medieval seats with carved backs and poppyheads have on their elbows grotesque animals, a hound, and a fine carving of a nun kneeling at her prayer desk with a rosary. Ever since 1488 Edmund Clere and his wife have been here in brass. He is a knight in armour with vizor raised and a hound at his feet; there are carved flowers at the feet of his lady, who wears a tall headdress and jewels round her neck.

The yellow creeper-covered Old Hall with big thatched barns for company has inherited stones older than itself, for built into its garden wall are fragments which may have come from the Norman church or from a college founded here 450 years ago.

Stow Bardolph

In an oak case in the Hare Chapel of this church is the wax figure of Mistress Sarah Hare, whose untimely fate might have served as a subject for one of Maria Edgeworth's Moral Tales. We are told that she was sewing on a Sunday and a prick of her needle caused her death! (We have seen a similar story on a stone in Westminster Abbey.) Wearing the fine dress of her Georgian day (she died in 1744) Sarah Hare lies in wax, locked in her case, hidden from view.

Here is one of many memorials to the Hares whose story is linked with this village, which lies so charmingly among the woodlands on the busy road to Downham Market, looking across to Wimbotsham's tower a few fields away. For nearly 400 years the Hares have been lords of the manor, living

here through seventeen reigns. One in the seventeenth century was a great lover of trees, and he planted cedars abundantly.

Their dark green masses adorn the grounds of the hall, a fine house which they have twice rebuilt, first soon after the armada, and again in 1875. Sir Ralph, who was 'remarkable for his charities', has a marble monument in the church and another memorial in the alms-shaded houses he founded in 1603 for six poor persons. They stand at a shaded corner by the fine gates of the hall. ... The aisleless church is by the rectory, which has a fine old cedar on its lawn. Though much restored and partly made new, it keeps its massive tower with a wide Norman arch, and two Norman windows, its top storey being fifteenth century. The remarkable feature of the tower are the stone steps outside, leading to a priest's room. The thirteenth-century triple sedilia and the double piscinia have five stepped arches, and in a low window is the Madonna.

Stow Bedon

Perched on the hill above the cottages and the salt water lake of Stow Bedon Mere is the plain little church with the school for company. It comes from the three medieval centuries, restored last century. The stone turret for the bell and the porch are modern. Two thirteenth-century lancets in the chancel are filled with glass from Hildersham in Cambridgeshire, in formal pattern of black and white, touched with red, blue, and gold. Thirteenth-century bracket piscina is hiding in a corner of the sanctuary. The fourteenth-century east window, with fine flowing tracery, has a new hood. Other remains of the fourteenth century are the simple west doorway, and the very striking embattled font with fine tracery on its eight sides, roses and heads under the bowl, and a traceried stem. It is five feet high and forty inches across.

Stradsett

It is part of a wooded countryside, and its crossroads meet under the trees. A long avenue of chestnuts leads to the church in a pretty setting near the great house, which stands by a rush-fringed lake of 20 acres. We found hundreds of rabbits playing in a corner of the churchyard, their holes being round the roots of a tree.

A medieval doorway lets us into the church, a continuous nave and chancel with a thirteenth-century tower. There are many memorials to the Bagges, who became lords of the manor in the eighteenth century and have been good friends to the church. One gave the glass filling the east window, made nearly four centuries ago and showing a fine scene of the Wise Men in rich robes with their servants in the courtyard, offering gifts to the blue,

white, and gold Madonna and Child. Joseph, with the ox and the ass, looks on, and minstrel angels are in the sky. A lancet in the tower has similar glass in a roundel, and in a panel showing the Crucifixion and a Lamb.

Beyond the church and the hall is the old farm of Paradise Manor, with a pinnacled turret and an inscription telling us that Francis Parlet built it in 1600. This old home of the Pallets, and a little group of thatched and tiled cottages with dormer windows, are framed in trees on the edge of the woods.

Stratton St Michael

Down a lane with two small cottages and a farm for company stands the medieval church, with tall sweet limes among its encircling trees. Its sloping walls, its pantiled roofs, its low tower, with the spire like a cap within the parapet, intrigue the visitor, and an ancient door with its original strap-hinges leads us into a nave and chancel which have no separating arch, though with different roofs. The nave roof is black and white with flower bosses; the chancel roof is green with old wallplates at its sides. On the old font bowl are lions and angels, but the lions on its base have lost their heads; the piscina is still elaborate with its carving and its pillars. The altar rails and the fronts of the choir seats are Jacobean and on two old poppyhead bench-ends is a bishop with his crozier and St Catherine with her wheel. Only a few fragments of glass recall the glory of these windows in bygone days.

Stratton Strawless

Here the Marshams lived from century to century, making two blades of grass grow where one grew before, until out of the bare Buxton Heath they created an oasis of fertility. They were here in the days of Edward the First and had only just gone when Edward the Seventh was crowned. One of them planted beeches and silver firs, oaks and cedars of Lebanon, and lived to see the fine beech avenue which still survives. The church, with a fine square tower built in 1422, is divided by their great pews. An alabaster figure of Thomas Marsham of Stuart days lies in a shroud on his altar tomb, with two angels blowing trumpets, and a group of seventeenth-century Marshams kneel on a tomb by the wall, a child in swaddling clothes among them. Here also is a figure of great dignity carved in black stone, and representing a lady in long and flowing robes. In two windows is some fifteenth-century glass with Gabriel and Mary and winged Evangelists, and above the manor pews is richly coloured glass with a Madonna gazing fixedly at the Child as if entranced.

Strumpshaw

From one of Norfolk's highest hills (though it is hardly more than 100 feet), the church with the tall narrow tower looks over the Yare and the marshes to the spire of Norwich cathedral, and on a clear day picks out the gleam of the sea at Yarmouth and the dark tower of that town's great church. Strumpshaw's tower, built about 1500 and crowned with deep battlements and eight pinnacles, rises high above the long low nave and chancel, both thirteenth century with some later windows. There is a founder's recess in the nave, and the fine fifteenth-century font has lions round the stem and angels under the bowl. At the side of a window with a sill lowered for sedilia, is a medieval double piscina, its richly moulded arches and shafts with bell capitals and foliage at the ends of the hood. From one bunch of the foliage a lizard is creeping out. Another notable possession is the fifteenth-century screen, still bright with original green, red, white, and gold. The feathering of the arches is tipped with golden roses, and the panels are dotted with painted flowers and the letter R, probably standing for Rex, as the S and P on the tower battlements stand for St Peter, patron saint.

Suffield

The trees of Gunton Park shelter its cottage homes and its church stands aloof. It has a great treasure in its screen on which eight of the twelve painted panels remain after 400 years. Among the figures on the panels are some rarely seen: Longinus, the repentant soldier of the Crucifixion; Julian, a third-century nobleman who did penance for a terrible crime by devoting his life to ferrying pilgrims across a dangerous stream; and John Schorn, a rector who won a wide reputation as a worker of miracles in Buckinghamshire 700 years ago; he is shown here thrusting his hand into a boot to illustrate his chief miracle, 'Sir John Schorn, Gentleman born, Conjured the devil into a boot.' The gold tracery framing the figures in the panels has masterly carving in which we noticed a stag and a camel, a lion and a dragon, a man with a cudgel, an eagle and an owl, and a hog sitting on a tub playing a viol to three little dancing pigs. It is like a Silly Symphony of the Middle Ages.

The chancel which this screen adorns is thirteenth and fourteenth century and has a richly carved piscina. The lofty nave and the aisles are fifteenth century, and the traceried door through which we come in has still the massive key which has been opening it for 400 years. A medieval mass dial is on the wall and there are old bench-ends with fine poppyheads, a sixteenth-century font, a window with heads of saints in fifteenth-century glass, the Elizabethan altar tomb of John Symonds, gay with painted heraldry, and the old roodloft staircase.

Surlingham

The round Norman tower was given its octagonal belfry when the rest of the church was made new in the fourteenth century. A lychgate to six men who died for peace brings us to it. A cluster of cottages keeps it company, but its setting is spoiled by the Aunt Sallys of the Petrol Age. The arcade and the font are medieval, the font bowl supported by cross-winged angels. Round the bowl are lions with bushy tails and angels holding shields, and at the foot are four lions with big manes. John Alnwik, a priest who was baptising children here perhaps when the font was new, is here in brass, and has been sleeping in the chancel since 1450. The ruined walls of another old church were covered with ivy when we called, and the attractive Broad of 70 acres was overgrown with reeds.

Sustead

The round Norman tower stands in the midst of it, guarding the medieval church with a mass dial and a fourteenth-century window with a medieval portrait of St Catherine. The traceried chancel screen is fifteenth century; so also is the font with its eight heraldic shields. The handsome double piscina is fourteenth century. In the churchyard is a curious thing, a grave from which, in spite of the railed-in tomb above it, a weeping ash has burst its way and grown up 30 feet or more.

Swaffham

Fine limes make shady avenues in the churchyard, where the church stands like a cross and is as lovely inside as out. It was made new in the fifteenth century, though the lovely west tower is sixteenth and its delicate spire is

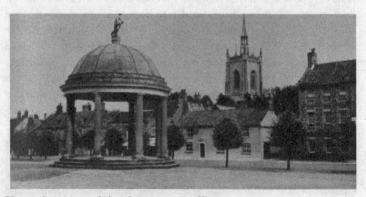

The market cross and church tower at Swaffham

younger still. The tower has a fine old door, and a lovely arch opening to a nave with arcades like a stately avenue, seven arches on each side on clustered pillars. A host of 150 lovely angels looks down from the magnificent double hammerbeam oak roof, carved 500 years ago with beams and borders richly moulded and edged with Tudor flowers. There are fine old bench-ends in the reading desk, and remains of a painted screen. The handsome rails in the chancel are of brass and ironwork. Here and there in the modern poppyhead benches are carvings of a pelican and her young, a bishop, the bull, the eagle and the lion for three of the Evangelists; and on the ends of the two front seats we see the Pedlar tramping along, his pack on his back and his dog at his heels. In the upper room of the old vestry is a library of books presented to the church soon after the Restoration.

The church has remains of the thirteenth century in the walls of the chancel and the north aisle; the porch is fifteenth century; the tower with the rest of the old work is fourteenth. The porch with brick seats and an old sundial is patterned with flush-work, the bricks arranged to show the words Nazarene and Margaret (the patron saint). She is carved in the spandrels of the entrance arch; and on one side is seen swallowed by the dragon and emerging from its back; on the other side St Margaret and a man are in triumph, the dragon having collapsed at their feet. Three fine arches of the tower rest on great piers within the church, two joining up with the arcades. It is an effective and unusual feature of this pleasing interior. Under the tower is the 700-year-old font on new pillars. Opposite the door are faint traces of a wall painting of St Christopher. There is an Elizabethan altar table, and some old poppyheads. The carving on the stalls and the priest's seat, showing flower borders, a pelican and a dragon, was the work of a rector. Under a fourteenth-century window with lovely tracery are the canopied stone seats and carved in the spandrels are fine sprays of oak, acorns, and blackberries. Resting in the old piscina niche is the church's great treasure—the square head of a Norman piscina, carved on three sides with two scenes of St George in armour spearing the dragon. It was found blocked in the rood-stairs and is remarkably well preserved.

Swannington's tragic memory is that of Robert Kett, the tanner of Wymondham, who was taken prisoner here and led to his death at Norwich for leading a rebellion in 1549.

Swanton Abbot

Its 600-year-old church is perched on a hilltop like a guardian of the village below. It has a splendid brass portrait of a fifteenth-century rector, Stephen de Multon, a font which was new in his day, and a screen which divided

his chancel from their nave. The font has quaint heads below its bowl, and a seventeenth-century cover; the screen, which has much new work in its tracery, is curious for having its painted panels facing into the sanctuary instead of into the nave. There are many nineteenth-century ex-Blakes, who lived at the hall, approached by a fine avenue of Oaks.

Swanton Morley

It keeps green the memory of the Barons Morley, the foundations of whose ancient castle are on the bank by one of the many beds of the Wensum. The rest of its name is in the picture in the church, in carvings of the Swan and Tun on the chancel roof and on old and new doors. The striking church is by the wayside, standing magnificently on the hilltop and looking down a little valley to the river winding in the meadows.

This splendid example of a medieval church was begun in 1378 when Sir William de Morley left ten marks and his gilt cup towards its cost. The massive tower rising from the nave has belfry windows so huge that they dwarf the big windows of the aisles

The best of the beautiful doorways, adorned with rich mouldings and flowers, is sheltered by the porch, which keeps its old black and white roof with a lion and a quaint man's head on the flowered wallplate. An impressive sight as we open the wicket of the old door are the soaring nave arcades, the tower arches, and the rich tracery of the windows. The font is plain and old.

The flint church among the trees is fourteenth and fifteenth century, but one or two of its windows are Norman, and one tiny window is said to be Saxon. The old door is still on its hinges and brings us into an interior charming in blue and grey. Four great beams support the roof, and there are low arcades on each side of the nave, an old oak screen has tiny grotesque heads at the foot of its pinnacles and is painted in medieval colours. The windows have fragments of old glass, and the old roodstairs have been made to lead into the high and narrow pulpit. In the chancel is a trefoiled piscina cut in the corner of a stone seat, a Norman piscina cut into a niche, and a lovely Elizabethan chalice.

Gowthorpe Manor, near the green, is an Elizabethan house with stepped gables, fascinating doorways, a walled garden, a noble barn, and remains of a moat.

Syderstone

A wide common dotted with flocks of geese, red-roofed cottages climbing the hill to the long ivied church with a round Norman tower and the rectory

with honeysuckle on its walls, it is one of a thousand such villages of the peaceful countryside; yet about this common, the fields, the woods, and in the garden of the rectory and in the church, flits the shade of one of those pathetic figures unforgettable in our island story. She is Amy Robsart.

In the grounds of the rectory stood Syderstone Hall, home of Sir John Robsart, Sheriff of Norfolk and Suffolk. Here in fancy we may picture the slender figure of his daughter flitting among the trees and on the lawns. It seems most likely that she first saw Robert Dudley, Earl of Leicester, when, as a member of the expedition to quell Kett's Rebellion, he stopped at Sir John's later house, Stanfield Hall near

Wymondham, but from letters still preserved we judge that after her marriage she came back here to live for a time, and that her husband came with her, finding here some brief happiness in the years of distracted life which ended so tragically at Cum nor.

Only the foundations of Syderstone Hall are left. It became Amy Robsart's at her father's death, and after her own death passed with the manor to the Walpoles of Houghton, who made history two centuries later. Her initials A R are on the churchyard gate, and over the entrance to the Norman tower, reached by a sunken path between rocky walls strewn with flowers, is Robert Dudley's badge carved in stone.

It is a curious little church, but not without charm. Quaintly projecting from the walls of the long narrow nave, 18 feet wide, are the pillars and arches of a Norman and medieval arcade which led to vanished aisles. The chancel seats are interesting for being local work, and the odd tracery of the prayer desk for having been carved by a lady at the rectory.

Tacolneston

It has a few gabled and timbered cottages and a grey church with a tower facing an old house with clustered chimneys. The thatched and timbered house by the church is losing some of its glory, but has a gabled porch of three tapering storeys. Within a mile of the church is Tacolneston Hall in its fine park; it began as a Queen Anne house. The church was made new about 1500, but the tower is partly fourteenth century. The fifteenth-century roofs with moulded beams look down on a lofty and spacious interior. Part of an old oak screen in the aisle has rich carving of flowers and battered remains of two paintings, one showing the Annunciation with the Madonna kneeling at her bed, and the other the Temptation of Saint Anthony, with the saint in a patterned robe holding a golden casket and a black demon pointing to some passage in a book. The Jacobean pulpit has arcaded panels. There is a painted consecration cross on the chancel wall, a medieval mass dial, and

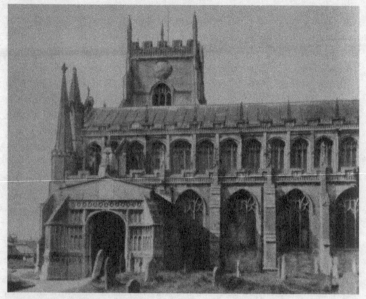

The Cathedral of the Marshes at Terrington St Clement

an ancient coffin stone.

Tasburgh

It has thatched cottages and charming houses, and by the ford at one end of the village stands Tasburgh Hall, a modernised Jacobean house among the trees. Where the church rises above the village Roman soldiers stood sentry on the hill in a great camp of 24 acres above the winding River Tas. An avenue of Irish yews leads us to the church, with a round tower which either the Saxons or the early Normans built; its height was raised about 1400, when it was given a crude round-headed window. The arch opening to the nave is later, and the hammerbeam roof of the nave, with fourteen cherubs at the end of the beams, is modern. Curiously placed under a chancel window is a tomb of Elizabeth Baxter, who died in 1587 at Rainthorpe Hall, the old manor house in wooded grounds through which the river flows a mile away.

Taverham

A charming ride from Ringland, along shady lanes and round the wall of Taverham Park, brings us to the small thatched church just above the

Wensum. It stands at the gates of the hall, which was made new last century and is now a school. The Normans built the round tower, but the octagonal was added in the fifteenth century, about the time the nave was destroyed by lightning. The screen between the nave and the fourteenth-century chancel comes from about 1500, and the chancel seats are of the same time. The altar rails are part of an old screen from a neighbouring church. A good Jacobean chest, carved and inlaid, has fleur-de-lys hinges, and modern poppyheads are carved with foliage and berries. In remains of fifteenth-century glass is a scene of the Crucifixion, with yellow-winged angels above it and kneeling figures below. Beside the Cross is the Madonna in red robe and blue cloak, and St John in blue and purple. The fifteenth-century font has shields and symbols adorning the bowl, and carved in niches round the stem are St Agnes with a lamb, St Leonard with chain and staff, St Giles with his doe and crook, St Anne teaching Mary to read, St Margaret and the dragon, St Edmund with an arrow, St Lambert with palm, and a saint with a club.

Terrington St Clement

They call its church the Cathedral of the Marshes, and we are not surprised. There are few of our ten thousand village churches to compare with this by the marshland and the sea.

It is an arresting spectacle, set back from the highway a few miles from Kings Lynn. Built in the shape of a cross with aisles and transepts, it is 167 feet from end to end, and its massive tower, with buttresses climbing in steps to the pinnacles, 80 feet up, stands detached, adding to the lovely picture of the west front, with nave and aisles enriched by pinnacled turrets and flying buttresses. At each side of the great west window is a handsome niche, and a smaller one above it. Into the charming picture of the south side of the church comes the lovely porch and a striking array of windows the clerestory embattled and with pinnacled parapets. Over it all peeps the top of the tower.

Carved on the parapets are the heraldic distinctions of fourteenth-century families and of Bishop Fordham, who was ruling the see of Ely at the time of Agincourt. It was during this time that the present church was built on its Norman foundations, though the tower which was for many years a Tower of Refuge in flood time is a little younger than the rest.

The glory as of a small cathedral persists inside, in stately arcades and in the soaring arches built to support the central tower which was planned and never built. It was found that as the structure settled it would not carry a great tower, and so the tower was built apart, like the Italian campaniles.

Quaint animals, men, and mermaids adorn the clerestoried walls and heads and angels enrich the stringcourse. There are stone seats for the priests,

a piscina, and an astonishing group of old altar stones, one under the altar table, and three set in the floor near the stalls. A child's coffin lid and a stone carved with knotwork are also in the chancel, and in a company of loose old stones by the tower are battered figures of St Christopher and St Clement. A 400-year-old chest has a gabled lid. The fifteenth-century font has a striking tabernacle cover, so lofty that it reaches the top of the arch by which it stands. It is sixteenth century, and has doors opening to show fine painted scenes of the Baptism (with a quaint crowd looking on), the Temptation, and the Fasting of Our Lord (with the Devil and wild animals around); here too is a Latin inscription which speaks of the Father revealed by the Voice, the Son by the Body, and the Spirit by the Dove. In the transepts are copies of the Lord's Prayer and the Creed, printed in Black Letter in 1635.

The fine east window sheds a blue, silver, and red light with glass showing Our Lord on the Cross, and again in glory with saints and martyrs; it is in memory of 100 men who did not come back. The altar has been reached by a flight of steps since the vault was made for the Bentincks, whose earliest memorial here is to William Bentinck of 1813, the admiral. One of the family, famous both in England and Holland, was a great benefactor of this place, where he held wide lands.

For centuries the sea has been threatening to take Terrington. The Romans built a bank to keep it out, and part of the bank remains. A dyke burst in 1607 and people fled to the church and its Tower of Refuge, being for days fed by boats from King's Lynn. Count Bentinck took up the work where others had left it and constructed new embankments to resist the tides. Those were the days in which the malaria called fen fever was still rife in the marshy lands, and Count Bentinck died of it, though not before he had made the village safe. Another bank was built by German prisoners during the Great War.

Terrington St John

Among sturdy farmhouses and weatherbeaten cottages stands the medieval church of St John. Big and rather like a barn within, it has leaning walls and arcades, and old box pews filling the nave and aisles. Its remarkable clerestory has round windows filled with fine tracery and alternating with pointed ones. A narrow chamber connecting the west tower with the south aisle is supposed to have served as a home for the priest. The font, standing on three carved steps, was over-decorated in 1632.

Tharston

Oldest of all the inhabitants in this small place of scattered farms and cottages, older than the farmhouse with a lichen-covered roof and a porch

with a room above it, almost as old as the fourteenth-century tower of the church on the hill, are some of the Tharston oaks, growing in solitary dignity in a field. Seven of these veteran giants are marshalled there, four in a square and three in a line.

The chancel is for the most part as old as the tower. From the fifteenth century come the nave and the north porch, which shelters an old door on strap-hinges. A medieval mass dial is on the wall. One of the few things of interest in the plain and aisleless interior is the fifteenth-century font with lions round the base, angels, roses, and lions round the bowl, and angels under it. One of about a score of old poppyhead pews is carved with St Michael weighing souls, a figure in one scale and the devil in the other; another has a crowned Madonna with two angels, and a third a crowned figure with a book and crozier. A skeleton in a shroud lies at the base of a monument to Robert Woode of 1623, and at each side of one to Sir Robert Harvey, the military link between the Duke of Wellington and the Portuguese, is the figure of a soldier of his day

Thelveton

Its red-roofed dwellings, its stacks and barns, the small church in the fields, and the Elizabethan hall, are all just off the Roman road to Norwich. Reached by a long avenue of oaks and hiding in trees, the hall was for centuries the home of the Havers and then of the Manns, who gave the village its reading room and built three cottages as a memorial to one of the family who fell in the Great War. They restored the fifteenth-century church, in which is a marble relief of the head of Thomas Mann, with side whiskers. Fine oaks, beeches, and pines completely hide the church, which has a bellcot crowning its flint walls. There are many quaintly clipped yews by the churchyard path, and under one of the walls is a Flanders cross. The interesting things to see are a pretty pillar piscina with a flower drain, and a fifteenth-century font with roses, lions, and angels on the bowl, heads of angels under the bowl, and on the stem three mitred bishops, a man in a bowler hat, and four bearded saints with wings and books.

Thelveton was the home of John Stubbs, a great Puritan who died in France in 1591 and was buried on the seashore. He is always cited by historians as proof that, no matter what her severity, her subjects loved Queen Elizabeth with a chivalrous affection no other sovereign ever won. He was arrested for publishing a protest against the proposed marriage of the queen with a Roman Catholic, and was found guilty and sentenced to have his right hand cut off, the fearful sentence being carried out on a scaffold erected at Westminster. Stubbs, while waiting for mutilation, declared to the

The old priory gateway at Thetford

crowd that he was warmly attached to the queen and that the punishment would in no way impair his loyalty. After his hand had been struck off, he put off his hat with his left hand, says Old Stow (who was present), and cried aloud, God save the Queen, while the people stood mute with fear.

Thetford

A Norfolk heath, such as Old Crome painted and George Borrow loved to roam on, stretches away from it, so that this pleasant little town of five thousand people seems to have sprung up from the moorland. In the heart of it two rivers meet, the Thet and the Little Ouse, the Ouse bringing barges from the sea and leaving a small part of the town in Suffolk. It has an old, old tale, for it goes back to the days when the Church was great, to the days when the Normans came and built great churches, to the days when the Romans came and set up their defences, and to days long before that when the Ancient Briton sought security by throwing up vast mounds of earth with whatever primitive tools they could find, generally shoulder blades of oxen or antlers of deer. Far back in the mists of time lie the beginnings of Thetford.

What is called Thetford Castle is the great mound rising with acres of ramparts all round it, now a very pleasant place to walk in with trees rising

from the hollows and crowning the hill. In ancient days this castle mound gave its owners command of the Icknield Way where it crosses two rivers. The land was ill-drained and largely primeval forest. The earthworks on the castle hill are the biggest defences of their kind in Norfolk. The mound rises 80 feet high and is 100 feet up the slope and 1000 round the base, where deep dry moats run between the remains of a double wall. From the top of the hill, now shaped like a crater, is a fine view over the red roofs of the town, and on the western side we see remains of ramparts and ditches known as the Red Castle and believed to be Roman. Something of an actual castle there must have been here in Norman days, for it is known that William de Warenne, who married the Conqueror's daughter, was lord of the Castle of Thetford, but there is little to remind us of the secular power of Thetford and much to show that it must have been a famous centre of the Church.

At one tree-fringed corner of the town are impressive ruins of the old priory founded 800 years and more ago by Roger Bigod, and now under the control of the Office of Works. The shape of the priory church is outlined by parts of the lower walls, fragments towering up like pinnacles of rough flint; it is said to have been more than half as big as Norwich Cathedral, and to have had one noble tower rising from the middle of a cross and two others at the west end.

The excavations have revealed the floor of the transepts and the chapels and have uncovered the sacristy in which the monks would keep their treasures and the oven in which they would bake the sacred wafers. There are extensive remains of the chapter house, the cloister, and the buildings around, but these are mostly buried. Near the high altar have been brought to light a series of small figures rare among our medieval sculptures, and they suggest an elaborate reredos. Fragments of a tomb of English workmanship have been found in which the quality of the work is so fine that it is considered to be part of a very costly monument, probably set up not many years before the break-up of the monasteries in 1540.

By the ruins of the priory stands the Tudor gateway, but most of the stones of the priory have been carried away for building What remains is beneath our feet, and among it lies the dust of powerful families of this countryside, Bigods, Mowbrays, and Howards.

The stones of Thetford speak of the days of its great fame, and remains of four ecclesiastical foundations besides the priory can be recognised. The oldest was a monastery south of the town, said to have been founded in 1020 in memory of a battle between King Edmund and the Danes. Its church has become a stable, and has an arch which led to a transept 700 years ago. Of the House of the Canons of the Holy Sepulchre, established in 1109 by

William de Warenne, slight remains can be seen from the road to Brandon, and a fine thatched barn is believed to stand on the site of its church. Near the house called Ford Place, between Castle Lane and the river, are traces of the Austin Friary founded by John of Gaunt. By the boys' grammar school stood Holy Trinity church, given by Henry, Duke of Lancaster, to a Dominican friary nearly six centuries ago, a fine arch from a transept being now built into the school.

Of the three fourteenth-century churches still remaining in use, the oldest is St Mary's on the Suffolk side of the river. It is chiefly fifteenth century as we see it, with some Norman remains. The lofty tower has a soaring arch under which stands the Norman font and there is a simple Norman doorway leading to the vestry. What is left of the altar tomb of Sir Richard Fulmerstone now makes an alabaster wall monument; he was the benefactor of the town and founded the grammar school, living in Tudor days where Place Farm stands about the old Nunnery. The flint church of St Peter, in the heart of the town, has nothing older than the fourteenth century, and looks better outside than in; its tower was rebuilt in 1789. By the church is what is known as the King's House because it is thought to have been King James's hunting lodge. St Cuthbert's is a medieval church which was entirely rebuilt after the falling of its tower in 1851, its north aisle belonging to our own century. One of the many windows which dim its interior shows a fine figure of St Cuthbert and is in memory of a missionary who was a choirboy here. Two windows glowing with rich colour are of the Nativity and Jesus in the workshop, and in a pretty blue window, with this church and Castle Hill for a background, we see Our Lord with a group of children of our time, one bringing a bunch of daisies, one with her skipping rope, and a little boy with his Teddy Bear.

A fifteenth-century black and white house in White Hart Street, with an overhanging storey and fine carving, has been known as the Ancient House and Museum since 1921, when it was given to the town by Prince Frederick Duleep Singh, who made his home in this countryside. Here we may see a fine collection of the Stone Age implements for which the countryside is famed. There are coins and medals, fossils and minerals, ancient pottery, and many books, papers, and pictures concerning Thetford's great folk. We may see more of these in the Council Room of the twentieth-century Guildhall, which has a fine collection of ninety portraits of members of Norfolk and Suffolk families bequeathed by Prince Frederick Duleep Singh. Here also is the corporation regalia, with two silver maces bearing the arms of England and two gifts of 1678, a splendid sword and a mace that is among the finest in the country. By the guildhall is the Lock-up Cage, with the iron grille

through which we see the ancient stocks. The oldest of the many inns in Thetford is the Bell, opposite St Peter's church. Some of it may be part of an inn belonging to the Guild of St Mary in the fifteenth century, and in one of the rooms there are wall paintings discovered in our time and now preserved under a glass panel. The Dolphin Inn is seventeenth century, and facing the Ancient House is a dwelling which was famous as the White Hart Inn in coaching days. There is a small group of seventeenth-century almshouses founded by Sir Charles Harbord.

Thetford is famous not only for its Castle Hill, its priory, and its ancient ecclesiastical dignities, but for its grammar school, which is one of the oldest in England, having sprung from a school originally founded in the seventh century. Its modern foundation dates from twenty years before the Spanish Armada, and it was reconstructed 300 years later, in 1876. Associated with it is a grammar school for girls which has celebrated its jubilee and has a fine record as one of the best schools of its kind.

Thompson

Its dwellings are scattered in the lanes, and its flint church is by the fields. Like most of the building, the fine tower comes from the fourteenth century, though the next century gave it the battlements. Within the great porch is a massive doorway with three mouldings, framing its original door with a key 13 inches long. The door opens to the wide and lofty nave with an old roof of trussed rafters. In the splay of one window are the roodstairs. The chancel has lovely window tracery spoiled by being blocked, and its canopied sedilia and piscina have heads with foliage from their mouths.

A big fifteenth-century window lights the south chapel, which was built in the fourteenth century by Sir Thomas de Shardelow as a church for Shardelow College, which had been raised to eminence by the munificence of Sir Thomas and his brother John about the time of the Black Death. Several de Shardelows are said to have died through the scourge. Their college has gone, but traces of it are in College Farm, which stands on the site, and here in the church, among the carvings of a few original miserere seats left in eleven old stalls, are the family arms. The charming picture of the church as seen from Sir Thomas's chapel has the quaint charm of white walls and grey old oak in the 300-year-old benches, the squire's high horsebox pew, and the fascinating group composing the canopied three-decker Jacobean pulpit. On the lowest stage are two old poppyheads, and behind the pulpit is the fourteenth-

century screen with fine tracery and a gabled entrance, still with its faded colouring of medieval days.

Other old relics are the fourteenth-century font, the Jacobean altar rails, and a chest shaped from a solid block. The unusual reredos is a modern oil painting showing one of Joseph's brothers bringing the bloodstained coat of many colours to the distraught Jacob.

Thornage

Above the meadows and the stream stand the hall, ancestral home of the Butts, and the small church in which we may read something of their story. It has on its altar a chalice given by John Butts and his wife in 1456. A lover of old silver will find a discrepancy in the date, for the silversmith's work on it is of a century later, the explanation being that the chalice and paten were at some time melted down, and the record of the gift then inscribed.

Much restoration has left the church few traces of its antiquity. The medieval arcade which led to a vanished aisle is seen in the wall, and there is an interesting run of old windows, one Norman. Quaintly set in the tops of a crude triple lancet are small pictures of Christ and angels, the Madonna and Child, and Joseph with a flower branch. Two old quarries of black dragons are in a fourteenth-century window, and in the splay of one of the next century, of which the sill forms a seat, is a corner piscina. In the tower is an old oven for baking the wafers. Some old poppyheads are in the chancel, a plain oak table comes from 1640, and the altar is made of olive and cedar wood from the Holy Land. A fine ironbound almsbox has two locks. An old door with a big lock lets us in and out. In the churchyard is the shaft of an old cross and a horse chestnut rising higher than the tower.

In Hunworth parish is a piece of land which was left to Thornage three centuries ago by an unknown donor who lost his way in a snowstorm, and was guided to safety by the ringing of the bells. It is a story often told, but this land in proof of its tradition produces a yearly sum to be spent on the church, and is called Bell Acre.

Thornham

It has grown old beautifully by a creek of the North Sea, and trees have risen like friends to shield it from the winds that blow across the marshes, once turning the sails of the old windmill. Charmingly grouped are the fine church, the inn with flowered walls and an attractive sign of a King's Head, and the manor house of 1616, screened by trimmed limes and delightful with its gardens, pool, and yew hedges. At the other end of the village is Thornham Cottage, an E-shaped house with gables and old oak mullions, a porch dated

1624, and a lavender hedge. Opposite the cottage is a house with red pantiles, and a sign showing the Thorn-ham ironworkers at the forge, reminding us of the craft for which the village was once widely known.

Most of the church is fourteenth century, but the chancel is modern, and the tower has been capped with a new storey in our time. Fine trimmed yews make an avenue to the lovely porch, which has an upper room resting on a roof with bosses of flowers, and a beautiful thirteenth-century doorway with a fine old door. Inside it is spacious and lofty, with a splendid array of fifteenth-century windows in the clerestory over the leaning arcades of the strikingly wide nave. Between the arches are corbels carved with heads of a king, a bishop, and women in fine headdress, supporting the restored hammerbeam roof.

What is left of the 500-year-old screen has rich golden foliage carved in the spandrels of its sixteen panels, on which are paintings of David, eleven prophets of the Old Testament, Paul, Mary Magdalene, and Lazarus. The paintings are much defaced, but enough is left of their rich robes to suggest that it may be the work of the artist responsible for the figures on Ranworth's beautiful screen.

Carved on a few fine old bench-ends in the nave are quaint animals and a pelican, a post windmill, a ship in sail, a merman, a man with a rosary in the jaws of a dragon, a man stabbing himself in the heart as he is being swallowed by a dragon, and still another man having a last drink before he too is swallowed by a dragon. The 300-year-old pulpit has a border of scroll carving, and the fine old font still has traces of colour. In the floor of an aisle are inscriptions to two merchants of Thornham to whom none of these things were old, for they died in 1464 and 1488.

Thorpe Abbots

It clusters about the small green, where we may sit round the trunk of a chestnut tree shading the village pump. Near it stands a wayside Calvary with the names of seven men who did not come back. The church stands charmingly behind a screen of trees on the road from Diss to Bungay, in company with two ponds and an old gabled farmhouse which was once the hall, and has 1701 on a chimney. House and church look over the pleasant valley of the River Waveney. In roundels of the churchyard gates is the initial K for the Kay family of Thorpe Abbots Place, the great house in the fine park on the edge of which the village lies.

The round Norman tower has a massive pointed arch and a fourteenth-century belfry. The chancel is fourteenth century and the nave fifteenth, and the medieval porch being still the old door. The old roof of the chancel has

a carved border, and is supported by angels. Two shields in old glass have three yellow crowns, the fine fifteenth-century font has cross-winged angels under the bowl, and remains of the screen of the same time still show the lovely delicate tracery. Brass inscriptions tell of Edmund Wallace, a rector's son killed in 1876 by falling off a spar on HMS Minotaur; and of Henry Scott Manistry, who won the military cross before he was killed at Ypres in 1917.

Thorp-Next-Haddiscoe

Two neighbours make a pretty picture here, an old gabled farmhouse with cream walls, red roofs, and chimney stacks, and the church with a round tower peeping from a girdle of trees as it rises above a thatched roof with a patterned ridge. The Saxons built the lower stages of the tower, and the Normans gave it the belfry with pillars and capitals adorning the double windows. A medieval porch protects a Norman doorway barely six feet high, with roll mouldings in its arch, and a plain Norman doorway is blocked in the north wall. The massive square font is of the same time. In contrast with this ancient stone is the chancel, which was built of brick a century ago but keeps its medieval arch. The stout walls are gleaming in their cream coat inside, where we find remains of the roodstairs in a window splay, a thirteenth-century piscina with its oak shelf still here after 700 years, and

The modern church by the river at Thorpe-next-Norwich

a good Jacobean chest carved with arcades of leaves. The piscina has been curiously placed in the west wall of the nave.

Thorpe-Next-Norwich

It was John Cotman's first home, and a road bearing his name keeps his memory green in this charming village by the River Yare. It is a close neighbour of Norwich, and is known as the Richmond of Norfolk.

Willows and chestnuts grow by the river, gay with boats, and on the green verge of the road stands the memorial cross to forty-one men. Tall poplars guarding the cross, and rose bushes on each side, add to its lovely setting, and here on a summer morning the river mists lend their charm. Old houses line the road facing the river, and at the entrance to the village, close by the stream, is an Elizabethan house with yellow walls and many gables, once a country seat for bishops and now a club for yachtsmen.

An old gabled house projects into a churchyard trim with lawn and roses, where the spire of a nineteenth-century church soars 150 feet. To reach the church we pass under another tower inside the churchyard, almost all that is left of an earlier church. Old memorials line the lofty walls of the new tower, and the old font is dwarfed by a new one in Norman style. The striking thing inside is the great arcade of brick and stone, with pillars on high carved bases, and tremendous capitals with a mass of carving. On one are four angels, another has four pelicans feeding their young.

The oak eagle lectern is twentieth century, and the chancel screen is a fine copy of one of the fifteenth. On the arches are little faces with tongues out, and there are carvings of a saint with a dragon and a king enthroned with another dragon. On the panels is a very interesting gallery of rich paintings of Apostles, their faces being fine portraits of notable people. Among them are Lord Leighton, Lord Salisbury, Bishop King of Lincoln, General Booth, Mr Birkbeck a Quaker of Thorpe, Canon Liddon, and Admiral de Ruyter.

John Sell Cotman, who shares the glory of founding the Norwich School of Artists with Old Crome, was born here in 1782, and died in London after a life of remarkable achievement sixty years later. We see his pictures to-day in Norwich Castle and at South Kensington, and one is in the National Gallery, but he knew little of success in his life and never sold a picture for more than a few pounds. His first success came with his etchings of old buildings, but his water-colours were championed by Turner and at last he was made Drawing Master at London University. His health broke down and he gave way to fits of melancholy, and in spite of his mastery of colour, his fine draughtsmanship, his great originality and versatility, he had little of the joy of fame or prosperity. Most of his drawings sold for a few

shillings apiece at the sale of his estate at Christie's. Today they command high prices, and John Sell Cotman is safe among the masters. Some of his splendid drawings of Norfolk brasses are reproduced in this book.

Threxton

It has an ancient story. From the main road we see the small church in the fields, set on the slope of the valley near a great mound where once was a Roman camp. A dovecot stands there now, and homing birds flutter where flew the eagles of the Roman standards. Roman coins and other antiquities have been turned up by the plough, many preserved at Threxton House.

It is believed that the Saxons built their church on the site of a Roman cemetery. There is still Saxon masonry in the south wall, and foundations of a Saxon nave only 21 feet wide came to light last century. The Normans built the round tower, and the fourteenth century gave it the belfry windows. We come in by a Norman doorway to find the church still lighted by candles, and seated with only fourteen small benches. The chancel has its old triple east window, and faces are here and there among old glass fragments. The font is 600 years old the pulpit is Jacobean, and there are fragments of fifteenth-century tracery in the screen. The striking thing within the church is the red painting of trailing scrollwork on the thirteenth-century arcade.

A tablet with verses and the words 'Alas, poor children,' recalls the tragedy of five of one family who died within two weeks, and another sad memory is of plague victims buried in the churchyard.

Thrigby

Though in the heart of Broadland, with Filby Broad only half a mile away, this little place hides in beautiful trees. There are oaks and beeches by the fourteenth-century church, which is big enough for Thrigby's fifty people, and a fine copper beech grows by the hall. We found trailing creeper over the east window and over some of the nave windows, which have rare oak mullions. On two walls of the chancel are consecration crosses, engraved and painted, and there is also a medieval mass dial. Over the chancel arch are carved two quaint heads and two stars in circles which are perhaps as old as anything here. There is a trefoiled piscina in the chancel and a square one in the nave. The font bowl comes from the time of Richard the Second. The best possession of the church is the south doorway letting us in. As old as the font, it has fine moulding adorned with flowers, a shaft on each side with a capital, and an original head of a wimpled woman. Her companion head is new.

Thurgarton

All roads have led to Rome for a thousand years, and for 600 years in old Thurgarton five lanes have led to this thatched church. It is a modest building with neither tower nor aisles, but the porch has a room above it. The font has been in use five centuries, and the pews have stood on their bases through all these years, still with their quaint faces and poppyheads. They are like little pictures of a medieval circus—a musician and a jester, a griffin and a dragon, two barrels of beer and a soldier with a crossbow, an elephant looking round as if to see that his howdah is straight, a lion slinking with his tail between his legs, dogs fighting, and a man with a cudgel creeping round a poppyhead to separate them.

We may read on a wall the will of John Bacon, who died in 1734, providing for the distribution of sixpenny loaves to the poor every Sunday. The will was kept for generations in the church chest, so strongly bound with iron bands and curious locks, along with the ancient paten, engraved with the head of Christ. There are many tablets to the Spurrells, who since the reign of Queen Elizabeth have lived at Thurgarton Hall, rebuilt 200 years ago.

Thurning

The Blackwater and the Thurne, headstreams of the River Bure, both meander by, and between them, surrounded with great oaks and chestnuts, stands the fourteenth-century church. Its old chancel is a ruin, but the massive seventeenth-century altar rails and one of the medieval windows are preserved in the new chancel formed out of the nave. The fine three-decker pulpit and the high box pews still give it an old-world air, and a horned demon grins down from the wall.

Thurlton

It is relieved from the commonplace by its fifteenth- century church, standing finely as it looks out across the ploughlands towards the marshes. It has some old things to see. The fourteenth-century chancel and the fifteenth-century nave are thatched. The north porch has for 500 years sheltered a beautiful doorway adorned with roses, crowns, and angels at each side of a figure of God the Father. The original door still brings us in, and has fine tracery, but older than anything else is the fine south doorway, which is Norman and in a splendid state of preservation.

The walls inside are gleaming white, and on one of them is a painting, reaching the roof, showing St Christopher in a red robe, carrying the Child on his shoulder. In his hand is the staff bursting into bloom, while fishes swim in the stream. A fine treasure is the medieval oak chancel screen, which

keeps much of its old colour and has roses on the cusps of the bays. The oak pulpit has rich traceried sides below a border of oak and acorns. There is an hourglass holder from the days when the parson preached on as the people watched his sands run out, sometimes applauding if he turned it over to begin again! The fifteenth-century font has roses and shields on the bowl, angels with crossed wings under it, and lions round the stem.

Thursford

It has a few cottages and farms, and a restored medieval church in the old parkland of the Elizabethan hall which has been partly pulled down. It has still a great array of tall chimneys, but is no longer the proud house of its old days. The church is of no great interest. The tower is thirteenth and fourteenth century a thirteenth-century arcade divides the nave and aisle, seven steps mount to the south chapel which has a triple arch between it and the chancel, and the great pulpit is built round two piers. There is a poor Jacobean chest.

Thurton

An old farm made beautiful by barns with steep gables and thatched roofs keeps the church company as it looks own on the red roofs of the village; and not far from the church the old grey hall, now a farmhouse, stands by the wayside pond. A roof of patterned thatch covers the thirteenth-and fourteenth-century nave and chancel, and a small tower rises from the west gable. A thatched porch makes a charming frame for a lovely Norman doorway resting on four pillars with carved capitals. A second Norman doorway is blocked up. Some of the windows are bright with roundels and panels of old glass. That in the east window was brought from Rouen Cathedral in the time of the French Revolution, and shows St Cuthbert in a purple robe, St Andrew with his cross, a priest giving communion to four Knights Templars, Our Lord healing the cripple who has been let down through the roof and the Man of Sorrows. In other old glass St Mark is writing his Gospel, and among Bible scenes is the first Christmas morning, with the Wise Men and the Shepherds.

Thuxton

Its hundred people live in scattered farms and X cottages, and where the youthful River Yare begins to speed through a valley on its way to Norwich the plain little church stands on a bank above it, greeting the tower of Garveston in the trees. Its own fourteenth-century tower is dumpy and square till it reaches the nave root, and then has an octagon belfry. There is

more fourteenth-century work in the chancel, and the porch and the nave are a century younger. In a 600-year-old window are old glass fragments showing leaves. The Jacobean pulpit has carved panels, and the massive round bowl of the font, the oldest relic (shaped by the Normans or soon after them) is set on old carved stones crowning new pillars.

Thwaite All Saints

It has a round tower built by the Normans, and in its church is the medieval font at which was baptised a village boy who became the first Bishop of Quebec, in the days when there were only nine English clergymen in Canada. He was Jacob Mountain, and there is a tablet to him in the porch. The narrow windows of the church were inserted by the thirteenth-century builders of the nave. The chancel screen, dainty with tracery and aglow with red, green, and gold, is 500 years old, and the pulpit is Jacobean. There are some old seats with carved poppyheads, and bench-ends with shields of galloping beasts and other queer devices.

Thwaite St Mary

It has a secluded little church among farms and fields, a simple and aisleless place with a fifteenth-century tower rising above a richly patterned thatched roof. Its low eaves shelter a lovely doorway the Normans built, a muzzled bear surmounting the arch, which has many bands of varied ornament and rests on four shafts with carved capitals. The medieval font has a bowl on a cluster of pillars; the nave windows are fifteenth-century.

Tibenham

Pink-walled cottages make gay the village road, and at a pretty corner creamed-walled houses and the old harness-maker's workshop, all with mossy pantiled roofs, shelter snugly under the limes and beeches screening the flint church. Near by is a charming old farmhouse with yellow walls and a group of ornamental chimneys, and an old cottage with an overhanging storey and a huge chimney rising from the ground. Coming largely from the fourteenth century, the church has a massive 500-year-old tower rising impressively above the trees, its crown of battlements with symbols of the Four Evangelists for pinnacles. The porch has a doorway adorned with flowers and heads; and arches on clustered columns divide the nave and aisle, which both look up to worn old timber roofs. There is a traceried font 500 years old, quaint seats for priests under an arch, and in a niche by the chancel arch is an old wall painting. Across a bay of the aisle is a gallery reached by a flight of stairs, it bears the arms of the Buxtons, who

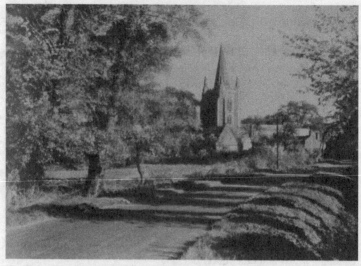

The old church by the roadside at Tilney All Saints

were given permission by Archbishop Laud to erect it for their servants. A fine Jacobean chest has carved medallions, and the canopied Jacobean pulpit has a mass of rich carving. We noticed a tablet to Robert Skinner who grew up in the vicarage garden behind the fine yew hedge and died for his country in Flanders.

Tilney All Saints

Red roofs clustering about the old church are dwarfed by the massive tower and spire which rises as a landmark in this countryside of orchards, where the River Ouse has been diverted from its bed to drain the marshlands. It is a Norman church disguising its origin outside with medieval dress for the tower began as thirteenth century, the spire is fourth, and the clerestory windows (running from end to end) are fifteenth. Tucked away within the double buttress at the north-west corner of the tower is a small room entered by a doorway, and over it is another room, approached by a passage from the stairway in the south-west buttress The two rooms were probably used by chaplains who came from a distance, and during floods.

Inside we are back in the Norman church whose foundations the marshmen laid so strongly in the yielding soil. Very impressive are the long arcades of eight bays, a continuous avenue the length of the church, for there is no chancel arch. Of this fine array of arches fourteen are round

Norman, with two orders of moulding, and two at the west end are thirteenth century. Except for two with clustered shafts all the pillars are round, with capitals carved in characteristic twelfth-century fashion. Traces of a Norman clerestory can be seen in the chancel. Crowning the nave is a rarely beautiful double hammerbeam roof with angels hovering near the top, and more enriching the hammer-beams, all the work of the fifteenth-century craftsman. The chancel roof is modern, but the screenwork of the chancel aisles is fifteenth century, and between the nave and the chancel is a quaint screen of 1618, with arabesque tracery over the bays, and a baluster top surmounted by a cornice with dragons. Nine fifteenth-century stalls have misereres carved with heads and foliage. The beautiful canopied sedilia and the piscina are fifteenth century, and the font, standing on two wide steps, is Elizabethan, its pillar arcaded, the bowl with Tudor rose. There is the medieval bowl of another font.

One of two coffin stones carved with crosses is nearly eight feet long and may belong to Sir Frederick de Tylney, who was of great size and strength, and was knighted by Richard Lionheart in the Holy Land. He was killed at Acre and his body was brought home.

Tilney St Lawrence

It is the name of Aylmer which lifts this village by the pleasant meadows into a place in history, for John Aylmer was born here. He was tutor to Lady Jane Grey in the days before he became Bishop of London and spoiled his fame.

The simple cross-shaped church has no monument to him, nor any other conspicuous relic of the past, for it was made largely new last century. But the nineteenth-century spire rests on the 600-year-old tower, and we enter through the old south doorway to find a plain old font, a trefoiled piscina with its original oak shelf, old arches leading to new transepts, and two old arches in the chancel. Under three of the ancient arches are what is left of the old screen.

Titchwell

Knight and friar, merchant and scrivener, and others travelling in goodly company along the coast road towards the great shrine at Walsingham, found here one of the tall crosses set to mark the pilgrim's way. Like the fame of the shrine, it has suffered a good deal, but it stands on a grassy mound where the road to the church beckons us from the highway.

It is a tiny church with a quaint spire crowning its round Norman tower, and with small cedar and oak trees about it lashed by the winds from the

sea. A medieval doorway with a richly moulded arch leads to the fifteenth-century nave, which is dim and cool on a sunny day, with coloured light filtering through four windows. The chancel is older and brighter, for clear glass fills the fifteenth-century windows, which are partly Norman, with original red painting still showing on some of the splays. The restored medieval screen, with traciered bays, has a patch of old painting, and there is a font with a massive Norman bowl. A tower window in memory of a farmer shows the sower going forth to sow.

Tittleshall

Pretty creeper grows on the walls of the fourteenth-century tower which has a good bracket niche in each west buttress and a richly moulded arch opening to the nave.

Most of the church, including the fine east window and the font, is as old as the tower, but the nave windows are fifteenth century. The old screen is still here.

Sir Edward Coke, to whom the laws of England owe so much, was brought here to be with his kinsmen when he died in 1634 at Stoke Poges.

Tivetshall St Margaret

The gold ring of old John Intwode has the prettiest story this place tells. In 1456 John died and left ten shillings (about £20 of our money) for a high altar for the church and another five marks for the tower. John lies by his church in an unknown grave, and three centuries after he had passed away his gold ring was ploughed up in the fields.

The church is chiefly fourteenth century and much restored, standing by stacks and red-roofed barns among lonely meadows. Its tower has an odd appearance, the chancel is thatched, and the fine old porch is leaning with age, old beams in its roof. We found it a little forlorn inside. A dozen old pews have lost their carved heads, and the Elizabethan screen with the queen's arms painted in a great panel above is but a shadow of its old self. Its bays are bereft of their tracery and the vaulting is gone; some of the panels have paintings and carving of flowers, and there is a painted shield with four ducks. We learned in the village that some years ago the rector brought together a carving class to fashion new flowers for the bottom of the screen, and all the new carving except a single rose perished in a fire one night, surely one of the most tragic little tales ever told your countryside.

Grove Farm has a moat, and preserves the stump of a famous oak which was 21 feet round and weighed 100 tons when cut down.

Toftrees

Down a little shaded lane we come to one of our charming English groups, the village pond, the golden meadows, a farmhouse from Elizabethan days (shaped like an E), and a church with something Saxon and something Norman for us to see. Saxon, Norman, and Tudor is this small village, and the Tudor hall is a fine example of Elizabethan flint work. It has a great chimney stack at each end, and a porch with two rooms over it. The neat little church has a low unfinished tower and leaning walls mostly about 600 years old. The doorway of the tiny porch is 700 years old, and there is an odd collection of old windows lighting the nave and chancel. One is a Saxon window with a baluster shaft between two gabled lights. It is the oldest thing the village has, and the light has been streaming through it for a thousand years.

This small church is a modest casket for a treasure that remains in its keeping after 800 years, one of the finest Norman fonts in the land. It is one of a famous group of four left in Norfolk by a great sculptor in stone, the others being at Shernborne, Sculthorpe, and South Wootton. Five sturdy pillars with cushion capitals all differently carved support the square bowl, and at each corner is another stumpy pillar with a carved capital. The four sides are a fascinating study in rich and varied interlaced work, and overhanging them is a handsome band of foliage trailing round the rim, held at each corner by a grotesque head.

Totten Hill

Its houses are dotted about a great gorse common where ducks and geese share two ponds. Close by is the old post windmill with two sails, idle now, and about a mile away, with only a cottage or two for company, is the church which once belonged to West Briggs. Part of the neat little church, with sloping walls, is Norman, and much of it, including the tower, is fifteenth century. The beautiful Norman doorway has quaint cushion capitals supporting the arch with zigzag mouldings, and a striking tympanum carved with a cross pate in a loop of cable moulding. The plain Norman north doorway is blocked, there is a narrow Norman window, and the east window is a good example of intersecting mullions, 700 years old. The font is plain and old.

Tottington

About the pretty mere and the marshy ground, gay in summer with purple iris and the kingcup's blaze, sturdy Abbot Samson of Bury St Edmunds roamed as a boy, for here he was born. He was at the coronation of Richard Lionheart and was chosen by the king to arbitrate in a quarrel between the

king and the primate. Much of the abbey of Bury St Edmunds was built in
his time and he was its masterful ruler for a generation, freeing it from debt
and endowing it with privileges. He lies within its walls.

There was a church here in his lifetime, but the lofty place we see comes for
the most part from the fourteenth century, with a fifteenth-century chancel.
It stands by the fields, the embattled tower (with a cat's face for a gargoyle)
rising above the red pantiles of the nave and chancel. Its best part is the
clerestoried nave, with the soaring arches of two arcades. The fine medieval
oak screen has pointed arches below the arcading, and carvings of a bird,
an angel, and a lion. The tower screen and the pulpit are Jacobean. There is
a decrepit dugout chest, and the roof of the north aisle has spandrels carved
with tracery. The fine old benches have quaint animals on the embattled
arm-rests, some winged, and some with heads looking round. There are old
glass fragments, and let into a wall is a stone shield said to have belonged
to the gateway of the old manor house. A small brass portrait of Margaret
Pory of 1598 is 'in token of a thankful and loyal mind,' and shows her in a
ruff and draped headdress, kneeling at prayer with her daughter.

Trimingham

This trim little village with a trim little church clings to the edge of the
cliffs high above the sea. The cliffs are formidable here, the highest along
the Norfolk coast. The grandeur of the scenery is ever changing with the
encroaching of the sea, stealthily undermining them in summer to make
easier prey to winter storms. Halfway down to the glorious beach are nearly
always huge masses of earth on which the corn is still springing, mute witness
that it has been torn from the fields above.

A thatched lychgate brings us to the thirteenth-and fourteenth-century
church, its tower low and sturdy as fits its windswept site, and strengthened
by huge buttresses outside and in. Between those inside stands the fine old
traceried font on clustered shafts. Over the north doorway is an image
niche, and on the door are crumbling old hinges wrought with scrolls and
roses. There are four old poppyhead bench-ends in the chancel, and the east
window has curious square tracery of quatrefoils. On the fifteenth-century
screen are new arches tipped with roses; but it has some original colour,
with painted daisies. In its golden tracery are carved a dragon, a lamb, and
a man's head, and below are fine paintings of eight saints.

A striking feature of this small church is the excellent carving in rich relief
by Reginald Charles Page, the rector, we found here; it enriches the pulpit,
the reredos, the priest's seat, and two memorial panels. On the pulpit we
see Christ preaching to a crowd in which are shepherds and children, a man

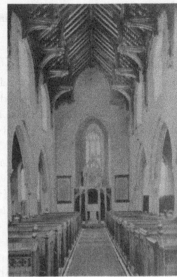

Clockwise: The canopied font at Trunch

The medieval church interior at Trunch

The old nave at Trunch

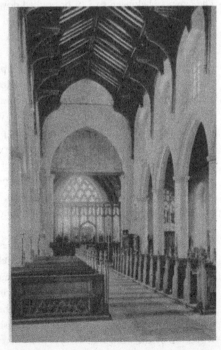

with a scroll, and a girl feeding a bird; and again by the side of a stream, with the five loaves and two fishes seen in a tiny boat. The reredos shows Christ and two Disciples at Emmaus, in a pastoral setting.

There are lovely trees on the panels of the priest's seat, where the Good Shepherd is finding the Lost Sheep and carrying it away. One of two splendid poppyheads is carved with roses and shamrock and thistle; the other, perhaps the most fascinating piece of all this work, shows St George slaying the dragon, the chained princess looking on, and a cleverly contrived scene of the Baptism in Jordan; John is pouring water over Our Lord in the stream, with two angels kneeling; there is a dove in a treetop, many people are on the banks, and on the mountain-side is a fine little castle. In the peace memorial panel with its border of vine is an animated scene of trench warfare, showing an officer and his men repelling an attack, an aeroplane flying above.

Trowse Newton

Here the River Yare finds green willows and buttercup meadows after passing the southern outskirts of the City of Norwich; it meets the Wensum opposite the park, not far from a ruined gateway and an avenue of limes. The gateway belonged to a priory pulled down last century.

The church stands near the water-mill, and great chestnut trees surround the churchyard, which has an avenue of delicate silver birch. The porch has an upper room. The tower, with a cat's head among its quaint gargoyles, is fifteenth century, as are some windows. A fine piscina and the priest's doorway are thirteenth century; the east window is fourteenth. By this window inside are painted figures of the Four Evangelists, and outside is a niche with a blurred inscription to William de Kirkeby, prior of Norwich from 1272 till 1288.

A few things old and new arrest us in the plain interior. The old font has angels with crossed wings under a bowl carved with lions and angels; on pedestals round the stem are seated figures of the Four Latin Doctors, who have lost their heads. An Elizabethan lady at prayer wearing an embroidered gown is here in brass, wife of Roger Dalyson. The reredos is a striking scene of the Last Supper, so deeply recessed that we look into a realistic room where a round window in the ceiling lets in the light; a lamp and vases are on ledges on the walls, and some of the Disciples are reclining on the floor.

The extraordinary possession of the church is the pulpit with traceried panels, a border of vine, and three lifesize minstrels sitting round the base. One is King David in sheep-skin cloak playing the harp, the fastenings of his sandals carved with lions' heads; the others are angels, each playing a flute. This amazing pulpit, of good craftsmanship but more odd than artistic, was given by the women of Trowse in memory of Queen Victoria, the three

figures being one of the gifts of Russell Colman of Crown Point Hall. He gave also the picture in the nave, showing Christ rising from the Tomb, with soldiers in flight. The oak lectern is a fine pelican with her young.

Hereabouts is Norfolk's Woodhenge, the oak temple thirty-five centuries old, which lies under a field; it is dealt with under Arminghall.

Trunch

When the looms of the medieval Flemish weavers thrummed with prosperity the grateful merchants raised a church which still sings its song of praise, though their looms have long been silent. They made it a splendid place, and crowned its fourteenth-century font with a magnificent oak canopy that has few rivals in the country. It has six slender pillars with delicate flowers and fruit on winding stalks supporting a vaulted canopy curving to a boss, and on the top of these slender columns are playful fancies of birds pecking grapes, a squirrel with its nuts, a monkey holding a crozier, a dog chasing a hare. The canopy is crowned by six painted panels, each under its own blue canopy, and above these rises yet another wealth of carving weaved into a perfect finial. A Crucifixion scene is fading away on the panels. This font cover, as majestic as a small cathedral spire, has lost some of its pinnacles and flying buttresses, but we can understand that when the craftsman finished it in 1500 it was almost unsurpassed in the land.

The screen was finished two years later, another masterpiece, its graceful arches carved and painted on each side, with painted panels of Apostles in scarlet coats and robes of gold brocade. Behind the screen are six misereres, three with men and three with angels, and on some of the arm-rests of the stalls are curious creatures with bat's wings. It is a peculiarity of these traceried stalls that they rest on stone sounding-boxes, one of the devices to which our medieval craftsmen resorted to give resonance to the singing and sent it echoing to the roof. And what a roof it is! Its massive hammer-beams are held up by stone corbels of figures bearing shields, and a score of angels are looking down. There is a spacious aumbry in the chancel, rare because it has two tiers with Gothic arches, and on the chancel wall is a tablet recording the burial of Launcelot Thaxton, chaplain to the pathetic boy king, Edward the Sixth. Outside a tiny porch cut through a buttress leads us into the chancel, but, unusual as this is, the exterior of this fine church has something more interesting still, for some of the dark stones helping to support the nave are Saxon, rescued from the Saxon church pulled down to make way for this. It is an impressive sight, and the tower with its huge telescopic buttresses seems to spring from among the old thatched houses round about it.

Tunstead

This tiny place was 500 years ago the hub of a thriving industry, of which today the only sign is the church the Flemish weavers built, so big for so few people. They built it 50 yards long and gave it spacious windows and an imposing tower with battlements, and round the aisles they set stone seats which were used in the days before our naves were filled with wooden seats, when the weakest went to the wall.

They gave the chancel a lovely screen with paintings of the Twelve Apostles and the Four Doctors of the Church. They built stone canopied seats for the priests, and gave a rich canopy to the little piscina. One other curious thing they did, building a remarkable structure behind the altar, a stone platform running 30 feet across the chancel. Three steps lead down to a tiny door still swinging on its medieval hinges, opening into a cell below. Hardly big enough for the setting of a miracle play, the platform was probably used at times to display relics usually stored in the cell below. We have not come across anything like it in any other church.

The door that opens for us is the one these Flemish weavers used to open, a 600-year-old door from the church before theirs, with 700-year-old ironwork of intricate and flowing grace.

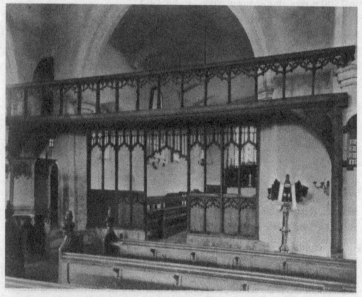

The old screen and roodloft at Upper Sheringham

Tuttington

It has a fine little gallery of medieval art in the old benches on which the village folk have been sitting for about 500 years. The church in which we found them has a Norman tower, but was made new when the carvers fashioned these bench-ends with their remarkable array of medieval life and fancy. Few village churches have a richer variety of carving. A farmer's wife with animals eating from her basket, a milkmaid with her churn, and a man sawing a log represent the pastoral scene; a squirrel with its bushy tail and a dog with a bird portray the life of field and wood; a cloaked man with a viol recalls the days of troubadours; a winged fiend biting the hand of a jester is a touch of rough humour perhaps pointing a moral; and the wild man of the woods and the elephant with a howdah belong to heraldry. With this wood-work is the 600-year-old font and the seventeenth-century pulpit; it is a church rich in craftsmanship over which the tower has watched 800 years.

Upper Sheringham

It lies sheltered by wooded hills about a mile from its namesake by the sea, and has a medieval church with clerestory windows of great beauty and woodwork of unusual interest. Stretching from pier to pier high up in the nave is a huge beam with chevron pattern, painted black and white, from which the cover of the fourteenth-century font used to hang; and the chancel screen has still the old roodloft from which the priest would declare the good news each morning before the Reformation. It is one of only a small group of roodlofts remaining in all England. On the outer spandrels of the screen are carvings of dragons. The bench-ends are 400 years old and delightful; a mermaid with her comb, Nebuchadnezzar crawling on the grass, and a cat with a kitten in her mouth, hares, lions, dragons, a baby in swaddling clothes, and human faces. There are Tudor portraits in brass of John and Madgalene Hook, both with rosaries.

In a square by the church is a reservoir supplying the village with water from the hills, given by the lord of the manor to celebrate the Peace that came to Europe when Napoleon was sent to Elba.

Upton

Within a mile of its lonely sheet of Broadland water, its fifteenth-century church rises proudly among its scattered houses. Surprisingly fine and impressive in so small a place, it is spacious and lofty, crowned by a tower both old and new, for, set up in 1170 and almost destroyed in a storm of 1550, it has been rebuilt in our own day with much of the old material, the names of the men who built it being recorded.

A roof of open timbers and embattled tie-beams looks down on the clerestoried nave, with fine arcades. There is the top of a Norman pillar piscina in a niche by the door, a pillar almsbox, a richly carved chair, a few poppyhead pews, remains of a carved and painted fifteenth-century pulpit, a consecration cross on each side of the chancel arch, the base of the old chancel screen, and a thirteenth-century coffin stone. A very odd relic for a church, recalling the days when churches were largely village museums, is the great bone of a whale which we found resting on a windowsill, five feet long and 130 years old. Wonderfully clear, though a little damaged, are the fifteenth-century paintings on the old screen, showing eight saints.

The treasure of the church is the magnificent fifteenth-century font; it has minstrel angels, a dragon with two bodies and one head, a man with foliage coming from his mouth, two lions with twisted tails, and two dogs biting each other.

Upwell

The River Nene comes here from Cambridgeshire into Norfolk, and the pleasant old houses and the cottages make the most of it, disposing themselves in a long broken line on each side of the slow-moving stream. At the Outwell end of the village is a windmill, the two neighbours making together perhaps the longest village in the land, spreading for nearly five miles.

In the heyday of Upwell's prosperity, when it was a market town, the big church of St Peter was built by the river, and its square tower with the octagonal top, standing among the trees and looking down on orchards, has been since the thirteenth century the symbol of steadfastness among changing fortunes.

Gates of delicately wrought iron lead to the church, which is for the most part 200 years younger than the tower. The fine porch has a vaulted roof supporting an upper room, and the lovely door letting us in has traceried panels and a border with sixteen pelicans. The beauty inside is marred by galleries and the crowd of pews, though the odd block of seats for two down the middle of the nave, between the high shut-in pews, is quaint and unusual. About twenty-five oak angels with outspread wings look down from the striking old roofs of the nave and aisles, which have richly carved beams and angels on the borders. The chancel roof has hammerbeams and saints. The canopied sedilia are carved with tracery, the font has angels holding shields, and part of a coffin stone is in the wall. One of the oldest of about fifty old brass eagles left in England is the fourteenth-century lectern; it has a comb like a cock, and three Hons at the foot.

Wacton

Cottages and farms among winding lanes, a church with an ancient story, and a big common at one end make Wacton a pleasant place. The Normans built most of its low round tower, now ivy-grown and with a red brick top peeping over the high roof of the nave; the nave itself, which has flint walls and fine windows, comes from about the time of Richard the Second, as most of the church does. The neat nave and chancel are divided by the upper part of a medieval screen with traceried bays. There are fine seats for the priests, Jacobean altar rails, an ancient door with original strap hinges, and a fifteenth-century font carved with symbols of the Evangelists on the bowl and four lions round the stem.

Walpole St Andrew

It lies just within the rampart the Romans raised to protect the marshland fens. Nearly a thousand years after the last Roman sentry had been withdrawn King John passed this way on his last journey to Newark, where disaster and death were waiting for him on the other side of the Roman bank.

The church stands in the trees, looking to its magnificent neighbour, Walpole St Peter, across the fields. It is remarkable to find two such fine neighbours half a mile apart in these byways of the fens. This church saw the early days of the fifteenth century. A turret stairway climbs to the top of the fine brick tower, which has a room halfway up and traces of a small room at the base which may have been a hermit's cell. Seven great windows in the chancel and a fine array in the clerestory fill the church with light. The font is as old as the church.

There are several old fleur-de-lys bench-ends in the chancel, and the Jacobean pulpit is carved with flowers. Projecting from the wall by the pulpit, just above the doorway of the rood stairway, is a curious fifteenth-century bracket, daintily carved, which is thought to have once supported a small wooden pulpit. A blocked doorway opened on to it. Here hangs a picture of the Marys by the dead Christ, painted by Sebastian Ricci, who spent some ten years in England during the building of St Paul's, anticipating a commission. He was said to have left the country in disgust because Sir James Thornhill was employed (at 40 shillings a square yard) to paint the roof of st Paul's.

Walpole St Peter

It gave its name to the family which gave England its first Prime Minister; from here the Walpoles took their name in Norman days, though they left the village about the time of Magna Carta. Godric of Walpole here opened his eyes on the world in which he lived as a hermit and was made a saint,

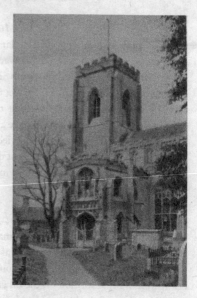

The church at Walpole St Peter

having been on long pilgrimage through Europe and to Jerusalem. Queen of the Marshlands the people call their church, and we do not wonder, for it is a magnificent spectacle in this out-of-the-way place, a structure rather to be expected in a city. Very impressive is the scene from the south side of the churchyard, with a glorious array of windows, the delightful porch, the fine battlements, and the western tower rising over all. An old house with clustered chimneys and the grey rectory with its fine yew hedge shaped into pinnacles and a cross, keep company with this old shrine. It is not easy to forget these noble battlements, the thirteen clerestory windows on each side of the nave, the turret stairways with small spires between the chancel and the aisles, and the old sanctus bellcot on the gable between the spires. A charming feature of the exterior which is unique in our experience is a curious vaulted passage at the east end of the chancel; it preserves an ancient right-of-way, and inside the altar is raised up a flight of ten steps to miss it.

The tower is fourteenth century, but the rest of this great church 16 feet long, and more than 50 feet wide, is fifteenth. Built in the reign of Henry the Fifth, the porch is a study in itself, enriched with lovely battlements and niched buttresses on each side of the window of its upper room, and having a handsome entrance archway through which we look up to a vaulted roof with saints at the corners and seventeen fine bosses carved with animals eating foliage, a dog biting a hare, a fox with a goose, a pelican and its

young, dragons, the Madonna, and the Last Judgment, in which the lost souls are being swallowed by fearful creatures.

A door with traceried panels lets us into the nave, with its fine roof supported on heads of men and women between clerestory windows rising above majestic arcades. They are best seen from the chancel, which is itself as big as many churches, its walls arcaded, and with five big windows on each side, and is striking with its flight of ten steps to the altar, under which the old pathway runs outside. The great east window glows richly with the Crucifixion, the Ascension, and eight saints in modern glass. These wooden stalls are unusual because they are set on stones and have stone canopies, enriched with flowers and faces in the vaulting, carved with animals, griffins, crowned heads, and dogs carrying heads of kings. On two misereres are an eagle and a pelican, and a modern poppyhead has two eagles and a face peeping from leaves.

The base of the old chancel screen has fine old paintings of a dozen saints, one of them believed to be the only portrait of Gudula on any screen There is a Jacobean screen across the west end, and Jacobean seats with carved ends and fonts. The remains of a screen in the south aisle has an iron gate of 1708. The old font, with inscriptions 'Thynk and Thank' and 'Remember Whetom Johannes, sometime parson here,' has a lofty cover richly panelled and carved; it is one of the best of its kind, and was made in Elizabethan or early Jacobean days. So, too, was the tall pedestal pulpit with a canopy, quaint trumpeting angels of iron supporting the book-rest. An almsbox of 1639 bids us remember the poor.

A faded wall painting over the chancel arch appears to have been a Doom scene; we see small figures rising from graves. The altar-piece in the north aisle is a fine oil painting of Jesus with the Doctors, and in the same aisle is a jumble of old glass. Two stone figures crouch in corners near the fine tower arch, the old brass eagle lectern has three lions at the foot, and there are fine candelabra.

A man who must have known this old church and its treasures, Robert Butler of 1632, is seen on an alabaster wall monument, his fine little figure clothed in a red vest with a black cloak and a ruff.

At the west end of the church stands a curious thing which at first sight appears to be a sentry box, but is actually 'a shade of wood to cover the minister when he burieth the corpse.' We are indebted to the Revd H. W. Wood, rector here, for the recovery of this strange piece of furniture from under the tower, where it was being used as a receptacle for firewood. It is of light construction, and when lifted by the two iron rails inside falls naturally on to the back and shoulders, to be carried with comparative ease.

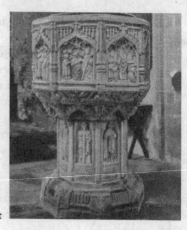

Walsoken font

Walsoken

It lies among the orchards, an ancient place named from the sea-wall built by the Romans, most of it taken from Norfolk into Cambridgeshire in our time, though Norfolk keeps the church. It has one of the finest churches in East Anglia, crowned by a splendid medieval tower with four turrets and a spire. The massive Norman arcades are rich with zigzag mouldings, and the chancel arch resting on banded shafts is magnificently carved, the work of craftsmen when the Norman style was passing. On one side is the fifteenth-century doorway of the old roodloft. There is a grand array of fine woodwork, and nearly all the roofs grey with age are richly carved. The nave roof has painted angels and other figures in delicately canopied niches. There are fifteenth-century screens in both aisles, one with most intricate tracery, stalls with old carved heads, battered figures on old benches, and over the tower arch two paintings of the Judgment of Solomon with a statue of a king enthroned between them.

But the chief treasure among so much splendour is the magnificent 400-year-old font, looking like ivory rather than stone, with sculptures of the Crucifixion and the Seven Sacraments, eight saints under rich canopies, and round the base this inscription to those friends of the church who gave it: 'Remember the souls of S. Honyter and Margaret his wife, and John Beforth, Chaplain, 1544.'

Warham All Saints

We found its cottages set in the Field of the Cloth of Gold, so lovely were its meadows with the buttercups. The lowly church, which time has shorn

of much of its glory, is on the hill. A bellcot has taken the place of the old tower, of which the ruins are here, the arch being blocked in the west wall. A black and white roof looks down on the nave where traces of arcades to vanished aisles are seen in the grey walls, which are enriched by glowing glass showing the Good Shepherd and the peace memorial window with St George in silver armour and a blue mantle, Joshua, and Gideon. Some of the windows are fifteenth century, but most of the old work is a century older. A chancel window has an odd niche in the splay, the sill serving as sedilia and a piscina at one end. The square bowl of the font is Norman.

Warham St Mary

Beautiful trees make a bower of this tiny neighbour of Warham All Saints. There is a splendid cedar in the churchyard, and a fig tree growing against a wall of the old church tower. The tower has Norman remains and a thirteenth-century arch opening to the aisleless nave. There is a sundial over the porch through which we enter and another quaint and fascinating porch sheltering the priest's doorway is set in a buttress of the chancel. The church is a quaint little place with white walls, the tower and the sanctuary on a higher level than the rest, and the nave filled with high box-pews from which rises a most imposing three-decker pulpit with big projecting reading desks, a great six-sided canopy and a flight of eight steps. There is old glass making a riot of bright colour in some of the windows, with saints and ordinary folk in a jumble, a group of nuns and a bishop, and a rich man giving to beggars. Six scenes filling the east window show the Transfiguration, the Entry into Jerusalem, the Betrayal, the Descent from the Cross, the Entombment, and Mary meeting Our Lord in the Garden. One old fragment is dated 1628.

Watlington

It lies in wooded country on the edge of the Fens, its houses scattered about the winding lanes between the highway and the Ouse. Though most of its church is 600 years old, the clerestory and part of the chancel are a hundred years younger, and the lower part of the tower is a century older. We enter through the old porch, by an old carved door with a ponderous lock and one of the heaviest keys we have seen. The chancel, with an old roof of trussed beams, has three fine stone seats, and has two aumbries and another piscina which have been curiously placed outside the wall. The lovely fourteenth-century font has lost some of its glory, for its great array of figures are battered; the bowl, with sixteen of them in niches, overhangs the stem, making a vaulted canopy for eight saints grouped round it. Its seventeenth-century cover is crowned by a golden pelican. There are two old

chests and a Jacobean pulpit, and two traceried bays of the chancel screen are from the fourteenth century. The finest woodwork is in the benches, many having their fifteenth-century back, and nearly all their old ends, with quaint heads in the foliage of some of the poppyheads. Below the poppyheads are bellringers and musicians and many curious animals. Some of the poppyheads and arm-rests are later copies of the old. On a monument of 1600 are the battered figures of Thomas Gawsel, lord of the manor, and his wife. Another shows John Freake in black gown and ruff, the son of a rector here in the time of James the First. There are two coffin lids in the trim churchyard.

Watton

Since 1679 the clock tower has stood in the middle of this long street, crowned by a hare with a barrel below it to show the way of the wind. At one end of the street is the pump and at the other end, hidden away, is the church.

It is old and new. The Normans built the round tower and the fourteenth century topped it with the eight-sided belfry. The old arcades divide the nave from new aisles which made the church wider than it is long. In the crowded little chancel is an old carved figure on the priest's seat. The quaint poor-box of 1639 has a wooden figure of a parson with a beard, holding a bag with a slot and bearing on his breast the words, Remember the Poor.

Nearly a mile from the town is Wayland Wood, where the gulls of Scoulton Mere come screaming over the trees—Wailing Wood some call it, As Wayland Wood it has a place in legend from which it has not been dethroned, for the story is that it was here the ruffians brought the Babes in the Wood at the behest of the wicked uncle, who is said to have lived at the neighbouring Griston Hall.

Weeting

It has the old flint town of Brandon for its neighbour, and fitting it is that it should be so, for it is a very ancient place. Here on the heathland are many milestones in our story, and in a wood not far away we stand in one of the cradles of our race. We have by us as we write fragments of charcoal from fires lit in these places by some of the first men in these islands.

These fires were lit in the circular pits that lie in hundreds hereabouts and are known in prehistoric history as Grime's Graves. Time was when these pits were thought to be the remains of a prehistoric village, but it is now known that they were the flint quarries from which the Stone Age men obtained their flints, the tools they worked with, the weapons with which

they defended themselves and hunted their food. This was a busy world before Rome was heard of; the crack of the stone hammer was heard in this place before the pyramids were built in Egypt.

Young beside these old flint workings, but still ancient, is the earthwork known as Devil's Dyke, a mound and a ditch not far from the Little Ouse which divides Norfolk from Suffolk here. Round about are many old burial mounds in which lie our ancestors far back in the mists of time.

We leap into history with the Normans, for here William de Warenne, the Conqueror's brother-in-law, built a castle and surrounded it with a moat. The water still runs in the moat inside the park, and within it rise the romantic grey walls of the ruined castle, like pinnacles among the trees. Coming into this scene is the pretty flint church with its round tower and the great brick and stone Weeting Hall—more useful now than picturesque, for we found the old home of the Angersteins, which once had in it the nucleus of our National Gallery pictures, clustered about with huts and sheds. The great house, in which hung the thirty-eight pictures bought by the nation for £57,000 from John Julius Angerstein, has fallen from its estate.

The little church has a fourteenth-century chancel and a fifteenth-century nave, and its round tower stands on Norman foundations. The clerestory windows, with clustered columns, are modern; perhaps the oldest possession is the font. There is a wooden cross from Flanders in memory of twelve men who did not come back.

Away from the group of castle and church and hall, but just within the park, are the ruins of an old church overgrown with creeper, gravestones about it in the shadow of the trees. The church was destroyed by the falling of the tower in the eighteenth century. In its great days the castle was the home of Sir High de Plaix, who founded Bromehill Priory 700 years ago. It has vanished, and a farm has taken its place; but it was interesting as the scene of much of the boyhood of Thomas Shadwell, who wrote a dozen comedies and tragedies in the seventeenth century.

Wonderful drawings on flint by the miners who first worked here were discovered. They are among the oldest drawings ever found in Britain, and show us that the first men who lived at Grime's Graves were men of the Early Mesolithic Period, who had inherited the tradition of art from the preceeding Cave Period. Buried in the sand which formed the surface level in those far-away days, close to the seat of one of the workmen, was found a most beautiful drawing of an elk. It had been drawn with a graving tool of flint—not an easy thing to do, for a line once drawn could not be erased as when drawn with pencil.

Neolithic man, Bronze Age man, man of the Early Iron Age, even the lordly Roman, each in turn occupied this fascinating site, and all left traces

of their occupation to be turned up by the spades today. But nothing used by them is so full of interest and meaning as the magical drawings made by the earliest inhabitants of them all.

Wellingham

Its few farms and cottages are gathered about the small church, which has a short plain tower and a continuous nave and chancel only 16 feet wide and four times as long. Its windows belong to the three medieval centuries, the font is 700 years old, and three bays of the arcade which led to a vanished aisle are now blocked.

The treasure of the church is the base of the old screen, with beautifully painted panels. St Sebastian is shown bound by Diocletian's soldiers to a tree and riddled with arrows, and next to him is a saint in armour and cloak with sword and spear. We see St George amid all the trappings of the ancient legend, the king, the queen, and the courtiers on the palace roof, the princess kneeling in her gold robe, and the knight on his white charger pinning the dragon to the ground with his spear. Adding to the realistic scene are the villagers striding up the hill, with dogs, rabbits, birds, and a lamb on the hillside.

St Michael with his scales is hardly less vivid, the archangel in red armour with blue and gold wings, and Mary standing with an angel by the scales, adding her rosary to tip the balance in favour of the white souls. In the ascending scale are red and black demons and a serpent. Another scene shows Our Lord rising from the tomb, and in a corner Pilate is washing his hands. It is one of the storied picture books of the Middle Ages, the paint as clear as the illuminated pages of a monkish missal, though the figures are damaged.

Wells

The sea has gone from Wells, leaving its name behind, for still its people call it Wells-next-the-Sea. The river estuary comes up through the marshes to a sally port, bringing up on its tide sailing barge and schooner and steam vessel to the handy harbour and the line of warehouses which still give the town something of the appearance of a seaport. Old gabled houses huddle together along the quayside, down to which the narrow streets thread their way. At one end of the quay, from where we begin the long walk to the sands beyond a dark belt of fir woods, is a memorial showing a mast, anchor, and lifebuoy. It is to eleven of the crew of the lifeboat which capsized in a gale in 1880, after saving the crew of one ship and going to the rescue of another.

The lofty church awaits the mellowing hand of Time, for it is only half a century old. It has grown in the place of the old one, which was almost destroyed by lightning in 1879. A vivid reminder of the fire caused by the lightning (which melted even the bells) is a fine chest of 1635, for some of its stout boards are black and charred. Remains of the older building are seen in the tracery of two chancel windows and in the mouldings of the chancel doorway, charming with carving of vines in which birds are pecking the grapes. The door itself has a lovely tracery.

There are more than fifty angels in the oak roof of the chancel, and over sixty in the nave's; and there are stone angels over the capitals of the nave arcades. Among much clear glass the pictures of Mary with Jesus holding a boat, St Nicholas with a ship, and St Christopher stepping out of the stream, give a fine touch of colour. Showing up on the grey wall is the Madonna and Child in a fine wreath of fruit and foliage, in Della Robbia ware.

Wendling

If the knight who took his name from the ancient manor could come back he would find little of the abbey he founded 700 years ago, save for its site, marked by the irregularity of the ground by the stream. But the modest little church by the long straight line of the railway has kept much of the masonry of its day, a tower with fourteenth-century windows in its belfry, and one of some fifteenth-century windows lighting the transept. The chancel has a piscina at the end of the priest's seat, there is Jacobean carving in the stalls and in a cupboard, and a little old work is left in the chancel screen. Its treasure is the fifteenth-century font with carved scenes of the Seven Sacraments and the Crucifixion, though most of the figures have had their heads hacked off.

West Acre

Here in a deep valley, where the River Nar meanders through grassy meadows thickly strewn in summer with marsh marigolds, a priory was founded in 1198 by Ralph de Toni. The years have taken chapel and refectory as they have taken prior and monk, but some of the old walling stands in a farmyard, the old gabled gateway with its vaulted roof is by the fifteenth-century church, and many of the old stones are built into cottages.

The river makes a ford just below the church, which is reached by a short avenue of Irish yews, and is a pretty picture with its ivied tower and the ivied gateway by the green. On the other side of the green is an old wooden cottage on stone foundations, with jutting eaves. A Medieval stone in the porch, with worn carving of the Madonna, may be a relic of the priory. The

panelling of the east wall was made from an oak planted by Queen Elizabeth in Compton Park and into it have been set carvings of Liberty and Justice.

West Barsham

In a garden-like setting in the quiet of the byways is the small gathering of a towerless old church, the old hall, the new hall, and a farmhouse. Adding to the charm is a fine avenue of chestnuts, and lawn and shrubs by the little stream flowing to the Stiffkey, with tiny islands on which are flower beds round the trees.

The little church, forlorn and ruinous for so long, has been given a new lease of life. A fine stout roof covers the chancel, which is longer than the nave, and the arch between them looks crude enough to have been the work of the Saxons who made the two tiny round windows in the nave, splayed on both sides and glowing with red glass. At the side of a window with a sill serving as sedilia is a plain old piscine. The Norman doorway is blocked, and so too is the Norman window by the old porch, within which is a doorway from the close of the Norman days, with its round and pointed mouldings, zigzag hood, and banded pillars with carved capitals.

West Bradenham

It is scattered about a maze of narrow lanes with the River Wissey flowing through the grounds of the old vicarage below the church. Close by Bradenham Wood stands the eighteenth-century red brick hall lived in by the Haggard family for a hundred years, and to it once came Nelson's Lady Hamilton. That was long the name which made it most famous, but through many generations the Haggards were quiet country gentlemen who were content to be good landowners and farmed their Norfolk lands well, and here was born to them Henry Rider Haggard, a good farmer whose pen made his name known to millions.

Guarded by fine Scots firs on a lovely little hill stands the old church, which we enter by a tower built at the end of the fourteenth century. The chancel and the font are fourteenth century, the roof and the nave arcades are fifteenth. In the chancel are three great stone seats, a piscina, and an aumbry. An old chest like a family trunk has arches and classical pillars.

There are inscriptions to the Haggards, and the west window is their memorial; but there is no monument to Rider Haggard who wrote his way to fame.

West Dereham

The church of the abbey is now a storehouse and a barn, but such menial offices cannot rob it of its dignity or its standing as a footnote to history.

The archbishop lies in Canterbury, and it was long after his day that Thomas Tusser of Essex, the literary farmer who wrote Five Hundred Pointes of Good Husbandrie, came to live at Abbey Farm and put some of his points into practice. Norman statesman and sixteenth-century husbandman meet here on common ground.

At the break-up of the monasteries the abbey and its lands were granted to the old family of Dereham, one of whom was Francis Dereham, kinsman of Queen Katherine Howard and one of Henry the Eighth's victims. Memorials to Robert Dereham of 1612 and Thomas of 1723 are in the church, which stands on the little hill beyond the cottages and once had a companion church in the same churchyard. Another memorial is a marble figure in armour, keeping green the memory of Colonel Edmund Soame who fought in Ireland for William of Orange. The Normans built the sturdy round tower, which the fifteenth century crowned with an octagonal belfry of arcaded brick. The south doorway is thirteenth century; the fifteenth-century nave and chancel have been restored.

Fragments of old glass dotted about the east window, and a jumble of others in the nave, are said to have come from the abbey. The roodstairs and doorways are still here, with the medieval font and the Jacobean pulpit.

West Harling

A road lined with oak trees and meadows runs between East and West Harling, good neighbours in the pleasant valley of the River Thet.

West Harling's great house has been pulled down, and among the old trees that have gone were some making a ring to mark the site of an ancient church. The existing church stands neat and trim in a clearing of the parkland, greeting East Harling's church a mile and a half away beyond a vista of trees. Coming chiefly from the fourteenth century, and crowned by a tall square tower, it has windows five, six, and seven centuries old, and is still lighted by candles. There are fragments of old glass and ancient painting on the walls. Flemish panels in the oak reredos show the Annunciation, Bethlehem scenes with the Shepherds and the Kings, and Christ before Pilate. An old chest mouldering away has four locks and a round lid hollowed out from the trunk of an oak. Modern days have given the nave a hammerbeam roof and the chancel a barrel roof with flower bosses.

West Lynn

The ferry across the Ouse links it with King's Lynn, and it looks over the river to the towers of St Margaret's rising above the warehouses and the mass of jumbled dwellings. Though its own shipbuilding yard has been silent

too long in our time, the town has not lost all signs of its old importance; we see it in the big and handsome house in the main street, as well as in the church and the rectory, with many fine cedars and an attractive farmhouse close by.

A changeful history the cross-shaped church has seen since it replaced the church swept away by floods 700 years ago. Built in the thirteenth and fifteenth centuries, with a chancel of our own time, it has a leaning tower, and a sanctus bell ringing in the bellcot on the eastern gable of the nave. An ancient headless figure with its hands on its knees sits by the door, heads of men and eagles are on the pews, there is a Jacobean pulpit and a Jacobean screen with tiers of arcading and carved spandrels looking like a score of windows, and two old stalls have heads on the arm-rests and a figure kneeling at one end. One of the finest old possessions is the fifteenth-century roof of the nave, which has fourteen saints supporting the embattled tie-beams, and angels on the hammerbeams between. The lovely medieval font has thirty-three sculptured figures in scenes of the Seven Sacraments, as well as a representation of the Trinity, God the Father with the Crucifix. The fine brass portrait of Adam Outlawe of 1503, a knightly chaplain, shows him in his priestly vestments. The effective reredos shining with gold on a blue background, and carved in relief with the Crucifixion scene, has figures of Peter with the key and Paul with the sword, St George in silver armour with the dragon, and St Nicholas with three children in a boat.

West Newton

It belongs to the Sandringham estate, and owes its attractive cottages to King Edward the Seventh. The timbered village club is another royal gift. In the beautiful red-roofed lychgate, with carved oak pillars, we see Queen Alexandra's memorial to villagers who fell in the Great War. It leads to the fifteenth-century church in a churchyard like a lawn, set on a bank and looking over delightful woodlands.

Edward the Seventh restored the church when he was Prince of Wales, and at the same time the north aisle was rebuilt. It is a neat little place, with low arcades, and a modern screen dividing the nave and chancel, which have no arch between them. The old roodstairs remain. Old relics are a coffin stone, a Jacobean chest, and a 500-year-old font adorned with shields and crowned by its lovely old tapering cover, which is like a spire in four stages, richly pinnacled. It is black with age and is a rare treasure.

Most of the furnishing and much of the stained glass in the windows has been given by members of the royal family. The German Emperor gave the jewelled altar cross, two candlesticks, and vases. The only striking glass is a

fine memorial of the Great War, given by the Fifth Battalion of the Norfolk Regiment. It shows St George in black chain armour and a white tunic with the red cross. He has a great sword, and on his shield is the robed Christ on Calvary. In a diamond panel is a scene of the cliffs at Suvla Bay, recalling the story of the battalion's gallantry.

Weston Longville

It is an out-of-the-way village where a tiny cream-walled inn, old cottages, and a grey church with a low square tower gather about the small green, on which stands the peace memorial cross. A mile and a half away, in lovely woodland setting near the Wensum, is the moated Weston Old Hall, a charming brick house with gables and lawns; it is seen from the wayside, and was built by the Rakewoods in Tudor days. Between it and the village is the fine Weston House in its great park.

Except for some fifteenth-century windows, and the earlier tower arch, most of the church is fourteenth century, and is entered by an old door with a ring and a huge wooden lock. It is surprisingly spacious inside, and over the tall nave arcades is the fourteenth-century clerestory with five quatrefoil windows on each side. There is nothing finer here than the three stone seats for priests and the piscina in the chancel. Delicate clustered pillars support the cinquefoil arches round which foliage is trailing, some coming from the mouth of a wild man, and the branches held by a little man. The square hood over it all is carved with flowers and ends with two women's heads. The old font stands well on two steps in an open space, its bowl set on five pillars. In the floor under the altar table is the old altar stone, and old glass shows angels and saints. The fifteenth-century traceried screen is in almost perfect state, and has on the panels paintings of the Twelve Apostles, their faces and their storied emblems unusually clear. Simon has his fish, Jude a gold spear, and Bartholomew his knife. The big wall painting of a Jesse Tree brought to light in our time is none too clear, but parts of about a dozen figures are seen in the branches.

West Rudham

The stream growing up to be the River Wensum rises in this village, which has old farms, a seventeenth-century inn, ponds on its straggling common, and golden meadows coming down the hillside. Above an avenue of beeches stands the church, with a low tower reached by a rose-bordered path. The last years of the nineteenth century restored it from neglect. Three steps of a vanished porch, and a fine thirteenth-century doorway with unusual clustered shafts, lead us inside, where among the old stone corbels supporting

the roof are two grotesques with tongues put out, a quaint figure with legs turned in, angels, a civilian, a queen and two kings. The queen is said to be Jane Seymour, the kings Henry the Eighth and Edward the Sixth, unworthy father and shortlived son. The nave has a stout arcade 600 years old with a singular small arch at its west end and a tiny niche in a pillar which may have been a heart shrine. In the medieval chancel is a battered piscina. The old font is carved with shields, an almsbox is 300 years old, and there is a little old glass and quaint old poppyhead bench-ends.

West Somerton

Martham or Somerton Broad is the inland water of this sequestered spot, with a church on a little hill looking out to the sand dunes and the sea. The simple church has a fine thatched roof, and a round Norman tower with a fourteenth-century belfry. Other remains of the fourteenth century are the porch and the nave, though the window tracery is made new. The Tudor chancel has a priest's doorway and an old screen. The pulpit was finely and cunningly carved by a fifteenth-century craftsman who left on the pinnacled buttresses a gallery of tiny heads the size of a hazel nut. Some are laughing and demure, but most of them are gone, and those which are left have to be sought to be seen. The plain font is 500 years old, and the old rood stairway is still here. Among the fourteenth-century wall paintings which came to light last century is part of a Doom scene showing angels with trumpets and the dead rising from their graves. There is part of a St Christopher with the Holy Child, and part of the figure of Our Lord.

West Tofts

New forests are growing up about its heath and woodlands, and an avenue of limes leads us to its church in the rectory park. It has a grand old beech keeping company with the medieval tower. The medieval arcade remains on its clustered pillars, but the chancel and its chapel were built by Pugin last century. The chief interest in the church is in its ancient glass, which is said to have been burned in the Fire of London in 1666. That in the chancel windows has figures of St Helena, Mary Magdalene, and Judas in a white robe and a green cloak. There are two fine old chests, and the nineteenth-century oak screen, with a lovely canopy vaulted on both sides, is painted in medieval colours with much gold. High up in the chancel wall the striking doors which fold over the organ pipes are painted with scenes from Bethlehem, by a modern artist. Dame Elizabeth Sutton, who died on the eve of Waterloo, has a richly canopied tomb painted and gilded; it has angels at the corners and an elaborate brass cross.

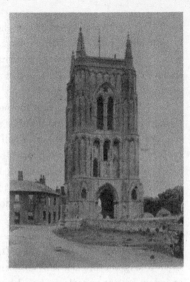

The thirteenth century tower at
West Walton

West Walton

Here where we found the orchards white with blossom, not far from the
River Nene, the marshmen built one of their grandest churches, ranking
with the best of the thirteenth century. It is a wonderful thing, in this big
and rather ordinary place, to come upon its magnificent campanile, towering
above trees and roofs, dwarfing the church from which it stands detached
with 60 feet between them. It is a mass of rich work from the ground to
the delicately carved parapet, resting on four open arches with beautiful
mouldings, through two of which we enter the churchyard. The great corner
turrets climbing to the lofty pinnacles have dainty niches in the lowest storey,
and are enriched on the other three stages with slender arcading continuing
round the tower. Not the least of its charms are the belfry windows.

The church is oddly askew here and there, and is said to have given way
soon after its building; but the ugly buttresses supporting the west end
cannot destroy the beauty of the doorway, with two openings under an
arch of rich mouldings dotted with flowers and resting on ten shafts with
foliage capitals.

The porch is charming, with an arcaded turret on each side of the fine arch.
It lost some of its depth when the aisles were widened 600 years ago, but still
shelters another lovely doorway with capitals of undercut foliage, framing
the old door with a wicket letting us into a flood of light. Of exceptional
beauty are the nave arcades, six bays on each side, the richly moulded arches

resting on pillars en-circled by detached shafts banded in the middle and crowned by capitals of graceful foliage. In the spandrels of the arches of the arcades are roundels showing the signs of the Ten Tribes of Israel, thought to have been painted about 400 years ago, and to be as good and complete as any in the land. Above all there are the clerestory windows.

The best view inside is from the sanctuary, where we see the beautiful chancel arch with its banded shafts as a frame for the gleaming arcades, the old font on three wide steps with half the nave to itself, and the fifteenth-century hammerbeam roof supported by twenty-four angels holding shields. The blocked arcades in the chancel led to aisles in olden days. Most of the windows are less attractive than the rest of the church, but one is a lovely old window of two lights, richly adorned with leaves and roses, with a quatrefoil for tracery.

Westwick

It has a magnificent park with lakes and groves and glades with great trees in lonely grandeur, a glory shared by a stately Queen Anne house and a handsome medieval church. Its fifteenth-century font has boldly carved roses and acanthus leaves, eight queer beads peering out below and four lions guarding its base. The screen, with rich tracery and panels of the Twelve Apostles, is 500 years old. In the modern east window is the Last Supper with angels looking down from the tracery.

West Winch

It has a windmill without sails and a high church tower with a 200-year-old clock. On the church porch is a sundial of 1706. The lofty arch of the tower reaches the roof inside. The old arcade has pillars of varying shapes, and the vestry is interesting for having a heavy old roof, a piscina, an aumbry with a niche above it, and a Norman stone in the wall. Three arches front the chancel, a great arch and two little ones; the font is old, there are a few old benches, and a fragment of the medieval oak screen, an almsbox on an old bench-end carved with a figure of Paul. There are four Evangelists on the altar rails, and the altar table is Jacobean.

Weybourne

The coast road brings us to old-world Weybourne, with its flint houses and narrow winding ways near the sea. We found it white and gold with hawthorn and gorse, and always the fir woods are a green mantle for the hill going down to the church. It is a quaint church, prettily set in the hollow with a house so close that it touches the north aisle; and it has an interesting

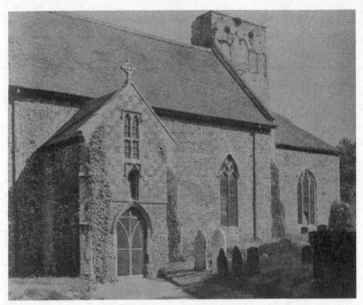

The medieval church with the tower of the early priory in Weybourne

story to tell and interesting remains to show, for it has something of an earlier Saxon church and a thirteenth-century priory.

It was Sir Ralph Mainwaring, lord of the manor and Chief Justice of Chester, who founded the priory in the time of King John, taking possession of the tower of a Saxon church and raising the priory church to the east of it. The old square tower, ruinous now, with bull's-eye windows over the blocked Norman windows of the belfry, still stands attached to the north side of the chancel, and other fragments of the priory church are the north wall, with seven clerestory windows and a splendid pointed arch.

Much of the present church is of the time of Richard the Second; but the fine west tower with panelled battlements is fifteenth century; so is the porch, with a peephole from its upper room. The two bays of the nave arcade are 600 years old. At each side of the old doorway is a bracket above a carved head. The new poppyhead benches are after the style of the few old ones (of which one is carved with a hooded head), and the Jacobean pulpit is mostly original. The chancel, looking rather odd with its old box pews and no east window, has an old piscina; and fragments of glazed ware, glass, and stone, are preserved in a case for us to see.

A five-storeyed tower windmill standing near is now a house. Here among the sandhills, which rise 200 feet and more above the sea, where the salt marshes begin and the sea's threat of invasion has never ceased in England's history, came the Angles in the very early days. Long before their time were the mysterious people who dug the pit-dwellings now so difficult to find in the hills above the dunes, and another link with the old, old far-off days is the tumulus in Hundred Acre Wood, a mile away.

Wheatacre All Saints

Its few homes are scattered, and its small wayside church stands on a little hill a mile or so from the River Waveney. The massive fifteenth-century tower, buttressed up to the belfry, and unusual in its masonry of chequered brick and flint, is the youngest part of the old church; the oldest is the thirteenth-century chancel and the south wall of the nave. The north wall of the nave comes from a widening in the fourteenth century, which resulted in the curious one-sided effect of a small arch by the original chancel arch, both being enclosed by a great arch reaching to the roof. Much of the fine oak chancel screen is as old as the tower, but the rest is much restored and with new vaulting; its bays have rich tracery, and the cornice has rows of leaves and cresting. The old font, painted red, green, and cream, has carving of roses, shields, and lions. Its elaborate old oak cover has pinnacles, and a spirelet richly carved. There is an Elizabethan chalice, and an altar tomb has an angel holding a shield.

Whissonsett

Its church has fragments from our three medieval centuries, and one thing much older—a Celtic cross carved with plaitwork. It was dug up in the churchyard, where a new cross now keeps green the memory of the men who did not come back. The church tower is fourteenth and fifteenth century, and we still come into the nave by the old door with a ring. It has barn-like white walls and bare windows, though with a little old glass. The font is fourteenth century.

Whitlingham

One delightful road to it runs under the woods of Crown Point Hall, through meadows dotted with flowers in spring, following the curve of the River Yare till it ends at the little church with a round Norman tower which collapsed while this book was printing. It has little else, this home of only a few folk, but its story goes back to fifty thousand years ago, when elephants and other giants were roaming about East Anglia. Here were found not long

ago 200 flint battle axes of the early Stone Age, buried deep down in an old gravel bed, some over a foot long, most of them with sharp, blade-like points, as if it were the store of some maker of weapons who had here carried on his craft.

Wicklewood

On the two roads winding upwards we find the cottages with blossoming orchards round about the windmill, and on the other the fifteenth-century church, in a churchyard with a fine pastoral view of the broad plain spreading below. It greets Deopham's lovely tower two miles away, and sees Hackford's church nearer still. Wicklewood's church is only an aisleless nave and chancel, with a tower which has a sundial over the massive entrance archway, and an ancient door with an old bar fastening. A tiny door in the tower opens to a winding stair which climbs to two rooms, each with a fireplace and one with an oven. A little old glass has a figure of a saint, and Christ with a sphere. The nave has its old piscina. There is a simple old chest, a fifteenth-century font, and new poppyheads better than the old ones keeping them company.

Wickhampton

Its landmark is the medieval tower of its lofty church, looking over a countryside dotted with windmills, with Yarmouth's great spire eight miles off. A wimpled woman and a hooded man guard the door through which we enter the 600-year-old nave of the thatched church; and the fine head of another woman and a boyish hooded face look from the arch leading to the chancel, built in the thirteenth and fourteenth centuries and with an east window of the fifteenth. More fine heads adorn the windows and on each side of the tower arch is a corbel carved with an ugly grotesque. The old chest is like a family trunk, the pulpit is Elizabethan, and a piece of an old pew on a wall has set the pattern for the seats, carved with tars and crosses.

Within two canopied recesses in the chancel lie a knight and his lady, who are said to have refounded the church while Edward the First was king. He has a lion at feet, with a flowing tunic over his armour, and has a sword, a shield, and a heart; she is charming in a wimple and long robe, with a headless dog at her feet.

Paintings of 500 years ago were found on the walls last century, and are more easily understood with the help of the small copies of them which were painted in memory of a churchwarden. In the story of the Three Living and the Three Dead Kings, told in a hunting scene, one of the figures has a falcon chained to his wrist, and one has hounds on a leash from which a hare is

running away. St Christopher is striding through the water with fishes about his feet, his legs bared to the knees, and holding a staff. The Child is not here. Dimly seen are some of the Works of Mercy, the clearest showing the visiting of prisoners, burying the dead, and clothing the naked. A prisoner has his feet in the stocks, a hooded figure is shovelling earth into a grave, and a nun is giving a robe to a man.

Wickmere

For 800 years a church has stood where Wick-mere's stands, and all this time the round tower of the Normans has remained like a castle keep. In our own time, while we have been touring Norfolk for this book, the old church has had its strength renewed in memory of the Earl of Orford. He lies in his earl's robes on a monument of English marble from Derbyshire, a fine figure carved by Esmond Burton, who has shown him with one hand on his heart and the other on his sword. In his memory the fabric of the church has been greatly strengthened by the insertion into the structure of imperishable metal rods. The ivy has been stripped from the walls and a concrete base formed to prevent the growth of vegetation, and the medieval parapet of the Norman tower has been rebuilt. It was found that the windows of the tower were being pushed outwards by the old wooden cases for the bells, and these have been renewed and the evil checked.

The lovely fifteenth-century screen, with three elegant bays on each side of the doorway and St Andrew still recognisable on one of the panels, has been restored, and is charming with the dainty pulpit beside it. There are old paintings on the walls, an old consecration cross, and verses from the Psalms; and on the sedilia at the ends of the arches and below the clerestoried windows of the nave are the stone heads carved by the medieval masons. The font is also theirs, and there are ancient bench-ends with poppyheads. The massive door which leads us in was also made by a craftsman 500 years ago, and still has the great iron boss and the heavy oak lock which have been on it all the time.

Wiggenhall St Germans

Off the beaten track, it is reached by miles of orchards, but is well worth the finding. The peculiar charm of a fenland village belongs to this trim community, where the River Ouse, broadening as it draws near the sea, and the Middle Level Cut draining the fens, lend to the landscape something of a Dutch character. Houses with cream walls, red roofs with dormers, the old hall with stepped gables, and the grey weathered church, cluster under the bank of the river, which is spanned by a big wooden bridge on trestles.

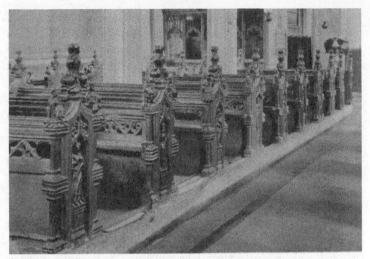

The richly carved oak benches of Wiggenhall St Mary the Virgin

The richly carved oak benches of Wiggenhall St Mary the Virgin

The old sanctus bellcot is on the nave of the medieval church, and the embattled tower has a fine arch and a hood carved with heads. Arcades with clustered columns rise under the fifteenth-century clerestory, and the great east window sheds a subdued light on the chancel, in contrast with the brightness of the nave and aisles.

To the seventeenth century belongs the pedestal pulpit with carved panels and the old hourglass in its stand, the reading desk and lectern, and a worn table in an aisle. Older still is the chest latticed with heavy iron bands. There is also a finely carved chair.

But the arresting sight here is the magnificent collection of benches, old and new and all richly carved, the new in the fashion of the old. Among the amazing variety of figures below the poppyheads are men and women being swallowed by monstrous jaws, as one clings to his money bags, one holds his sword, and another pours out his drink. Among the saints in canopied niches on some of the splendid ends are Stephen with a stone, one with a fish, Jude with his boat, Andrew, John, and Peter. Queer animals, sitting or climbing, are on other ends. Here and there we see a group of four little men, animals and other men, a priest blessing a man, and a monkey blowing a trumpet. Among modern carvings is a fine hunter with his dog, a curious broken tree with ugly beaked heads peeping from the branches, an animal dragging a bird, a chorister, and a priest.

Wiggenhall St Mary Magdalen

It is one of the family of four Wiggenhalls which lie among orchards and meadows where the River Ouse comes within sight of King's Lynn. The old farmhouse near the cottages on the river bank is called Crabb's Abbey, preserving the name which is all that is left of the Crabhouse Abbey of the nuns of Fontevrault.

The church is fine inside, with stately arcades, and ablaze with light. The font is old, and in the chancel are the old battered sedilia, and a stone altar not in use. Among the old woodwork, interesting for age rather than beauty, is some panelling with vine border on the east wall, screenwork across the vestry, a fragment of another screen by the south doorway, some loose panel paintings, and a few poppyhead benches.

Wiggenhall St Mary The Virgin

It lies among the orchards and cornfields of the remote fens where the Middle Level Main Drain meets the River Ouse, and has a charming group of vicarage, weatherworn church, and great house, all in the trees. The big house is St Mary's Hall which has grown round the brick gatehouse built

in the time of Henry the Seventh by the Kervilles; they were lords of the manor from the end of Norman days till the last of them died in Charles Stuart's day, leaving his tomb for us to see. It was made new when the fourteenth-century style of churches was changing to the fifteenth, but the doorways are a hundred years older, the south doorway charming with its rich mouldings resting on four shafts, and over it a fifteenth-century porch with a sundial of 1742. Arches on clustered pillars lead to the aisles. The old font has a quaint canopy cover of 1625 with a pelican at the top; the pulpit and an almsbox are also Jacobean. A Black Letter Bible is one of several old books, and the old hourglass stand is still here. The older chancel screen was replaced three centuries ago, and seven of the fifteenth-century panels with paintings of saints are kept in the vestry.

One of the treasures here is the brass eagle lectern with lions at the foot, and an inscription asking for prayers for Robert Barnard of 1518. It is one of about fifty that have been in our churches since before Reformation days. The great possession is the splendid collection of richly carved oak benches which are among the best in the land. Their backs are pierced with tracery. Their ends are adorned with fleur-de-lys poppyheads, small figures at each side, and some have larger figures carved in niches below—making a fine medieval gallery of saints, martyrs, disciples, men and women.

Wighton

The old windmill has lost its sails, and red-roofed houses line the road to the fifteenth-century church, looking down on golden meadows where we found the heron fishing in the River Stiffkey. In the lovely old doorway hangs a modern studded door with a border of quatrefoils, and carved on the porch are the head of Christ and a mermaid. Above the nave arcades is a clerestory of a dozen windows, and another window is over the chancel arch. In fourteen windows of the aisles is a portrait gallery of the Twelve Apostles with St Paul and St Barnabas. In a pillar of the chancel arch and one of the south arcade is one of the best newel rood stairways in the county. The font, set finely at the west end, is as old as the church. A rare possession is a medieval chest with a later lid, adorned on the front with rich tracery; a poor old chest of deal with two locks keeps it company.

When the vicarage was being built a hundred years ago part of the village's old story came to light with the finding of human bones and ancient pikes, believed to have been buried after a battle between the Saxons and the Danes. Two miles west are ancient entrenchments known as Crabb's Castle, where Roman coins and other ancient relics have been found.

Wilby

The village street with its thatched cottages twists and turns from the old church at one end to Wilby Hall at the other, the Elizabethan house having stepped gables and stacks of chimneys, attractive barns, and part of a wet moat shaded by trees. Built perhaps by one of the Lovells and used now as a farm, it was the home of the Wiltons in the seventeenth century. Robert Wilton has a stone in the chancel floor of the church describing him as a faithful patriot and a true lover of his country.

Chestnuts and firs, and a graceful copper beech in the garden of the house next door, are company for the quaint and lofty church, much of which comes from the fifteenth century, when the buttressed tower was built. The old porch has two ancient windows and a hood with two heads, one like a jester. The rather barn-like interior is filled with light. The great chancel, a little earlier than most of the building, has a lofty arch on clustered pillars, fine old tracery in the east window, and an old black and white roof. Here, too, is some of the Jacobean woodwork which furnishes the church—the altar table, the baluster rails, and the lower part of a screen. A screen under the tower arch, and a pillar almsbox with three locks, are of the same time. Massive oak benches with great poppyheads, carved along the backs, fill half the nave; they were perhaps made locally after fire swept through the church three centuries ago. Box pews of about 100 years later fill the other half, and between the two groups of pews rises the three-decker Jacobean pulpit with its canopy. Two coffin stones are carved with crosses, the fine old font is a little battered, and all that is left of a wall painting of st Christopher is a fragment showing the saint with its robes held up to keep them dry as he crosses the stream.

Wimbotsham

The church with a low tower stands high by the main road, and the houses line the byway to the green round which they gather with the smithy. The tower and porch come from the fifteenth century, the chancel and apse were made ne last century, but keep some ancient arcading under the eaves. The medieval windows of the nave are mostly restored, and between the two of them is a corner piscine, while in the frame of a fifteenth-century rood is the old stairway.

One of the three things left to take us back to Norman days is the tall north doorway, another is the beautiful south doorway (which has four shafts and arch mouldings of cable and zigzag, from which two faces peep out), the third is the chancel arch with roll mouldings and two shafts on each side. The apse's modern arch is elaborate with zigzags and medallions,

and the middle boss of its vaulted roof is elaborate with dragons, serpents and a lamb. Bosses with angels, quaint faces, and foliage are among the 500-year-old remains of the nave roof, but the great interest of the church is the array of medieval bench-ends. Some have quaint poppyheads, and in the gallery of figures carved on all the arm-rests, making a zoo of real and make-believe animals, are dogs, boars, lions, griffins and sheep.

Winfarthing

It is pleasant with cream-walled houses roofed with thatches and pantiles, and woodlands and meadows and ploughlands all around.

A possession which brought the village renown was a magnificent oak, once one of the biggest in the land, and now a decayed veteran held together by iron bands, with its enormous arms propped up. It stands north of the village on Lodge Farm, which is part of a thousand-acre deer park enclosed by the earl of Arundel early in the seventeenth century. Its hollow trunk is about 37 feet round. In a meadow close by is the hollow trunk of another oak, nearly 30 feet round.

Tall limes border the churchyard, and make a fine avenue to the church, which is mainly fifteenth century, with a fourteenth-century chancel and an ancient roof in its north porch. The roodstairs are still here, there is a priest's seat set in a window with a piscina beside it, the windows have fragments of old glass, and there is a Tudor chest and a Jacobean altar table. The treasure of the church is a fine Norman font with a bowl of fleur-de-lys set on carved pillars, one having a man's head and one a woman's. The clerestory above the nave has quatrefoil windows.

Winterton

It is loved for the sandy beach between the dunes and the sea, but it has a sad story to tell through its nearness to Winterton Ness, a dangerous headland once dreaded by sailors as much as any part of the coast between the Humber and the Thames. Daniel Defoe recorded that he found the village half-built of the timbers of wrecked ships, and gives a vivid picture of a shocking disaster of this part of the coast one night about 1692, in which were involved 200 light colliers from Yarmouth, a fleet of ships from the north, and vessels from Lynn and Wells laden with corn for Holland. Over 200 ships and a thousand lives were lost. In eighty years or so the Winterton lifeboat crew have saved 500 lives.

The fifteenth century gave the church two fine things—a splendid buttressed tower of flint and stone, looking from its 130-feet height to the dunes and the sea; and a stone porch which is one of the best in the county.

The tower, its walls flecked with yellow wallflowers when we called, climbs in six stages to a handsome crown of carved battlements adorned with pinnacles and figures, and over the panelling at its base is a band of chequered flint and stone. The porch has traceried windows and once had an upper room; shields and roses and faces are in the mouldings of the entrance arch, but the rich carving of the spandrels and the fine niches is wearing away.

The nave and the chancel (about 1400) are much restored. An unusual part of the church is a small thirteenth-century building on the north side of the chancel, entered by a pointed doorway and lighted by four lancets with trefoil heads in very thick walls. It is thought to have been built for one of the strange anchorites who lived immured in tiny cells, often sealed up to prevent contact with the world except for food and for a sight of the altar. Now this small place is itself a tiny chapel with an altar. The church has an old wooden almsbox and a seventeenth-century reading desk. The richly carved chancel screen, with a foliage cornice and deep cresting, comes from the end of last century.

An inscription here links Winterton with the nineteenth-century political philosopher Joseph Hume, who lived at the hall. In his young days he was a surgeon in the East India Company, and by the time he was thirty he was able to come home with all the money he needed. For thirty years he was one of our leading politicians, and though a bad speaker in Parliament he was a good leader for the abolition of abuses and an ardent advocate of freedom of trade with India. Untiring in exposing extravagance, his watchword was Peace and Reform, and it was largely owing to his efforts that flogging in the army, the Press Gang, and the old system of imprisonment for debt were abolished. He started the Savings Bank movement, and his daughter Eliza Greenhow, who has a memorial here, is remembered for the splendid work she did in helping on National Schools.

We found a unique thing here. It is the Fisherman's Corner, where almost everything is made from ships and has been to sea. It is railed off by ship's ropes and posts, and here ship's anchors lie. The curtains on each side of the altar are of fishing net, and a drifting net hangs by the wall. The Crucifix is made from ship's timber, the starboard lamp is on a windowsill.

Witton

Its houses are scattered between North Walsham and the sea, and its church stands aloof facing the park. It is one of the oldest churches in Norfolk, for the Saxons built the round tower and two round windows in the nave. The chancel and its rich sedilia are 700 years old, and the arcade is fourteenth century.

Wiveton

An old bridge spans the River Glaven as it flows through the marshes, quickening its gait as it nears the sea. Little channels of it, edged with blue irises, add to the charm of the lovely garden by the church. Wiveton Hall is halfway between the church and the shore.

Into the lovely view from the churchyard comes Cley under the woods, with its red roofs, its beautiful church, the windmill, and the sea, and in the view from the marshes is Wiveton's stately church on its little hill, the tower and the long nave and chancel standing darkly against the sky. It was made new in the middle of the fifteenth century and restored in the nineteenth, when part of the old chancel screen was set up under the tower. Splendid arcades divide the clerestoried nave and aisles, much of the old roof remains, the old font has rich but worn canopies round the stem, there is a massive candelabra, and an old iron chest with five locks has a lid which needs two men to lift.

Wolferton

If we should come in June the rhododendrons will bring us to this charming spot by heath and sea, along the roads that lead to its royal neighbour. Here old and new mingle. One of its old houses is the Tudor manor, with a stable built for the famous racehorse Persimmon, now known as Persimmon's drawingroom. The pretty black and white station with its flower beds is one of the best kept in the kingdom, the station for Sandringham.

No man can tell how long there have been dwellers by Wolferton Heath, where the sea-birds haunt the marshy ground and the shell-ducks make their nests in rabbit holes. On a grassy bank at the lovely corner near the station stands the village cross, keeping green the pleasant fancy that Wolferton's name arises from the conflict, famous in Norse mythology, between Tyr the god of war and Fenrir the demon wolf. Carved in wood and painted, the cross shows a great wolf striding over an early church, holding Tyr by the arm in its massive jaws.

Wolferton's church stands by the fields, its work of the three medieval centuries having been much restored. Beautiful within as without, it is impressive in its spaciousness, lighted by nearly all clear glass, and is enriched by fine woodwork in roofs and screens.

We enter through a lofty porch in which hangs a lamp of rich ironwork. The nave has a fifteenth-century clerestory over fourteenth-century arcades with tiny heads between their arches, and crowning it is a splendid roof both old and new; its old tie-beams have traceried spandrels and rest on figures in niches, with crowned figures on the intermediate hammerbeams.

These crowned figures are new and eight angels support the new roof of the chancel.

The old chancel screen has lovely modern vaulting and a vine cornice. Of the old screens of the chapels, that on the south is charming with carving of leaves and berries, quaint little heads, and faces on pinnacles and on the tips of the tracery. There is old and new work in the stalls and in the simple screen across the arch of the tower; and an Elizabethan chest with a table of the same age.

A rich pinnacled cover crowns the massive medieval font, there are beautiful stone seats for priests, a piscina, an old pillar almsbox, a gabled lectern of Florentine workmanship, and four stone coffins with battered covers. Over the chancel arch is part of a painted medieval Doom scene showing angels with trumpets and flags with symbols of the Passion.

Wolterton

Serene in its lovely park, here is the home of the Earls of Orford, descendants of our first Prime Minister, Sir Robert Walpole. His younger brother Horatio bought the estate after the old hall had been burned down, and built the new hall in its stead.

Part of the hall he built still stands, and in the park is a glorious avenue of oaks and beeches planted by his patron, Horatio Walpole. Here also the Norman tower still stands as the one relic of Wolterton's ancient church. The stones of the church itself are gone, and it is sad to relate that the man responsible for their removal was Sir Robert Walpole's son, second Earl of Orford, who succeeded his uncle as lord of the manor. Perhaps it was as an act of penance that for long years afterwards the funeral procession of each Earl of Orford drove slowly round the deserted churchyard on its way to the family vault at Wickmere.

Woodbastwick

The charm of English lanes and woodlands belongs to this delightful Broadland village, with houses finely roofed with thatch and mellow pantiles, gabled farmhouses, a thatched shelter for the pump on the green, and a charming sheet of Broadland water.

An oak lychgate leads to the churchyard, with its yews and chestnuts, and the little thatched church which restoration has robbed of much that was old. Only about a third of the fifteenth-century tower is left, the rest of it being new. The lofty nave has a stepped gable. In an old niche on the porch sits the restored figure of a saint (who had a bird's nest on his shoulder when we called).

The lovely old screen has delicate tracery above the arches, a band of quatrefoils on the base, and a new cornice of foliage and cresting. Dragons, a griffin, lions, and grotesque animals are on the armrests of the fine stalls, and the reredos has paintings in medieval colours of the Nativity scene with the Wise Men and figures of the Four Evangelists. The new oak pulpit and the new font are richly carved.

Wood Rising

Its trees justify the name of this little gathering of old thatched cottages, farm, rectory, hall, and an odd-looking medieval church. A mound with a bit of ruined wall is all that is left of the old west tower, the belfry now being a very quaint detached shelter with a great thatched roof.

An old door lets us into a nave all neat and trim with poppyhead pews, the high old box pew for the squire, a fine little Jacobean pulpit, and arches on clustered pillars. There are plain old sedilia and a canopied piscina.

One of the rectors was Sir Christopher Sutton, author of devotional works which influenced the Oxford Movement.

Woodton

Its church stands lonely by a farm, looking over to that of Bedingham. It is a plain little red-roofed building with a round Norman tower crowned in the fifteenth century by an octagonal belfry. Anne Suckling, wife of a lord of the manor in Cromwell's day, is an alabaster figure kneeling on a red and green cushion at her prayer desk; she may have been christened at the Norman font.

Wormegay

As we come into the village by the little bridge there are big mounds and a dry moat marking the site of the castle the Norman Bardolfs built, lording it over prior and priest, yeoman and labourer. The last Lord Bardolf lost lands and life fighting in the Northumberland rebellion which Shakespeare made the theme of his King Henry the Fourth.

On the small green at the other end of the village are two crosses, one from far-away days, the other in memory of the men who gave their lives for us. Nearly a mile away, among ploughed fields in the corner of a wood, is a small church, trim and well kept in its neat churchyard. The old tower has in its wall a stone sculptured with the Crucifixion, almost worn away, and said to have come from the priory. The chancel has fifteenth-century windows, and a tiny medieval piscina. The 500-year-old font is carved with quatrefoils and shields, an ancient coffin stone has a cross, and the old

roodstairs' doorways remain. One of several loose stones may be a Norman pillar piscina. A crude chair is made up of old oak.

Worstead

All the world knows its name, for worsted is named after it. We hear the word ringing down the centuries, and we remember that in the Paston Letters John Paston writes from London to his wife to send him worsted for doublets for he 'would make his doublets of worsted for the honour of Norfolk.' It was in Norman times that the little colony of Flemish weavers came across the North Sea to found this industry, and the church raised by them in their prosperity remains the finest spectacle in the town.

This grand building, built on foundations of worsted, was begun in 1379, and a few years later was as complete as we see it now, save for the vestry which was added in 1460. The tower is 109 feet high and has a sculptured doorway, a rich traceried opening halfway up, and modern pinnacles. The church has two fine doorways, the north with a rich cornice and the south with a two-storeyed porch, a lovely group of canopied niches over its arch, and a vaulted roof. All round the base of the flint walls runs a band of quatrefoils.

We come into the nave and find it like a small cathedral. The hammerbeam roof sweeps across with painted shields of benefactors standing out below the beams, and there is a painted angel in front of the tower arch, from which hangs the slender cover of the font. The cover is over 400 years old

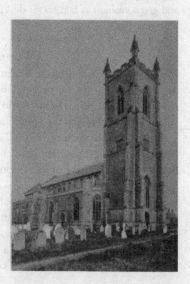

The fourteenth century church at
Worstead

and a masterpiece of tabernacle work worthy of the old font, which stands on a raised platform with its graceful bowl upheld by angels. There are more angels on the stone corbels supporting the roof and on the windowsill pedestals.

Great screens reach across the church, notable for their rich colouring and their fine design. They have double canopies and the panels are patterned in gold. The chancel screen has sixteen painted saints, with a figure of Our Lord as the Man of Sorrows among them; the screens across the aisles have each four panels with saints. The nineteenth-century screen across the arch of the tower is panelled with paintings of the Eight Virtues copied from Sir Joshua Reynolds, and above the screen is a panelled gallery which has been resting on its carved and painted wooden pillars since 1500.

On the walls of the nave are faint traces of medieval paintings, and on the chancel walls are two consecration crosses two feet wide. There is also a medieval mass dial. There are three brasses with portraits of men who worshipped here 500 years ago: John Yop a rector, Sir Robert Chamownde who died in 1492, and John Albastyr who is said to have given the chancel its fine screen.

Worthing

One of the tiniest of churches belongs to this village scattered along the lanes, near the stream which turns a water mill as it flows to the Wensum. Its round Norman tower is not so high as the ridge of the nave roof, and has an old pointed arch. A Norman doorway with pillars and zigzag moulding opens to a church without an east window. The rather odd font may be Norman, and the chest is Jacobean.

Wroxham

With its name comes a vision of a silver sheet of water fringed with reeds, and the sails of yachts heeling in the breeze, for here is Wroxham Broad. A mile long, over 100 acres, it is the queen of all the Broads in this beautiful country of lakes and woods and marshland through which the River Bure winds without a lock for thirty miles. Here there is nearly always a breeze for sailing. Though it is always beautiful, Wroxham Broad is most delightful in summer when the sedge warblers trill from dawn to dusk; and especially gay are the scenes here in August, the time of the famous regatta.

Over a mile from the Broad is the bridge spanning the river in one graceful arch, and here we look on animated scenes of boats coming and going on their adventures. A lovely avenue of oaks leads to houses in gardens sloping down to the river, their trees keeping the wind from the sails that pass this

way. It is like a fairyland with the little lawns at the water's edge and the small houses set back behind their gardens. Lord Kelvin knew one of these gardens, and heard the sudden surge of water breaking the silence as yachts raced by, for he stayed here with his two artist nieces, Elizabeth and Agnes Gardner King, who lived at the house called Hartwell in a garden like a veritable fairyland in summertime. The sisters lie in the lovely churchyard where the church stands on a steep bank above the stream, a peaceful corner of the village, and through the old oaks is a view of river and marsh, and a glimpse of the seventeenth-century manor house with its quaint stepped gables.

The fifteenth-century porch shelters the oldest and finest thing the much-restored church has, a splendid Norman doorway, deeply recessed and much enriched. There is zigzag and interlaced arching among the four fine bands of carving in its rounded arch, and three carved pillars on each side have carved bosses and capitals. Among their quaint sculpture we see a little man holding two serpents, crude and grotesque fellows, and three faces peeping out from foliage. This magnificent arch is a handsome frame for a 500-year-old door with its old ring and its big wooden lock.

The tower with its pretty sound-holes, the nave arcades, the clerestory, and the old rood stairway are all fifteenth century, and there is an ancient peephole from the south aisle. Most of the nave roof is old, and angels are holding shields at the ends of the beams. In the pulpit are fragments of Elizabethan panelling.

Wymondham

A fine windmill with its sails still turning keeps green the spirit of the past in this charming market town, home of about five thousand people, where the priory founded by Henry the First's chief butler was made an abbey six centuries ago.

Quaint and delightful is the octagonal market cross, built of brick and wood 300 years ago, with an outside wooden stairway leading to what is now a reading room, crowned with a pyramid roof and a weathercock, and resting on timber stilts and carved arches. The most charming of many old houses is the Green Dragon inn, which once belonged to the priory; it has latticed windows in the oak arcading of the ground floor, a timbered overhanging storey, and a little dormer in the roof. Thomas Becket's Well near the church has a bountiful supply of water, and the medieval chapel dedicated to the saint is now a church room after having been used as a school.

An array of Scots pines adds a romantic touch as we come to Wymondham's noble church, which is of commanding beauty and strange of aspect with

two splendid towers, both looking rather unfinished with plain tops. They rise at the east and west ends of the building, which is imposing outside with a fifteenth-century clerestory and a handsome porch adorned with niches, bands of quatrefoils, and a carving of the Annunciation.

Striking as it is today, it was finer still when it belonged to the priory, for now only isolated fragments are left of the church used by the monks. In the old days the octagonal tower was in the middle of a cross; now it is at the east end of the church, a hollow shell lighted by fine windows, and of more slender grace than its handsome neighbour at the west end. The nave of the priory church has always belonged to the parish, and it was owing to dispute with the monks about ringing the bells of the central tower that the town's people built their own west tower in the fifteenth century, enriching it with eight-sided buttress turrets at the four corners, and giving it the stately height of 142 feet.

Through the west doorway (with deep mouldings) we step into the dim interior of the tower; then a door opens to the church and words fail to describe the sudden burst of glory. It is a wonderful picture of a majestic Norman nave of gleaming stone, nine bays like an avenue 112 feet long. Massive square piers support arches enriched with zigzag, cable, lattice, star, and key-pattern mouldings, while the Norman triforium and the fifteenth-

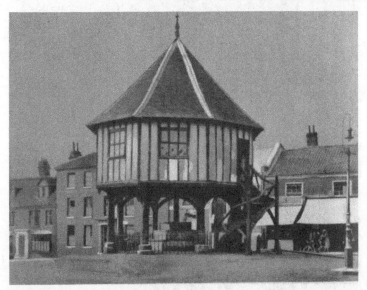

The seventeenth century market cross at Wyondham

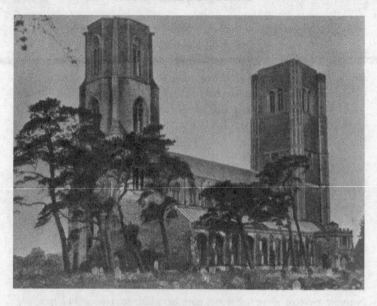

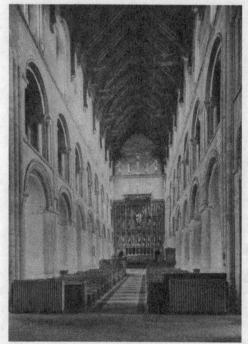

Above: The magnificent church at Wyondham

Left: The majestic Norman nave at Wyondham

century clerestory carry the eye to the exquisite hammerbeam roof, 500 years old and adorned with seventy-six angels and lovely bosses like stars of leaves.

At the end of the vista is the canopied reredos filling the east wall and shining with gold, an amazing mass of delicate carving with figures of fourteen saints and the Madonna in canopied niches, and a representation of Our Lord enthroned. It is a lovely thing of our own day (for it is the peace memorial), completing a picture of centuries ago. Above it are the rood figures, and by the altar are silver candlesticks with candles taller than men.

From the east end we look to the tower with its own vaulted roof, and its wonderful arch reaching to the roof of the nave. The tower serves as the organ chamber, below which an enriched arch spans the lofty pointed one. The north aisle was widened in the fifteenth century, the age of its fine roof with forty-two angels. The battered font stands on three steps, its bowl enriched with symbols of the Four Evangelists and angels with shields. The east end of the nave serves as the chancel, and here, under a blocked Norman arch, is a sixteenth-century structure in terracotta, with pillars and three tabernacled arches, perhaps intended for sedilia. In old glass we see the Madonna, the Nativity, the Crucifixion, and the Resurrection.

Wymondham keeps alive the memory of a feud far more tragic than that between monks and townspeople. Somewhere in its streets lived Robert Kett the tanner, who was the leader of the rebellion which ended in such misery and bloodshed at Norwich in the times of the Reformation. There is near here an oak still flourishing by the roadside, railed round and known as Kett's Oak, and by it we may pause in recollection of unhappy days of long ago, for though there are several Kett's oaks in Norfolk there is no doubt he knew this one, and it may well have been a meeting-place of his followers.

Yarmouth

It is one of England's famous gateways and a marvellous playground for her people. Its sands are magnificent; its sea-front is five miles long; it has one of the finest quays in Europe; and it has been a flourishing port since the Conqueror's day. On any summer's day it is one of our national spectacles; on any summer's night it is like a scene from fairyland. Its seaside gardens are a wondrous sight to see, with pools and rockeries and flower beds and green verges, and along its gay and beautiful front are seats for 25,000 people, with mile after mile of coloured lights at night. On its Central Parade is a great circular arena for outdoor performances, with sliding glass screens and a roof promenade, and next to it are bowling greens with cascades and fountains illumined by changing lights.

Even if Great Yarmouth had no sea it would be a captivating old town, with streets by the score which make us think of Naples or the old hill towns of Italy; but it is, of course, the sea which has made this old place what it is, one of our chief fishing towns, with three rivers pouring themselves into the sea. They are the Bure, the Waveney, and the Yare, flowing into the North Sea through a channel made in the 1560s by the Dutch engineer Joost Jansen, the old channel having become so choked with sandbanks that trade was stopped. In early days the three rivers formed a wide estuary which the Romans called Gariensis, guarding its entrance by military stations—one in the north at Caister, one in the south called Gari-anonum, of which the ruins (known as Burgh Castle and actually in Suffolk) are still to be seen. Yarmouth owes it peculiar situation to the forming at the mouth of these rivers of a sandbank, which grew into the long tongue of land joined to the mainland on its north side. It was a sandy islet in Saxon days, where the fishermen built their huts.

The old town clusters round the quay, and here we find the unique feature of Yarmouth, the Rows, the amazing huddlement of 140 alleys as quaint as anything in England. Dickens likened them to the bars of a gridiron. Growing up on a sand-drift, Old Yarmouth had little room for wide streets, and so narrow are some of these Rows that we can almost touch both sides as we walk through them; so jumbled are the houses that many of their walls and yards are whitewashed to give reflected light. In Tudor days a special cart was devised for traversing these alleys, with the wheels set under the body. Although the Rows are now numbered, some of them keep their quaint old names, and some of them still have signs of the better days when rich folk lived in them. An old house at the end of one Row has a plaster ceiling with flowers and the arms of James the First; Row Fifty-Seven (Middlegate Street) has remains of a monastery built by the Greyfriars 600 years ago; in Row Fifty-Seven lived Sarah Martin, Yarmouth's good angel. Number Four South Quay has an Elizabethan house with a modern front which still keeps its old panelling, ceilings, and chimneypieces; it was the home of Cromwell's friend John Carter.

Of the old fortifications of the town, which were over a century in building in the Middle Ages, there are still some remains in the walls, which once had towers. We know what Yarmouth was like in Tudor times from old Thomas Nashe, who describes it as having a flinty ring of sixteen towers which sent out thunder whenever a Spaniard dared to come near. Parts of ten of these towers remain.

As fishing gives the town its most remarkable spectacle today, so it has given the old town its most charming corner, a place where the Fishermen's Hospital stands at the shaded end of one of the biggest marketplaces in the

world, close by the parish church of St Nicholas and the timbered house in which Anna Sewell, the author of Black Beauty, was born. Built round three sides of a square, this fishermen's charity is a lovable place, with gables, dormers, and a cupola sheltering the figure of the patron saint, another figure of Charity crowning a pedestal in the quiet courtyard. For 200 years it has been the tranquil home of twenty old fishermen when their stormy days are o'er; we have only to go down to the shore when a gale is blowing to realise what their stormy days were like. A fine sight it is to watch the ships making the harbour when a heavy sea is running. There is great excitement in the coming and going of the herring fleet, and the spectacle of this harbour in a storm so impressed Turner that he painted it. Hardly a winter goes by without a stirring battle for life being fought out here, and it was the wreck of a ship and seventy lives in this place which led a Norfolk man, George Manby, to invent his life-saving rocket. Standing here watching that dread event, he saw that the chance of saving life would have been much greater if a line could have been thrown to the ship, and he went home to think it out, so that today there are over 300 of his rockets in use, and thousands of lives have been saved by them.

Near Yarmouth's nineteenth-century Town Hall stands its old Tolhouse, one of the oldest municipal buildings in England, a gaol and a courthouse

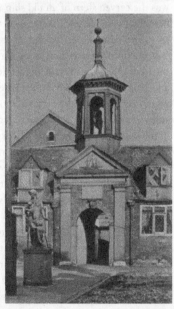

The Fisherman's Hospital at Old
Yarmouth

The ancient tollhouse at Old Yarmouth

till the end of last century, when it was given better work to do, housing first the library and now the museum. The museum is housed in the main hall, which has a fine timbered roof, and among the many things we found here was the carved stern of an old ship wrecked off Yarmouth, beams to which prisoners were chained in the bad old days in the dungeons down below, an old watchman's rattle, and a penny-farthing bicycle.

It was in this place that Sarah Martin started her work. Here she came to read the Bible to men and women locked up in a room not fit for animals, and year after year this poor seamstress appealed to the town to wipe this foul prison away. She brought with her to this place the little prayer book we may still see in the church, reading it to these wretched prisoners. She held a school in the vestry of the church for factory girls. She found these wretched folk in underground cells thrown together regardless of age or sex and without any sanitation, and she fought until the town removed this shame. She worked among them for twelve years with little money but her earnings, and her name became so revered in the town that when she died a bishop declared that he would canonise Sarah Martin if he could.

Near the Fishermen's Hospital stood the ancient priory founded by the first bishop of Norwich, builder of the cathedral; the old dining-hall of the monks was restored last century and is now a school. In the playground of the modern grammar school are the ruins of St Mary's Hospital where sixteen poor folk found a quiet home 700 years ago. Here still are fragments

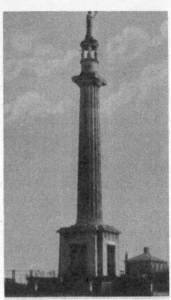

The Nelson Monument at Old Yarmouth

of the old town walls with stone seats where the watchmen sat. Old carved figures in one of the classrooms show us the boys and girls of long ago, the girls in blue frocks and white tuckers, the boys in breeches and black coats. The town hall, dominating the harbour with its clock tower, is nineteenth century, but it is a fine home for old pictures and charters of the town, the civic regalia, and an old chest called the Yarmouth Hutch.

Yarmouth has given itself an infinite variety of appeal. It has public gardens which are a picture all the summer through, charming walks, and everything the holidaymaker needs. Its handsome peace memorial to nearly 1500 men stands in St George's Park; the other great monument of the town is the Nelson Monument, standing so proudly on the front, crowned by a figure of Britannia and bearing the names of four of Nelson's battles, Aboukir, Copenhagen, St Vincent, and Trafalgar. We climb over 200 steps for the splendid view from the top, 144 feet above the street. Another of the town's great landmarks is the tower built for its water-supply on a hill at Caister; it is 162 feet high and 225 feet above sea-level.

The glory of the town is its noble parish church, a marvellous place from the time of King John, built in the shape of a cross, 236 feet long, 112 feet wide, and covering an area of more than 23,000 square feet. It has a central tower and spire rising above a mass of gable roofs and tall turrets, crowned

with lofty little spires. The three gables of the great west front crown the nave and the aisles, each of the aisles being nearly twice as wide as the nave itself. Under three windows with carved hoods is the west doorway with four columns on each side, its door hung on beautiful iron hinges. The huge porch has stone seats and a vaulted roof.

The church was founded by the founder of Norwich Cathedral, but the restorers have left little from his day save some Norman masonry in the bottom of the tower. The nave is from the days of King John, and the aisles were widened in 1286 to accommodate about twenty chapels. These were swept away at the Reformation when the monumental brasses were turned into weights and measures for the town and the gravestones were turned into millstones. The transepts are six and seven centuries old, but the east end of the chancel was refashioned in the eighteenth century. A little of the glass which dims the vast interior is old, the work of a sixteenth-century German artist showing Eli in blue, Samuel in purple, a head of St Andrew, and a gold vessel on a table. One great window is a tribute to Yarmouth's glorious dead, glowing with fine shields, a figure of Britannia, and portraits of national patron saints: George of England and Joan of France in armour, Saba of Serbia as a bishop in green robes, Michael of Belgium in gold, the Madonna in blue for Italy, Bishop Nicholas with a boat for Montenegro, Liberty for America, and a Samurai warrior (in a quaint cap) for Japan. The names of over 800 heroes, inscribed on vellum, are on the shelves of a curious Elizabethan reading desk which may have been used in the old priory joining the church, its six shelves so arranged that by a system of cog wheels they remain horizontal as they revolve for the reader to reach any book he wants.

A window to another of Yarmouth's heroic spirits has the Good Samaritan, Peter escaping from prison, and Christ's charge to Peter, a tribute to Sarah Martin; here in the church is kept the prayer book she used to take with her when she visited the Old Tolhouse. Hanging on the walls are naval flags as symbols of Yarmouth's service at sea and in the air, and out of the sea has come one of the strangest possessions we have found in any church, part of the skull of a whale cast up on the beach a few years before the Armada. It has been made into a big seat, and stood for 200 years in the churchyard. Hundreds or thousands of brides have hurried to sit on it, for they will tell you here that who sits first on this seat will rule the house.

The remarkable wooden pulpit was made last century to match the size of this vast church; it is like a small room and may be the biggest in England, twelve feet long and 4 feet wide. Round it are sixteen big sculptured figures under canopies. Patriarchs, Prophets, Apostles, Evangelists, a priest and a

king. There are carved panels of the feeding of the 5,000, Christ blessing little children, the miraculous draught of little fishes, and John the Baptist preaching. The staircase is enriched with carving of vines and wheat. The font is 600 years older than the pulpit, and the chancel has both old and new stone seats for the priests, with a piscina on clustered shafts. The reredos is modelled from the one destroyed in the sixteenth century and has original doorways at each side; the modern stalls have a great company of poppyheads, making a fine avenue down the middle of the chancel. They are carved with angels and figures of the Good Samaritan, the Prodigal Son, Mary in the Garden, and the Woman at the Well. Fixed on a wall are carved panels from ancient seats used by the corporation in Queen Elizabeth's day, and in one of the roofs are medieval bosses with red and gold heads of lions. Carvings of a king and a bishop watch over the east window of the north chancel aisle, and a striking copy of the Rubens painting of the Elevation of the Cross hangs in a transept. The church has three interesting old Bibles, one printed in 1541.

One of the oldest memorials is the prior's tomb in the north aisle, with a battered coffin stone under a recess, probably belonging to Prior Hoo of the fourteenth century.

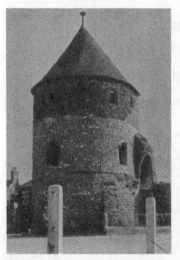 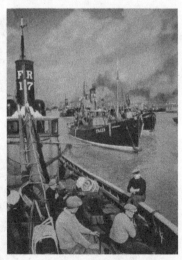

Left: A medieval tower at Old Yarmouth

Right: The drifters of Yarmouth

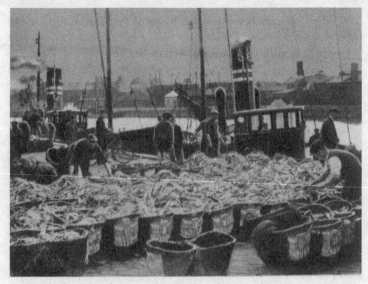

Yarmouth's herring industry workers packing fish in baskets

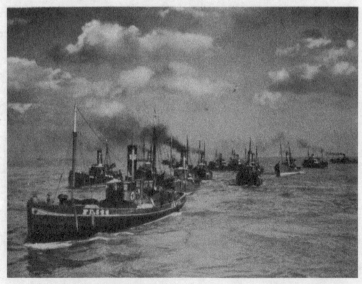

Yarmouth drifters homeward bound

Yaxham

A sundial reminding us that our days on earth are as a shadow is on the clerestory wall of the fourteenth and fifteenth-century church, with a round Norman tower crowned by a 600-year-old belfry. Over its crude archway to the nave is an equally crude doorway. Clustered and eight-sided pillars support the arches of the one arcade On a step adorned with quatrefoils stands the beautiful fifteenth-century font, of which the stem and the base of the bowl form traceried and vaulted canopies, with finials rising to the top of the bowl. It is sumptuous and elegant, and has been copied in the church at Cromer. A battered coffin lid has a cross and part of the Omega emblem, and roundels and shields of old glass remain.

Yelverton

Down one of the byways five miles from Norwich we come to this small village on a slope near a heath, with a few houses and farms, a pond at the cross-roads, and a wayside church buried in trees. Lofty and cared-for, the church has twelfth-century walls in the nave and part of the chancel, which is entered by a 600-year-old arch. The porch, the south aisle, and the tall arcade are fourteenth century; the flint tower with dark red brick battlements comes from the sixteenth. A Jacobean bench has a carved back. The roodstairs climb through a window splay, and the oak chancel screen of about 1500, made partly new, has its old base with original paintings of angels and a landscape of quaint trees and hills.

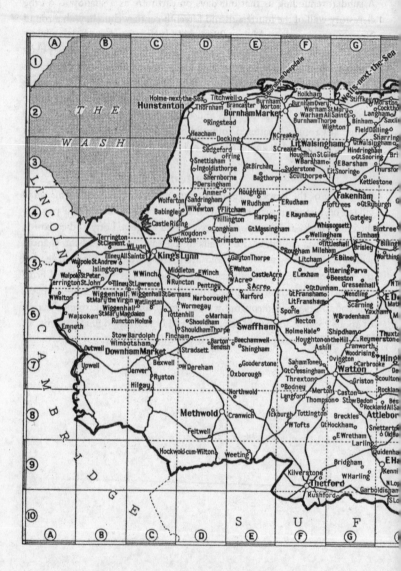

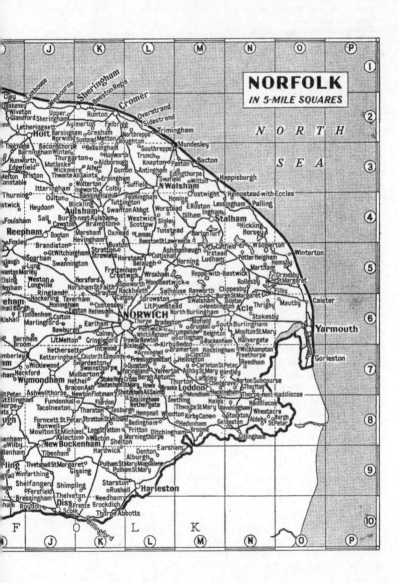

NORFOLK
IN 5-MILE SQUARES

NORTH

SEA

NORFOLK TOWNS AND VILLAGES

In this key to our map of Norfolk are all the towns and villages treated in this book. If a place is not on the map by name, its square is given here so that the way to it is easily found, each square being five miles.

Frenze	J10	Heckingham	M7	Kilverstone	F9	NarfordE6
Frettenham	L5	Hedenham	M8	Kimberley	J7	Necton F6
Fring	D3	Hellesdon	K6	King's Lynn	C5	Needham K10
Fritton	L8	Hellington	M7	Kirby Bedon	L7	Newton
Fundenhall	J8	HemblingtonM6		Kirby Cane	M8	Flotman K7
		Hempnall	L8	Knapton	L3	North
Garboldisham	FI9	Hempstead-				Burlingham M6
Gateley	G4	with-EcclesN4		Lamas	L4	North Creake F2
Gayton Thorpe		Hemsby	O5	Langford	F8	North Lopham
	E5	Hethel	K7	Langham	H2	H9
Geldeston	N8	Hethersett	K7	Langley	M7	Northrepps L2
Gillingham	N8	Hevingham	K4	Larling	G9	North
Gissing	K9	Heydon	J4	Lessingham	M4	Runcton C5
Glandford	H2	Hickling	N4	Letheringsett	H2	North
Gooderstone	E7	Hilgay	C7	Litcham	F5	Tuddenham H5
Gorleston	O7	Hillington	D4	Little		North
Great Bircham	E3	HindringhamG3		Fransham	F6	Walsham L3
Great Cressing-		Hingham	H7	Little Melton	K6	Northwold E8
ham	F7	Hockering `J6		Little		Norton
Great Dunham	F5	Hockwold-cum-		Plumstead	M6	Subcourse N7
Great Elling-		Wilton	D9	Little Snoring	G3	Norwich L6
ham	H8	Holkham	F2	Little		
Great Frans-		Holme HaleF6		Walsingham	G3	Ormesby St
ham	F6	Holme-next-		Loddon	M7	Margaret O5
Great		the-Sea	D2	Long Stratton	K8	Oulton J4
Hockham	G8	Holt	J2	Ludham	M5	OutwellB7
Great		Honing	M4	Lyng	J5	Overstrand L2
Massingham	E4	Honingham	J6			Ovington G7
Great		Horning	M5	Marham	D6	Oxborough E7
Ryburgh	G4	Horsey	N5	Marlingford	J6	OxneadK4
Great		Horsford	K5	Marsham	K4	
Snoring	G3	Horsham St		Martham	N5	Palling N4
Great		Faith	K5	Matlaske	J3	Paston M3
Walsingham	G3	Horstead	L5	Mattishall	H6	Pentney D5
Great Witching-		Houghton	E4	Mattishall		Poringland L7
ham	J5	Houghton-on-		Burgh	H6	Postwick L6
Gresham	K2	the-Hill	F7	Mautby	O6	Potter
Gressenhall	G5	Houghton St		Melton		Heigham N5
Grimston	D5	Giles	G3	Constable	H3	Pulham St
Griston	G7	Howe	L7	Merton	G7	Mary K9
Guestwick	H4	Hunstanton	D2	Methwold	D8	Pulham St Mary
Gunton	L3	Hunworth	H3	Metton	K2	Magdalene K9
				Middleton	C5	
Hackford	H7	Ickburgh	E8	Mileham	G5	
Haddiscoe	N8	Ingham	M4	Morningthorpe	L8	Quidenham H9
Hales	M8	IngoldisthorpeD3		Morston	H2	
Halvergate	N6	Ingworth	K3	Moulton St		Rackheath L5
Hanworth	K3	Intwood	K7	Mary	N6	Ranworth M5
Happisburgh	M3	Irstead	M5	Moulton St		Raveningham N8
Hardley	M7	Islington	B5	Michael	K8	Reedham N7
Hardwick	K9	Itteringham	J3	Mulbarton	K7	Reepham J4
Harleston	L9	Mundesley	M3	Mundesley	M3	Repps-with-
Harpley	E4	Kenninghall	H9	Mundham	M7	Bastwick N5
Hassingham	M7	KetteringhamK7				Reymerston H6
Heacham	D2	Kettlestone	G3	Narborough	D6	Ringland J5